D0203757

A Distant City

Chiara Frugoni

A Distant City

*Images of Urban Experience
in the Medieval World*

TRANSLATED BY

William McCuaig

PRINCETON UNIVERSITY PRESS
PRINCETON, NEW JERSEY

LONGWOOD COLLEGE LIBRARY
FARMVILLE, VIRGINIA 23901

N
5975
.F7813
1991

Copyright © 1991 by Princeton University Press
Translated from Chiara Frugoni, *Una lontana città.*
Sentimenti e immagini nel Medioevo.
Copyright © 1983 Giulio Einaudi editore s.p.a., Turin.
Published by Princeton University Press, 41 William Street,
Princeton, New Jersey 08540
In the United Kingdom: Princeton University Press, Oxford

All Rights Reserved

Library of Congress Cataloging-in-Publication Data

Frugoni, Chiara, 1940–
[Lontana città. English]
A distant city : images of urban experience in the medieval world /
Chiara Frugoni ; translated by William McCuaig.
p. cm.
Translation of: Una lontana città.
Includes bibliographical references and index.
ISBN 0-691-04083-4 (cloth : alk. paper)
1. Art, Medieval—Themes, motives. I. Title.
N5975.F7813 1991 709'.02—dc20 90-8876

This book has been composed in Linotron Bembo

Princeton University Press books are printed on
acid-free paper, and meet the guidelines for
permanence and durability of the Committee
on Production Guidelines for Book Longevity
of the Council on Library Resources

Printed in the United States of America by
Princeton University Press, Princeton, New Jersey

10 9 8 7 6 5 4 3 2 1

LONGWOOD COLLEGE LIBRARY
FARMVILLE, VIRGINIA 23901

*To the smiling gaze of
Silvano, Andrea, and Marta as
they read these words*

Contents

Illustrations

modern restorations). Milan, Sant'Ambrogio, apsidal vault. (Photo: Saporetti, Milan.)

30. *Bull of Henry IV*, 1065. Hannover, Staatsarchiv. (Photo: Hauptstaatsarchiv, Hannover.)

31. *Triumph of an Emperor*, Byzantine fabric, ca. 1000. Bamberg, cathedral treasury. (Photo: Limmer, Bamberg.)

32. *Christ among the Apostles*, mosaic, ca. 400. Rome, Santa Pudenziana, apse. (Photo: Istituto centrale per il catalogo e la documentazione, Rome.)

33. *The City of Ravenna*, mosaic, first quarter of the sixth century (with alterations after 527). Ravenna, Sant'Apollinare Nuovo, nave. (Photo: Anderson-Alinari, Florence.)

34. *The City of Classe*, mosaic, first quarter of the sixth century (with alterations after 527). Ravenna, Sant'Apollinare Nuovo, nave. (Photo: Alinari, Florence.)

35–36. *Procession before the Emperor Arcadius*, reliefs from the west and south sides of the column of Arcadius at Constantinople (ca. 404), now destroyed (from a drawing by D. W. Freshfield, enlarged by Mario Epifani, Pisa.)

37. *The Construction Activity of the Archbishop Anno*, illumination from the *Life of Anno*, ca. 1183. Darmstadt, Hessische Landes und Hochschulbibliothek, MS 945, f. 1v. (Photo: Hessische Landes und Hochschulbibliothek, Darmstadt.)

38. Tommaso da Modena, *Saint Catherine with a Model of Treviso*, fresco, sixth or seventh decade of the fourteenth century. Treviso, Santa Caterina. (Photo: Fini, Treviso.)

39. Taddeo di Bartolo, *The Bishop s. Gimignano*, panel (detail of the panel with *s. Gimignano and Histories of His Life*), 1393. San Gimignano, Museo Civico. (Photo: Alinari, Florence.)

40. Taddeo di Bartolo, *Sant'Antilla with a Model of Montepulciano* (detail of the altarpiece from the high altar), tempera on panel, 1401. Montepulciano, cathedral. (Photo: Grassi, Siena.)

41. Meo da Siena (collaborator of), *The Bishop Ercolano*, tempera on canvas, glued to a panel, fourteenth century. Perugia, Galleria Nazionale dell'Umbria. (Photo: Alinari, Florence.)

42. *The City of Verona*, illumination, ninth–tenth centuries (from a copy by Scipione Maffei, after 1739, of the lost original). Verona, Biblioteca capitolare, MS 114 (106), ff. 187v–188r. (Photo: Roncaglia, Modena.)

43. Bicci di Lorenzo, *San Nicola da Tolentino Protects Empoli from Divine Wrath*, panel painting, ca. 1450. Empoli, Santo Stefano. (Photo: Soprintendenza per i beni artistici e storici, Florence.)

44. Jacopo di Cione, *Coronation of the Virgin*, tempera on panel, 1373. Florence, Uffizi. (Photo: Soprintendenza per i beni artistici e storici, Florence.)

45. Duccio di Boninsegna, *Temptation of Christ on the Mountain* (detail from the predella of the *Maestà*), tempera on panel, 1311. New York, Frick Collection. (Photo: Frick Collection, New York.)

Abbreviations

CC	*Corpus Christianorum*, cited by volume and page number
CSEL	*Corpus Scriptorum Ecclesiasticorum Latinorum*, cited by volume and page number
DBI	*Dizionario biografico degli italiani*
JWCI	*Journal of the Warburg and Courtauld Institutes*
Kaftal, TS	G. Kaftal, *Iconography of the Saints in Tuscan Painting*. Florence: Sansoni, 1952.
Kaftal, CS	G. Kaftal, *Iconography of the Saints in Central and South Italian Schools of Painting*. Florence: Sansoni, 1965
Kaftal, NS	G. Kaftal, *Iconography of the Saints in the Paintings of North East Italy*. Florence: Sansoni, 1978
Kaftal, NW	G. Kaftal, *Iconography of the Saints in the Paintings of North West Italy*. Florence: Le Lettere, 1985.
MEFRA	*Mélanges de l'École Française de Rome—Antiquité*
MEFRM	*Mélanges de l'École Française de Rome—Moyen Age, Temps Modernes*
MGH	*Monumenta Germaniae Historica*
MGH, AA	*Monumenta Germaniae Historica, Auctores Antiquissimi*
MGH, SS	*Monumenta Germaniae Historica, Scriptores*
PL	*Patrologia Latina*, cited by volume and page or column
RIS	*Rerum Italicarum Scriptores*

Translator's Note

The original edition of the present work, *Una lontana città: Sentimenti e immagini nel Medioevo,* was published by Giulio Einaudi editore at Turin in 1983 (ISBN 88-06-05476-7), as number 651 of the series "Saggi." The present English translation contains alterations and additions made by the author to her text and therefore constitutes the second edition of *Una lontana città.* The footnotes now include references to works that appeared down to 1989.

The translation was made with the author's collaboration but the translator assumes final responsibility for the English text of *A Distant City.* Where published English translations of ancient, medieval, or Renaissance authors have been used, the fact is of course noted. When words and passages are italicized for emphasis in the many quoted passages in this book, such emphasis is always added by the author unless otherwise stated in the relevant footnote.

Author's Note

Chiara Frugoni wishes to thank William McCuaig for the translation—which is perhaps an inadequate term to describe the patient and scholarly collaboration with the author which has produced the present work.

A Distant City

An Empty Circle

"Cities of stone; cities of men . . ." The hackneyed distinction made by Isidore of Seville, aligning *urbs* and *civitas* on two separate, parataxical planes and cutting each of them off from the necessity of interacting with the other, can be said to remain fixed in the consciousness of writers and artists from antiquity down to the age preceding the formation of the communes.

The definition takes as its point of departure a position outside the city, distant and describing exclusively the solid and concrete facts: the city is seen with the eye of a wayfarer close now to the end of his journey. Already he can spot human figures, many of them, and numerous houses instead of the clumps of two or three seen along the route or in the fields. "A city [*civitas*] is a number of men joined by a social bond. It takes its name from the citizens [*cives*] who dwell in it [intensity of human settlement, therefore, makes it a city]. As an *urbs* it is only a walled structure, but inhabitants, not building stones, are referred to as a *city*."[1] What Isidore aims to give is clarification of the split in terminology that results from considering structures of stone inhabited by humans, first with the focus on the stones, and then with the focus on the humans. There is not even the beginning of the idea (still unfortunately given by Dupré in negative form) that the city "when seen as an entity composed of buildings, fails to reflect and reproduce its own social characteristics, juridical relations, or institutional structures."[2] For this historian, the city of the mature Middle Ages will certainly become, to use a well-known expression of Lopez, "a state of mind, a matter of consciousness," but the feeling that drives Dante, in the epistle to Cangrande, to define himself as "florentinus natione" can be recovered, for Dupré, only as literary reverberation.[3]

[1] "Civitas est hominum multitudo societatis vinculo adunata, dicta a civibus, id est ab ipsis incolis urbis, nam urbs ipsa moenia sunt, civitas autem non saxa, sed abitatores vocantur." Isidore of Seville, *Etymologiarum libri* 15.2.1 (all citations are from the edition of W. Lindsay [Oxford: Clarendon Press, 1911]).

[2] Cited by A. Peroni as "indicative of the lack of interest of historians . . . in the archaeological sources for urban history" (in "Raffigurazione e progettazione di strutture urbane e architettoniche nell'alto medioevo," in *Topografia urbana e vita cittadina nell'alto medioevo in occidente*, Settimane di studio del Centro italiano di studi sull'alto medioevo, 21 [Spoleto, 1974], vol. II, p. 690, n. 21).

[3] E. Dupré Theseider, "Problemi della città nell'alto medioevo," in *La città nell'alto medioevo*, Settimane di studio del Centro italiano di studi sull'alto medioevo, 6 (Spoleto, 1959), p. 22.

The present work, in contrast, is an "invitation to the images" that portrayed the city, for the splitting of word and figure seems to me to mutilate the historical reconstruction of a reality in which the two were naturally fused, in the consciousness of the men of those times, and in the daily flow of their lives that we wish to bring back to life. But let us return to Isidore of Seville.

Just because the city is seen only as the multiplied version of an inhabited modular unit, the single house, it becomes a magnified reproduction of it: "A house is the habitation of a single family, just as the *urbs* is that of a single people, and the earth is the domicile of the entire human race."[4] I want at the outset to draw attention to this characteristic way of advancing through concentric circles, which we will encounter again both in texts and in images, in which every more general experience advances through a series of restrictions that have as their point of reference the individual experience that gives rise to the rest: in this case, without the prior definition of the household, it would have been impossible to arrive at that of the world. This psychological attitude is due as well, I believe, to the felt impossibility of talking about a "cityscape." The gaze of Rudolph Glaber, a little after the year 1000, sees only "a white mantle of churches" populating, unexpectedly, Italy and Gaul. It will be a different story in the communal, and especially in the postcommunal, ages; but for now there is only *one* city, a city more conceptual than real: *the* heavenly Jerusalem; *the* Jerusalem on earth, goal of primarily spiritual pilgrimages; *Rome*, the eternal city, which through its imposing ruins, and as the center of the Christian religion, transformed the myth of empire into that of spiritual magisterium. For this reason Jerusalem remains, on medieval world maps, a circle at the center of the world, and is defined as "umbilicus terrarum . . . in orbis medio posita" by Urban II when preaching the First Crusade, in an expression attributed to him by Robert of Reims in 1095.[5] If we link the notion of a correspondence between heaven and earth, and that of the circle as the symbol of cosmic perfec-

[4] Isidore of Seville, *Etymol.* 9.4.3. When, in the Renaissance, the city is felt above all as a place of social aggregation, the definition will be taken up again, but altered in accordance with this new conception. Instead of the house, urban spaces meant for shared use will be the sources of comparison: "If (as the philosophers maintain) the city is like some large house, and the house is in turn like some small city, cannot the various parts of the house—atria, *xysti*, dining rooms, porticoes, and so on—be considered miniature buildings?" (Leon Battista Alberti, *De re aedificatoria*, 1.9, cited, but without any comment, by G. Simoncini, *Città e società nel Rinascimento* [Turin: Einaudi, 1974], vol. II, p. 15). [Translator's note: the translation is taken from Leon Battista Alberti, *On the Art of Building in Ten Books*, translated by Joseph Rykwert, Neil Leach, and Robert Tavernor (Cambridge, Mass., and London: MIT Press, 1988), p. 23.]

[5] Cited by W. Müller, *Die Heilige Stadt, Roma Quadrata, himmlisches Jerusalem und die Mythe von Weltnabel* (Stuttgart: Kolbhammer, 1961), p. 53.

tion, a "historical" fact will also have influenced the construction of this mental model.[6]

Even in the Trecento, the city in the miracle of san Nicola painted in the lower church at Assisi (figure 1) is conceived as an unreal edifice of circular plan, the result of sticking together isolated bits of individual structures.[7] Hence, if the city is at bottom a large household (Bethlehem is "domus panis" in the well-known definition of Gregory the Great),[8] then more than anything else, one feels protected by it: this is the elementary impulse that has driven man to fabricate for himself a refuge, but the impulse is entirely individual rather than choral, it joins walls to walls but not individuals to individuals so as to transform them into citizens. Thus, in the *Vita Boniti* (datable not long after the eighth century) it is said that the roof of the monastery of Manglieu and its walls recall those of a city: "the roofs and ceilings stand firmly, and the walls of the different buildings shine in their bright whiteness like those of a city."[9] This dominant feeling of protection, the primary feeling for many centuries shaken by invasions and raids, has its refraction in little things as well. A type of cloak, the *casula*, can for this reason be defined as "a garment with a hood, the diminutive of the word 'house' [*casa*], because it covers a man all over, like a small house."[10] In the apices of the shutters of a little tabernacle by Bernardo Daddi[11] (active from 1312 to 1348) are painted two stories about san Nicola (figure 2): the saint frees the cupbearer Adeodato from servitude to the pagan king, and he restores Adeodato to his parents. The two scenes are completely identical: in both a married couple is seen at a table in a room lined with a high curtain. In the apex on the left, which depicts the liberation of the youth in a foreign land, the cloth has only a richly gilded border above it, but in the one on the right, in

[6] This second aspect is absent from the rich selection of illustrative material given by Müller, ibid.

[7] E. Guidoni, *Arte e urbanistica in Toscana, 1000–1315* (Rome: Bulzoni, 1970), p. 268 and fig. 140.

[8] Gregorius Magnus, *Homil. in Evangelia* 1.9 (*PL* LXXVI, 1104), echoing the Johannine verses "Ego sum panis vivus qui de coelo descendi" (Apocalypse 6.41) and "si quis manducaverit ex hoc pane, vivet in aeternum, et panis quem ego dabo, caro mea est pro mundi vita" (Apocalypse 6.51–52).

[9] "Tigna laquearia affixa consistunt nec non et domorum candido decore rutilant muri, urbis modo." J. Hubert, "Évolution de la topographie et de l'aspect des villes de Gaule du Vᵉ au Xᵉ siècle," in *La città nell'alto medioevo*, p. 538. The asyndeton *tigna laquearia* recalls (and derives from) Psalm 1.16: "tigna domorum nostrarum cedrina, laquearia nostra cypressina."

[10] Isidore of Seville, *Etymol.* 19.24.17.

[11] P. Torriti, *La pinacoteca nazionale di Siena, i dipinti dal XII al XV secolo* (Genoa: Sagep, 1977), pp. 228–29, and figs. 269–70. Bernardo Daddi repeated the same subject in another little tabernacle (*altarolo*), now in the Museo del Bigallo at Florence, but in a "banalized" version (cf. A. Kiel, *Il museo del Bigallo a Firenze* [Florence: Electa, 1977], pp. 117–18, and pls. 15–16).

which the youth is shown as he is brought home to his parents, the cloth is drawn back so as to leave room for the walls of the city. This detail, selected as the sole particular differentiating the two scenes, is for that reason charged with significance: on the left, the golden sky is a sign of abstraction, of removal, of the absence of place; on the right, the walls, even if their presence is only sketched, are the most appropriate way to express the feeling of returning "home," to family and native city.

The city covers and protects the individual, who for that reason is felt as a passive object, and not an active and integrating part contributing to the city. Hence the monotonous repetition of the ideogram for the city, a circle of turreted walls forming the background, in so many images of the early Middle Ages, to the actions of the various personages: an idea purely topographical and reassuring, but soon reduced, precisely because of its simplicity, to a conceptual stereotype, entirely detached from man and his lived experience.

I select, as a point of departure, merely two examples: the Annunciation from the Carolingian ivory in the Schnütgen-Museum in Cologne[12] (figure 4), and a Visitation in the illumination of the Gospels of Saint-Médard from Soisson, in the Bibliothèque Nationale of Paris[13] and datable to the early ninth century. The angel brings his message to the Madonna "in her house at Nazareth," but the image splits the *house* and *Nazareth* into two distinct notations: the angel brings his message to the Madonna *at Nazareth*, which therefore appears high up in the background, as an ideogram, and *in her house*—hence a rippling curtain forms the background to the Madonna's throne and her impetuous interlocutor. The miniature, which illuminates the initial letter of the gospel of Luke, includes the two episodes that open Luke's account: the Annunciation and the Visitation. The phrase "[Mary] *went* into Zachariah's house and greeted Elizabeth" has been translated by showing the embrace of the two women *in front of* a hexagon cut into diamond points, and absolutely empty inside. This is a simplified image of the city, the same city that in the same miniature appears between the announcing angel and the Madonna, floating quite freely in the heavens. House and city are interchangeable here; but there is also interchangeability between one city and another in the same ivory we have already looked at, in which a similar hexagon with towers—Bethlehem it will be now, instead of Nazareth—forms the background to the Nativity. The two cities appear here extraordinarily tiny and

[12] H. Fillitz, "Die Elfenbeinreliefs zur Zeit Kaiser Karls des Grossen," *Aachener Kunstblätter* 36 (1966): 22 and fig. 11.

[13] J. Hubert, J. Porcher, and W. E. Volbach, *L'impero carolingio* (Milan: Feltrinelli, 1968), fig. 73.

distant. The characters often act as though they found themselves immediately before the walls, or in front of a church or a house. Consider for example an ivory book cover from Metz (late ninth–early tenth centuries)[14] in the Victoria and Albert Museum of London (figure 6): the three Magi are presenting their gifts to the infant Jesus with Bethlehem synthesized in the background by walls and a church, in order to give a sense of the sacral to the scene of the event. In another scene, the presentation of Jesus in the Temple takes place before that structure, which is represented, for the sake of clarity, in an *interior* on the left, in a view that recalls the apse of a church, and directly to the right in a compact view of an *exterior* angle of the building.

Likewise in an illumination of the Gospels (executed perhaps at Mainz in the second quarter of the eleventh century) in the Hessische Landesbibliothek at Fulda,[15] the evangelist Mark is shown seated on a sumptuous throne, with a rich curtain about him, while receiving divine inspiration. But behind him, gleaming with gold, rises a church, which is "where" that throne and that hanging are.

In the mosaic of San Vitale at Ravenna[16] (figure 5), in which, prefiguring the communion, the double sacrifice of Abel and Melchizedek is represented, they are flanked by a hut and a temple respectively. These structures are personal indications of their different social roles in exactly the same way that the shepherd's cloak of the one and the priestly tunic of the other are.

Such a functional contraposition of buildings for the purpose of rounding out the substantial identity of the personage can be observed as well in the Adoration of the Magi by Giotto in the Lower Basilica at Assisi. Whereas in the Scrovegni cycle at Padua the scene of the recognition by the three kings of the *rex Iudaeorum* unfolds in tranquillity under the roof of the same humble shed that had witnessed his birth, Giotto (?)—at Assisi—chose to change the setting of the occurrence to the beautiful portico, preciously ornamented, of a rich dwelling, in order to emphasize that in that instant Jesus was a king receiving the recognition of kings. And so, if on the left we can still perceive the roof of the humble manger "quia non erat eis locus in deversorio" (Luke 2.7), the portico on the right, beneath the rich gallery, amounts to a spontaneous reply to the Magi, who had demanded of Herod, "ubi est qui natus est *rex* Iudaeorum?" (Matthew 2.2). Giotto's image was taken over detail for detail by a Perugine follower of Meo of Siena, in

[14] J. Beckwith, *Early Mediaeval Art* (London: Thames and Hudson, 1964), fig. 58 and p. 66.

[15] L. Grodecki, F. Mütherich, J. Taralon, and F. Wormald, *Il secolo dell'anno Mille* (Milan: Feltrinelli, 1974), fig. 161.

[16] A. Grabar, *L'età d'oro di Giustiniano* (Milan: Feltrinelli, 1966), fig. 168.

a wing of a triptych with the Adoration of the Magi, now in the National Gallery of Umbria at Perugia (figure 7).[17]

Further: in the scene of Sarah preparing the bread for the guests of Abraham, in the mosaics of Santa Maria Maggiore in Rome (between A.D. 432 and 440),[18] the woman is shown in the open air with a table before her, while a house is placed in the background, to convey just where this task is in fact being carried out. It is necessary in all these cases, following Überwasser,[19] mentally to relocate the human figures within that architectural space from which they seem to have been expelled, if one does not wish to run the risk of misreading the images. But that is not all: as well as placing *within* that which is shown *without*, we also have to place *behind* that which appears to be *above*. Without such a mental reordering, there is no sense to be made of the cities on arcades[20]—all those buildings, that is, that weigh like groves of pinnacles upon the roofs of churches or houses, in manuscript illuminations, especially those of the Ottonian age. In the Codex Aureus of Speyer[21] (executed between 1043 and 1046 [figure 8]), Henry III and his wife Agnes bow down at either side of the Madonna, the emperor in the act of offering her the very manuscript he had commissioned, his wife in a humble gesture of prayer and submission. Behind looms the cathedral of Speyer, to which this codex was to be donated, and where Con-

[17] This is without question the significance that Giotto wanted to give to the buildings, and it would be useless pedantry to want to explain them as deriving from a verse of Matthew's account of the Epiphany (2.10–11), which says "videntes autem stellam, gavisi sunt gaudio magno valde. Et intrantes domum, invenerunt puerum cum Maria matre eius." The custom of representing the Adoration as taking place in the manger was too engrained for Giotto to have made an innovation solely on the basis of this passage of Matthew—the more so in that if he had indeed done so, he would certainly not have left the shed on the left. As regards Giotto, a good reproduction of the fresco is available in *Giotto e i giotteschi in Assisi* (Rome: Canesi, 1970), fig. 129. The Adoration in Perugia is in F. Santi, *Galleria nazionale dell'Umbria: Dipinti, sculture, e oggetti d'arte di età romanica e gotica* (Rome: Poligrafico dello Stato, 1969), fig. 31a (with the catalog entry at p. 66). On the other hand, the shed will entirely disappear (and with it the significance of the opposition in Giotto) in the celebrated Adoration of the Magi by Bartolo di Fredi (reproduced in Torriti, *La pinacoteca nazionale di Siena*, fig. 178), where—in line with the rich and ostentatious character of the entire depiction—the Madonna and Child are seen beneath an edifice (for the chronology, which oscillates between 1364 and 1370, see Torriti, p. 165).

[18] W. Oakeshott, *I mosaici di Roma* (Milan: Electa, 1967), fig. 24.

[19] W. Überwasser, "Deutsche Arkitekturdarstellung um das Jahr 1000," in *Festschrift H. Jantzen* (Berlin: Mann, 1951), pp. 45–70.

[20] J. Baltrušajtis, "Villes sur arcatures," in *Urbanisme et architecture: Études écrites et publiées en l'honneur de P. Lavedan* (Paris: Laurens, 1954), pp. 31–40. The author limits himself to a list of examples, without discussion of problems, showing the extraordinary diffusion of the theme in all media from antiquity until the fourteenth century, when it becomes rare.

[21] C. Frugoni "L'iconografia del matrimonio e della coppia nel medioevo," in *Il matrimonio nella società altomedioevale*, Settimane di studio del Centro italiano di studi sull'alto medioevo, 24 (Spoleto, 1977), pp. 958–60, and pl. 45.

rad II and Gisela, the parents of Henry III, were buried. On its roof, however, almost obscuring the architectural particulars that allow us to identify the cathedral, rise other structures grouped in spires, reversing both proportion and the principles of statics. But it is man as an individual who wants here to have pride of place, it is he who is the expression and the vehicle of emotion, while the city, in this conception (still so far from choral), is only a framing projection. The same can be said of a relief in the cathedral of Chartres,[22] in the portico of the southern transept (A.D. 1230–1240), in which a warrior with shield and sword unsheathed (a Virtue) is seated above a trefoil arch, on which a towered city blossoms. In the Codex Aureus such a background suggests piety and devotion, but here the suggestion is rather defense and protection. This way of proceeding by purely mechanical accretion, which seems so strange to us, finds its justification in the principles of medieval aesthetics formalized earlier by Plotinus,[23] which tend to give to an image the fullest possible legibility, putting all the components of it in the frontal plane, and avoiding for that reason shadows and foreshortening, developing a solid form whose sides are aligned with one another like those of an unfastened cardboard box, and finally adopting a reversed perspective in which the sight lines appear inverted, that is, they diverge: the images increase in size as they are pushed back into the picture space. So, if the end that justifies the technique of addition is "didactic," the direct consequence is the loss of any fusion between the space and the character thought to be acting in it, and the former sometimes assumes, as with the gilded background, the opaque density of an architectonic set design, felt as "something in between"[24] (from which the head and shoulders of an angel protrude), absorbing and compressing all the other shades of distance that in fact stood between earth and heaven. Even when the figure has palpably been set down in an internal space, for instance in a miniature whose subject is Jesus in the Temple,[25] he appears to be in an empty city—inside a perfectly barren space, that is—and surrounded by a circle of towered walls. It is the ideogram for "city" that is lowered into place like a stockade around the figures to indicate to us where they are. In another illumination whose subject is the evan-

[22] A. Katzenellenbogen, *The Sculptural Programs of Chartres Cathedral* (Baltimore: Johns Hopkins University Press, 1959), p. 88.

[23] A. Grabar, "Plotin et les origines de l'esthétique médiévale," *Cahiers Archéologiques* I (1946): 15–34.

[24] Überwasser, "Deutsche Arkitekturdarstellung," p. 51.

[25] Hubert et al., *L'impero carolingio*, fig. 107: the illumination is taken from the fragmentary Gospels of Saint Florin of Koblenz (ca. 830) in the Landesbibliothek of Düsseldorf.

gelist Matthew[26] (figure 9), he appears alone inside a perfect circle of towered walls; the sky seen above his head is the assurance of divine inspiration. Behind the walls are painted, by way of a framing device, four corners, as though the city had been placed upon a colored page: the spatial information given is thus felt as something highly artificial, a graphic convention in which the polygon of the walls and the four angles (neither feature intended to be any more realistic than the other) *taken as a whole* produce a star-shaped frame.

At times the city can appear in the heavens, by contrast, and to indicate the purely conceptual weight of this presence, the base of its walls is shown as undulating, in order to recall the unevenness of the terrain from which it has been plucked. The interior of the city is also the place for the churches, and for humankind, which belongs to God, with the walls denoting the separation from the surrounding space—a space that is natural, unmarked by human action, hence inhabited by demons, and by evil. In this connection may be noted a passage from the *Life of Saint Anthony* by Athanasius:[27] "The devil, fearing that the saint might gradually transform *the desert into a city* with his ascetic practices, came upon him one night with a horde of demons." It is for this reason, in my view, that in an illumination (figure 10) from the Gospels of Liutard depicting the dance of Salome,[28] the handing over to Herodias of the head of John the Baptist, and the beheading of the saint, John is the only one to be located *inside* the walled enclave of the city, from which he protrudes, looming as though from a balcony, whereas all the other characters are located in an indistinct golden space. This extraordinary mark of distinction falls to John the Baptist alone, differentiating him from the profane world of guilt (the two trees beside Salome and Herodias are present to underline that the locale in this scene is a "rustic," not urban, place; they contrast emphatically with the city walls). For the same reason a portion of wall and a door conventionally enclose Jesus at prayer in the garden of Gethsemane, with his disciples asleep in a group, in a polyptych from about the middle of the Trecento (figure 11) by Giovanni da Milano.[29] This

[26] Ibid., fig. 108: from the so-called Gospels of the Célestins, coming perhaps from the school of Reims in the middle of the ninth century. The manuscript is presently in the Bibliothèque de l'Arsenal in Paris.

[27] Edited by G.I.M. Bartelink, *Vite dei santi* I (Milan: Mondadori, 1974), pp. 24–25. On the desert as the realm of evil, see G. Cracco, "Chiesa e cristianità rurale nell'omelia di Gregorio Magno," in *Medioevo rurale. Sulle tracce della civiltà contadina* (Bologna: Il Mulino, 1980), pp. 360–79, esp. 372. For the Byzantine world, see J. Seiber, *Early Byzantine Urban Saints*, British Archaeological Reports, Supplementary Series, 37 (1977).

[28] Hubert et al., *L'impero carolingio*, fig. 127: from the so-called First Bible of Charles the Bald (Saint-Martin de Tours, about A.D. 846) in the Bibliothèque Nationale of Paris.

[29] The polyptych of Giovanni da Milano is in the Pinacoteca comunale of Prato; cf. M. Boskovits, *Giovanni da Milano* (Florence: Sadea, 1966), fig. 61. The painting by Bar-

place, linked to one of the principal events in mankind's history, *cannot* be the open countryside, which is exorcized by that architectonic insert, the sign of the work of man.

The same vivid opposition between walled city and external chaos, or at least external solitude colored by negative feeling, meets us in a painting by Bartolo di Fredi, which probably belonged to one of the wings of a Deposition done by him in 1382, in which Saint John is shown being taken into the desert by the angel. The angel, clothed in blue and with great gilded wings, guides him by the hand along a rocky path toward the entrance to a wood which, although dense, has a minute delicacy (for the painter was unable, as it seems, to deny himself the pleasure of a nicely ornate design). High up, atop a rock separated from the holy protagonists of the scene by a crag, a city is planted, bound closely by its own walls; and for this reason, given that the black and white religious edifice at its center dominates and seems to press down on the other buildings, we cannot fail to realize—rightly—that this is Siena. Clearly there is an enormous distance between that desert toward which John and the angel are making their way, and the colorful and gracious city, wrapped far off within its walls. And there is only superficially a contradiction in the fact that the stigmatizing of san Francesco, in the painting by Bonaventura Berlinghieri,[30] occurs in a mountainous landscape—which is nevertheless surrounded by houses and churches on every side. In the following centuries, down to the Renaissance, this awareness of a contrast, denoted by the walls, between order and chaos, organized space and savage nature, grows more acute; as a result every violent death, every event that disturbs the peaceful unfolding of a life regulated by laws—like the executions that, the statutes tell us, did in fact take place "outside"[31]—is ordinarily represented occurring in the open. That is

tolo di Fredi is in the Museo civico of Montalcino, and probably constituted, together with others held there, the side panels of the Deposition from the Cross (also in the Museo civico), which bears the date 1382. (See E. Carli, *Montalcino. Museo civico. Museo diocesano d'arte sacra* [Bologna: Calderini, 1972], pp. 13–15, figs. 29 and 31.)

[30] E. Sandberg Vavalà, *La croce dipinta italiana* (reprint, Rome: Multigrafica editrice, 1980), fig. 372. The painting, from 1235, is in the church of San Francesco at Pescia.

[31] W. Braunfels, *Mittelalterliche Stadtbaukunst in der Toskana* (Berlin: Gebr. Mann, 1953), p. 41 and n. 78 (the statute of the city of Siena, 1309–1310). Giordano da Pisa, in one of his sermons (*Prediche recitate in Firenze dal 1303 al 1306 ed ora per la prima volta pubblicate*, ed. C. Moreni [Florence: Magheri, 1831], vol. I, p. 96), relates the following about san Barnaba, put to death for having broken an idol: "and after having put a cord around his neck, they dragged him *out of the city*, and there prepared his pyre." The same Giordano, to underline the humility of Christ, specifies that he was born "in a small and lowly town, *nor was he born inside it, but outside*" (*Prediche inedite recitate in Firenze dal 1302 al 1305*, ed. E. Narducci [Bologna: Romagnoli, 1867], p. 420). This significant affirmation of Giordano really does seem to receive a fitting commentary through the medium of a fresco in the Galleria nazionale dell'Umbria at Perugia, belonging to a later

the case for the martyrdoms of the saints, such as for example that of Cosmas and Damian by Beato Angelico[32] (figure 12); and observe how, in the scenes of the life of Saint Stephen in the Chapel of Nicholas V in the Vatican,[33] also by Beato Angelico (figure 13), the city walls (in the lunette of the martyrdom) enforce a violent division between the interior of the city from which the saint is cruelly driven, and the place—beyond them—of his torture. And this continues to be the case when the saints must confront evil (Saint George and the dragon by Mantegna).[34] In the Lament of the Virgin over the dead Christ, again by Beato Angelico,[35] the ideal state reflected by the distant Jerusalem, closed within its tranquillizing walls in the background, is violently contraposed—heightening the disturbing impact of the emotion—to the scene in the foreground.

The city appears, until sometime close to the year 1000, only as a "sign," a circle of turreted walls (figure 4) condensing the sole sentiment that it seems to arouse in its inhabitants: a feeling of refuge and protection. Therefore it is shown either miniaturized in the background—and in this case all our attention is concentrated on the personages or figures that fill the page—or else as a large zone encompassing like a frame the vignette that defines the place of the action. Even the earthly Paradise, which ought to be shown as a pure natural landscape filled with trees and animals, takes on, at the moment at which Adam and Eve have to abandon it after their sin, the appearance of a city. Its walls, for the first-created human pair who must now confront unaided the great world rendered hostile by the biblical curse, concentrate the anguish of the separation. Those walls are the protection and the security denied them from this moment on. On the

period, it is true, but perceptibly shot through with the same idea: a Perugine painter of the second half of the Trecento portrayed the Nativity with the Babe and his parents under the modest shelter of the roof of a shed which struggles to occupy a space amid overhanging rocks, immediately *outside* the walls of a city, Bethlehem. The feeling of exclusion (almost violent, and—it goes without saying—sacrilegious to the mentality of the devout artist) leaps to the eye, in the midst of all those roofs and those houses egotistically closed in on themselves, in which "non erat eis locus in deversorio." (Originally from the monastery of Santa Giuliana, the painting is reproduced in Santi, *Galleria nazionale dell'Umbria*, fig. 65a, with commentary on pp. 77ff.) For the contrast between civic space and wilderness space in the Renaissance, see R. Le Mollé, "Le mythe de la ville idéale à l'époque de la Renaissance italienne," *Annali della Scuola Normale Superiore di Pisa*, ser. III, 2.1 (1972): 275–310, esp. 278ff.

[32] Part of the *predella* (dispersed in various museums) of the "Pala di San Marco" (datable between 1438 and 1440); the one cited is in the Louvre at Paris. Cf. U. Baldini, ed., *L'opera completa dell'Angelico* (Milan: Rizzoli, 1970), pl. 38.

[33] Ibid., fig. 113.

[34] N. Garavaglia, ed., *L'opera completa del Mantegna* (Milan: Rizzoli, 1967), pl. x (Venice, Galleria dell'Accademia).

[35] Baldini, ed., *L'opera completa dell'Angelico*, plates 28–29 (Florence, Museo di San Marco; the work was executed in ca. 1436).

bronze doors of the cathedral of Hildesheim[36] (figure 14), in the episode of the expulsion, Adam is seen closing the gate of the towered city, while Eve casts her last woeful glance at the inexorable angel. In a detail from a painting of 1477,[37] now at Vienna, it is interesting to note how only inside the earthly Paradise are there trees growing: outside the walls, the hills and meadows are entirely bare, as though the painter had called to mind the biblical verse "The Lord God took the man and settled him in the pleasant garden to cultivate and care for" (Gen. 2.15). An illumination (figure 15) taken from the *Liber floridus* of Lambert of Saint-Omer, which depicts Paradise[38] (as the inscription *Paradysus* attests), has nonetheless drawn upon the theme of the heavenly Jerusalem as its model. We may compare the illumination derived from it (figure 16), which explicitly identifies the *Iherusalem celestis*: a walled enclosure full of churches is the mental landscape of felicity. At its center is a lone tree with beautiful and ordered foliage: certainly the "lignum vitae adferens fructus . . . ad sanitatem gentium" that concludes at the end of the Apocalypse (22.2) the description of the heavenly Jerusalem; but it is interesting to note, "outside the walls," a menacing pile of rocks, added by the illuminator without any suggestion from the text, in order to pose a starker contrast with the good that lies within.

The fixing of the ring of walls as the symbol for the city, and its persistence, were no doubt helped by the fact that this symbol had already been adopted in classical art on coinage, a medium that circulated everywhere and was an important vehicle for the familiarization of this imagery.[39] Since the period of ancient art, this stereotype was present as well on maps: it is enough to mention the Peutinger Map.[40] In surveying and dividing up the soil, whether it was for a city, an encampment, or a territory, the Romans used precise land-surveying techniques: a *corpus* from the second half of the fifth century, which received additional material, and some reordering, in the sixth, has preserved for us numerous maps and charts. Alongside purely geometrical elements such as the centuriation of the soil or the lines of the *cardo* and the *decumanus*, are ranged others drawn from the figurative

[36] H. Focillon, *L'arte dell'Occidente* (Turin: Einaudi, 1965), fig. 27.

[37] L. Behling, *Die Pflanzenwelt der mittelalterlichen Kathedralen* (Cologne and Graz: Bohlau, 1964), pl. 6b.

[38] Ibid., p. 61 and figs. 4a and 4b.

[39] J. Ehrenberger Katz, "Les représentations de villes fortifiées dans l'art paléochrétien et leurs dérivées byzantines," *Cahiers Archéologiques* 19 (1969): 1–27. For a brief summary, but one that also contains observations not included in the longer article: J. Katz, "Les répresentations de villes dans l'art chrétien avant l'an Mil," *L'information d'histoire d'art* 3 (1964): 130–32.

[40] K. Miller, *Die Peutingersche Tafel* (Stuttgart: Brockhaus, 1962).

repertoire: thus, in regard to the city, the two lines of the *cardo* and the *decumanus* bisect a completely empty "cartographic" space, delimited—like a house of cards—by four sections of turreted wall. Evidently it is they, rather than the joining of a number of buildings, that concentrate the idea of city.[41] Such dematerialized imagery will be accepted in succeeding centuries, both in the West and in the East, and remains unaltered until around the sixth century. After this period, it is possible to observe a diversification of the formula, in which the Byzantine world prefers to give a circular plan to the walls, and often to fill them up as well with cupola-bearing buildings (a distant echo of a characteristic and elaborate architecture), while the West remains faithful to the ancient model: hence the walls describe a quadrangle, or more often a hexagon, in any case a polygon,[42] and, from the ninth century onward, an octagon.[43]

The habit of considering the walls of the city as its essential characteristic produced a curious deformation in the most outstanding series of early medieval representations of cities in a monumental key that has reached us: the mosaics in Santa Maria Maggiore at Rome, executed during the pontificate of Sixtus III (432–440). Here the narrative specifics (we see the spies lowering themselves from the walls of Jericho aided by the prostitute Rahab, the destruction of Jericho[44] [figure 3], the battle of the Amalekites, hence armies entering and leaving the city by its gates) have entailed the representation of the city in a more realistic way, showing its inhabitants and its buildings. Hence the empty space within the walled zone has been filled up and animated by structures and vaults, but the necessity not to obscure with these additions the traditional embodiment of the notion of fortified place, which must always be perceived as preeminent by the observer, constrained the mosaicist to increase the vertical dimension of the city, which thus takes on the odd appearance of one of those children who are "all legs," or, as one might say here, "all walls."

In the early Middle Ages, the city, beyond its function as *memento* of the place where an action occurred—especially, and specifically, the events of sacred history in manuscript illuminations—is linked to the idea of voyage. This precise theme lies at the origin of two trends of imagery quite opposed to one another: on one hand the image of the city is "disembodied" as map, sketch, geographic indicator, and employed for purely practical ends; on the other, it becomes the visuali-

[41] A. Weitzmann, *Ancient Book Illumination* (Cambridge, Mass., 1959), p. 7, pls. 2, 3.

[42] Katz, "Les représentations de villes fortifiées," p. 11.

[43] P. Lavedan, *Représentations des villes dans l'art du Moyen Age* (Paris: Vanoest, 1954), p. 33.

[44] Grabar, *L'età d'oro*, fig. 160.

zation of a whole nexus of spiritual states caused by the voyage itself, such as leave-taking, loss, the joy of arrival. This, it seems to me, is the explanation of the insertion of a woman, as city personified, in some early medieval images connected to the present theme.

In classical antiquity, a divinity with a turreted crown was the emblem of a locality and of a city, on account of the easy assimilation of the ring of walls to the circularity of the crown. This symbol lives on in the Middle Ages, and Deonna has followed its course;[45] but my purpose is to draw attention to an internal change in what is signified, despite the overall continuity of the scheme. In antiquity the image appeared alone as a statue or on coinage, the symbolic equivalent of a geographic entity, and as such it comes down to the Middle Ages in scenes of homage or of submission: for example there is an illumination[46] (datable between A.D. 997 and 1000) that depicts Otto III enthroned, with the four quarters of his empire, *Sclavinia, Germania, Gallia,* and *Roma,* bowing down to him. Rome, the city that leads the group, is not so much a geographical idea as a spiritual one.

The personified image very often is humanized and becomes the locus and expression of emotions and conflicting affects. Take for example the origin in Carolingian ivories of a theme destined for a notable fortune in the High Middle Age, that of the *Ecclesia* (Church) versus the *Synagogue.* In these we do not yet find the opposition of the two faiths resulting in the crushing victory of the one, and the humiliating defeat of the other: dialogue is open, a sign of the *rapport* between the two worlds in the coming of Christ. The two cities of Bethlehem and Jerusalem, which, in the apsidal vaults of so many churches send forth symmetrically their lambs (the apostles, that is) to be united at the center by the cross, or by the mystic lamb, appear (with a genetic link to the other theme of the two churches,[47] *Ecclesia ex gentibus, Ecclesia ex circumcisione*) on the cover of the evangelary of Tournai (tenth to eleventh centuries A.D. [figure 17]) in the contraposition of *Sancta Ecclesia* and *Jerusalem,*[48] both turning toward Jesus on the cross. Above him stands the mystic lamb sustained by two angels, and above that in turn, Christ in his majesty amid the four evangelists, holding in his hand an open book with the words "salus mundi." On the left, *Sancta Ecclesia* extends the chalice to gather the blood that spurts from the ribs

[45] W. Deonna, "Histoire d'un emblème: la couronne murale des villes et pays personnifiés," *Genava* 18 (1940): 119–212.

[46] Beckwith, *Early Mediaeval Art,* fig. 85 and p. 104.

[47] On the precise significance of the two cities and their connection with the two churches, scholarly opinion is not yet unanimous; for the different positions, see the entry "Städte, zwei," by N. Schneider in the *Lexikon der christlichen Ikonographie* (Rome and Freiburg: Herder, 1972).

[48] Reproduced in *Lexikon der christlichen Ikonographie,* s.v. "Ecclesia und Synagogue."

of Christ, with an ecclesiastical edifice in the background; on the right, *Jerusalem*, a woman identical in raiment and gesture, but whose hands are empty to express her dismay; in the background, the turreted walls of the city. *Ecclesia* is already identified with the Christian religion; on the other hand the *Synagogue*, the religion of the Jews, is not yet present, but instead a city marked by the death of Christ, in which the veil of the temple has been rent. What is seeking to be represented here is spiritual magisterium that aims at hegemony over a people; a paten of the twelfth century,[49] with the crucified Christ at its center surrounded by the different destinies of the Elect and the damned, seems to me to confirm this, for the latter make their way toward the flaming city of the Inferno in a huddled group, displaying a scroll labeled *Synagogue*.

In two other very similar ivories of the ninth century, now in Munich and Paris, the two women are brought together in an animated scene of *altercatio*. In the one at Munich[50] (figure 19) we see the Church with ample banner rippling while she gathers the blood of Christ; then we see the Church again, standing before her rival, attempt to take away from her (if this interpretation is correct) the disk of the world, while the other attempts to hold it in her bosom. The second woman wears a rich diadem and is shown seated before (that is: within) her temple. Disrobed and defeated, she reappears in the bottom portion of the ivory between the symbolic figures of Earth and Sea. In the ivory at Paris[51] (figure 18) the Church, with her banner as before, argues in a very agitated manner with the Synagogue, shown seated with a banner in her hand also and, in addition, the knife for the sacrifice; behind, the turreted ring of walls is displayed in flattened perspective, like an oversized halo. This time it is the Church that reappears triumphant amid the symbols of Earth and Sea, holding the disk of the world in her hand, and with her banner unfurled. In sum, in these two ivories the concrete temple of Jerusalem, and the ring of her walls, come to-

[49] B. Blumenkranz, *Le Juif médiéval au miroir de l'art chrétien* (Paris: Études Augustiennes, 1966), fig. 122 and p. 108.

[50] See the catalog of the exhibition *Judentum im Mittelalter, Schloss Habturm, 4 Mai–26 Oktober 1978, Burgenland 1978* (Eisenstadt: Rötzer-Druck, 1978), p. 243 and fig. 28. I am not in agreement with the identification proposed there, which recognizes the prophet Hosea in the figure between the Sea and the Earth, a figure that seems to me as well to be female. Neither does the more usual identification with Rome seem satisfactory (cf. O. Homburge, "L'art carolingien de Metz," *Gazette des Beaux-Arts* 62, no. 6 [1963]: 34–46). Rather, if the plate is compared with the one in Paris, the scheme of the composition is seen to be identical, except that here the Church could not be repeated a third time, so her defeated rival appears in her place. The Synagogue with breasts bared is documented (in the ivory of Tournai the breasts are clearly shown): see for example the so-called cross of Gunholde, datable to before 1076 (*Judentum im Mittelalter*, fig. 47) or the Norwegian fresco from the second half of the thirteenth century in the church of Aal (Blumenkranz, *Le Juif médiéval au miroir de l'art chrétien*, fig. 123 and p. 108).

[51] *Judentum im Mittelalter*, p. 244 and fig. 27.

gether to enrich a personification charged with emotive and conceptual implications of great significance. Again, *Jerusalem* (so labeled), a woman with a high turreted crown, weeps crouched beside the crucified Christ in the fresco of San Vincenzo al Volturno (between A.D. 826 and 843).[52] A crowned girl, her clothing emblazoned with the imperial eagle, appears as Pisa rescued by sant'Orsola, who with the gesture of Christ in the underworld helps her emerge out of a destructive flood of the Arno, in a painting of the late thirteenth century.[53]

In all of the examples I have analyzed so far, the personification was an essential element of the narrative, and as such its insertion in the scene was perfectly justified. If, however, we consider two illuminations taken from two different Bibles of Charles the Bald, the woman inside the walls might on a first impression seem redundant, being the personification of the city itself. In the first[54] (figure 20) Saint Jerome is shown on an upper plane leaving Rome for Jerusalem; the saint has already passed through the gate of the city, which is closed in fact, and is advancing to the ship that awaits him. The buildings in the city are crowded against the walls to leave space at the center for a large arch, beneath which there appears the figure of a woman, wearing a veil, holding a lance in her hand, and resting against a large oval shield: it is Rome, in the Carolingian retranslation of a classical statue. But her face is violently turned to follow Jerome, and that intent gaze which accompanies his departure cancels at a stroke all dependence on the antique. The same can be said about the second and very similar illumination[55] (figure 21), in which the subject is the same: Rome has gone further toward an explicit declaration of her sentiment by extending her head and shoulders from the walls—as if saying goodbye from a window—with the useless globe no longer *in her hand* to display her triumph, but between her *hands*, as though it were a gift left behind by Jerome in his great haste. Yet the city can also welcome those who arrive, condensing into her personification the opposite sentiment—the joy of reaching the goal, of meeting. Hence we see her bow down before Christ in the entrance into Jerusalem, for example, in a panel of the sixth century from the episcopal throne of Maximian at Ravenna, or before the holy travelers in the flight into Egypt.[56] Again, Ravenna

[52] F. Bologna, *La pittura italiana delle origini* (Rome: Editori Riuniti, 1962), pp. 25–29; *San Vincenzo al Volturno* (Salerno: Edizioni dell'Abbazia di Montecassino, 1970), fig. 51.

[53] E. Carli, *Il Museo di Pisa* (Pisa: Pacini, 1974), pl. 20 and p. 82.

[54] From the Bible known as the First Bible of Charles the Bald (from Tours, now at Paris, Bibliothèque Nationale, MS lat. 1, f. 3v); see P. D'Ancona and E. Aeschliman, *The Art of Illumination* (London: Phaidon Press, 1969), fig. 23.

[55] From the so-called Bible of San Paolo fuori le Mura (originally from St. Denis, now at Rome, San Paolo fuori le Mura, f. 2v; cf. Hubert et al., *L'impero carolingio*, fig. 131).

[56] E. H. Kantorowicz, "The 'King's Advent' and the Enigmatic Panels in the Doors of Santa Sabina," *Art Bulletin* 26 (1944): 216, n. 62 and figs. 23–25.

must have appeared in a similar attitude of homage, albeit transferred into a profane context, moving from the sea to greet Theodoric, in the lost mosaic known to us only from a (not entirely clear) passage of Agnello of Ravenna.[57] At times two cities are shown at the extreme edges of an image, to signify the beginning and the end of the voyage. In a panel from the celebrated altar frontal of Sant'Ambrogio at Milan,[58] for example, two identical floating cities form the backdrop to the Nativity in the foreplane, in a precise recollection of the passage from Luke 2.4, "So then Joseph too set out from Galilee, *from the town of Nazareth, toward the city of David which is called Bethlehem.*" The two cities of departure and arrival, which to the modern mentality would not have seemed to be necessary, also appear in illustrations of stories in order to render the whole didactically complete and well defined. In an Ottonian illumination illustrating the healing of the possessed man of Gerasa,[59] the *herdsmen* are seen in groups of two as, turning their backs, they set out toward two cities, *urbes Gerasenorum.* What has happened here is a contamination of two passages, 5.1 and 5.14, of Mark: Jesus arrives "in regione Gerasenorum" (5.1); the herdsmen who have lost their demon-possessed herd tell of the miracle "*in civitatem* et in agros" (5.14). This contamination has however been provoked by the desire to portray in a vivid fashion the spreading of the news. Likewise a heartfelt adherence to the text has caused the desire of the mother of the sons of Zebedee (Matthew 20.21), who pleaded with Christ to be able to see them "unus ad dexteram tuam et unus ad sinistram *in regno tuo,*" to be translated as two cities.[60] Again, in an illumination of the eleventh century[61] illustrating (figure 22) the healing of the leper (Matthew 8.1–2), the ornamental mullioned window delimits the two groups, on one side Christ with his disciples, on the other the leper and the crowd. Two cities signify the two converging paths of Christ and the leper, which are joined by the miracle, as though to mark the infinite distance between the divine thaumaturge and the wretched life of the sick man. The distance is annulled at the moment of the miracle: only the hand of Christ and that of the leper do actually meet, on the central column. The redoubling of the two cities is owing, therefore,

[57] See below, chap. 2, pp. 37–38.

[58] G. Bishop Tatum, "The Paliotto of Sant'Ambrogio at Milan," *Art Bulletin* 26 (1944): 37 and fig. 21. The front of the altar, of which this panel is a part, is not, according to the author, the work of Vuolvinio, but is to be dated almost a century and a half later, that is to the end of the tenth century (ibid. p. 45).

[59] A. Goldschmidt, *Abendlandische Miniaturen*, Trier, Stadtbibliothek, cod. 24, from Reichenau, pl. 30 (datable between 977 and 993).

[60] *Lexikon der christlichen Ikonographie*, s.v. "Stadt" (from the evangelary of Otto III, from the end of the tenth century, in the cathedral of Aachen).

[61] L. Grodecki et al., *Il secolo dell'anno Mille*, fig. 153, from the Gospels of Limburg, from the beginning of the eleventh century.

not to straightforward desire for symmetry,[62] but to attentive reflection on the episodes to be illustrated.

Another spur to the representation of cities, as was already mentioned, was the need to have geographical points of reference. Hence the presence of the city in the preparation of itineraries and accounts of travel, especially those of pilgrims: the privileged place is Rome, and also the Holy Land, later to be the goal of the crusaders. In the *Itinerary* from London to Jerusalem of Matthew Paris (A.D. 1352), the city of Paris is indicated by three towers on an island in a river, but it is the river and its two bridges that are identified in a caption: it is always the notion of passage, as Lavedan has noted,[63] that is given primary emphasis. The fascination with Jerusalem contributed to a flourishing growth of descriptions and maps, in which the very purpose of direct utilization had the effect of repressing the aesthetic possibilities of representation while accentuating instead the abstract planimetric element. As a result we have above all plans and maps in which, in addition to the roads, the principal edifices of the Christian faith may be shown, but never the complete plan of a city. About A.D. 679–680, the French bishop Arculf, returning from the Holy Land, supplied to Adamnan, abbot of the monastery of the island of Iona, together with his memorial *De locis sanctis*, four sketches of the buildings of Jerusalem, among them the Holy Sepulcher and the church of the Ascension (presumably they are those accompanying the text in the oldest copy that has reached us, from the ninth century).[64] Arculf himself was well aware that he had sketched those plans, on a portable and temporary writing surface, purely for the purpose of immediate utilization, "not by any means because their precise aspect could be conveyed by my picture."[65]

The sketch that in fact reproduces the Holy Sepulcher (figure 23) has some links to the unusual representation of the heavenly Jerusalem in a few contemporary manuscripts illustrating the Apocalypse (figure 24), even though the former is not to be considered the unique source

[62] Bishop Tatum, "The Paliotto of Sant'Ambrogio at Milan," p. 37.

[63] Lavedan, *Représentations des villes dans l'art du Moyen Age*, pp. 11 and 24. On Matthew Paris, see Suzanne Lewis, *The Art of Matthew Paris in the Chronica Majora* (Berkeley: University of California Press, 1987).

[64] Peroni, "Raffigurazione e progettazione di strutture urbane e architettoniche," p. 705. On the chronology of this work, the narrative of Arculf, and the redaction of Adamnan, cf. C. Heitz, *Recherches sur les rapports entre architecture et liturgie à l'époque carolingienne* (Paris: Sevpen, 1963), p. 113; idem, "Retentissment de l'Apocalypse dans l'art de l'époque carolingienne," in *L'Apocalypse de Jean: Traditions exégétiques et iconographiques, III*ᵉ*–XIII*ᵉ *siècles*. Actes du Colloque de la Fondation Hardt, 29 février–3 mars 1976 (Geneva: Droz, 1979), p. 228 (with a slightly different chronology).

[65] Heitz, *Recherches*, pl. 29 and p. 135. Arculf wrote *in paginiola cerata*, that is, on a small tablet, wax-covered so that it could be wiped clean and reused.

of their inspiration.[66] The rotund cupola of the Anastasis of Jerusalem, which reproduces the vault of heaven, was adapted very freely in the West to the Westwerk type of church (*antéglise* with three towers) as defined by Heitz, who had the merit of clarifying the way in which, in the Carolingian period, the Apocalypse was felt as the triumph of Christ victorious rather than of Christ the judge. In this spirit, the sacred text is closely tied, in liturgy and in architecture, to the celebration of the Passion and Resurrection of Christ. The result is that a tightly linked chain binds together the earthly Jerusalem through its buildings, which recall the death and Resurrection of Christ; the heavenly Jerusalem of the Apocalypse (the triumph of the Lamb); and lastly sacred building construction in the West, whose architecture is influenced by the liturgy itself, in the yearning to anticipate here on earth the heavenly Jerusalem. Previously Krautheimer, in a famous article,[67] observing how the various western churches intended to reproduce the Holy Sepulcher are extraordinarily dissimilar among themselves, had established that the copy is achieved not when a particular architecture has been reproduced but when a concept is reproduced—the one which that architecture aimed to establish. The copy is not of reality, that is, but of the symbol. In images, for this reason, a mere name is enough to release a stereotype; an example of this is found indeed in the theme of Jerusalem and Bethlehem. At Bologna, the church complex of Santo Stefano was organized so as to give pilgrims the opportunity of following the same itinerary they would effectively have done in Jerusalem. And so, because of the emotional investment directed toward Jerusalem in the hearts of the faithful, topography is reabsorbed into theology, and the celestial city is projected onto the actual earthly one, with Jerusalem becoming "comme celle de son prototype idéal, un cercle parfait, parfois même une série de cercles concentriques."[68] Typical of this mentality is the choice of the circle as the symbol of perfection. Even the oil lamps inside the churches, crown-shaped, represent the "ymaginem caelestis Jerusalem,"[69] where yet

[66] So M. T. Gousset, "La représentation de la Jérusalem céleste à l'époque carolingienne," *Cahiers Archéologiques* 23 (1974): 54 and fig. 1, against the more positive affirmation of Heitz, *Recherches*, pp. 113–14. Surprisingly Heitz in the article "Retentissment de l'Apocalypse" does not mention Gousset's article.

[67] R. Krautheimer, "Introduction to an Iconography of Mediaeval Architecture," *JWCI* 5 (1942): 1–33.

[68] Lavedan, *Représentations des villes dans l'art du Moyen Age*, p. 12. On the ecclesiastical complex of Santo Stefano, cf. H. Bauer, *Kunst und Utopie* (Berlin: De Gruyter, 1965), pp. 8ff.

[69] *Chronicon Hildeshimense* 17 (*MGH*, *SS*, VII, 853); Honorius Augustodunensis, *Gemma animae* 1.141 (*PL*, CLXXII, 588): "corona . . . in templo suspenditur . . . ut coelestis Jerusalem nobis ad memoriam revocetur, ad cuius figuram facta videtur."

again the circle and the radiance evoke heaven in general, rather than a precise correspondence to the data of the Apocalypse.

In the illuminations illustrating the heavenly Jerusalem mentioned previously (figure 24), in contrast to the text which describes it as quadrangular, or rather as cubic, supplied with walls and guardians, the city appears, following an entirely abstract schematization, as a series of twelve concentric circles (the empty center is occupied by the lamb) spanned by the arms of a cross formed by the twelve gates, grouped three by three at the four cardinal points. This image thus departs from the very precise data furnished in scripture, and, given the weight of this textual source, the separation is decidedly a conscious one. There was an effort to substitute for the textual data a new symbolism, as though to deepen and reflect upon the Johannine text: the gates have been grouped three by three as if to form a cross. In Bede and Sedulius Scotus the entire earth is already marked with the sign of the cross: "ipsa species crucis quid est nisi forma quadrata mundi?" ("what is the very appearance of the cross if not that of the quadrate form of the world?") is the question put in a seventh-century text. The circle on the other hand is the image of the universe.[70] In the *De natura rerum* of Isidore of Seville, for example, the images of the cosmos are constantly rendered using this symbolism, but so too are abstract concepts that refer to it—for example, "some think that the year is called *annus* because it is like a ring (*anus*), that is, like a circle."[71]

In the so-called Carpet of Ewald, originating in Saint Cunibert in Cologne (ninth to tenth century),[72] we see *Annus* represented at the center with the sun and the moon in his hand, surrounded by the circle of the months and then by that of the Zodiac. The letters *alpha* and *omega* assimilate him to Christ, master of earthly and of eternal time. And the twofold nature, human and divine, is suggested by an illumination from the Bible of Viviano (ninth century) in which Christ in majesty appears, in the sky certainly, but inscribed within a rhombus, "forma quadrata mundi."[73] The correlation of circle and square fuses the traditional image of the spherical cosmos as it had been transmitted by antiquity and the mental image that the Middle Ages had forged.

In the Apocalypse the destiny of the world is lit up. The eternal

(Throughout I use the conventional appellation "Augustodunensis" in referring to this author.)

[70] For this and other texts, see Gousset, "La représentation de la Jérusalem céleste à l'époque carolingienne," p. 54.

[71] "Annum autem quasi anum dici quidam putant, id est circulum," *De natura rerum* 6.2 (ed. J. Fontaine, *Isidore de Séville, Traité de la Nature* [Bordeaux: Féret, 1960], p. 193).

[72] E. J. Beer, "Nouvelles réflexions sur l'image du monde dans la cathédrale de Lausanne," *Revue de l'art* 10 (1970): 57–62 and fig. 4.

[73] Ibid.

kingdom of God, in the conclusion of the Johannine text, is unfolded upon a new earth, from whose sky descends the new Jerusalem, the dwelling place of God, and of the people of the new pact that Christ has made. In the illumination before us, as a gloss on the Apocalypse, the Church of the future kingdom is shown therefore, both by means of the cross (in memory of its former dwelling), and by means of the circle—that is, the universe (its new station).

The disposition, in the apocalyptic Jerusalem, of the gates at the four cardinal points, immediately understood as the Cross of Christ, influences as well the planning of the churches that are intentionally set up at the four points of the city. Thus the biographer of the bishop of Paderborn in the eleventh century says that the bishop had died too soon—that is, before bringing to completion his plan; he had already founded two monasteries at the eastern and western borders of the city and had wished to raise another two on the north and the south *in modo crucis*, so that the city should be placed under the protection of the Crucified and armed against the enemy by the prayers of the religious.[74] An analogous example is found in the life of the archbishop Bardo of Mainz (eleventh century): Richard, abbot of Fulda in the first half of the eleventh century, having noted that three churches stood about his abbey, considered that God had suggested to him that he should erect another to complete the cross. The churches were aligned cruciform at Bamberg, Chester, and Utrecht, and it is worth noting that in all these cases the churches and the walls of the city reproduced, in their plan, the scheme that had been adopted to illustrate in abstract form the heavenly Jerusalem in the illumination here under consideration.

I wish to dwell a little longer on two other illuminations from the same codex that illustrate—this time in fully figural manner—the new Jerusalem (figures 25, 26). In one,[75] the city is shown as a circular fortress composed of twelve towers, placed over the solid foundation described in the text. Once more, the perfection of the new kingdom can only be expressed by a circle, but this attempt of the illuminator to reconcile respect for the sacred text with the possibilities opened by his own mental outlook seems to me of interest: the city may be absolutely circular, but the appropriately arranged peaks of four of the towers, differently colored than the others and darker, permit the reconstruc-

[74] For this and other examples, cf. E. Herzog, "Problemi urbanistici nell'XI secolo in Germania e in Italia," *Critica d'Arte* 3 (1950): 17.

[75] Gousset, "La représentation de la Jérusalem céleste à l'époque carolingienne," fig. 4: the Apocalypse of Trier, f. 69r, the angel shows the new Jerusalem to Saint John. Gousset (ibid., p. 56), relating an already odd opinion of Katz, goes so far as to maintain that the heavenly city must have been designed square and circular at the same time because of a dependence on the way cities were represented in the Byzantine world!

tion of an ideal square. And as the center had been occupied, in the schematic representation, by the *agnus Dei*, here, where a figurative representation has been chosen, the only possible image of God is the concrete one of a church. The Apocalypse may say "et templum non vidi in ea, dominus enim Deus omnipotens templum illius est et agnus," but despite this explicit negation, the equation *Deus = templum* alone has been selected and depicted. In the second illumination,[76] which, following the development of the Johannine text, shows the Elect on the road to the heavenly Jerusalem, the city that receives them is now without any walls—the idea I think is to suggest that they are already inside—and is embodied as a single large church of the *antéglise* type. We might compare the facade of the church of Centula, known today as Saint-Riquier, with its tower of the Savior, as it must have appeared in the Carolingian period, when it was an intentional reproduction of the Anastasis of Jerusalem.[77] Heitz adduces the similarity between a reliquary with three towers from the early thirteenth century which forms part of the treasure of Saint-Riquier, a small-scale model of the church as it was in its original form, and the eleventh-century fresco in the church of Saint-Chef, representing the heavenly Jerusalem "à silhouette d'antéglise occidentale."[78]

The symbolic interpretation that sets up an equivalence between the heavenly Jerusalem and the *Ecclesia* is later applied, in what might be called a centripetal-reductive process, to the sacred edifice itself as a material construction. An inscription placed at the level of the tribune of the *antéglise* of the church at Corvey says "Civitatem istam tu circonda Domine, et angeli tui custodiant muros tuos."[79] The liturgy of the office for the dedication of a church, too, reminds us that every church is the image of the heavenly Jerusalem. "Urbs, beata Jerusalem, dicta pacis visio quae construitur in coelis vivis ex lapidibus" (in which there is an echo of 1 Peter 2.5): so begins a hymn already very well known in the seventh century, which continues with a paraphrase of the text of Saint John.[80] The line "angulare fundamentum lapis Christus missus est," a gloss on the passage that recalls the copresence of the twelve tribes of the sons of Israel and the twelve apostles of the lamb, signals the union between the "dilecta civitas plena modulis et canoro jubilo" and its mirror image on earth: "hoc in templo, summe Deus, exoratus adveni." It is here, so to speak, that the hope of heaven is

[76] Ibid., fig. 11.

[77] Heitz, *Recherches*, pp. 219 and 234.

[78] Heitz, "Retentissment de l'Apocalypse," p. 227 and fig. 9.

[79] These lines are part of a text that continues: "Avertatur furor tuus Domine | a populo tuo et a civitate sancta," the heavenly Jerusalem therefore (ibid., p. 229).

[80] F. J. Mone, *Lateinische Hymnen des Mittelalters* (Freiburg, 1853–1855), vol. I, p. 319; and Gousset, "La représentation de la Jérusalem céleste à l'époque carolingienne," p. 56.

born: "Now may each one be worthy to have and to hold that which he has always sought, to enter forever into Paradise together with the saints, having traversed the path of peace."

Even earlier, in *De civitate Dei*—the work that Augustine began in the shattered aftermath of the sack of Rome, forcing himself to make their own history meaningful to the men of the new religion which was accused of being the cause of so many disasters—the road of the two cities, of God and the world, does not just unwind as a parallel advance through time toward the closure in which they will reign eternally with God, or else "undergo eternal punishment with the devil."[81] The visible terrestrial city, doomed to death, contains within itself the invisible, celestial, and eternal one. If it suffers travail here on earth, intermingled with the other, it will have its victory later in heaven. "The house of the Lord, the city of God, which is the holy Church, is built in every land by men believing in God, who are like living stones from which the house is built, after the end of the captivity in which the demons held them."[82] In the actual Church the wheat and the tares are mixed, even though it can already be called the Kingdom of Heaven. Yet they who live as pilgrims on earth, "anxiously longing for the peace of the supernal city,"[83] are living right now the heavenly life. "In sum, they reign with Christ who live in his kingdom in such a way that they themselves are his kingdom;"[84] "hence we find two groups in the earthly city, the one that makes its own presence manifest, the other that with its presence is the image of the heavenly city which it has the duty to represent. Now nature corrupted by sin gives birth to citizens of the earthly city, but grace, freeing nature from sin, gives birth to the citizens of the heavenly city."[85]

The great fresco in the Spanish Chapel at Florence (figure 27), where the mission and the triumph of the Church are portrayed by Andrea di Bonaiuto (ca. 1366),[86] has the semblance of a late commentary on these lines. The passage is indeed from the church as edifice to the Church as the assembly of the faithful, tending—and this is its task—to coincide with humanity as a whole, progressively driving out evil: the Church that is at the same time the keeper of the flock, and the flock

[81] Augustine, *De civitate Dei*. 15.1.1; *CSEL* 40, 2, p. 58. I use the Italian translation of C. Borgogno (Alba: Edizioni Paoline, 1973), p. 811. [Translator's note: the English translations of Augustine given here are based on the Italian version cited by C. Frugoni, checked against the original Latin text in the CSEL edition.]

[82] Ibid., 8.24.2; *CSEL* 40, 1, p. 398; trans. Borgogno, p. 468.

[83] Ibid., 15. 6; *CSEL* 40, 2, p. 67; trans. Borgogno, p. 820.

[84] Ibid., 20.9.1–3; *CSEL* 40, 2, pp. 448–52, the passage cited at p. 450; trans. Borgogno, pp. 1216–20.

[85] Ibid., 15.2; *CSEL* 40, 2, p. 61; trans. Borgogno, p. 814.

[86] F. Antal, *La pittura fiorentina e il suo ambiente sociale nel Trecento e nel primo Quattrocento* (Turin: Einaudi, 1960), p. 287 and fig. 112 (original edition: London, 1948).

itself, making its way toward its celestial home. We find direct asser-
tions very close to this in the commentary on verse 21.1 of the Apoc-
alypse by Aimon of Halberstadt: "this city is the holy Church, which
is called *civitas* for just these reasons, that it has many inhabitants, it
extends to the four quarters of the earth, and above all it is the dwelling
place of God." The four cardinal points are then explained in this fash-
ion:

> The Orient signifies the people of the Jews, of whom Christ was
> born, the true sun of justice who shines in the hearts of the faithful
> . . . by North are understood the gentiles, symbol of infidelity
> and of ignorance . . . South signifies the light of faith, scattered
> over the earth, because when the sun rests in the South—that is,
> in the center of heaven—it illuminates all the world, an image of
> Christ who illuminates the entire Church. By West, we are to un-
> derstand the last age of the world, in which, according to Enoch,
> Elias, and the other prophets, the one faith in the Holy Trinity is
> scattered to the four ends of the earth, embracing at once Jews and
> Gentiles.

Christ, who, like the sun at the center of the heavens illuminates the
Church, has gathered to himself the two peoples who are joined in his
person, and it is by means of the Church and its preachers that the new
light will spread "per quadripartitum orbem," meaning that, if the
Savior has driven away the night of sin, the Church's task is to propa-
gate through time and in the hearts of all men, and it will be brought
triumphantly to a close in the "novissima mundi aetate."[87] Saint Au-
gustine had expressed this idea in the sermon *In Epiphania Domini*. Re-
calling the celebration of Christmas just concluded, and the occasion
of the present feast day, he says, "On that day the Jewish shepherds
saw the Babe: on this day the Magi came from the East to adore him;
with him indeed was born the cornerstone, the 'concord of the two
walls [circumcision and prepuce]' coming from afar 'to join themselves
in him,' him who became our peace, and of two things has made one
thing alone."[88]

This conception finds expression, it seems to me, in an almost con-
temporary mosaic (dated to the second half of the fourth century) from
one of the smaller apses of Santa Costanza[89] at Rome: in it Christ, at
the center of the composition, has Paul on one side and Peter on the
other, each flanked by a hut and by a palm. From beneath the feet of

[87] Aimon of Halberstadt, *Expositio in Apocalypsim* 7.21 (PL CXVII, 1199–1200; the first
passage at 1192).
[88] Augustine, *Sermones* 201: *In Epiphania Domini* 3.1 (PL, XXXVIII, 1031–33).
[89] Oakeshott, *I mosaici di Roma*, fig. 41.

Christ spring the four rivers of Paradise, and to them are coming four little sheep. Christ holds in his hand a scroll, its words are "Dominus pacem dat." The two sheepfolds and the palms must signify the two churches, the *ecclesia ex circumcisione* and the *ecclesia ex gentibus* (these are the titles that identify the two women who personify the two churches in the mosaic of Santa Sabina at Rome).[90] Paul, the apostle to the gentiles, is for that reason placed before the sheepfold that represents the converted pagans, whereas Peter represents the church that has left Judaism. The four little sheep symbolize the four evangelists, who drink in the word of Christ to spread it through the world.

Saint Augustine continues in his sermon to develop the notion of the diffusion of the faith: "Pilate and the Magi signify the peoples who must join together from the East and the West . . . the Magi were *ex gentibus*, as for that matter was Pilate. They came from the East, he came from the West, and because of this the Magi gave testimony to the king of the Jews at the moment of his rising, that is of his birth, Pilate on the other hand at the moment of his passing, that is of his death." On this basis, I believe, the two cities of Bethlehem, place of the incarnation and manifestation of the human nature of Christ, and Jerusalem, place of his Passion and Resurrection, the manifestation of his divine nature—in other words the two poles of the human experience of the Savior—are constantly counterposed in the figurative representations at the base of triumphal arch or apsidal vault (figure 28). Both of them, however, adorned with gems and precious stones, have the transfigured appearance of the heavenly Jerusalem described by the Apocalypse. From the two gates, six by six, the little sheep rush out to meet before the *agnus Dei* or else in the apocalyptic figure of Christ amid the clouds. In the twelve sheep (the twelve apostles, that is), the living Church is reflected in its leaders and as the assembly of the faithful. In the two cities, Christ is reflected, man and God, founder of the Church, whose word the apostles then spread and which the Church continues to propagate still. Jerusalem and Bethlehem, exactly because they are the home on earth of those who are pilgrims toward heaven, foretell the appearance of the unearthly city: the presence of the *agnus Dei* or of the Christ of the Apocalypse shows the reaching of the goal.

The theme of the two cities adumbrates then the course of the redemption of the human race, which has its beginning and its end in the coming of Christ on earth and in his triumphal *parousia* in heaven. The presence of the twelve little sheep does not in itself exclude a second signification (Aimon recalls in his commentary), given that Jerusalem and Bethlehem can also be the two churches *ex gentibus* and *ex circum-*

[90] Ibid., fig. 74.

cisione. On the triumphal arch of Santa Maria Maggiore in Rome, the two cities are represented on the base, and in the center, at the top, is seen the empty throne of the Apocalypse adored by the symbols of the four evangelists and of the two apostles Peter and Paul. The mosaics of the arch and the apsidal vault of Santa Prassede, from the beginning of the ninth century,[91] mark the extreme development of this subject: in the vault there is the experience of the Church in history, the two cities with twelve little sheep and the *agnus Dei* and, immediately above, Christ between Peter and Paul, a few saints, and the pope who gave the commission, holding a model of the church in his hand. In the arch, seat of the celestial Church, we have the twenty-four elders of the Apocalypse on the two sides, and at the summit the *nova Jerusalem* already inhabited by the Elect, by the angels, and by Christ; on either side, a column of men and women clutching the crown of victory are invited to join their companions already within the walls by huge angelic figures. On this image, an opportune comment seems to me the eighth homily of Gregory the Great on the announcement by the angels of the birth of Christ in Bethlehem to the shepherds. Before his advent, says Gregory, "since through sin we had been made strangers to God, the angels, citizens of God, felt that we were strangers to their own company. But from the moment we recognized in him our sovereign, the angels too recognized us as their fellows. Because the king of heaven has taken on the earth of our flesh, those extraordinary angelic persons no longer despise our inferiority . . . and us, whom before they had despised as weak and wretched, they now love as companions."[92]

The model of the heavenly Jerusalem did not remain a merely literary image, fit to adorn the commentaries and the texts of churchmen, but was, as far as possible, applied to the real world. All strove visually to make out this concept of the "divine city," fundamental to them, in the very structures of their churches, in the layout of their cities—in sum, in the corporeal concreteness of what lay about them. In the statutes of 1339, although Florence at this point had reached its third circle of walls, and a complement in reality of fifteen gates, these last are still reduced to the sacred number of twelve. In a statute from Imola of 1334, the city is described as having twelve chapels, "three in each of the city's quarters."[93] Sometimes, in contrast, it is the earthly Jerusalem that—as the privileged place preserving the most sacred relics of Christ, which was chosen for his triumphal entrance—overlays a medieval city. This occurred at Siena, for example, on Palm Sunday,

[91] Ibid., fig. 121.
[92] Gregorius Magnus, *Homil. in Evangelia* 1.8 (*PL*, LXXVI, 1103–5).
[93] ". . . in quolibet quarterio tres," Bauer, *Kunst und Utopie*, p. 9.

when the procession guided by the bishop around the walls of the city proceeded to the Porta Salaria in order to welcome Christ.[94] In contrast, the entrance of Christ into Jerusalem painted by Duccio on the reverse of his famous Maestà reveals that the actual city of Siena was used by him as his model.

Just as the city walls offer protection from the enemy, so sacred walls assure spiritual defense; observing a series of coins and bulls of emperors from Charlemagne onward, one sees how a church, very often shown with towers (figure 30), resumes emblematically the idea of city, with a continual passing over from the concept of material defense to that of the spiritual defense that the Christian emperors can provide.[95] In the eleventh-century mosaic of the vault of Sant'Ambrogio in Milan[96] (figure 29) narrating the miracle of the saint's ubiquity, Tours and Milan, identified by inscriptions, are represented simply by two churches shown in a sectional view. In an ivory panel of the tenth to eleventh centuries,[97] the turreted walls of a city frame an ecclesiastical building seen from above and open in corolla form; inside, a group of clerics intent on their liturgical chant cluster about the figure of the priest who towers, oversize, at the center. "Sing, traveler, thus; sing, boatman, thus;" Sidonius Apollinaris concludes a brief poem in which the identification of the church with the city is completed, "for towards this place all should make their way, since through it runs the road which leads to salvation."[98]

In the same way as the aperture of a lens, which may narrow or

[94] Braunfels, *Mittelalterliche Stadtbaukunst in der Toskana*, p. 85.

[95] H. Schaefer, "The Origin of the Two-tower Facade in Romanesque Architecture," *Art Bulletin* 27 (1945): 85–109. The author does not take a position concerning the various hypotheses of preceding scholarship, although he considers (p. 108) that the original idea was imported into the West from the Holy Land and from Syria. But it is interesting for our purposes to note the analogies proposed: funereal monuments, city gates, Westwerk. On this subject, see also G. Bandmann, *Mittelalterliche Architektur als Bedeutungsträger* (Berlin: Mann, 1951), esp. pp. 92ff.

[96] *Tesori d'arte cristiana*, vol. 1: *Milano, Sant'Ambrogio*, ed. A. M. Romanini (Bologna: Il Resto del Carlino, 1966), figure on p. 220.

[97] A. Della Corte and G. Pannain, *Storia della musica*, vol. 1 (Torino: UTET, 1964), p. 37 (antiphonary of Reichenau, tenth–eleventh centuries).

[98] "Sic, sic psallite nauta vel viator; | namque iste est locus omnibus petendus, | omnes quo via ducit ad salutem." Sidonius Apollinaris, *Epistolae* 2.10.4, lines 28–30. (Sidonius, *Poems and Letters*, ed. W. B. Anderson, Loeb Classical Library [London: Heinemann, 1965], vol. 1, p. 466, with the English translation used here). After describing the church, Sidonius Apollinaris had added: "hinc agger sonat, hinc Arar resultat, | hinc sese pedes atque eques reflectit | stridentum et moderator essedorum, | curvorum hinc chorus helciariorum, | responsantibus alleluia ripis | ad Christum levat amnicum celeuma." Ibid., lines 22–27, which Anderson translates: "On one side is the noisy high road, on the other the echoing Arar; on the first the traveller on foot or on horse and the drivers of creaking carriages turn round; on the other the company of the bargemen, their backs bent to their work, raise a boatmen's shout to Christ, and the banks echo their alleluia."

widen, but whose focal point remains fixed at the center, and like the walls of the city, which are a projection of the household (to the one and the other the entrances were closed up in the evening), so the church, in which the community of the faithful come together to find there protection and reassurance, really is a spiritual citadel.

Cities of Memory,
A Dream in Mosaic

The slow death, between the fourth and the sixth centuries, of many cities in Italy is relayed to us through a plurality of contemporary voices, for whom reduction to the status of fortress marks the decline of *civilitas*, and therefore of the city, which is emptied and dies.[1]

Jerome, in a letter written shortly after A.D. 374 to his friend Innocentius, recounts[2] a miracle that had taken place in Vercelli: a Christian girl condemned for adultery is recognized as innocent shortly before being executed. At the hour of the execution, "all the people hurried out to see the spectacle, so that it really seemed that the *civitas* wished to go forth; the crowd, in its hurry, pressed together at the thronged gates" ("totus ad spectaculum populus effunditur, ut prorsus quasi migrare civitas putaretur; stipatis proruens portis turba densatur"). The identification of *civitas* with *populus*, and therefore with the inhabitants, is implicit, as is the custom of inflicting violent death beyond the reassuring walls of the city.[3] The fact that the city, Vercelli, was a nodal center of great importance from the military point of view, at a time of mobilization of the Roman army under barbarian pressure along the frontier, is reflected in the quantity of Roman soldiers within its walls. "At this announcement [that the execution had been interrupted], the nearby *urbs* seethes, and a whole squad of lictors gathers [*et tota lictorum caterva glomeratur*]." This historical memory leads, in contrast, to a very different present: "The Ligurian city of Vercelli, not far from the foot of the Alps, potent at one time, is now a city semi-destroyed and almost depopulated [*nunc raro est habitatore semiruta*]." It is the loss of inhabitants that leads to the ruin of the buildings.

Even more telling is the testimony of Ambrose, which reflects the experience of a man who had been governor (*consularis*) of Emilia and Liguria between A.D. 370 and 374.[4] For Ambrose the crisis is both so-

[1] L. Cracco Ruggini and G. Cracco, "Changing Fortunes of the Italian City from Late Antiquity to Early Middle Ages," *Rivista di filologia e istruzione classica* 105, no. 4 (1977): 448–75. They draw attention to a series of significant passages, and I use these citations in places, but following my own line of inquiry.

[2] Jerome, *Epistolae* I (*PL* XXII, 325–32, here in the order 328, 329–30, and 327).

[3] Cf. chapter 1 above, pp. 11–12.

[4] On Ambrose, see Cracco Ruggini and Cracco, "Changing Fortunes of the Italian City," p. 453. The letter is found in *PL* XVI, 1098–1101, esp. 1099.

cial and economic, it is reflected in the cities but also in the countryside: the famous letter to his friend Faustinus, consoling him on the death of his sister, deviates from the literary topos that generates it precisely because of the "geographical" attentiveness with which the panorama of desolation is described. Alongside the "semirutarum urbium cadavera" of which the dismaying list is given, appear "et florentissimorum quondam populorum castella" (with the same relation of cause and effect registered by Jerome), and finally *Appennini inculta*. For Ammianus Marcellinus, these cities are all *oppida*, the deterioration of the agricultural countryside having brought about their metamorphosis, and only as fortresses do they survive.[5]

It is the inhabitants, too—living on in the memory of their exceptional deeds—who give a sense of the city for Saint Augustine in the *Sermo de urbis excidio*.[6] Rome, if it no longer appears so secure behind its walls as before, nevertheless has still an impregnable defense: "thousands of saints are gladdened in the place of solace" and for this reason neither barbarians nor the devil, nor the hail, nor hunger are to be feared. For Saint Augustine the relics guarantee divine forgiveness, felt as essential: there is victory, therefore, even in the moment of defeat. (In the following centuries, when uncertainty of survival will become the rule, there will be felt a need to locate the invisible zone of the saints around the city walls instead, invoking not—or not exclusively—spiritual salvation, so much as the thaumaturgical protection of the walls.) And Augustine continues: "What city of the humble is it that says these things? Or do you imagine, brothers, that a city is defined by its walls, and not rather by its citizens?" If God did in fact allow the Sodomites to flee, even while razing their walls to the ground, did that not mean that he had therefore pardoned them? Then he recalls the destruction with which Constantinople was threatened at the time of the emperor Arcadius. In order to convince the people that the revelation announcing his wrath was genuine, God sent a cloud of fire, announcing imminent destruction. The people all rushed to the churches to be baptized. God then delayed his punishment until the following week. All flee: "The entire city [*civitas*] went out together with the emperor, distancing themselves from the city walls and gazing back at their own dear roofs; leaving behind their beloved dwellings, they bade them farewell, in a voice full of sadness." Here not only is the concept of *civitas in civibus* reaffirmed, but its buildings are described in the language of the emotions: the leave-taking of those who look back at the *dulcia tecta* and the farewell to *carissimis sedibus* express

[5] Cracco Ruggini and Cracco, "Changing Fortunes of the Italian City," p. 475.
[6] *De excidio urbis Romae sermo* 6–7 (*CC*, Ser. lat. XLVI [1969], 257–59 = *PL* XL, 721–22; the following citation on p. 259 = 722).

the pain of seeing destroyed the residence of a feeling, a feeling that we can call one of ancestral belonging (*sentimento patrio*). In Augustine the point of view is strictly religious: even the dead, if they are saints, are dwellers, very potent ones, in the city: "the souls of the faithful departed in reality are not separated from the Church, which is even now the reign of Christ. . . . The Church thus reigns from now on with Christ in the living and the dead."[7]

With Cassiodorus, a century later, we find the expression of yet a different feeling of the city, seen now above all as the place of civility. The docile and mild animals—he says[8]—love to stay together, whereas predatory and savage ones "wish to act alone, they do not wish to capture their prey together with a companion. The will of those men who flee the sight of their fellows is for that reason detestable." The opposition between city and country (the abundance of whose produce will nevertheless be described by Cassiodorus with delighted satisfaction in a lingering catalog) is presented immediately, then, as an opposition between life together in an organized and hence civil fashion, and a space that the impossibility of a life of association qualifies as detestable: "let the men of property and the decurions of Calabria return to their cities; those who *cultivate* the fields without cease are mere *coloni*." "Why," asks Cassiodorus, "should they who admit that they take delight even in the fields of this province, be unwilling to inhabit its cities?"

The first direct consequence, felt therefore as the principal one, is the end of culture: "What is the point of men so outstanding remaining hidden away, deprived of letters? The youths seek access to schools of liberal arts, and within a short time they would have been ready to enter the forum; as it is they immediately start to grow ignorant, being confined to the country." And the essence of citizen life appears in a flash of illumination: "Who would not hold it dear to engage in talk with one's companions, seek out the forum, gain experience in the honorable arts, defend one's causes under the law, sometimes to occupy oneself with the counters invented by Palamedes, go to the baths with one's friends, arrange dinner parties at shared expense?" If the emphasis falls insistently on the necessity of a life in common, the edifices and public buildings which alone can maintain such a life are indissolubly linked to it: the forum, the baths, but also the houses, the palaces, the meeting places for schools and for banqueting.[9] I find in-

[7] Augustine, *De civitate Dei*, 20.9.2; *CSEL* 40, 2, pp. 451–52.

[8] Cassiodorus, *Variae*, 8.31 (*MGH, AA*, 259 = *CC* ser. lat. xcvi [1973], 336ff).

[9] On Cassiodorus, see A. Momigliano, "Cassiodorus and the Italian Culture of his Time," *Proceedings of the British Academy* 41 (1955): 207–45; and, by the same author, the entry "Cassiodorus" in *Dizionario biografico degli italiani*, vol. 21 (Rome: Treccani, 1978).

teresting the comparison here with the words of Ennodius in the panegyric to Theodoric, where, in the guise of flattery, the aspirations of Cassiodorus are realized: "All your predecessors loved their lack of culture because they never did any deed of greatness. A man of great eloquence sank into misery among the ploughshares, and that which experience had given to him, the rule of time denied. The tribunals were in decay because of the silence of the advocates, and no victory was won by the arts of speech."[10]

The cities, shaken by the repeated waves of the barbarian invasions, in the collapse and disappearance of the Roman Empire, are now only a panorama of desolate ruins, and nothing seems to me more clearly to illuminate the divergence between the political ideology that inspires and sustains the building activity of Theodoric, and the surrounding reality into which it is inserted, than a few passages from the same panegyric of Ennodius to the Ostrogoth king. The very rhetorical exaggeration of the praise gives more weight to the explicit admission of failure: "I see an unexpected beauty reawaken from the ashes of the cities, and the roofs of palaces glittering everywhere in the fullness of civilization. . . . The mother of cities herself, Rome, grows young again as those parts of her rotted by decrepitude are lopped off [*marcida senectutis membra resecando*]." The conclusion is melancholy and unexpected: "It is a greater thing to hold off decline than to found anew" ("plus est occasum repellere quam dedisse principia").[11] The recovery of youth, is, alas, possible only through mutilation; though sunset may indeed be stayed, it is vanity to hope for a dawning.

Theodoric, wishing to present himself as the natural continuator of the greatness of the Roman Empire (to Romanize the origin of the Goths, according to Cassiodorus),[12] is described in the same panegyric as a Byzantine emperor—the unique term of comparison at that time. He looks to emulate the living incarnation of a tradition, and at the same time to recover autonomously and directly that same tradition.[13]

[10] Ennodius, *Panegyricus dictus clementissimo regi Theodorico* 16 (*MGH, AA* VII, 212).

[11] Ennodius, *Panegyricus* 11 (p. 210).

[12] "Originem Gothicam historiam fecit esse Romanam . . . ," Cassiodorus, *Variae* 9.25 (*MGH, AA*, XII, 292 = *CC*, 379).

[13] Theodoric, writing to the emperor Anastasius, declares: "nos . . . qui divino auxilio in re publica vestra didicimus, quemadmodum Romanis aequabiliter imperare possimus. Regnum nostrum imitatio vestra est . . . qui quantum vos sequimur, tantum gentes alias anteimus" (*Variae* 1.1 = *MGH, AA*, XII, 10 = *CC*, 9). E. Bach, "Théodoric, romain ou barbare?" *Byzantion* 25–27 (1955–1957): 416, rightly underlines how this letter opens, not by chance, the twelve books of the *Variae*, as a declaration of formal homage to the emperor: yet the desire for an autonomous role is apparent. His efforts appeared to be crowned with success in A.D. 519 when Theodoric obtained a consulate at Rome for his son-in-law Eutaric "avec l'empereur Justin I comme collègue à Constantinople." The festivities for this event were so extraordinary as to astonish—says Cassiodorus in the *Chronica*—the Byzantine ambassador Symmachus himself (*Chronica*,

A Byzantine emperor is how he appears in the presumed portrait in Sant'Apollinare Nuovo[14] and *Palatium* is written on the grandiose construction (figure 33) that embraces, likewise in the mosaics of Sant'Apollinare Nuovo, the city of Ravenna. As well Theodoric had been represented between the personifications of Rome and of Ravenna "supra portam et in fronte regiae quae dicitur ad Calchi"[15] (*ad Calchi* is clearly a transliteration from *Chalke*, the entrance to the imperial palace at Constantinople). The Anonymus Valesianus describes him to us as "putting on circus games and theatrical shows [*exhibens ludos circensium et amphiteatrum*], so that the Romans call him by the names of Trajan and Valentinian, whose times he sought to recreate."[16] Trajan is recalled again in describing the feverish building activity of Theodoric, which aimed to give back a classical aspect to the city in ruins: "erat enim amator fabricarum et restaurator civitatum." At Ravenna he restored

> the aqueduct that Trajan had built, and brought water back to it after so much time. He brought the palace to completion without being able to inaugurate it, and had porticoes constructed around it. He constructed a palace and baths at Verona also, and to the former he adjoined an arcade, which extended as far as the gate; he renovated the aqueduct that had been so long in decay, so that there was water again. He built new walls around the city. Likewise at Pavia, he constructed a palace, baths, an amphitheater, and new walls for the city.[17]

For Theodoric, to build means above all to rebuild, to readapt: "It is our intention to build afresh, but even more to preserve old buildings, because in preserving them we shall win no less praise than from build-

MGH, AA, XI, I, 161). Theodoric "was the chief of the Goths and the Romans, without this de facto situation being clearly fixed in a legal definition: the Empire was able to make a show of believing that it had to do with an imperial *magister militum* with delegated powers, and Theodoric, without proclaiming it explicitly, to behave in actuality as a genuine occidental colleague of the Byzantine *Basileus*" (see P. Lamma, *Teoderico* [Brescia: La Scuola, 1951], p. 103). On the vagueness of the titles that the sources attribute to Theodoric, despite the clarity of his function, which "is that of interpreter of the real interests of Rome, and reconstructor of western unity," see the valuable pages in Lamma (esp. pp. 53–61). See as well M. Reydellet, "La Royauté dans la littérature latine de Sidoine Apollinaire à Isidore de Seville," *Bibliothèque des Écoles Françaises d'Athènes et de Rome* 243 (1981): 129–81, 184–278, 280–89.

[14] F. von Lorentz, "Theoderich—nicht Justinian," *Römische Mitteilungen* 50 (1935): 339ff.

[15] On the interpretation of this contorted passage from Agnello of Ravenna, and on the possibility that the portrait of Theodoric ought mentally to be relocated on the pediment of the mosaic of Sant'Apollinare, see below.

[16] Anonymus Valesianus, *Theodoriciana* (*RIS* XXIV, 4.16).

[17] Ibid. (18).

ing anew."[18] Nor does it matter that this entails the transfer, even from one city to another, of columns and stones and tablets of marble demolished *vetustatis invidia*—so that they may *ad ornatum* (in this case, of Ravenna) *surgere redivivum*. If no less praise may derive from conservation than from innovation, Theodoric, speaking through Cassiodorus, even goes so far as to declare that the merit of he who preserves is greater: "It is more necessary to pay attention to the conservation of things than to the creation of new ones, because, when one commences, recognition must be given to inventiveness, but when one preserves, it is possible to arrive at praiseworthy perfection."[19] This acknowledged inability of the present to give life to autonomous artistic forms shrinks drastically the margin for "novelty"; everything is reduced to the longed-for restoration of the past: "and so the earlier emperors properly owe the praise they receive to us, who have prolonged the youth of their fabrics that had sunk into a dark and lethargic decrepitude, making them shine now with pristine freshness."[20]

But the directives addressed to the inhabitants of the cities allow us to see that the overriding preoccupation was defense. If the ruins of the amphitheater at Catania rise up again, incorporated into the new walls of the city, they bring from the ancient construction to the new one a sense of shared enjoyment, and of the fetishistic grandeur of the past: "Your protection is at the same time our strength, and everything that shelters you from peril redounds to the glory of our defense." Those ancient stones now scattered uselessly on the ground, defacing the city by revealing its ruin, "are to be transformed for the good of all into a facade for the city walls [*in murorum faciem*]. So, carry out in confidence those works that prudence requires for defense, and that ornament suggests for public embellishment."[21] In another letter, addressed this time "universis Gothis et Romanis," the same principles are stated in an even more general way: the *constructio civitatis* in which the *cura regalis* is exalted is worthy because—and here a desperate attempt at identification is made—"the restoration of the ancient cities is the glory of our times."[22] Not only does the situation not permit Theodoric to build, but only to repair; in reality the available forces have to be concentrated, rather than on dilapidated buildings, on the erection of walls, the offspring of those ruins: a sorry phoenix of urban renascence. Indeed, Theodoric continues:

[18] Cassiodorus, *Variae* 3.9 (*MGH, AA,* xii, 84 = *CC,* 104). The letter is addressed to the city of Estuni (Sestinum?).
[19] Ibid., 1.25 (*MGH, AA,* xii, 28 = *CC,* 33).
[20] Ibid.
[21] Ibid., 3.49 (*MGH, AA,* xii, 104 = *CC,* 132).
[22] Ibid., 1.28 (*MGH, AA,* xii, 29–30 = *CC,* 35).

[in the restoration of the ancient cities] an adornment is gained for times of peace and protection is readied for the necessities of war. Therefore with the present mandate we ordain that should anyone have lying in his fields any type of stone of use for walls, he should consign it, willingly and without delay; it will more truly be his when he has given it for the good of his city. What is there more sweet than to watch the growth of public beauty, in which everyone's utility is included in the generality?

In this way the immediate requirement of defense seeks to veil itself in the memory of a departed grandeur, that might reunite the citizens not only in the needs of defense, but also in aesthetic satisfaction. Even when he orders the fortification of a *castrum* Theodoric recommends the construction of houses, he recommends that it be adorned *pulcherrimis fabricis*, as though to stifle the military aspect under contradictory directives for building programs that evidently exclude the specter of war.[23]

The state of grace of the New Jerusalem, where the treasures and precious objects of the peoples will be brought, where the doors will never be closed (Apocalypse 21.6) is surpassed in the encomium of the Anonymus Valesianus: from every region there hurried to the kingdom of Theodoric "negotiantes vero de diversis provinciis"; everywhere, even in the countryside, there is the same complete security "ac si intra muros civitatis." "And throughout Italy his only vaunt was this, that in no city did he build a gate; nor in the city were the gates closed. Anyone went about his business at any hour, as though it were day."[24]

To beautify Ravenna, Theodoric causes to be conveyed from various places, among them Rome, marble tablets and columns; in his letters, through Cassiodorus, we feel his satisfaction in bringing back into the present a splendid past. After a lengthy description of all the phases that have led to the restoration of the aqueduct of Ravenna, he exclaims: "Then the baths will make a fine display, then the pools will ripple from crystalline springs; then there will be water that cleans instead of dirtying, no longer requiring continually to be washed itself."[25] Speaking of the *basilica Herculis*, Theodoric gives orders to search out marble workers capable of repairing it: "de arte veniat quod vincat naturam"; let the discolored stones be covered over with pictures "since what has been excogitated for beauty is ever valued." "Let us not admit that the beauty of antiquity is out of our reach—we who

[23] Ibid., 1.17 (*MGH, AA,* XII, 23 = *CC,* 27).
[24] Anonymus Valesianus, *Theodoriciana* (*RIS,* XXIV, 4, 18).
[25] Cassiodorus, *Variae* 5.38 (*MGH, AA,* XII, 164 = *CC,* 212).

are not unequal to the happy splendor of past centuries" he had written at the beginning of the same letter.[26]

It is at Ravenna, above all, that Theodoric desires to reawaken the antique grandeur of the eternal capital. It was at Ravenna that he had himself portrayed between the personifications of these two cities. The testimony for this is found in a very difficult passage from the *Liber pontificalis* of the ninth-century chronicler Agnello of Ravenna, reporting in rapid sequence a list of some portraits of the king at Pavia and at Ravenna.[27] I believe it is possible to understand that one of the images of Theodoric on horseback, in mosaic, placed between Ravenna and Rome, was to be found "in fronte regiae . . . ubi prima porta palatii fuit . . . in pinnaculum ipsius loci": in the pediment, that is, of the entrance gate of the Palace. If we take this interpretation as valid, then we can picture to ourselves a composition similar to that shown on a piece of Byzantine cloth of the tenth century, conserved at Bamberg (figure 31); it shows a *basileus* in triumph between two female figures—while receiving, that is, the homage of two subject provinces.[28] In the mosaic at Ravenna the two cities are differentiated: Ravenna, moving away from the sea, advances to meet Theodoric, who seems to arrive in the company of Rome, and for that reason, enveloped, so to speak, in her greatness. The iconography is that of the *adventus* of the emperor, following a tradition that continued from the classical period down to the Carolingians, and in the Byzantine world.[29] The problem of whether or not this same image appeared on the pediment of the *Palatium* on the mosaics of Sant'Apollinare Nuovo has long been crit-

[26] Ibid., 1.6 (*MGH, AA,* xii, 16–17 = *CC,* 17).

[27] Agnellus Ravennas, *Codex pontificalis Ecclesiae Ravennatis* (*MGH, Script. Rer. Lang.,* pp. 265–391; new edition in *RIS²,* 2–3). The passage in question is at pages 339–40 of the *MGH* edition; it will be convenient to cite it here: "Post vero depraedata a Langobardis Tuscia, obsiderunt Ticinum, quae civitas Papia dicitur ubi et Theodericus palatium struxit, et eius imaginem sedentem super equum in tribunalis cameris tessellis ornati bene conspexi. Hic autem similis fuit in isto palatio quod ipse haedificavit, in tribunale triclinii quod vocatur Ad mare, supra portam et in fronte regiae quae dicitur Ad Calchi istius civitatis, ubi prima porta Palatii fuit, in loco qui vocatur Sicrestum, ubi ecclesia Salvatoris esse videtur. In pinnaculum ipsius loci fuit Theodorici effigies, mire tessellis ornata, dextera manum lanceam tenens, sinistra clipeum, lorica indutus. Contra clipeum Roma tessellis ornata astabat cum asta et galea; unde vero telum tenensque fuit, Ravenna tessellis figurata, pedem dextrum super mare, sinistrum super terram ad regem properans." As will be evident, the difficulty is twofold: to understand the exact significance of the individual words, and to decide on the punctuation (are we dealing, that is, with two quite different portraits, or is the same one being repeatedly referred to?). For a polemical résumé of the various "readings" and for a new—not to my mind persuasive—interpretation, cf. N. Duval, "Que savons-nous du palais de Théodoric à Ravenne?" *Mélanges d'Archéologie et d'Histoire de l'École Française de Rome* 72 (1960): 337–71, esp. 356–67.

[28] L. Bréhier, *La sculpture et les arts mineurs byzantins* (Paris, 1936; London: Variorum Reprints, 1973), pl. 88, figs. 1–2 and p. 100.

[29] Kantorowicz, "The 'King's' Advent," pp. 207–32.

ically debated. The mosaics, as is well known, underwent radical alterations when the Arian church was reconciled to the Catholic cult (a little later than A.D. 561).[30] On the pediment, now a uniform area of gold, traces of an image of some kind were found on the supporting mortar during restoration work. This datum inclines me to adopt the affirmative answer to the problem.[31] In addition, the tall figure of Theodoric on horseback at the center, between the shorter figures of the two women, would be well adapted to the triangular scheme of the pediment. An example of an "occupied" pediment can be seen in the temple of the goddess Roma in the mosaics of Santa Maria Maggiore, where we see the divinity towering at the center between the sun and the moon.[32] Visually, too, a useful and immediate *pendant* would have been achieved with the figure, this one preserved, of Christ between two apostles, in the act of crushing the asp and the basilisk, placed on the lunette of the gate that leads into the *Civitas Ravennae,* a matching-up that, as will be seen, appears to me likely to have deeper implications than merely surface iconographic consonance.

The problem of the interpretation of the passage from Agnello of Ravenna, and of mentally putting back in their place the original contents of the now-empty pediment, is tied to that of correctly reading the entire *Palatium* in the mosaics of Sant'Apollinare Nuovo, a reading made more difficult by the necessity of reconstructing, as in a palimpsest, two different moments: that of Theodoric, and that of the bishop, also called Agnello, who altered the contents of the mosaics. The first has left its testimony in the hands that remain on the columns of the colonnade, in the outlines of the heads that clearly protrude above the curtains that presently are draped in the intercolumniation,[33] and fi-

[30] F. W. Deichmann, *Ravenna Hauptstadt des spätantiken Abendlandes, II: Kommentar,* part I (Wiesbaden: Steiner, 1974), p. 129. On Agnello (A.D. 488–570), "reconsacrator" of numerous Arian churches in Ravenna, and ancestor of the later chronicler bearing the same name, see M. Mazzotti, "I monumenti agnelliani," in *Agnello Arcivescovo di Ravenna,* Studi per il XIV centenario della morte (570–1970) (Faenza: Lega, 1971), pp. 53–60. And in the same volume, J. O. Tjäder, "Ravenna ai tempi dell' Arcivescovo Agnello," pp. 2–23. An exhaustive bibliography is given for these mosaics by N. Duval, "La mosäique du *Palatium* de Saint Apollinaire le Neuf représente-t-elle une façade ou un édifice aplani," *Corso di cultura sull'arte ravennate e bizantina* 25 (1978): 93–122, esp. 120–22. (The author also reports the often conflicting opinions on all points of the complicated problem.)

[31] Deichmann, *Ravenna,* p. 141: the traces point "auf das beste für eine Reiterfigur."

[32] Grabar, *L'età d'oro,* fig. 162.

[33] P. D. Pasolini, "Del Palazzo di Teodorico in Ravenna," dissertation in *Atti e Memorie della R. Deputazione di storia patria per la Romagna,* ser. II, I (1875), pp. 200–203, cites the testimony of Sidonius Apollinaris, who in a letter to Agricola (1.2), said that the soldiers, during the royal audiences, stood "on the other side of the veils" so as not to create a disturbance with their voices. But this passage is then used improperly to justify the curtains in the intercolumniation, which do not belong, as we know, to the program of Theodoric. Another particular of the *Palatium* does have a precise parallel in the sources.

nally in the outline of an enormous figure in the arch of the gate of the city.[34] The hypothesis can be advanced—I now summarize the points that are in question—that the procession of dignitaries, and Theodoric, set out from here, making its way toward Christ enthroned, who stands out at the end of the wall (this last part of the mosaic is Theodorician). Not only did Agnello cancel all the figures that stood out against the background of the *Palatium* and the *Civitas*, but he substituted for the procession of the Arian king and his court a train of martyrs. (The same procedure was followed in the mosaics of the front wall: very clear signs in the mortar and in the disposition of the tesserae permit the secure affirmation that a group of figures was placed [figure 34] before the *Civitas Classis*[35]: in this case they would have been the wife of Theodoric and her dames, whereas at present a train of virgins departs from the empty city toward the Madonna enthroned, who welcomes them at the extremity of the wall.)

The phantasmal reappearance of these shadows has led, generally speaking, to two different interpretations of what we should understand as having been represented on the walls and on the buildings, which are clarified only by the inscriptions *Palatium* and *Civitas Ravennae*. Dyggve saw there not a facade but the interior of a hypethral basilica for ceremonies.[36] On this view the two wings of the colonnade would have closed toward the viewer; in the intercolumniation of the facade, which thereby becomes the internal rear wall, he supposed that Theodoric sat enthroned at the center, with the dignitaries beside him.

Duval, "Que savons-nous?" p. 364, has called attention to a passage from Cassiodorus (*Orationum Reliquiae* [*MGH, AA*, xii, 481]) in which there is a reference to the porticoes about the palace, which had for decoration "roseas virgines . . . pinnis rutilantibus alatas quales pomposas decet esse Victorias . . . Margaritarum quin etiam lacteae coronae flexis auro circulis pulcherrima rotunditate clauduntur."

[34] Duval, "La mosäique du *Palatium*," pp. 97–98. The lost figure placed in the arch of the *Civitas Ravennae* might have been the Tyche of Ravenna. As for the part of the mosaic occupied by the central archway under the pediment, it is not the case, as Duval affirms (ibid., p. 97), that it is an intact portion. The curtain is original, as is a part of the golden background, but from the traces left on the supporting mortar it is highly likely that an empty throne was represented, upon which perhaps a cross was erected. This is the hypothesis of Fiaccadori (G. Fiaccadori, "Ancora S. Martino in ciel d'oro. Appunti di topografia ravennate," in *Atti del VI Congresso Nazionale di Archeologia Cristiana*, Pesaro-Ancona, 19–23 settembre 1983; the volume is unfortunately not yet published), to whom I am grateful for communicating this article to me, and for many helpful references. In support of his hypothesis Fiaccadori cites among other things "the surviving portrayals of 'empty thrones,' especially those with the same 'architectonic' scheme (sarcophagus 'with three or four niches' with *velum*: the sarcophagus on the lawn of S. Stefano at Bologna, the sarcophagus at the Museo Oliveriano of Pesaro . . .)," emphasizing, as regards the *Palatium* of Ravenna, "the decidedly 'liturgical' connotation of the mosaic *velum* (the original, not as restored)."

[35] G. Bovini, "L'aspetto primitivo del mosaico teodoriciano raffigurante la *Civitas Classis* in Sant'Apollinare Nuovo," *Felix Ravenna* 55 (1951): 57–62.

[36] J. E. Dyggve, *Ravennatum Palatium Sacrum* (Copenhagen: Munhigaard, 1941).

Decidedly contrary to this reconstruction is that of Duval, who has dedicated a series of polemical writings to the problem, but has finished up, in the most recent ones, meeting halfway the predecessor who had been the target of his shafts.[37] Duval began with a minute examination of the edifices represented in the Psalter of Utrecht, concluding that already, at the period in question, two simultaneous points of view were employed to represent buildings: the internal vantage point, that is, was given (and in this case we must imagine that the colonnaded walls advance toward the viewer) contemporaneously with the external one, in which the wings of the roof are visualized as curving rearward. Even if such an interpretation were valid (for the illuminations in the Psalter) it does not seem to me possible to transfer it to the *Palatium* with which we are concerned. Duval has omitted to give a convincing explanation of the wide grey strip which separates the two porticoes, at their points of attachment, from the central block. It has been interpreted in the past as the shadow due to the pedimented block jutting with respect to the two wings of the colonnade. Further, in all of the images examined by Duval that aim to render a building through didactic simplification, the whole is always, and correctly, at the same height: the internal space of an edifice brought to the fore in this way to give a clearer message is no higher than the wings and does not have its own covering. But precisely these two features are found in the *Palatium* with which we are concerned.

Setting aside the hypothesis—for lack of archaeological support—that the figure of Theodoric was in the central archway, and substituting for it the more probable one that an empty throne was shown there, one is no longer forced to see, as Dyggve did, a scene in which the king is giving audience in the presence of the court, but instead the setting out of the regal procession.[38]

I wish to make one last observation about the different color of the background, blue in the intercolumniation, gold in the pediment and the central arch. The more precious color seems to me to be well suited to the symbolic presence of the divinity, or at any rate of the king (throne and portrait), who was not averse to assimilating the conventions that, in Byzantine art, accompanied the image of the emperor.[39]

For these reasons I align myself, again, with the unfashionable hypothesis that sees at the center the jutting block of the facade of the *Palatium*, and at the two sides the porticoes, which the sources unani-

[37] Duval, "La mosaïque du *Palatium*," pp. 118–19.

[38] This hypothesis had already been formulated by Deichmann, *Ravenna*, vol. 1, pp. 144–45. For the empty throne, see n. 34.

[39] The portrait of Theodoric, transformed by the inscription into one of Justinian, is that of a Byzantine *basileus*.

mously tell us were there.[40] I now wish to propose a comprehensive reading of this complex architectonic image, beginning with a comparison of the apsidal mosaics of Santa Pudenziana in Rome (figure 32),[41] which have in my opinion an extraordinary resemblance to those in Ravenna. The scheme is the same: a series of figures before a colonnade closed by a roof, which embraces the celestial Jerusalem, represented through the buildings of the corresponding earthly city of late antiquity: the *Anastasis*, the church of the Ascension, and many more as well[42] are recognizable, buildings that turn up again punctually at Ravenna.

The inscription *Palatium* underlines the aspiration of Theodoric to rise to the dignity of a *basileus* and, paradoxically, that is the most realistic detail, it seems to me, of the image: it is here that the political program of the king of the Ostrogoths is summed up. The city, on the other hand, appears (with the addition at the sides of a few edifices of obvious classical derivation, plus contemporary ones, to recall the building activity of the king, and the other pole of his ideology: "propagator romani nominis")[43] transfigured as the heavenly Jerusalem, but with a decisive departure from tradition.

When Theodoric had visited Rome for the tricennial festivities, the

[40] Anonymus Valesianus, *Theodoriciana* (*RIS*, XXIV, 4, 18), and cf. n. 35.

[41] J. Engemann, "Images parousiaques dans l'art paléochrétien," in *L'Apocalypse de Jean*, p. 79; idem, "Zu den Apsis-Tituli des Paulinus von Nola," *Jahrbuch für Antike und Christentum* 17 (1974): 21–46, esp. 34–36.

[42] Heitz, *Recherches*, p. 116 and table XXX. In particular it seems to me possible to recognize in the *Civitas Ravennae* the Martirium and the Anastasis; in the *Civitas Classis*, as it appears, the Imbonon. But a great deal of caution is necessary, in light of the massive restorations of Kibel in this part of the mosaic, documented by Ricci. In a seventeenth-century print by Ciampini (but how faithful in intention?) we see an ample building with a cupola marked. Ricci collects a series of items of figurative testimony that document the successive transformations and innovations. It may still be asked: on the basis of what suggestion did it come about that the city of Classe was filled up with buildings so much like those in Santa Pudenziana—in other words, like those in the Jerusalem of Constantine? In "our" Imbonon at Ravenna there is even the aperture in the center of the roof. Cf. C. Ricci, *Tavole storiche dei mosaici di Ravenna* fasc. IV, *Sant'Apollinare Nuovo* (Rome: Istituto di archeologia e storia dell'arte, 1933), pp. 54–64, and figs. 22–25, 27–29. On Santa Pudenziana and Constantine's Jerusalem, see A. Grabar, *Martyrium* (Paris, 1943–1946; London: Variorum Reprints), vol. I, p. 288; vol. II, pp. 165 and 205.

[43] I refer to the pages of Lamma, in the chapter "Per la definizione del potere" in *Teoderico* (pp. 53ff.). It will be worth citing the passage from Procopius of Caesarea adduced there (p. 60): "Theodoric ruled having arranged all things in a way fitting to one who was emperor by nature; . . . he was formally a tyrant (in the sense of usurper) but in reality a basileus, no less than those who had enjoyed great fame since the beginning in that dignity." Notable as well is the epigraph of Terracina (p. 123), in which the land reclaimer "exalts his own undertaking and at the same time glorifies the king in such terms that he clearly wants to make evident the identification with the ancient emperors." (Theodoric is called "victor ac triumphator semper augustus bono rei publicae natus".)

imperial fascination of the ceremonies in which he participated brought to the mind of Fulgentius (according to the saint's biographer) the thought of the celestial city. As Paolo Lamma notes, to arouse this parallel in the minds of observers was something the *basileis* had always been able to do; and as he insists, the passage is "important because in assimilating the Roman festivities in honor of Theodoric to the notion of the celestial Jerusalem, it repeats a motif that recurs often in the Byzantines with reference to the imperial ceremony."[44]

The bringing together of two conceptually similar themes has already been mentioned. Christ trampling the dragon and the serpent— which, as the inscription in the church of Santa Croce in Ravenna makes clear, signifies the triumph of Christ over death and sin—is an adaptation of the imperial iconography of the victory of the sovereign over the enemy.[45] Theodoric between Rome and Ravenna is intended, I think, to allude to a victory on the earthly plane, thus establishing a direct link between the two triumphs. A homily of John Chrysostom, *In Matth.* 2.1, seems to me relevant here, in which felicity within the heavenly city is described as a vision of peace to be enjoyed by angels and saints after a war, terrible but victorious, waged by Christ against sin and death. As Grabar brings out, this description is inspired by a triumphal composition celebrating the glorious and fruitful peace that resulted from a victorious campaign led by one of the emperors.[46]

The radical operations of the bishop Agnello, as we have seen, are the source of the two trains of virgins and martyrs; but the starting points of the two processions (the cities of Classe and Ravenna) are Theodorician, as are the points of arrival: on one side, the Virgin with the Child and the Magi, on the other Christ enthroned with his angelic guard, and likewise the stories of Christ and the great figures of the prophets that occupy the superior parts of the two walls. On the north wall the procession of the virgins sets out from the port of Classe, preceded by the three kings, to arrive at the throne of the Madonna

[44] P. Lamma, "Teoderico nella storiografia bizantina," *Studi Romagnoli* 3 (1952): 94. The passage from the life of Fulgentius is found in *PL* LXV, 130–31.

[45] A. Grabar, *L'Empereur dans l'art byzantin* (Paris, 1936; London: Variorum Reprints, 1971), p. 238. The mosaic has been lost, but the inscription has been preserved: "te vincente tuis pedibus calcata per aevum germanae mortis crimina saeva iacent." According to C. Mango (*The Brazen House*, Arkaeol. Kunsthist. Medd. Dan. Vid. Selsk. IV, 4 [Copenhagen, 1959], p. 24), the interpretation of the scene remains enigmatic, since the identification of Christ between the two apostles does not seem to him to be justified. Deichmann, *Ravenna*, part II, 1, p. 145, conversely, does not doubt it. In any case it is interesting for our purposes to note the close relationship, emphasized by Mango, between the encaustic of Constantine and his sons (see n. 59 below) and this detail of the mosaic.

[46] Cited by Grabar, *L'Empereur dans l'art byzantin*, pp. 256–57; the passage is found in *PG*, LVII, 23–24.

with the Child. In the panels above, Christ is represented as beardless, almost a youth. On the south wall the procession of the saints leaves from the city of Ravenna to arrive at the throne of Christ, who is dressed in purple—the imperial color par excellence—and is bearded, holding the *volumen* and making a gesture of allocution; the figure of Christ is without exception bearded in the panels here. Hence: on the north wall the earthly nature of Christ the son of man, begotten of Mary, is emphasized, and in the episodes from his life, his works as thaumaturge and savior. Conversely, on the south wall is shown "the heavenly lord, the Basileus, the Pantokrator: Christ in his passion is not a human sufferer, but is God, who is . . . lord of the world and sovereign of the Church, becoming such with his return to heaven."[47] It is here that we find the *Palatium* of Theodoric, from here he must have been shown setting out with his cortège of dignitaries and officers. The sources convey his desire to be assimilated to an emperor and to soften his own adherence to Arianism.[48]

On the opposite wall, instead, we can imagine, in the place of the virgins, the women of the royal family and the dames of the court. In San Vitale Theodora has on her raiment images of the Magi, whom we see here explicitly doing homage to the Madonna.

With the insertion of the virgins and the martyrs (Martin, the persecutor of the heretics, wearing a purple cloak, and Lawrence, another military saint, distinguished by a golden tunic, lead the file) Agnello transformed the *militia* of Theodoric into a *militia Christi*.[49] From the *Palatium*, the seat of earthly authority (the Byzantine emperor is the vicar of Christ),[50] the sacred procession now sets out, representing the Elect, those members of the body of the Church who have already earned their reward. The effigies of Agnello and of Justinian gave au-

[47] F. Gerke, "Nuove indagini sulla decorazione musiva della chiesa ravennate di Sant'Apollinare Nuovo," *Felix Ravenna* 103–4 (1972): 140. The article is posthumous and unfortunately without notes.

[48] Lamma, *Teoderico*, pp. 141–74. The Anonymus Valesianus, *Theodoriciana* (*RIS*, XXIV, 4, 17) records: "post factam pacem in urbe ecclesiae ambulavit rex Theodericus Romam et occurrit beato Petro devotissimus ac si catholicus." On the Arianism of Theodoric, see G. P. Picotti, "Osservazioni su alcuni punti della politica religiosa di Teodorico," in *I Goti in Occidente*, Settimana (III) di studio del Centro italiano di studi sull'alto medioevo (Spoleto, 1956), pp. 173–226. I wish to adduce also the opinion of Sidonius Apollinaris (*Epistolae* 1.2.4, the recipient is Agricola): "antelucanos sacerdotum suorum coetus minimo comitatu expetit, grandi sedulitate veneratur; quamquam, si sermo secretus, possis animo advertere quod servet istam pro consuetudine potius quam pro ratione reverentiam." On Arianism in general, see the recent work by R. C. Greey and D. E. Groh, *Early Arianism: A View of Salvation* (London: SCM Press, 1981).

[49] Gerke, "Nuove indagini," p. 147.

[50] The Byzantine emperor Anastasius, for example, is called *vicarius Dei* by Pope Anastasius II (A.D. 496–498): cf. I. D. Mansi, *Sacrorum conciliorum . . . Collectio* (Florence: Zatta, 1762), vol. VIII, f. 190 (ep. 1.6).

thenticity and actuality to the symbolic vision. In the representation of Justinian and Theodora in the mosaics of San Vitale,[51] which are a little earlier than those of Agnello's program of reconcilement in Sant'Apollinare, we see on one hand the emperor accompanied by dignitaries and ecclesiastics, and on the other the empress and her court, moving (within their panel) to enter a church[52] but from the observer's point of view, toward the Christ Pantokrator of the apse; his sacrifice is prefigured by Isaac, Abraham, and Melchizedek. Above the Pantokrator are the two cities of Jerusalem and Bethlehem, a reminder of the coming of Christ to earth in the incarnation, and his death, which prepares for his triumphal return. Would it not therefore be possible to envision a reconstruction of the same theme by Agnello? From the two holy cities of Ravenna and Classe the two processions depart, that of the virgins advancing toward the Madonna with the Child, thus toward Bethlehem, and that of the martyrs toward the apocalyptic Christ, thus toward Jerusalem. Confirmation of this is seen in the panels above, illustrating on one hand the miracles of Christ, on the other the *via Crucis*.

The program of Theodoric must have been very different. Let us remind ourselves that the title of the catalog of the things in which the monarch as constructor took pride was entitled *Palatium*: "These are the delights that attend our power; the splendid aspect that our empire wears; a celebratory witness to kingship. These buildings are shown to legates, arousing their admiration, and causing them straightaway to have of their master the opinion that such a dwelling suggests."[53] This must be *cura palatii nostri*, continues Theodoric in his directions to the *curator Palatii*: "you must conserve the ancient elements in their brilliance, and give to the new ones the same sense of antiquity, for a like beauty ought to be diffused in all parts of the palace, as a decorous body should be clothed in garments of one color."[54] But the precept "ab opere veterum sola distet novitas fabricarum,"[55] which sums up concisely the dream of Theodoric, remains in fact a dream command. It was on the level of propaganda, as it must have resulted from the vista of the two vast mosaics, those of Ravenna and Classe, anticipating the Heavenly Jerusalem in the second *parousia* of the Savior, that

[51] According to T. F. Matthews, *The Early Churches of Constantinople: Architecture and Liturgy* (London: Pennsylvania State University Press, 1977), pp. 146–47, the two panels must represent "the first entrance," those ceremonies, that is, that at Byzantium began the liturgy of the catechumens.

[52] Justinian and Theodora are bearing gifts. On the theme of the imperial offering, cf. Grabar, *L'Empereur dans l'art byzantin*, p. 147.

[53] Cassiodorus, *Variae*, 7.5 (*MGH, AA*, XII, 204 = *CC*, 264).

[54] Ibid.

[55] Ibid. (*MGH, AA*, XII, 205 = *CC*, 265).

the king—an emperor in his own desire—moved with his court toward the enthroned Christ who is surrounded by the angelic guard and wrapped in a mantle of purple, and toward the Madonna. Ravenna, I repeat, was wholly resumed in the *Palatium*, the structure that must principally have emphasized the political program and the aspirations of Theodoric.

The representation of a specific city—albeit with important symbolic implications—on the interior of an ecclesiastical edifice, and therefore in a monumental key, is an absolute novelty at this period, and it remains an isolated exception. Probably a particular role given to Sant'Apollinare as a palatine church[56] justifies the unusual program; and just as in the building religion and power were interpenetrated, so too the same interaction was felt in the contemplation of those images which, in this church, found an ideal framework.

Again I wish to recall what a conditioning example the Byzantine world was for Theodoric, who had passed an entire decade (A.D. 461–471) at Byzantium as a hostage, raised at the court there like a young prince.[57] A memory, visual even, of those moments and those ceremonies of which he could have been a spectator, seems to me to transpire from the mosaics of Sant'Apollinare Nuovo. Agnello of Ravenna says that one of the images of Theodoric was to be seen "in fronte regiae quae dicitur ad Calchi istius civitatis." Chalke was the name for the monumental vestibule of the imperial palace at Constantinople—later the same name was extended to the immediately contiguous buildings also. According to Eusebius, Constantine had constructed the Chalke, of whose design we know nothing, but which had atria where the palace guard kept watch (they burned down in 532).[58] Before the vestibule of the palace, the emperor had had placed a picture

[56] Deichmann, *Ravenna*, vol. I, p. 128.

[57] The sources are given by Lamma, *Teoderico*, pp. 16–20. Ennodius, in the panegyric to the king had exclaimed in 507: "Greece raised you in the bosom of her culture, foreboding the future" (*Panegyricus* 3 [*MGH*, *AA*, VII, 204]). On the level of culture of the king, *purpuratus philosophus* according to Cassiodorus (*Variae*, 9.24 [*MGH*, *AA*, XII, 290 = *CC*, 377]) and on Ravenna, the center of intellectual life at the time of Theodoric, see F. W. Deichmann, "La corte dei re goti a Ravenna" (*Corso di cultura sull'arte ravennate e bizantina* 27 (1980): 41–53. The author rejects decisively the judgment of the continuator of the Anonymus Valesianus, who described Theodoric as *inliteratus*, which is a topos applied to barbarians and not a considered opinion. To the Gothic court had flowed "the greatest orators then alive in Italy, the finest literary scholars, poets, writers, scientists. All of this could only be the work of a *rex litteratus* and not of a barbarian *illiteratus*" (ibid., p. 53). Deichmann further brings out (p. 52) the place assigned to Greek culture by Theodoric, who surrounded himself with "personalities who knew Greek well, or who were even of Greek cultural extraction." See as well C. Pietri, "Aristocratie et société clérical dans l'Italie chrétienne au temps d'Odoacre et de Théodoric," *MEFRA* 93 (1981): 417–67.

[58] R. Janin, *Constantinople byzantine, développement urbain et répertoire topographique* (Paris: Institut Français d'Études Byzantines, 1964), pp. 110–11.

in encaustic in which he himself, with the cross above his head, showed to his sons the dragon transfixed by a lance and sucked down into the maritime abyss that represented the enemy of the Church.[59]

Christ, between the two apostles, trampling the dragon and the lion in the lunette above the gate of the *Civitas Ravennae,* cannot be a casual choice, in light of the fact that the goal of the Theodorician procession was a Christ Pantokrator holding in his hand—before the restoration of the mosaics—a book with the words "ego sum lux mundi."[60] It should also be remembered that the procession on the front wall that departed from the *Civitas Classis* finished—and finishes—with the Magi before the Madonna.

For the Feast of the Epiphany, according to the *Liber de Caerimoniis,* the following was chanted to the emperor: "let he who has broken in the waters the head of the *dragon . . .* Christ who *lights up* the world with his epiphany, exalt and augment the force of your power for the prosperity and glory of the Romans." And, shortly before, outside the Chalke, during the same procession, were recalled—again—the *Magi,* adoring the dominator of the sun, guardian of the power of the sovereigns. The procession continued toward the church of the Holy Apostles, the church that Constantine had wanted to be a symbolic repetition of the Anastasis of Jerusalem,[61] and these words were chanted: "he who fills all creation and is its lord, made himself nothing with an annihilation that brings him close to us, but not entirely in vain, to fill up the world above with our race from down below. Let he who gives the gift of life raise up your power, O sovereigns, in all the universe, *let him enslave all the peoples, until they offer, like the Magi, gifts to your regal power.*"[62] A correspondence between the terrestrial sovereign and the celestial one, between the two kingdoms, is explicitly affirmed in

[59] Eusebius, *Vita Constantini* III 3 (cf. G. Dagron, *Naissance d'une capitale* [Paris: Presses Universitaires de France, 1974], p. 390). The interpretative slant given by Eusebius barely dissembles the transfer into a Christian setting of a motif of Roman triumphal art, that of the *calcatio* of the vanquished enemy (and for Constantine the wounded monster was perhaps his rival Licinius). On the origin of this iconographic scheme, see Grabar, *L'Empereur dans l'art byzantin,* pp. 237–39. Mango, on the basis of documentation from the fifth century (*The Brazen House,* p. 24), denies that this is truly an example of the motif of *calcatio* as Grabar thinks (*L'Empereur dans l'art byzantin,* p. 44), even if he himself uses as a close parallel the figure trampling the serpent between two companions in the lunette of the *Civitas Ravennae.* Mango recalls the fact as well that the encaustic was located before the vestibule of the palace, the place customarily identified *tout court* with the Chalke (Mango himself inclines to this identification, though with prudent reserve).

[60] Mango, *The Brazen House,* p. 103.

[61] On this complicated question, see Dagron, *Naissance d'une capitale,* pp. 401–8, esp. 406.

[62] Constantinus Porphyrogenitus, *Liber de caerimoniis* I 2 (in the edition of A. Vogt [Paris: Les Belles Lettres, 1967], p. 33).

the Byzantine sources: in the period of Justinian, the deacon Agapetus writes, in a work that we may compare to a "Mirror for Princes": "[God] gave you the scepter of earthly power after the likeness of the heavenly kingdom."[63]

The emperor Arcadius, on the column that bears his name, apppears on the summit of the monument crowned by victory while he tramples underneath his feet the maleficent serpent.[64] The program of this column—of which the Theodorician mosaic could be a version translated out of scroll form—is the exaltation of the emperor and of his victories under God's protection. The great procession sets out, on the column, from a facade with a triple arch (figure 35) and a pediment and six honorific statues, which Becatti identifies with "the entry to the imperial Palace, the Chalke of the Constantinian period, which was to be destroyed by fire in 532 and then rebuilt by Justinian."[65] Higher up on the column (figure 36) the emperor appears, viewing a parade of his army as it moves against the enemy: in the background, an arcaded building with two towers in profile. Where the emperor is, a *velum* hangs "indicating as always the imperial surroundings."[66] The column is an imitation of that of Trajan, with whom Arcadius, according to the literary sources, wished explicitly to be compared.

Valentinian I and Trajan are, for Theodoric, the models to follow, according to Cassiodorus: Trajan, the Roman Empire, the spell of the greatness of the past; Valentinian, the same empire translated, Christianized now, to the New Rome of which Theodoric wanted to appear as the worthy representative in the West. (Theodoric had chosen as his residence, according to Agnello of Ravenna, the palace constructed by Valentinian III.)[67] If we compare the imperial edifices from the spiral column with the *Palatium* from Sant'Apollinare, and with the porticoes and the entrance towers of the *Civitas*, it seems to me that we can detect an undeniable consonance. And I wonder whether the *six* personages from between the columns, who were later removed, were not in reality *six statues*, given that the hands belonging to them that can

[63] E. Barker, *Social and Political Thought in Byzantium from Justinian I to the Last Palaeologus (Passages from Byzantine Writers and Documents)* (Oxford: Clarendon Press, 1961), pp. 54–55 (chap. 1; other similar passages at chap. 21, p. 57, and chap. 37, p. 59: the emperor is like a god, no man on earth is above him). See as well the passages in the same volume (p. 72) taken from an anonymous treatise of political theory from the sixth century. Themistius had counseled Valentinian II to imitate "the king of heaven"; cf. Themistius, *Orationes* 9 (ed. H. Schenkl, G. Downey [Leipzig: Teubner, 1965], vol. 1, p. 191).

[64] G. Becatti, *La colonna coclide istoriata, problemi storici, iconografici, stilistici* [Rome: L'Erma di Bretschneider, 1960], p. 270.

[65] Ibid., p. 198.

[66] Ibid., p. 230.

[67] Ibid., p. 270.

still be seen appear to be making a gesture quite similar to that of the *six statues* that flank, on the column, the Chalke. Can it be a pure co-incidence that even the number is the same?

Let me recall, too, that the facade of the Chalke was decorated, probably in niches, with numerous *statues*. The sources record among others that of Theodosius I and of his "family," at least two of whom had *their arms "outstretched."*[68]

To those who were on the point of ascending into the interior of the column in Constantinople, there was visible, on the ceiling of the bottom staircase, a cross between the two apocalyptic letters; and the Christian symbol reappeared in six other places. The emperor becomes the medium of divine power: to the reign of the Savior in his second *parousia* corresponds that of the emperor, his vicar on earth; to Christ who pierces the dragon of the abyss, Arcadius who tramples the serpent. On a coin minted at Constantinople between 326 and 330, the labarum topped by the Chrismon spears the dragon with the legend *spes publica*.[69] Sozomenus insists on the desire of Constantine to honor "like a new city of Christ" the city rebaptized in his own name, "adorning it with beautiful sanctuaries."[70] But the city on which Constantine—and in the legend his mother Helena—showered money and attention was in reality Jerusalem, where the churches erected by him to exalt the memory of the Passion and the Resurrection were intended to bring to life the new Jerusalem announced in the Apocalypse.[71] "Truly it is a thing extraordinary, to hear ourselves addressed familiarly, who are foreigners; to become fellow citizens of the saints, we who were from another land; and to acquire the title of sons of the Heavenly Jerusalem, of which the Jerusalem constructed by Solomon was the terrestrial representative"; that was written, in an Easter letter collected by Cosmas Indicopleustes, by Saint Athanasius.[72]

At Byzantium the sole structure of those erected by Constantine that was inspired by the Holy Sepulcher of Jerusalem was the church of the Twelve Apostles. At the center—this had alarmed his contemporaries—he had planned to place his own tomb, paralleling himself directly to Christ surrounded by the *thekai* of the twelve apostles.[73]

[68] Mango, *The Brazen House*, pp. 99–100 and 104.

[69] Becatti, *La colonna coclide istoriata*, p. 249.

[70] The passage from Sozomenus (3.2) is cited in Dagron, *Naissance d'une capitale*, pp. 386–87.

[71] Ibid., p. 408.

[72] Cosmas Indicopleustes, *Topographie chrétienne*, ed. W. Wolska-Conus (Paris: Les Éditions du Cerf, 1968), vol. III, p. 253 (10.13–14).

[73] Deichmann, *Ravenna*, vol. I: *Geschichte und Monumente* (Wiesbaden: Steiner, 1969), pp. 213–19, esp. 215, has suggested a comparison between the mausoleum of Theodoric and the church of the Twelve Apostles, a comparison taken to the point of proposing a

At Ravenna too there are conscious references to the Byzantine city—for example, Santa Maria ad Blachernas and San Lorenzo in Calce.[74] At Constantinople, precisely in the region called *Blachernai*, there existed a gate of the Sant'Anastasis[75] and it is highly probable that a Sant'Anastasis existed at Ravenna as well.[76]

Over a long period in the Byzantine capital—Dagron brings this out clearly—Christianity passed through "the mediation of the Christian emperor." The relics, or the legends of the translations of relics, coming from Jerusalem, "are drawn into the imperial cult."[77] Beneath his own statue Constantine had placed a fragment of the Cross found by his mother Helena, and relics of the Cross were used in the palace ceremonies, thus taking on "a very decidedly imperial character." After Constantine the distance between the New Rome and the New Jerusalem is reduced continually, for example in the massive flow of relics sent to Byzantium from Jerusalem—precious talismans for the security of the city. In the life of Daniel Stylites written by one of his disciples at the beginning of the sixth century, the saint was dissuaded from going to Jerusalem, the goal of his voyage, to go instead "toward this other Jerusalem, the city of Constantine"[78] and "Néa Jerusalem" is the title given to Constantinople by the anonymous continuator of Georgius Monachus.[79] For all these reasons, it becomes possible to under-

conscious analogy in the article of G. Tabarroni, "La cupola monolitica del mausoleo di Teodorico," *Felix Ravenna* 106 (1973): 119–42.

[74] M. Mazzotti, "Elenco delle chiese ravennati attraverso i secoli," *Felix Ravenna* 106 (1973): 241 and 246. The church of San Giovanni Evangelista, built as a palatine church after A.D. 426 by Galla Placidia and her sons following an escape from danger at sea, would have derived from the custom, current in Constantinople, of designating a palatine church. Cf. Deichmann, *Ravenna*, vol. II, *Kommentar*, part I, pp. 97–98.

[75] Janin, *Constantinople*, p. 288. Idem, *La géographie ecclésiastique de l'empire byzantine*, I; *Constantinople*, 3: *Les églises et les monastères de Constantinople* (Paris, 1953), pp. 24–26. But according to Sozomenus, the church of Sant'Anastasia as well owes its name either to the resurrection of the orthodox faith at Constantinople, or to the resurrection of a woman at the hands of Saint Gregory (ibid., pp. 26–27).

[76] I do not find convincing the arguments advanced to the contrary by F. W. Deichmann, "Ancora sulla ecclesia legis Gothorum S. Anastasiae," *Felix Ravenna* 105–6 (1973): 113–19; the author supposes a translation of relics of sant'Anastasia from Constantinople to Ravenna in the period of the Goths. Not by chance, he says, sant'Anastasia is found in fifteenth place in the procession of the virgins in Sant'Apollinare (p. 117); but if she had been a Gothic saint par excellence, she would not have escaped the *damnatio* of the bishop Agnello!

[77] Dagron, *Naissance d'une capitale*, pp. 408–9.

[78] Ibid., p. 409, n. 3 (11–12).

[79] E. Fenster, *Laudes Constantinopolitanae* (Munich: Institut für Byzantinistik der Universität, 1968), p. 121. For a series of other analogous passages, all belonging to the same encomiastic literature, see ibid., pp. 102, 106, 114–15, 139, 159–60. See also E. Follieri, *I calendari in metro innografico di Cristoforo Mitileneo*, I: *Introduzione, testo e traduzione* (Bruxelles: Société des Bollandistes [Subsidia hagiographica, 63], 1980), p. 470 (Can. Aug.): "It was fitting that the first among the martyrs be translated from Sion to the new imperial city of Sion, obtaining justly for his lot the most important of cities." For this and

stand, in my opinion, how extremely provocative the Theodorician program must have appeared to the bishop Agnello and to the Byzantine administration (in fact the portraits of Justinian and of the bishop are the ones that appeared immediately in the church under the new regime). The Ostrogoth king had been interfering directly in the political and also the religious spheres, presenting himself as a protagonist in both. From the city of Ravenna, represented as a duplicate of the Byzantine capital (through the complex of structures of the *Palatium*) and therefore of the imperial power and of the heavenly Jerusalem in its Constantinian embodiment (but at the time of Theodoric the heavenly Jerusalem had already been transferred notionally to Constantinople, the new Jerusalem), the procession of the king and his court took its departure. As a virtual colleague of the Byzantine emperor, Theodoric catalyzed round himself the sacrality of the vicar of Christ as well. What is more, the procession that started at Ravenna and at Classe finished directly before Christ and the Virgin, promoting the august pilgrims as worthy residents of heaven while still here on earth—a glorification that Agnello suppressed, substituting for an earthly procession, configured as celestial, that of the martyrs and virgins, who, secure in the Church's judgment of their merits, traverse the paradisal fields. In this, the surviving version, Ravenna and Classe become, at most, only the starting point of their holy careers: from the earth they make their way back to Christ, following the new and difficult road opened by him. For Theodoric, on the other hand, there is not this sense of being remote from the world to come and from eternity: heaven and earth were shown as being in direct correlation in space and time.

The view that an awareness of such a fine web of allusions in the program of these mosaics may be attributed to Theodoric and to his advisers ought not to appear unjustified, I think. I recall Theodoric's long sojourn at Constantinople, the education he received there, the high level of culture—Greek culture—of the court of Ravenna. I have cited sources contemporary to Theodoric, as well as sources from a later period, to show how the names of Constantine and Constantinople were associated with that of Jerusalem, so that Constantinople equals the new Jerusalem. And the continuity, I think, confirms the radical vitality of this concept.

If the hypothesis that in the intercolumniation of the *Palatium* statues were placed, and in the central arch an empty throne, is correct (it

other valuable references, I am grateful to Vera von Falkenhausen. Constantinople is also called "New Jerusalem" in the life of Saint Andreas Salos, dated to the beginning of the eighth century by C. Mango, *Byzantium: The Empire of New Rome* (New York: C. Scribner's Sons, 1980), p. 208. (For the text: *PG*, CXI, 852ff.)

would render much more logical the *compact* departure of the dignitaries with Theodoric toward Christ), the allusion to the other "Constantinopolitan" statues must have been felt as equally disquieting. On this view, that is the reason it was not possible to put names above those visages to transform them into saints, in the way a name was able, on the other hand, to transform the portrait of Theodoric into that of Justinian. Everything in the mosaic that appeared to be a glorification of Theodoric was removed, its program was radically modified to antisepticize places and persons, depriving them of all their dangerous allusions to a recent and recognizable past.

An examination of the episodes from the life of Christ—which were spared this treatment—in relation to the commencement and the conclusion of the two processions reveals how complex and charged with significance the Theodorician program was. The panels are to be read clockwise beginning on the left at the rear of the church, from the city of Classe that is, and finishing again at the rear, but on the right, above the *Palatium*.

The first two miracles, the healing of the paralytic in the pool at Bethsaida, and the healing of the maniac with the herd of pigs that hurl themselves into the sea, an allusion to the baptism, have ideally a connection with the water of the sea of Classe, where, in the mosaic, one of the three ships also hoists a small cross.[80] At the end of the same wall the epiphany of the infant Christ before the Magi seems to me to correspond to the other epiphanies of Christ in the compartments above: the multiplication of the loaves and the fishes, the wedding at Cana. On the front wall, the Last Supper and Jesus in the garden of Gethsemane correspond to Christ enthroned as Pantokrator, but both of these scenes are rendered through a particular iconography that modifies their traditional significance. Bread and fish are the food offered to the apostles, and so the saving function of Christ *after* his death is already adumbrated. In the second scene,[81] contrary to the biblical narrative, we see the apostles wide-awake and alert, and Christ high up on a mountain covered with olives trees, in a frontal position with his arms raised. For the feast of the Ascension the emperor heard the following

[80] Ricci, *Tavole storiche*, pp. 56–59, discusses the various restorations carried out; the cross however is original. He refers (p. 58) to an observation of Ciampini, of interest in the present context: "Crux in mali summitate expressa, Imperatorum Christianorum servitio Naves destinatas fuisse indicat."

[81] Gerke, "Nuove indagini," pp. 159–60, denies his own earlier interpretation to the effect that the garden of Gethsemane was shown. In that case, this would be the illustration of the passage of Mark, 13.3ff., where the apostles interrogate Christ on the Mount of Olives about the destruction of Jerusalem. But at the end of the article (p. 175), to which the author was unable to give a final review, he interprets it, without justification, as the Ascension.

words chanted: "Christ presented himself to his disciples, appearing and saying 'Peace,' and explaining to them the words of the prophet, he led them *up* on the *Mount of Olives* and *having raised his hands to the sky* and having blessed them he was raised to heaven. . . . It is for this reason that our god, O benefactors, will bless you in everything and will fill your kingdom with joy."[82]

None of the sacred texts contains all the details that the chant for the feast of the Ascension includes. In Luke 24.50 it is said that Christ raised his hands to the sky, but the place is Bethany. In Acts 1.9–12 it is said that the disciples descended from the Mount of Olives but the entire episode is recounted in a different fashion.

In chronological succession the Garden of Olives ought to have followed the Last Supper: the coincidence of place has caused the scene of the Ascension to be introduced instead (nor is this the only time the narrative undergoes inversions or displacements).[83] Therefore the Ascension not only finds a conceptual correspondence with the great figure of Christ Pantokrator enthroned, but Christ, through having been inserted in the chant of praise to the emperor, comes into the program of self-aggrandizement, which it seems to me could have been Theodoric's.

Finally, above the panel occupied by the *Palatium* and by the *Civitas Ravennae* are found: the pious women at the sepulcher after the resurrection of Christ; the pilgrims encountering Christ on the road to Emmaus, with Jerusalem seen in the background; and lastly Christ appearing to Thomas and the apostles. Gerke, without extending the observation to the other parts of the program, had already noted the symbolic architecture of the three scenes: "Jerusalem, the lofty city in which the glory of the *Logos* was realized in the *via Crucis* and in which the Apostles must remain until they are invested with the virtues coming from on high; the holy sepulcher, elevated to a symbol of the Resurrection of Christ by the first Christian emperor, Constantine, makes Jerusalem into the celestial city to which (also according to Luke 24.52) the disciples returned full of joy after the ascension of Christ, as we see at the beginning of the church."[84] The closed door, finally, reveals that the *Kyrios* has brought peace: "pax vobis: ego sum, nolite timere" (Luke 24.36).

In the acclamations for the feast of Easter Sunday, the emperor heard the following chanted: "though the tomb was sealed, the sun of life has arisen, and having appeared to the apostles behind closed doors he

[82] Constantinus Porphyrogenitus, *Liber de caerimoniis* I 8 (pp. 52–53).

[83] For example the scene of the denial of Christ: cf. Gerke, "Nuove indagini," pp. 150ff.

[84] Ibid., p. 175.

communicated to them, he himself, the Holy Spirit, and gave peace to the universe. Let the rising of the star that never sets renew and magnify the imperial authority like a shining sun."[85] Thus, with the triumphal trilogy of the Resurrection underlined by the strongly allusive architecture of the mosaics, the Ostrogothic king who guaranteed on earth the peace of heaven set out from Ravenna, the new Jerusalem, on his journey toward the true celestial king.

[85] Constantinus Porphyrogenitus, *Liber de caerimoniis* I 6 (p. 46).

The Better City:
In Search of the
Past

In the foregoing chapter the guidelines to which I held were primarily temporal ones, but in what follows the investigation will move along spatial coordinates. From the world of "Carolingian" Europe, that is, the focus will be narrowed to Italy, and the long final chapter of the book will be devoted to Siena. The small spiral columns of so many medieval churches also embrace, as they wind about themselves, diverse motifs. In like fashion, my method is grounded in the stereotype that, as I think, the image of the city presents in the early Middle Ages: one with a range of nuances of which I try to take account.

The defensive aspect—as with the high circle of walls in the mosaics at Ravenna—is the first trait that is emphasized in a series of texts that survive from the ninth century onward, containing the praises, and hence the descriptions, of cities. Some of these belong to a very precise genre, called in fact *laudes civitatum*. A late-antique treatise on rhetoric, preserved in a Lombard manuscript of the eighth century, sets out its principles, which are, in descending order, "the dignity of the founder . . . the aspect of the walls, the region and the site" (whether on the plain or in the hills), its natural resources (these include the customs of the inhabitants), its ornaments, and finally—if there are any—the names of local nobility. If possible, praise of nearby cities should also be included.[1]

In about A.D. 739, during the expedition of Liutprand into Provence, a "praise" of Milan, preserved in a unique manuscript of the ninth century at the Biblioteca Capitolare of Verona, was composed. The fact that it has come down to us in a codex that postdates the epoch of composition by a hundred years is a proof of its fortune.[2]

The Milanese *ritmo* has been thoroughly studied, and for my part I wish merely to add a few observations. Rather than placing emphasis

[1] G. Fasoli, "La coscienza civica nelle 'Laudes civitatum,' " in *La coscienza cittadina nei comuni italiani del Duecento,* Atti dell'xi Convegno del Centro di studi sulla spiritualità medievale (Todi: Accademia Tudertina, 1972), p. 13, n. 6.

[2] *Versus de Verona, Versum de Mediolano civitate,* critical text and commentary, ed. G. B. Pighi (Bologna: Zanichelli, 1960) pp. 3ff.

on the description of the city as such, "the first expression of felt citizen patriotism,"[3] I wish to underline its adherence to a topos: if one takes the trouble to compare it with the principles enunciated in the treatise on rhetoric just mentioned, we see that the latter have been followed throughout. The idea of making a picture with a landscape as its exclusive subject will arise only many centuries after, and equally it would seem to me anachronistic to perceive in this little poem a "picture" of a city. What is of interest, without losing sight of the supporting structure of the topos, is to see how it has been fleshed out, and to what ends it has been turned; and so we will examine the "praise" of Milan as if reading it along two staves of a musical score.

The origins of Milan are felt to have little importance: no real or mythical founders are recorded, only the fact that from antiquity the city was called *Mediolanum*; the persistence of the toponym wings over centuries of history like a bird in flight. The city is in a state of alarm: the danger of imminent war (or perhaps of one already under way) throws the past into shadow and casts a harsh light on the present. The probabilities of victory are enumerated (that is, calculated). The topos, offering ready-made the catalog of praises, lays out the lines of a composition that is both a hymn and a prayer, begging God to keep off the peril of the Saracens, and at the same time making an effort to reassure the citizens in arms.

"De specie moenium locus et situs, qui aut terrenus est, aut maritimus et in monte vel in plano": these are the words of the treatise of rhetoric. The first adjective that defines Milan is *alta*,[4] an adjective that anticipates the "firmiter edificata opere mirifico" of the following line, taken up again and enlarged upon in the three succeeding strophes. These are dedicated to the city walls, which are accurately described with respect to the towers and the solid amplitude of the rectangular masses; to the gates "cleverly guarded by rules, and bolts, of iron"; and to the fortifications that protect the drawbridges. The city lies in a plain, guaranteeing agricultural abundance, so that "locus ita fructuosus."

Exactly as in the manuscript illuminations of the same period, which sum up the city in an empty circle of turreted walls, here too it is the defensive aspect that is preeminent. The number of lines dedicated to this are proof of it, and so is the fact that the description starts from an external vantage point, putting the high defensive ring in first place. Inside the walls, the city is empty: of its buildings, only those that butt right up against the walls are memorialized, as though to underline

[3] G. Fasoli and F. Bocchi, *La città medioevale italiana* (Florence: Sansoni, 1973), p. 100.
[4] For the text and translation, cf. *Versus de Verona*, ed. Pighi, pp. 145–60.

their protective value. A single church is described, resplendent with marble and gold, San Lorenzo, *edita in turribus* ("lofty among the towers"); the adjectival phrase is a signifier anticipating that which is signified: spiritual defense, a theme picked up by the concentric ring of churches and relics outside the walls. The holy defenders, always vigilant, always praying, keep Milan *invicta*. The face of the medieval city is completely absent; only the forum is mentioned, the paved streets, the aqueduct—and we recall that a street of pure gold, a river, and a piazza are the only elements of the city par excellence (also empty), the heavenly Jerusalem. Perhaps the insistence on the "splendor" of the city comes from the same source, too: "it is radiant . . . it has nine precious gates . . . it sparkles gloriously, adorned with sacred churches" ("rutilat . . . pretiosas habet novem ianuas . . . gloriose sacris micat ornata ecclesiis"). Let us return to the directions given in our manual: "thirdly, [one should speak of] the high yield of the fields, the abundance of the fountains, the customs of the inhabitants: and then, of the adornments, or further felicity, that subsequently were added to them." In the concrete exemplification, the principle is reversed: for the unknown author, who was certainly an ecclesiastic, it is important above all to insist on the adornments (sacred) and on the *felicitas* (spiritual) of Milan, to reassure his threatened fellow citizens and direct them toward this form of salvation through insistent prayer. In result, the richness of the soil is perceived in an ethical key; though Milan "is famous for merchandise of every sort, and full of cereals of various kinds, wine and meats are abundant, found in great quantities . . . outsiders and natives become rich there through advantageous gains," the writer is eager to suppress this industriousness, aimed, as it seems, only at profit, and to redirect it to a Christian possibility of redistribution: "generous charity is natural in its inhabitants, who all zealously make the shortest way to the church of God, offering their presents devoutly at the altars . . . the naked are there fully clothed again; the poor and the pilgrims there are fed." Note how the travelers take on a religious coloration, not wayfarers but pilgrims. Apart from these allusions, in which the face of the city of Milan shines faintly rather than being fully visible, seen not in the richness of its fields but in the diversification of commerce and in social variety, the praise of the city continues in an exclusively religious vein. For this reason the adornments are all Christian, and so is its *felicitas*: "O how fortunate and happy is the city of Milan, that it merited such saints to be its protectors, making it invincible and wealthy with their prayers." The *nobiles viri* of the topos are, in this perspective, the close ranks of saints that almost create a second, and more invincible, circle of walls, among whom stands out the *magnus presul*, Ambrose, and then also (with an insistence cer-

tainly intentional), the "magnus presul Theodorus," who, it is sug-
gested, follows in the tracks of his illustrious predecessor, "whom the
people carried to the cathedral with affectionate impulse." Theodorus,
who is here declared "de regali germine," is easily linked to the pious
king Liutprand "meritis almificus," to whom Christ has given such
sanctified grace. Even a military enterprise can take on a Christian hue:
"in battle they will force the necks of the infidels under the yoke" and
the prize of victory is entirely spiritual: "theirs is the palm, and the
name of the faith that it most honors."

The last item of the topos ("solemus et a finitimis civitatibus laudem
mutuare") is turned, with perfect coherence, into excellence in reli-
gion: "this is the queen of the cities and mother of this country, called
by its proper name of metropolis, praised by the peoples of all times
. . . ; to her come all the bishops of Ausonia, and there they are trained
in the discipline of the conciliar canon."[5] With self-satisfied superfluity,
a further strophe is dedicated to the minute description of the Ambro-
sian liturgy and rite. The conclusion, resolving itself in this hour of
imminent danger into a prayer to God, is harmonious, giving reassur-
ance to the inhabitants of Milan that they are protected by the saintly
power of the relics and praying for entry "into that city where the
saints give thanks eternally." In this passing over, viewed so naturally,
from one city to the other, the heavenly Jerusalem is already being
modeled as the triumphal goal of eternity for the greater encourage-
ment of the citizens of Milan—itself the anticipation on earth of the
realization of the kingdom of God. The fact that it is a metropolitan
see is the reason for its eminence; "the dignity of its power remains
great" because of this. In the Merovingian period, exactly because the
diocese was already generally identified with the city, Gregory of
Tours, after having described and praised his own native city, with an
insistence above all on its powerful walls, the fertility of its surround-
ing territory, and the abundance of its waters, expresses his surprise
that Tours does not have the title of *civitas* ("cur non civitas dicta sit,
ignoro").[6] In the "praises" of Verona, a poem composed about sixty
years after the one about Milan, upon which it may have been modeled
even in its material aspect, the innovations are substantial, although the
unknown author is again an ecclesiastic.[7]

The "praises" of Verona (*Versus de Verona*) together with a large il-

[5] Fasoli, "La coscienza civica," pp. 18–19, underlines the metropolitan function of
Milan, extolled all the more to compensate for the "bitter blow" received when the
bishopric of Pavia was taken from its control and subjected directly to the Holy See (after
680?).

[6] *L'Europe au Moyen Age, documents expliqués, 395–888*, vol. I (Paris: Colin, 1969), pp.
85–88 (Collection U, Série histoire médiévale, directed by G. Duby).

[7] *Versus de Verona*, ed. Pighi, p. 5: between A.D. 796 and 805.

lustration (figure 42) of the city (held unanimously by scholars to be posterior by more than a century to the poem)[8] were inserted in a miscellaneous codex containing lives and miracles of saints disposed in accordance with the ecclesiastical calendar, the assembly of which is owed, in all likelihood, to Ratherius, bishop of Verona. The codex, which Ratherius is thought to have taken to Lobbes, disappeared in 1793 when the French invaded Belgium, but two copies made about fifty years earlier have transmitted the text, and the great view of the city, to us.[9]

The little poem, in line with the other parts of the codex to which it belonged, recounts at length the facts of the lives of the saints Zeno, Fermo, and Rustico. The heart of the composition lies here: the "praises" of the city serve as the proper preliminary to the account of the miracles, underlining the spiritual patrimony of the relics of those same saints.

The recovery of the sense of the past and of a historical continuity with pagan antiquity arises from the very purpose of the poem—that is, from its hagiographic narrative. Sacred history allows the dual face of the city, both ancient and medieval, to be "seen" and appreciated, since it proposes to tell a story of beneficent intervention in a different, in fact diametrically opposed, reality—that of the men who did not know God.[10] In this light the Roman edifices of Verona are not simply remains that survive alongside, but unconnected to, the newer ones that have arisen; in the synchronic description of the city, they are relocated in accordance with a temporal scansion that gives the density of tradition, memory, and consciousness to the present. The turreted walls that make of Verona a heavily fortified quadrangle are recorded, but without dwelling upon the external, defensive aspect. Right away we are inside, admiring the Arena, "the steep labyrinth forming a majestic ring: who enters there without knowledge of the place is unable to come out again, except by lantern's light or the strand unwound from the skein": Ariadne's thread, a memory of the mythical past, is replaced by the thread of light cast by the medieval lantern, in the exploration of the antique structure.

Evidently the tunnels connecting the dressing rooms, the cages for the beasts, and the hollow spaces beneath the tiers, of the Roman amphitheater, their function not being understood, had been interpreted

[8] Ibid., pp. 6ff.

[9] Scipione Maffei added, after 1739, the large view at the end of one of his miscellaneous codices (Verona, Biblioteca capitolare, MS cxiv [106], ff. 187–88, from which figure 42 in the present work is taken). Cf. also P. L. Zovatto, "L'arte altomedioevale," in *Verona e il suo territorio* (Verona: Istituto per gli studi storici veronesi, 1964), vol. ii, pp. 482ff., and fig. 1, p. 484.

[10] For the text and translation, see the edition of Pighi, pp. 152–54 and 158–61.

as a mysterious labyrinth. The image was a familiar one, present in many medieval churches to symbolize the complexity of the world and the dangers it held for the souls of the faithful.[11] The *arena* of Milan, "arena quae et Arengum tota rotunda, in cuius circuitu tot erant camerae quot in anno sunt dies per occultos meatus inclusae," is described in Benzo of Alessandria (ca. 1316)[12] with the same medieval eye, incapable of locating in a historically defined past the vestiges of the ancient monuments and mentally fitting them into it according to their exact appearance and function, which he recreates instead by drawing—for both aspect and function—upon fable, and upon his own times. There in the arena, according to Benzo, the Roman soldiers gathered, taking their places on the tiered steps to hear the orator who spoke from the central *platea*. Giovanni Villani describes a Roman theater at Florence following the same procedure, as "a place for speeches, intended for holding public assemblies [*fare suo parlamento*]." The substructures for the tiers of seats and the central platform are transfigured into a marvelous structure "built in the round . . . with a piazza in the middle . . . where the people came together for their public meetings [*a fare parlamento*]."[13]

A brief digression: anachronism does not render useless these descriptions, in the medieval authors, of the "Roman" face of the city, inasmuch as, through the ingenuous temporal annexation of it that takes place, we are able to recover the city as the author saw it and lived it in his time. An example might be the Roman Florence of Villani, in which Caesar with his collaborators proceeds all over again to found the city, guided by medieval needs and models:

> Caesar measured out the boundary of the city fabric, and placed inside it two habitations called villa Camarti and villa Arnina. . . . Albinus set about paving the *entire* city, which was a noble work, and beauty and *cleanliness* of the city. . . . Macrinus had the aqueduct built with conduits and arches . . . so that the city should have plenty of good water to drink, *and for washing the city*. . . . Gnaeus Pompeius had the walls of the city built of *baked bricks*, and upon the walls of the city he built very thick circular towers with a space of twenty cubits from one tower to another, so that

[11] *Lexikon der christlichen Ikonographie*, s.v. "Labyrinth" (H. Birkhan); C. Frugoni, "L'autocoscienza dell'artista nelle epigrafi del Duomo di Pisa," in *Atti della decima settimana internazionale di studio, Mendola, 25–29 agosto 1986* (Milan: Vita e Pensiero, 1989), pp. 276–304, esp. pp. 293ff.

[12] Benzo d'Alessandria, *De Mediolano florentissima civitate*, ed. L. A. Ferrai in *Bullettino dell'Istituto storico italiano per il medioevo* 9 (1890): 26.

[13] Giovanni Villani, *Cronica* I 36. The edition cited throughout is G. Villani [and Matteo and Filippo Villani], *Cronica*, ed. A. Racheli (Trieste: Lloyd austriaco, 1857); this passage, p. 20.

the towers were of great *beauty and strength*. . . . Martius, another Roman lord, had the Capitolium built in the Roman fashion, the palace, that is, or master fortress of the city, and that was of *marvelous beauty*; into it the water of the river Arno came through canals with drains dug under vaults, returning to the Arno underground; and the city, at every feast day, was washed from the discharge of water from those canals.[14]

Faith in the marvelous Roman network of drains and water pipes, the wished-for answer to the vexing problem of keeping the overcrowded medieval streets clean, returns, but in the form of praise of the present state of things, in the admiring description that the Anonymus Ticinensis gives of his city, Pavia, where, even if in the streets the city's pigs roamed—those raised, that is, on the garbage they could find there—there were also *latrinarum cuniculi* and deep underground sewers covered with supporting structures, *pulchra hedificia* almost, and *orificia* in the crossroads, allowing the water to cleanse the city when it rained, and then flow back into the Ticino.[15]

To return to the interrupted description of Verona: Verona *magna* (following the customary descending spiral) shines forth over Italy, forth over the three Venetian provinces, forth from its own walls. Wrapped into a great circuitous labyrinth ("laberintum magnum per circuitum"), the city invites us to traverse its interior at the same time. There follows immediately, as in a rapid pan, the piazza paved with stone, with a great arch at each of its four sides, streets paved in marvelous fashion with squared blocks, ancient temples built with the names of the gods. In this "Ptolemaic" vision of ancient Verona there is yet something to recall the heavenly Jerusalem in its quadrate form, in the splendor of the towers, in the golden light that envelops it everywhere ("within it gleams, without it shines, girded by a nimbus of light; bronze, laminated with gold, is common metal there"), but above all there is an admiration almost inexpressible for the beauty of the city. Here it really does seem possible to speak of the sentiment of belonging to the city (*sentimento patrio*), in the enthusiasm with which the familiar places are enumerated, the attention of the eye to details, the concluding exclamation that implies a direct colloquy with the

[14] Ibid., 1 38 (p. 21). [Translator's note: this chapter is included in the recent selection, edited with extensive helpful footnotes by Giovanni Aquilecchia, of portions of the chronicle: Giovanni Villani, *Cronica* (Turin: Einaudi, 1979), pp. 6–11. The emphases are added to the text by C. Frugoni.]

[15] The anonymous author is probably to be identified as Opicino de Canistris, who composed the work between 1328 and 1330. For the bibliography, see Fasoli, "La coscienza civica," p. 21, n. 14. For the text, see Anonymus Ticinensis, *Liber de laudibus civitatis Ticinensis*, ed. R. Maiocchi and F. Quintavalle, *RIS*, XI, 1, 36 (the city pigs), 20 (the sewer system).

city: "O happy Verona, both rich and glorious." In the praise of Milan the author spoke *of* the city, turning, as if in church, to his audience of faithful, exorting them to prayer; here, instead, the writer speaks *to* the city, which therefore is felt as living, like a person;[16] even the prayer to God, giving thanks for all the advantages it is possible to list, is turned immediately in the direction of Verona and laid at its feet, as if in homage. The poet is insistent, at the close, on this "interpersonal" relationship ("Aquileia lauds you . . . every road passes through you . . . a great king dwells within you . . . glory to the Lord who embellished you"). The city does not appear as inert architectonic backdrop for the pious personages who live there: the gaze of the citizen, not just that of the believer, notes that it is an important commercial and strategic center. The buildings, sacred and profane, the deeds of the saints, the relics, everything is taken in by an equally affectionate regard, by that look of affection with which we contemplate a person dear to us. The symbolic aspect of the personification falls off like an empty chrysalis, and at the close of the poem there remains in our memory the image of a true queen: "We sing glory to the Lord, invisible king, who adorned you with such mystic garland, by which you are beautiful, and shine, radiant like the sun." Of Verona it is the fully medieval visage that emerges, yet juxtaposed with monuments that are still entirely Roman; the Castle, huge and high, is remembered, and its strong bulwarks, "the bridges of stone, on piles sunk in the Adige whose extremities touch *in orbem in oppidum.*"[17]

"Behold it, founded well by pagan men, who knew nothing of our God and venerated the old idols of wood and stone." There is no negative judgment of non-Christian antiquity;[18] rather the fact that the pagans, although ignoring the law of God, built monuments so beautiful and long-lasting, is almost emphasized. But this pagan era is felt as a sort of prehistory with respect to the Christian era, to the true history which is that inaugurated by the coming of Christ, the story of men who converted, and who convert, not of edifices. This is the rea-

[16] On the implications of the divergent use of the personal pronoun, see E. Norden, *Agnostos Theos: Untersuchungen zur Formengeschichte religiöser Rede* (Leipzig and Berlin: Teubner, 1913), pp. 221ff.

[17] "Quorum capita pertingit in orbem in oppidum": so reads the text. According to Pighi (*Versus de Verona*, p. 80), *orbem* must stand for *urbem*, and hence he translates "whose extremities touch the city and the *borgo*." L. Simeoni in his edition of the verses on Verona (*Veronae rythmica descriptio*, in *RIS²*, II, 1, 7) translates "whose extremities touch the city and the fort."

[18] In the *Prologus* of the archpriest Leo to the *Romanzo di Alessandro* (tenth century), there is also reference to the victories "excellentium virorum infidelium," a spur and a motive for "fideles et membra Christi" to show themselves "multo magis meliores" than they. Cf. A. Frugoni, "La biblioteca di Giovanni II duca di Napoli," *Annali della Scuola speciale per archivisti e bibliotecari dell'Università di Roma 9*, nos. 1–2 (1969): 170.

son that in the following lines, after a brief résumé of sacred history, the main focus is on the saints and bishops of Verona in chronological order, and in particular on san Zeno, whose miracles and life are recounted. The patrimony on which Christian Verona prides itself is hence purely spiritual, and it is interesting to note that it is the relics of the saints that are identified, not the churches that contain them, following mentally the circle of the walls (that is, following a topographical order of edifices).[19] The relics of Fermo and Rustico, triumphantly recovered by Annone, offer the chance to narrate the pious deeds of that bishop, the precious aromas that he poured out to honor the saintly corpses and the splendid veil of silk that was got ready to cover "the gilded altar with the *images* of the proclaimers of the faith; the shimmering silk glows, and enchants the senses of men: a band of white and a black one alternate between bands of purple." Certainly it is not by chance that the poet, indifferent to the sacred architecture of his city, shows himself receptive to the appearance of a piece of cloth, which is described in such detail, even to the extent of the impression it is able to make on bystanders.[20] In so doing he describes above all the appearance presented by the holy relics, and so the relics themselves; he sees the whole sacred history of his city interwoven, moreover, in the images of its bishops. The excellence of Verona is always religious: "splendid, powerful, and redolent of the relics of the saints, exceptionally wealthy among the hundred cities of Italy." For this reason Verona receives the praises of the other cities, of Aquileia, of nearby Mantua and Brescia, and of the three historic capitals, Pavia, Rome, and Ravenna.[21] The praise (I repeat) brings with it a notice of the important road junction that Verona is, as though the poet had imagined the route taken by the cities coming to extend their homage, and their arrival at their goal like kings from the Orient before the divine king; such a one would then be the great king of Italy and son of Charlemagne who lives there, "the most pious Pippin, not oblivious of piety, and of just mind, who acting always with the good, does good to all."

The reference to the king is dutiful, but extremely rapid. The poetic composition closes not with thanks to the highest political authority in the city, but to God, who adorns Verona with the mystic garland: defense and liberation from the enemy of justice are not entrusted to Pippin and his army, but to the wall of saintly guardians who make Verona rich and glorious. In this entirely religious vision, which

[19] *Versus de Verona*, ed. Pighi, p. 157.
[20] A fragment of it has fortunately been preserved. For a minute description, see *Veronae rythmica descriptio*, pp. XXXIff., and the plate between pp. XXXII–XXXIII.
[21] *Versus de Verona*, ed. Pighi, p. 157.

makes the city into a domestic shrine, it is the bishop-saint who is felt to be the city's real protector, something we see also in the later sculpture from the basilica of San Zeno (thirteenth century), which portrays the saint blessing the Veronese people in arms.[22]

The large view of the city that accompanies the poem is, together with the mosaics of Theodoric, the sole, striking exception to the "conventional" representations of cities that are the norm throughout the Middle Ages. In my opinion, only by attributing the initiative behind it to Ratherius can this singularity be understood: grown old, he leaves Verona for the third and last time in A.D. 968, and it is possible to imagine that on this occasion he wished to carry with him a visual memorial in addition to the manuscript, in order to have before his eyes, as well as in his mind's eye, the city in which he had passed so many—albeit difficult—years.[23] The view shows a broad panorama of public buildings and churches; the Roman and Theodorician walls are depicted and so is the wide river; but in addition—a fairly unusual detail—many plants spring from the *mons* labeled in the inscription. A few constructions are also explicitly labeled: the *Theatrum* in the foreplane (the Arena, that is); the *Pons marmoreus*,[24] the steps (*gradus*) leading to the "ecclesia Sancti Petri" situated on the *mons*. And further, the *arena minor*, the palace of Theodoric (*Palatium*) and the granary of the city (*Horreum*), and outside the walls, Santa Maria in Organo (*orfanum* may be a misreading suggested by the word *fanum*).[25] Over the archi-

[22] Fasoli, "La coscienza civica," p. 23; P. Toesca, *IL Medioevo*, vol. II (reimpression, Turin: UTET, 1965), fig. 487 and p. 773.

[23] On the complex personality of Ratherius (Rather, Raterio), see *Raterio da Verona*, Atti del X Convegno del Centro di studi sulla spiritualità medievale (Todi: Accademia Tudertina, 1973). On the date of composition of the view or illustration of the city, opinions vary, but converge around the tenth century; between 915 and ca. 922, according to C. G. Mor, "Dalla caduta dell'impero al comune," in *Verona e il suo territorio*, pp. 232–33, who recalls however the opinion of Simeoni: after 922. None of the supporting arguments offered seems to me decisive, beyond the rather generic one of the presence of a single bridge (see the following note).

[24] The text speaks of bridges in the plural, of the two Roman ones, that is. But in the ichnography of the view, only one bridge is shown, the other one having already collapsed (certainly before A.D. 873). Cf. *Veronae rythmica descriptio*, ed. Simeoni, pp. XXXV–XXXVI.

[25] Mor, "Dalla caduta dell'impero," p. 35, reports, but without taking a position himself, a hypothesis of E. Arslan, who believed he could see, given the rounded form of the monument, a church of the Santo Sepolcro; but the nearby gate began to be called the gate of the Santo Sepolcro, in relation to the "real" church, only in the first half of the eleventh century. L. Simeoni, in an article of 1911, reprinted in his *Studi su Verona nel Medioevo* (Verona, 1958), vol. I, p. 23, speaking of the precommunal age, says "did the *Organum* that the ichnography shows us still exist? What was it? Perhaps, given its position on the ancient course of the Adige, we may imagine a hydraulic structure." The connection between the *Organum* of the "Ratherian" plan and the church of Santa Maria in Organo, which took its name from it, is not fully accepted by recent scholarship (Zovatto, "L'arte altomedioevale," p. 483). For recent bibliography, cf. G. Mazzi, "La

tectonic particulars great care has been taken, for example on the structure of the *arena minor* the volute reliefs and vegetal forms of the facade are shown, and likewise on the *orfanum* we see the large Greek key pattern surrounding the cupola, or again on the facade of the *Palatium*, the umbo, very similar to the one in the Museo Nazionale of Ravenna. Seemingly out of a desire for verisimilitude, the forms of the towers, the windows, and the roofs (some peaked, others with cupolas) are extremely varied, with the result that many scholars have tried to identify all the structures represented by comparing them with historical reality. I do not intend to review the identifications offered,[26] merely to underline the fact that they were attempted just because the design offered a very lifelike panorama of Verona, together with inscriptions that identify the most significant focal points. There are a few framing verses; at the top: "de summo montis castrum prospectat in urbem dedalea factum arte viisque tetris" ("from the top of the hill, the camp, built with daedalian cunning, its streets grim, overlooks the city"). This is the viewpoint of someone surveying the city, and also an indication of the spirit in which the view was executed. The labyrinth of dark streets, which in the poem was attributed to the amphitheater, is here instead the graphic definition of the now medieval *castrum*. Two lines are dedicated on the left to the Arena: "nobile, praecipuum, memorabile, grande theatrum, ad decus exstructum sacra Verona tuum" ("noble, outstanding, memorable, magnificent theater, constructed to enhance your luster, O holy Verona"). The absence of antagonism already noted in the lines of the poem between the two cultures, bearers of different, but not opposed, values, is the rule here as well. Praise for the pagan past flows into that for *sacra Verona*, leading the author to use the affectionate "tu," and continuing—with a rise in intensity—in the ultimate line: "magna Verona vale, valeas per secula semper, et celebrent gentes nomen in orbe tuum" ("hail, great Verona, fare you well for endless centuries; may the nations celebrate your name throughout the world"). This augury of eternal fame is mixed with the regret of separation, made more acute by the awareness of what is being left behind.

Contrasting situations, peace on the one hand and the menace to life brought by raids and the dangers of war on the other, also occasioned

cartografia: materiali per la storia urbanistica di Verona," in *Ritratto di Verona: Lineamenti di una storia urbanistica*, ed. L. Puppi (Verona, 1978), pp. 617–20 (and pp. 539ff.; 562ff. for information on the various copies of the "Ratherian" plan).

[26] Mor, "Dalla caduta dell'impero," in the plate facing p. 192 (which reproduces, schematized and numbered, the plan of Verona; on the reverse, the list of the single monuments identified. On the same subject, see pp. 39–43 and 232).

the description of Modena composed around A.D. 910.[27] This threat brings about an increased awareness, an intent scrutiny of the face of the city and the history it reflects, now in danger of being canceled forever. This description is preliminary to the life of san Gimignano, bishop of Modena, invoked as its supreme and unique bastion. The citizen community recognizes in the bishop its hero (until the seventh century it had been the martyr who had spilled his blood there), and both martyr and bishop are invoked with the title of "patron." The public functions and the authority accorded, from the Carolingian epoch on, by the imperial authorities to the bishop—a firm presence in the life of the city, and not caught up in changing political currents—make him a chief to whom resort is had especially when the seat of official power is unstable and distant, and the enemy is nearby, and threatening.[28]

But the community of Christians looks to the efficacy of the prayers of this religious leader, and to his authoritative ability to intercede with God, not only to the military defense that he can organize, and to him it entrusts itself even after death "in an extension beyond the period of the accustomed functions of a bishop, in the sense that in the minds of the faithful he does not cease to carry them out when he abandons contingent life and becomes a member of the heavenly Jerusalem."[29] Thus, against the snares of the enemy, his relics will be the paramount weapon of defense, spiritual defense and nonetheless tangible and concrete, since his flock feels that it can still expect from its shepherd, from heaven, protection and assistance.

The very close ties that unite the city to its bishop are another topos that we might add to the canonical ones in the "praises" of a city; we will find it, for example, in those of Naples, Metz, and in another one of Milan. In the "praise" of Modena an initial paragraph is dedicated to running through, in orderly fashion, the arguments set out in the treatise of rhetoric mentioned above. Then, after the commencement of a new era with the advent of the Christian religion has been signaled, the praises in circumstantial detail of Modena's most illustrious citizen begin. The fine description, in romantic tones, of the grandiose Roman edifices swept into ruin by floods, and abandoned by men, imposes right away a question: "Should someone ask why the admirable edifices, worthy to be seen by men, of this city are not displayed, nor

[27] *Mutinensis urbis descriptio, sive additamentum ad vitam Sancti Geminiani (auctore anonymo qui circiter annum Christi DCCCCX floruit—sic* on the title page) in Muratori, *RIS*, II, 2 (1726), 691–92.

[28] A. M. Orselli, *L'idea ed il culto del santo patrono cittadino nella letteratura latina cristiana* (Bologna: Zanichelli, 1965), esp. pp. 99 and 106.

[29] Ibid., p. 113.

triumphal Capitols, as in other cities, the sincere answer he will receive is that in this city, in its prime, there were varied works in stone and countless beautiful things" ("si quis requirat, ut quid non eiusdem civitatis operosa monstrentur aedificia, spectaculo hominum condigna, Capitolia quoque, ut in aliis assolet, triumphalia? Veridica ei respondetur assertione, quod in eadem, dum viguit, Urbe, multiformia lapidum insignia, innumera quoque fuere praestigia"). The imposing spectacle of the ruins is already confirmation of a glorious, but devastated, past, which asks to be justified: "certainly, what this city now is, you all can see; its past greatness must be shown in telling its story." But until the present, only natural events have set their snares against it, without obliterating its glorious history; now the urgent threat of the terrible Magyars is about to rage mercilessly against humans, as well as against structures of stone. The medieval city, which was unable to prevent the collapse of the Roman buildings, and which can oppose to the pagan past only the walls of true religion, can take pride in just one patrimony—the spiritual one, its possession of the relics of san Gimignano. As previously in the "praises" of Milan and Verona, glory is not reflected in the construction of sacred buildings (they are unable to bear comparison with those of pagan antiquity) but in the new values that faith in Christ has brought, values unknown to the pagan world and hence not subject to comparison, but rather totally victorious. And yet the triumphalistic tone falters in places, before the unstoppable tidal wave of the Magyars to which history bears witness, and the author is constrained to suggest some sort of shared guilt, or inscrutable divine will, guiding the overwhelming course of events. And so prayer, emboldened by the intercession of Mary and of the bishop Gimignano "whose holy corpse is venerated here," is directed to Jesus: "let him defend us with his potent right arm from the assault of all our enemies on this earth." Imminent peril has condensed enemies in general into those on the immediate horizon. They penetrate to the cathedral itself (here the anonymous writer underlines the immediate identification of the city with its church and its pastor) where they find the people and the bishop barricaded, in the shelter of the corpse of the saint there preserved—and the enemies flee, leaving men and relics intact, through the grace of the holy protector (as the writer categorically emphasizes).

Yet again the city finds its identity in a religious sentiment that makes its inhabitants into a *plebicula* gathered about the bishop, who is supreme religious authority, and still almost in a physical sense a military hero. The repeated diminutives (*corpusculum, ornamentulum, plebicula*) draw specifically upon the language of the affections, sentimen-

tal language, in which the aspect of personal relationship is most
important.

The defense of the city of Modena, a problem continually posed by
its ever-perilous historical situation, is reflected as well in the famous
"Canto delle scolte modenesi" ("Song of the Sentries of Modena"),
which bears a conceptual, and even lexical, resemblance to the passage
just examined.[30]

In the life of the bishop Atanasio, written in circa A.D. 875, the de-
scription of Naples is a means of giving concrete identity to the mira-
cles of the saint.[31] The city is certainly protected by its two ancient
patrons, Agrippino and Gennaro, but also by the contemporary one,
Atanasio. Citizen consciousness is filtered, as always, through reli-
gion, in the explicitly stated need to praise those who are currently
working actively in the city. Naples is described following all the ca-
nonical points of the genre of "praise," yet not everything is mere
rehearsal. Naples presents itself as "beautiful in all the constructions
that defend it, beautiful for its outlying quarters, and for the religious
piety of the Christians who dwell inside the walls [*situ suburbano, et
Christicolarum, interius degentium, religione*]":[32] an articulated judgment,
therefore, which widens to consider the city together with its adjacent
settlements; no longer is it purely a fortress. It is a point of view that
grasps geographic and human-environmental interactions as a specific
characterizing element, even if the community of inhabitants is above
all a community of the faithful. A rapid profile of the city's structural
evolution, the work of Octavian, Constantine, and Belisarius, is then
traced, with an attentive eye for the changes in the forms of the towers
and the largeness of the fortified harbor. From the walls, the transition
is made to the interior of the city, again with evident haste to be done
with the topos: "but why should we prolong our description of the
external appearance of the buildings, which every person who views
them can take in better than the best of sophists could describe it?" The
real, essential defense is inside the walls, in the presence of the numer-
ous churches that are so famous, "antiquae videlicet et vetustissimae
structurae" (we seem to hear again the voice of Cassiodorus), and in
the monasteries for both men and women, from which rise up contin-
ual prayers that make Naples "invictrix . . . et tuta."[33] Furthermore,
ascending to a higher magnitude of protection, the city has within it a
church that boasts the relics of the two bishops, Agrippino and Gen-

[30] A. Roncaglia, "Il 'Canto delle scolte modenesi'," *Cultura neolatina* 3 (1948): 5–46.
[31] *Vita sancti Athanasii episcopi Neapolitani (auctore anonymo coaevo*—sic on the title page)
in Muratori, *RIS*, II, 2, 1051–64.
[32] Ibid., (1052–53).
[33] Ibid., (1053).

naro, who govern and guide it, "like the head governs the parts of the body." Here "the laity together with the clergy chant the psalms continually in Greek and Latin . . . local people and immigrants are abundantly nourished without having to become pilgrims." Different languages and social situations are joined in the city of faith. Naples is "a city of mercy and of piety . . . fortified entirely by goodness" ("civitas misericordiae et pietatis . . . vallata omni bonitate"), and *Christicolae* its inhabitants. For this reason it passed unhurt through the storms of the Vandals and the Langobards. Into the normal pattern of religious themes, the thread of profane history is woven, time is God's time, but the time of men as well. "Why then do we attempt to speak of the ancient structures, of the great number of the ancient saints in this city . . . who are in heaven?"[34] Let us speak instead of our contemporary, Atanasio, starting with his forebears. The specific need to trace a genealogy justifying the sanctity of his character reveals a general impulse to give the substance of tradition to the present, to live it historically.

Further scope for interpretation in this sense can be found in a reading of the life of the bishop Deoderic (written between A.D. 1050 and 1060 by Sigebert of Gembloux), which includes a full description of his city of Metz.[35] The city, which cannot boast confessors or martyrs, can still raise its head above the others for the great number of relics which Deoderic especially acquired. Its very name is an occasion for history and an explanatory key: "there is no clash between the etymology of your name, Mediomatrix, and your graceful felicity."[36] As a female parent [*matrix*] gives warmth and food to the child in her lap, "so you are placed at the center, and through the exchange of local and imported goods you sustain the territories that lie roundabout you, and protect them, as though at your maternal breast." The name of the city was later changed to Mettis, after the Roman *Metius*; the fact that two different sources are given for this transformation leads one to think that a process of refinement of historical research took place, for there is an oral, folk account (*vulgo fertur*) and a learned, epigraphic one, which records a distich carved "in effossis terra lapidibus." The victory of *Metius* over *Mediomatrix* was a linguistic victory as well, which supplanted the toponym: "tunc Mediomatricam superavit Metius urbem."[37] The magical power of etymology, summoning the memory of glory, remains intact. The novelty of these coordinates

[34] Ibid., (1054).
[35] Sigebert of Gembloux (Sigebertus Gemblacensis), *Vita Deoderici I* (*MGH, SS,* IV, 461–83); chapter 17 (476–79) is entitled *De laude urbis Mettensis.*
[36] "Ipsa quoque nominis tui, id est Mediomatricis, ethimologia non dissidet a tuae felicitatis gratia," ibid., (477).
[37] Ibid.

seems to me worth emphasizing: no longer is it a question of proving continuity between the pagan and Christian worlds, leading to a single religious reality. In the comparison of the various historical sources and the various linguistic forms, we catch the inkling of the scholar's glance, a desire to investigate the world as it is, in its interconnections, and not in stipulated recourse to a transcendental authority. As well, the truthful past no longer begins with the Christian religion, pagan antiquity being merely the terminus post quem (think of the "praises" of Verona) nor does it sink back into fabulous time such as that of the mythical Trojan founders—Aeneas in the case of Naples.[38] The approach to the past is new, historical, it requires a real personage.

To go back to the description of Metz: the invincible walls and towers also contain "many machines of war." The houses appear to be *Romana palatia* and the *teatrum*—like the one in Verona—a *Dedaleum laberinthum*. But within this conventional portrait the human hand makes its presence felt: "the ingenious effort of man assured the supply of the waters that you, Nature, failed to furnish. In the end, Time alone succeeded in shattering those channels. But even today the rubble of those imposing constructions remains a source of admiration."[39] The city does not yet have a variety of trades, an individual physiognomy that can be felt as breaking with the past; it is tied indissolubly, even in the encomium, to the fertile fields that surround it: "many cities are fortunate and plentiful, but natural abundance enriches you with the horn of plenty . . . all the neighboring cities give way to you, respecting you as a mother."[40] Life remained essentially rural, and the author's gaze slides naturally out to the countryside, where the activities of the peasants throughout the agricultural calendar are depicted simultaneously: "one trims the vines, one hoes them, one binds them to the trees, one girds the fountain with leafy fronds, another adorns the hills with trees; one sees to drainage, and another enriches the fields with seed; I fish with my hook, you with your basket, he with his net" (lines 88–91). Amid this idyllic scene ("Ipsos ruricolas pascit tam grata voluptas") the Christian note of work as tribulation and fatigue is sounded, even though a voluntaristic buoyancy mitigates it: "while the countryside keeps faith with their modest desires, they, detesting ease, relieve with their passion the burden of labor."[41]

Even earlier Sigebert had ambled over hills covered with vines,

[38] *Vita sancti Athanasii* (*RIS*, II, 2, 1052): "post civitatis Trojanae excidium, ab Enea filio Anchisae, et Veneris, condita."

[39] Sigebert of Gembloux, *Vita Deoderici* I, lines 59–61 (*MGH, SS*, IV, 478).

[40] Ibid., lines 94–96 (479). In the fountain of Perugia (cf. p. 170) the personified city sits enthroned like a queen, she has a cornucopia in her hand, and she receives the homage of Chiusi and of the lake of Trasimene, who offer her ears of corn and fish.

[41] Ibid., lines 85–87 (479): "Ipsos ruricolas pascit tam grata voluptas, | dumque fides ruris votis respondet avaris, | exosi requiem solantur amore laborem."

wooded mountainsides, green meadows, fields waving with stalks ("prata virent, silvae frondescunt, fluctuat ager"). The abundance of waters gives to the city "decus et fructum . . . munimen et usum"; "their use serves the body, the sight of them soothes the spirit, their sound delights the ears" ("usus alit ventrem, species mentem, sonus aurem").[42] In this there is the origin of an appreciation of nature not only utilitarian but also aesthetic, which in painting signifies the birth of a new genre, the landscape as autonomous subject of representation.

A text whose dating is still under discussion, but in current opinion belonging to the end of the tenth or beginning of the eleventh centuries, the *De situ civitatis Mediolani*,[43] is doubly apt here, offering the possibility of a comparison with the more or less contemporary text of Sigebert, and furnishing a useful corollary to the much older description of the same city of Milan. This description again follows the topos of the ancient rhetorical treatise: "I am forced to steer the course of the voyage I have begun . . . so as to illustrate 'quicquid reperierim pro modulo meo,' as regards the site, the qualities of the place, and the origin of the glorious name of the city, toward which I propose to guide my sails."[44] Perhaps because of the length of the text and the complexity of the arguments it treats, the *De situ* has been examined as an independent work,[45] without taking account of the explicit affirmation of the author, who says at the close of the first part: "what I have said is sufficient as to the site, the quality of the place, and the cause of the name. Now I will attempt to speak of the prestige of divine things—of the first propagation of the Christian faith, that is." And the second part of the work, dedicated to the bishops of Milan, follows, beginning with the advent of the "apostle" Barnabas.[46]

The *De situ* at this point returns to the customary description of the city as a prologue to the life of the bishop, and despite all, it is as an ecclesiastical city that Milan is therefore spoken of. For that matter, the insistence on *dignitas* in *De situ*, traceable throughout to a religious ambit, and creating a continuity with *dignitas* as a theme in the remaining part of the work, does not seem to me casual: the Gauls, the Roman emperors, the bishops, are seen as part of the transmission of power

[42] Ibid., lines 69–70 (479).

[43] Anonymus Mediolanensis, *Libellus de situ civitatis Mediolani* (*RIS*, 1, 2). P. Tomea, in a book that has just been published (*Tradizione apostolica e coscienza cittadina a Milano nel Medio Evo. La leggenda di s. Barnaba* [Milan: Vita e Pensiero, 1989], esp. the last chapter) offers a new analysis of the whole work. I owe to his courtesy, in anticipation of the results of his research, the indication of the date.

[44] Ibid., (6).

[45] Cracco Ruggini and Cracco, "Changing Fortunes of the Italian City," p. 465. In the second part, signed by G. Cracco, it is held to be of the Carolingian epoch; the city, not yet medieval, follows a "Roman model."

[46] Anonymus Mediolanensis, *Libellus de situ civitatis Mediolani* (*RIS*, 1, 14).

and of *dignitas*, without even drawing attention to the opposition of the two worlds, pagan and Christian. "The site of the metropolitan city of which we speak is a very rich zone of fertile mother Italy";[47] even in a purely geographical discourse, pinpointing Milan with the usual concentric indications, there emerges a criterion of evaluation that more than anything identifies it: the fact that it is a metropolitan see: "situs igitur civitatis metropolitane" (and not *civitatis Mediolani*, as might have been expected).

Quite rightly, Gina Fasoli does not see any break between the introduction and the body of the work, "in which the apostolicity of the Church of Milan is asserted, to justify its aspirations to autonomy in the face of the Holy See."[48] And it can be added that after the destruction of the imperial headquarters in Pavia in 1024, Milan emphasizes the antagonism through the influence that its archbishops claim to have in the election of the sovereigns: according to Arnulf, the emperor Conrad came there expressly to have himself crowned by Ariberto *ut moris est*.[49] So also the extended encomium dedicated to the Gauls might seem to be a veiled anti-Roman polemic. Their successors are the emperors, who construct *more patrio* a splendid palace, but also *theatrum, aumatium, thermas et viridarium*: this portrayal is entirely stylized, the buildings listed are important solely from a rhetorical point of view, they contribute to the *dignitas* of the city and of its august inhabitants.[50]

To Charlemagne also is attributed the foundation of a city, *Roma secunda*, said to rise beside a deep wood, to which the emperor resorts for the pleasures of the chase; foundations are laid for a forum, a theater, a harbor, baths. The description is so conventionalized that the editor of *De situ* imagined this to be Milan itself. And yet a substantial difference seems to me to be the lack in *De situ* of the slightest reference to the city walls, to the defensive aspect, which are certainly present in the original Carolingian source.[51]

[47] Ibid., (6). For the rest, even in the *Versum de Mediolano civitate* the *dignitas* of the city derived from being a metropolitan see: "ingens permanet ipsius dignitas potentiae ad quam cuncti venientes presules Ausoniae iuxta normam istruuntur senotali canone."

[48] Fasoli "La coscienza civica," p. 26.

[49] H. D. Kahl, "Der Chronist Arnulf von Mailand und das Problem der italienischen Königsweihen des 11. Jahrhunderts," in *Historisches Forschungen für Walter Schlesinger*, ed. H. Beumann (Cologne and Vienna, 1974), p. 428. My thanks to Livia Fasola for this reference.

[50] Anonymus Mediolanensis, *Libellus de Situ* (*RIS*, 1, 9). *Aumatium* is a rare word meaning "latrine, public privy." It appears in the fragments of Petronius, *Satyricon*.

[51] Ibid., (7 n. 1): the editor maintains that the *De situ* was composed at the time of Charlemagne. He took an appellation that recurs in the work as an important indication for this dating: (Milan =) *altera Roma*, an echo of one used in the Carolingian source: *Roma secunda*; for the latter text, cf. *MGH, Poëtae Latini Aevi Carolini*, ed. E. Dümmler, pp. 366–81; cf. line 94.

In *De situ* the temperate climate also adds a new touch to the *dignitas* of the city—and behold, abundance of sweet vines, and varieties of grains which the *fessus agricola* gathers. The idea of Sigebert resounds here: "hence he who for the space of an entire year has not given way to idleness will enjoy the riches of the nourishing earth."[52] Whether it be the activity of particularly skilled men, or merely that of simple fullers of cloth and millers, aided by a plentiful supply of water that is also exceptionally rich in fish, work is a rewarding experience. *Patriotae* and *concives*, no longer plain inhabitants—these are the terms for the Milanese, caught in their varied tasks. A gamut of human undertakings is described, with a natural shift from the profane world to the religious one, and a further narrowing of the focus to the lives of the saintly bishops. While in the preceding descriptions it was the city as a whole that functioned as prologue to the "praise" of the bishop, here the element of continuity in the commendation is entrusted to men, the Gauls and Romans of the glorious past, the *concives* in the present, who already foretell the excellence of their bishop. The new place given to man lies, too, in the value put on the historical sources, in the care taken to document what is said: the primacy of Milan is very ancient, "found in the most reliable chronicles."[53] For the first time we find a preoccupation to date an event, and also to make sure of the correctness of the year by turning to the chronographers ("secundum peritissimos calculatorum").[54] And again two possibilities are given in justification of the name *Mediolanum*: either it was equidistant from the two rivers Adda and Ticino (a hypothesis accepted by Sigebert for Metz as well), or else, "as many declare," the name was taken from the discovery of a fleeced monster, a pig with *half* (in Latin, *medium*) of his dorsal ridge covered with a lock of wool (*lana*). But the widespread consensus of contemporaries about this is not enough; proof is needed, and it is found in the use made by the Romans of banners woven half of wool: "support for this etymology can be found in a custom which grew up etc."[55] To be noted as well is the reference to various trades, symptom of an already striking specialization of labor (whereas the industriousness mentioned in the "Praises" of Milan was at that earlier time still generic). The citizens, as well as the buildings, are losing the unfocused contours they had in the past: in the *Laudes* of the city of

[52] Anonymus Mediolanensis, *Libellus de Situ* (*RIS*, I, 11). The image of the nourishing earth ("gaudebit passim telluris ubere profluo") has counterparts in the iconography; see for example the manuscript illuminations that exhibit the earth as a woman nursing in the *Exultet*.

[53] "ut in veracissimis reperitur annalibus," ibid., (7).

[54] Ibid., (8).

[55] "ad cuius rei indicium mos inolevit ut . . . ," ibid., (13ff.).

Lodi, a late reprise of a declining literary genre (ca. 1253–1259)[56] the novel element is the space given to the intellectual professions: *scriptores* and *medici* are mentioned, "omnibus artistis valet urbs decorata magistris," and Lodi is happy above all because of one of its citizens, the jurist Orfino, cited twice over with flattering appellations.

In the *Chronicon Astense* (1294)[57] the city of Asti not only boasts of being ornamented by the sapience of its nobility ("sapientibus et nobilibus civibus"); it glories in its wise populace and—with the sensibility, one might say, of a boy who has suddenly grown up—"in her beautiful ladies, loaded down with ornaments of gold and silver, and with pearls and precious stones."[58] Here, too, a fellow citizen receives a special eulogy, Manfredo Pelleta,[59] whose merit it was to have compiled the "register" of the economic profile of the city, an indicator of the riches accumulated by the artisans through loans at interest "in France and other parts of northern Europe, where they made a great deal of money."[60]

In the drab *Chronica parva Ferrariensis* (ca. 1308),[61] although the particular nature of the terrain, a dense pattern of canals, ponds, and swamps, allows the topos of the location of the city to be varied a little (it is like reading a very detailed map of the city's physical geography), the long list of once noble families speaks to us of a civic pride far from dead, and of a desire for precise documentation (the notices are drawn from testaments and from memories of ancestors and parents).

A civic pride very differently articulated is found in the *Liber Pergaminus* (*Book of the City of Bergamo*) of Mosè di Brolo,[62] written not long before 1125, and therefore preceding the Ferrarese chronicle by almost two centuries. A quite unusual work, "premature," and perhaps for this reason without a fortune, it comes from an outstanding personality of notable and original breadth. The author is writing at the time of the episcopate of Ambrogio di Mozzo (who succeeds to the excommunicated Arnulf), of whom Mosè evidently is a partisan—a long eulogy is dedicated to his forebears. This is the single formal element that makes it possible to include the *Liber Pergaminus* in the literary genre

[56] In *MGH, SS*, XXII, 372–73, here at line 52; cf. as well J. K. Hyde, "Medieval Descriptions of Cities," *Bulletin of the John Rylands Library* 48 (1966): 326.

[57] Muratori, *RIS*, XI, 140–52.

[58] "pulcherrimis Dominabus, plenis ac imbutis ornamentis auri et argenti, quae plenae sunt margaritis, et lapidibus pretiosis," ibid., 149–50.

[59] Ibid., 150.

[60] ". . . in Francia et ultramontanis partibus, ubi multam pecuniam lucrati sunt," ibid., 142.

[61] Muratori, *RIS*, VIII, 469–87.

[62] Muratori, *RIS*, V, 521–36. A more recent edition, from which I cite, is the one by G. Gorni, "Il *Liber Pergaminus* di Mosè di Brolo," *Studi medioevali* 11, no. 1 (1970): 409–60; the text is at pp. 440–56.

of the praise of the city and its bishop. An end to religious turbulence, and to the repercussions it caused in the political arena—this is the author's desire, and for this reason he is content at the arrival of Ambrogio. But for the maintenance of concord and calm he has faith above all in the efficacy of the methods of the commune, about whose origin and character he shows "a rare understanding,"[63] and as a result a landscape decisively secular, of concord and peace, is the one he presents of his city, without—practically—churches, without patrons, without relics. In this situation, social or political conflicts are neutralized and lose their force. If someone should want to know the appearance of the houses, or what the material is of the gilded roofs, "let him know that even the best houses, the fruits of hard toil, whether of rich man or poor, are made beautiful by a shared propriety," the walls are of good stone, and in the one case and the other, the perfectly covered roofs gleam. "Truly the towers climbing up to the sky are few, rare the fighting among the citizen population: a wonderful peace joins the citizens among themselves with a stable bond, the poor man lives in peace, in the accord of peace the rich man lives. Nowhere else does such respect for the laws reign, and it is the civic traditions, holding the reigns of command, that guide the people, and there is decorum, solidarity, and unblemished concord." The care of all this is entrusted to twelve *viris sanctis* who, day and night, meditate *sanctas leges.*[64] The numerical perfection of the apostles and their sanctity is here carried over to the guardians of the communal institutions—and let it not escape notice that the golden glitter of the city of Jerusalem is transferred to a city composed only of houses and a few scattered towers, and that the adjective "holy" is the epithet not of a cleric but of a member of the laity.

In addition to the towers and the handsome houses, Mosè describes with enthusiasm a beautiful spring with a marble staircase, and other springs and wells from which gushes excellent water, *piazze* where children play, girls dance, horses for racing and for war are tried out and sold: all places of sociability, upon which the gratified regard of Mosè falls, observing (and desiring) the concord and the industrious fervor of the inhabitants. With affection he sees, too, the joyous agitation of the babes, who will nevertheless, from the time they are small, be taught habitually to bear the fatigue of arms and of every discomfort.[65] To these places are indissolubly linked persons and voices which his lines (superior in this respect—declares Mosè—to the simple contemplation of admiring outsiders) are able to reawaken and

[63] Fasoli, "La coscienza civica," p. 30.
[64] *Liber Pergaminus* 263–80 (p. 452).
[65] Ibid., 185–94 and 286–90 (pp. 449 and 452).

consign to lasting fame: "because knowledge of things committed to verse endures, the text not varying with repeated readings."[66] For this reason Brenno, the founder of the city, is shown in a series of passionate utterances, from his first stupor before the spot upon which Bergamo will arise, until he submits to the fatal necessity which he feels driving him to convince his followers to march against Rome, to death and ruin, bowing to the inscrutable destiny that chooses the eternal city to be dominant and victorious. As if in a funeral eulogy, he is compared with Aeneas, Cato, and Cicero for *pietas, rigor,* and *patriae cura vel amor.*[67] It has been noted as a constant in Lombard historical traditions that there is an absence of Trojan heroes at the origins of the cities (whereas Aeneas had landed at Naples), which claim as their founders principally the Gauls.[68] This trait, I think, denotes a refusal of legend and fable, and a desire for a historical approach to their own past, articulated along a chronological armature which they believed they had reconstructed. There is to be seen as well the simultaneous desire to forge a link between themselves and the eternal city, and the wish to appear independent of it,[69] with rival heroes and events (as, on the level of politics and religion, medieval Milan feels itself the rival of Rome: we have seen this, for example, in *De situ*).

Bonvesin de la Riva in the *De magnalibus Mediolani* (composed about 1288) goes so far as to proclaim that, since the city has no equal in the world, and is almost "alter mondus ab altero condivisus," it is "not only worthy to be called a second Rome, but, if it be permitted me to speak my mind without being accused of presumption, it would be right and proper in my judgment that the seat of the papacy and the other dignities should all be transferred here from there."[70]

The *altercatio* of Canossa and Mantua, contained in the life of the Countess Mathilda by Donizone (a work written around 1115)[71] may conclude this brief review of texts, on account of the elements belonging to the tradition that it still includes, although by this point they are inserted into a context of innovation. The work was occasioned by the

[66] ". . . sed quia carminibus melius commissa sciuntur (nam non mutatis verbis repetita leguntur) . . . ," ibid., 201–2 (p. 449).

[67] Ibid., 361–62 (p. 455).

[68] F. Fossier, "La ville dans l'historiographie franciscaine de la fin du XIII^e et du début du XIV^e siècle," in *Les ordres mendiants et la ville en Italie centrale (vv.1220–1350)*, a special number of *MEFRM* 89, no. 2 (1977): 642.

[69] Ibid., p. 645.

[70] Bonvesin de la Riva, *De magnalibus Mediolani (Le meraviglie di Milano)* the Latin text with Italian translation, ed. G. Pontiggia with introduction and notes by M. Corti (Milan: Bompiani, 1974), p. 188.

[71] Donizo, *Vita Mathildis* (ed. L. Simeoni, *RIS*, v, 2 [1930], I, 8, 27–31). The translation edited by F. Davoli is not always reliable (*Vita della Grande contessa Matilde di Canossa scritta in versi eroici da Donizone* [Reggio Emilia: Artigianelli, 1888]).

arrival at Canossa of the marble sarcophagi for the ancestors of Mathilda, and the problem of securing possession of the remains of the members of the great family is one of its main motifs. The viewpoint is entirely ecclesiastical on the part of Donizone when he invests those corpses with the aura of sacred relics, thus attaching immense value to them; but in the exaltation of a family, of the profane deeds and undertakings of its members, he is of the laity: the dead are assimilated to saints; the living partake of glory on earth.

The two cities, each claiming those advantages that in the preceding texts we have always seen attributed to one city alone (but which, in a sort of change of script, are here shared out), are at odds over the corpse of the marquis Bonifacio, the possession of which each wants to secure for itself. On one hand, Mantua says that she is an *urbs* and not simply an *arx*, encircled as she is by a river furrowed with ships; but she is immediately taunted with being an *urbs* in name only, with not being encircled by solid walls, with having a humid and unhealthy climate, being short of wine, meat and grain. Mantua then replies that it is she who possesses relics, in the church to which her rival is constrained to travel; Canossa retorts that *she* is a direct dependency of the pope and not of the patriarch, and attempts to dismantle the myth that Virgil was Mantuan. Victory goes to Canossa, but the speciousness of the arguments shows that it is a purely formal success. In this *altercatio*, though the arguments used by the two cities in their lively contest to establish which of them deserves the greater praise and hence the prize, may be entirely stylized, the reason for the contention is quite new: the relics are no longer those of the saint, the protector bishop, from whom aid and defense are expected, but of historical personages, near in time, or even contemporaries, who operated in the realm of the laity while alive. Their corpses are destined to give vaunt and renown to the earth that receives them—a fact that betrays a scale of values not necessarily related to heaven. The theme of the relics, which the ecclesiastic Donizone still uses, is only a stereotyped frame for a totally new canvas: in the poem, written to gratify Mathilda's sense of her family's glorious past, an unintentionally bold transposition has taken place with the promotion of corporeal remains that in themselves have nothing of the religious into a sphere of sacrality. This is the new sentiment with which the city is represented, and experienced.

Let us turn now to images, and consider the theme of the bishop or saintly protector. From the fourteenth century on, it is the entire city that he holds in his hands, no longer the church alone, as the bishop Ecclesio does for example, offering it to God, in the mosaic of San Vitale at Ravenna (middle of the sixth century).[72] From being one who

[72] This results from a systematic review of the four volumes of G. Kaftal: *Iconography*

makes an offering in this way, the saint becomes himself the guarantee of protection; if he is a bishop, the entire city, thick with churches, towers, and palaces, turns to him—for he is now no longer simply spiritual pastor, or patron of the edifice in which his flock gathers.

The oldest witness to this process—even if the protector saint is here the Madonna herself—comes from Salimbene de Adam (1221–1287),[73] who recounts the terror of the "the women of Parma, especially the rich, noble, and powerful" at the announced intention of Frederick II to destroy the city and scatter salt upon the earth: "they all came to the blessed Virgin, praying that she might wholly free *their city* of Parma from Frederick and from their other enemies, for the reason that her name and appellation were held in the greatest reverence by the citizens of Parma in their mother church." And to be sure of receiving this grace, "they had a model of the city made of pure silver, which I have seen, and which they offered as a gift to the blessed Virgin. It included the principal large buildings of the city, worked entirely in silver, such as the main church, called the *domus* . . . and the Baptistery was there as well, the bishop's palace, the palace of the commune, and very many other buildings, so that it really should look like Parma." (The earliest view of Florence—1342—appears at the feet of the Madonna as well; it is possible to recognize the Baptistery, and on the Duomo the incomplete facade of Arnolfo, with the close-knit houses and towers serried round them.)[74]

In the Palazzo Pubblico of Siena—this location is significant—in the fourteenth century, Taddeo di Bartolo painted the Dominican Ambro-

of the Saints in Tuscan Painting (Florence: Sansoni, 1952); *Iconography of the Saints in Central and South Italian Schools of Painting* (Florence: Sansoni, 1965); *Iconography of the Saints in the Paintings of North East Italy* (Florence: Sansoni, 1978); *Iconography of the Saints in the Paintings of North West Italy* (Florence: Le Lettere, 1985) (cited henceforth with the abbreviations *TS, CS, NS, NW*). For the mosaic at Ravenna, see Kaftal, *NS* col. 271, fig. 325. The illumination (ca. 1183), aiming to laud the prodigious building activity of the archbishop Anno of Cologne (figure 37), shows him spangled with a garland composed entirely of churches: cf. *Monumenta Annonis, Köln und Siegburg, Weltbild und Kunst im hohen Mittelalter* (exhibition at the Schnütgen-Museum of Cologne, 30 April–27 July 1975) (Cologne, 1975), fig. 5.

[73] Salimbene de Adam, *Cronica*, critical edition, ed. G. Scalia (Bari: Laterza, 1966), vol. I, p. 283. The following extracts from Salimbene are translated into English in the text above: "mulieres Parmenses, maxime divites, nobiles, et potentes . . . totaliter se contulerunt ad beatam Virginem deprecandam ut civitatem suam Parmam a Friderico et ab aliis inimicis penitus liberaret, eo quod nomen et vocabulum suum in matrice ecclesia a Parmensibus in reverentia maxima habebatur. . . . fecerunt fieri unam civitatem totam argenteam, quam vidi, atque beatae Virgini obtulerunt et donaverunt. Et erant ibi maiora et precipua edificia civitatis fabrefacta totaliter de argento, ut maior ecclesia, que appellatur domus. . . . Bapisterium similiter erat ibi et palatium episcopi et communis palatium et alia edificia quam plura, que civitatis effigiem presentarent."

[74] Circle of Bernardo Daddi, *The Madonna of the Misericordia* with the antique view of Florence. For a detailed description, including the inscriptions, see L. Becherucci and G. Brunetti, *Il Museo dell'Opera del Duomo a Firenze* (Milan: Electa, n.d. [1970]), vol. I, pp. 118–19.

gio Sansedoni,[75] who was Sienese by birth, with a model of the city in his hand; he had become its patron for his success in having the interdict of Gregory X lifted, after having refused while alive the episcopal dignity. In the fresco, the city, bristling with towers, displays in the foreplane the Palazzo Pubblico, recognizable in its details, and, somewhat to the rear, the Duomo. The same painter, a specialist in depicting models of cities, is responsible for an extraordinary miniature portrait (figure 40) of Montepulciano (1401) with gardens, fences, and meadows inside the walls, which the holy patron Antilla exhibits as her own meritorious attribute, like the breasts on a plate of Agata, who stands beside her.[76]

But the most monumental work is the dossal—1393—painted by Taddeo di Bartolo, entirely dedicated to san Gimignano, patron of the Tuscan town that bears his name, bishop and patron of Modena as well[77] (figure 39). The holy bishop, enthroned and in the act of giving a blessing, sits securely at the center of the great panel—any trace of deferent homage to a superior power having vanished. At the borders four small rectangles recount episodes of his life and his good deeds. The city, unusually large, reposes in tranquillity in his lap, minutely described in its *piazze*, walls, gates, green areas, but especially in the handful of slender towers culminating in the one, rising up at the center, of the palazzo of the commune, while the only church present has slid off to the right, almost fetching up against the walls (although the concrete topographical reference here may perhaps be exact). Civic pride is mirrored in the spreading presence of public buildings, houses, and towers, while the religious element is muted not only by the subdued position of the single church, but by the attitude assigned to the holy patron: he blesses the spectator, and by his fixed, and yet human, gaze, one feels oneself constantly accompanied. The saint does not intercede *for* the town of San Gimignano with prayers to God or the Madonna, it is *he himself* who protects and blesses. We have descended to a level beneath divinity, one occupied by a man who turns to his fellow men, among whom he acts still. If in one little story we see the bishop save his city from Attila by wrapping it in a mist, in the one

[75] Kaftal, *TS*, col. 31, fig. 32.

[76] Ibid., coll. 91–92 and fig. 88. In the same Palazzo Pubblico, Sano di Pietro, as well as redoing Ambrogio Sansedoni, painted Pietro, bishop of Alessandria (in 1446), protector of Siena from 1403 until 1500, and protector also of the local Arte degli Speziali. An illumination, now lost, perhaps from the same painter, adorned the statutes of the Speziali (1355), now in the Archivio di Stato of Siena; the illumination was added about a hundred years after: cf. ibid., coll. 31–32 and figs. 817–18.

[77] C. Meli, *San Gimignano*, in *Storia dell'arte italiana*, vol. VIII: *Inchieste su centri minori* (Turin: Einaudi, 1980), pp. 107–32, fig. 208 (but without any discussion of this work in the text).

painted beside it he frees the city from the outcasts and brigands who besieged it in 1342.[78] It is noteworthy in this second story that san Gimignano swoops down from the sky (in an access of zeal, one might think), not by himself but with angels all about him; and that in the midst of a deserted section of houses and towers there rises the figure of a supplicant woman, the personification of the city and its fears. San Gimignano, therefore, time and death annulled, is felt as a real, continually interacting presence in the life of the city, and not as a distant transcendental figure.

The satisfaction taken in a display of numerous towers is a trait that we find consciously referred to in the chronicles as well: the Anonymus Ticinensis (Opicino de Canistris) in the *Liber de laudibus civitatis ticinensis* (composed, as stated previously, toward 1330), notes that Pavia, although located on a plain, "is visible at a distance of a full day or more" ("a longe per planam dietam et per amplius videatur"),[79] because of the very high buildings and towers. Bonvesin de la Riva in the *De magnalibus Mediolani* (1288), after observing that one hundred twenty bell towers of city churches are "constructed in the manner of gentilician towers," advises that to view the form of the city and "the quality and quantity of her palaces and of all the other buildings," one should ascend "with grateful heart to the top of the tower of the communal court: from there, wherever he many look, he will be able to admire marvelous sights."[80] In the desolate *ubi sunt* of Bonvesin for his city, "prostrated in a slavery so shameful" (a veiled reference to the advancing *signoria*), Milan as a city of buildings is encapsulated in the "*murus altissimus* atque solidissimus" that encircles it, and its "*turres mirabilles*."[81]

Giovanni Villani, describing the Florence of the early medieval period, as always with a contemporary eye, seems to repeat the words of Opicino: "and not very long afterward, [there were] more than a hundred fifty citizen towers, of a height of a hundred twenty *braccia* each, not counting that of the city; and for the height of the many towers that there then were in Florence, they say that *from far in the distance, she appeared* the most beautiful and flourishing city for her limited area that could be found. And at this period she had a large population and

[78] G. Coppi, *Annali, memorie, ed homini illustri di San Gimignano*, part I (Florence, 1695), p. 5.

[79] Anonymus Ticinensis, *Liber de Laudibus*, p. 17 (cf. n. 15 above). Giordano da Pisa expresses a very similar idea in one of his sermons, at the beginning of the Trecento, in relation to the ever-renewed desires of the usurer: "if you ask him about the field, he would wish the soil were better; about the tower, he would wish it higher . . ." (*Prediche inedite recitate in Firenze dal 1302 al 1305*, ed. Narducci, p. 250).

[80] Bonvesin de la Riva, *De magnalibus Mediolani* 2.9 (pp. 42–44).

[81] Ibid., 5.7 (p. 120).

was full of palaces and blocks of dwellings, and many people, for those times."[82]

The town of San Gimignano later becomes all towers and nothing but towers, identifiable by the inscription in volgare, in the model of it that Lorenzo di Niccolò places in the hand of Santa Fina, the other patron of San Gimignano, in the great panel (1402) that portrays her standing surrounded by stories of her life.[83]

In the fresco, unfortunately very much damaged, at the church of Santa Caterina at Treviso,[84] the homonymous saint holds in her hand (figure 38) the city, with a worshiper, now lost, at her feet. Tommaso da Modena, who painted her (between the sixth and the seventh decades of the Trecento) has issuing from her mouth an inscription: "haec est civitas mea Tarvisina pro que [?] Deum meum rogo"; but a numerous group of inhabitants of the city also leans out from the walls in a prayerful attitude, and all the pulse of citizen life can be seen in the different shields that adorn the various towers, in the construction of the still unfinished church, in the ample fluttering banner with the arms of Treviso on the highest tower, in the great bell, clearly visible, that beats the rhythm of work, prayer, and the decisions of the city. With this radiant vivacity of expression and emotion on the face of the material city, the presence of the citizens is fully in harmony. With their gestures they give authoritative support to the prayer of the saint; united and active in entreaty, they override the deferent homage of the tiny devout donor who surrenders himself to Caterina, and release the city from the role of simple attribute of the saint.

By contrast, Ercolano, the bishop and patron of Perugia, clutches a model of his city (summarized as the ecclesiastical edifices of the Piazza Maggiore) against his breast, so that it is almost flattened into a decorative compartment painted on his episcopal mantle, in an entirely religious interpenetration of the saint with his sanctified city (figure 41). The work, ascribed to a collaborator of Meo da Siena (fourteenth century),[85] although reflecting only a religious perspective, yet seems to me notable precisely for its least successful aspect: the large squared-off area of sky behind the model of the city robs it of all plasticity and thus makes the "reading" of it ambiguous, for one feels the hesitation

[82] Villani, *Cronica* VIII, 3 (p. 171).

[83] Kaftal, *TS*, col. 376 and fig. 429; C. Frugoni, "The City and the 'New Saints,' " in course of publication in the proceedings of the conference *Athens and Rome, Florence and Venice. City-states in Classical Antiquity and Medieval Italy*, held at Brown University, Providence, R.I., 7–9 May 1989.

[84] *Tomaso da Modena* (catalog edited by L. Menegazzi [Treviso: Canova, 1979]), church of Santa Caterina, Capitolo dei Domenicani, p. 165 and fig. 15. I give the inscription as transcribed by Menegazzi.

[85] Santi, *Galleria Nazionale dell'Umbria*, p. 62 and fig. 26a.

of the painter tempted to express not a static attribute but a cityscape seen from a definite vantage point, and hung like a small painting on a decorated wall (the mantle, that is, of san Ercolano).

At times, it is not protection in general but immediate and decisive intervention for which one begs. It is this that is asked of Nicola da Tolentino, shown gathering up the arrows of pestilence that divine anger directs at Pisa (easy to recognize), which lies distended under his feet, in a panel of the fourteenth century in the church of San Nicola at Pisa.[86] He is shown in the same position while protecting Empoli in the panel of Bicci di Lorenzo (figure 43) from ca. 1450—the Collegiata is clearly in evidence. Here however the saint has in his hand a large scroll that conveys his words of peremptory reassurance: he promises to pray to the Virgin, and is certain that she will intervene with God. But there follow the words of the invisible recipients of his assistance as well, who once again join their spontaneous initiative to that of the saint: "Domine Deus ad te sunt oculi nostri ne pereamus."[87] Fear and anxiety do indeed send the city to the saint for protection, but by now, with the evolution of the political institutions that have made it possible for the inhabitants actively to participate in the life of the city, they cannot be kept any longer from attempting to influence, with their own role and their own presence, even the last desperate entreaty, and thus the voice of the citizens does not fall silent, in limitless faith in their patron, but prays too, along with him.

[86] Kaftal, *TS*, col. 772 and fig. 867.
[87] Ibid., col. 772, fig. 870.

The Characters
on Stage

The collapse of the regime of the Nine at Siena in 1355 is punctuated—
in the *Cronaca* of Donato di Neri—by a turbulent succession of de-
structive attacks carried out by "many nobles together with the *popolo
minuto*." Their first target is the Palazzo dei Consoli della Mercanzia,
where "books and records" are seized and torn into bits; then to the
Biccherna, where "they took away all the books of penalties and for-
feitures," and burned them on the piazza del Campo. Next to be
burned were the houses of the "workers of the wool guild," and fol-
lowing that the prisons, after the prisoners had been liberated. Finally
the chest "in which the entire office of the signori Nove had been en-
closed" was broken open, and the houses of its members damaged.
Only at this point does the chronicler speak directly of the Nine,
forced to conceal themselves, all of them "robbed" and reviled in every
possible way.[1]

It is interesting how, in this text, the immediate and direct goals of
the popular fury (single persons and their houses) seem to recede: they
are mentioned incidentally to the main action, which is centered on the
principal instruments and symbols of the power of the hated regime.
Books and records taken from the Palazzo dei Consoli della Mercan-
zia, the books of penalties and forfeitures ("condenagioni e 'ncamara-
zioni"), the chest with the ballot slips used for the sortition of office
holders are all testimony to the pulse of the city, of all the financial,
civil, and penal operations that constitute the *public* life of Siena. Even
when the chronicler does speak of individuals, the emphasis is not so
much on a vivid and colored description of an immediate vendetta
(woundings, killings) that befalls a few separate individuals, but on the
psychological and social isolation in which the Nine find themselves after
the tumult. It is more important to the chronicler to highlight a sub-
jective feeling than the spilling of blood: "there were none who were
willing to take them in, nor to see or listen to them, neither clerics nor
anyone else. . . . Workers, servants and serving girls, their foster fa-
thers, all separated from them; the clerics and everyone else cried after

[1] *Cronaca senese* of Donato di Neri and his son Neri (1352–1370, 1372–1381) in *RIS*²
xv, 6, 577–78.

them, and there was none to converse with them, or accompany them." The Nine were ostracized on the very ideological basis that had been set before the eyes of the people in the Mal Governo of Lorenzetti:[2] the condemnation of the egoistical and tyrannical interests of the individual as being destructive of the good effects of *living and working in common.*

"In the sedition they used spears and javelins to deface all the painted coats of arms of the *popolo*, including those painted on the houses of the Nine; and the rebels did this because, the government of the commune being popular, they were unhappy that the Nine, now that they had lost the power to govern, should continue to use those arms." The *popolo* destroys its own insignia, which it feels to be speaking images of itself, of a living and active consensus; the sight of them was unbearable, after the "romore."

The city, once represented in images (figure 45) as a serried group of roofs and deserted houses,[3] comes alive; it is as though its inhabitants now were showing their faces at those doors, and at those windows so often darkened,[4] through a burgeoning of symbols, signs, and images, each a manifesto of a new dimension of the city, in comparison with the early Middle Ages. This reflects a newly discovered value in man, not inexorably related to his destiny in the next world, but finding full justification in the feverishly busy activity of every day, and even explicit anxiety in the face of death—which is no longer accepted as a necessary step toward the "true life."

"If you wish to spend money in quantity, I counsel you rather to restore a ruined and abandoned church, or a hospital disused because of poverty, donating what you can, rather than to build afresh," wrote the Dominican Giovanni Dominici (1356–1420) in his *Regola del governo di cura familiare* to Bartolomea degli Alberti; "your reward will be greater because you will have less renown for it, since presumably in this case you will build on a fabric already belonging to somebody else, and *his family arms will gain the glory*; hence *the name of the patronate will also stay with his descendants.*"[5]

Franco Sacchetti, commenting on the evangelical passage concern-

[2] See pp. 142ff. below.

[3] Particular from the *Temptation of Christ on the Mount*; New York, Frick Collection, part of the predella from the Maestà of Duccio (1311), see E. Baccheschi, ed., *L'opera completa di Duccio* (Milan: Rizzoli, 1972), pl. 60 and cat. 81.

[4] Particular from the fresco of the Buon Governo of Ambrogio Lorenzetti; cf. A. González-Palacios, ed., *Ambrogio Lorenzetti: La Sala della Pace* (Milan: Fabbri-Skira, 1968), p. 69.

[5] G. Dominici, *Regola del governo di cura familiare*, ed. D. Salvi (Florence: Garinei, 1860), p. 122. On Dominici, see also C. Ginzburg, *Folklore, magia, religione*, in *Storia d'italia* vol. 1, *I caratteri originali* (Turin: Einaudi, 1972), pp. 603–76, esp. 624ff.

ing the necessity of giving alms in secret, used the same example: "One pays for a painting in a church, and adorns it *with many shields of his arms*; and he seeks to gain merit in this way. Where does he get it? In the world. 'Who had this made?' 'So-and-so did.' And he has his reward right there."[6]

One thinks immediately of the chapels of the Bardi, of the Peruzzi, of the Baroncelli in Santa Croce in Florence, families whose desire for fame and prestige was anchored there.[7] I note rapidly that for a single member of the Bardi, a Universal Judgment was celebrated, and that the three heads in the ornamental bands of the Peruzzi chapel are probably among the earliest examples in the history of the portrait.[8] Numerous coats of arms burden less distinguished works as well, as for example a panel (1373) with the Coronation of the Virgin (figure 44), including the ten saints especially venerated at Florence, executed by Iacopo di Cione for the civic mint, whose directors were the members of the principal corporations.[9]

An "arliquiera" (reliquary) painted in the middle of the Quattrocento (figure 46) by Lorenzo di Pietro, known as Il Vecchietta,[10] has a particular interest, and may be examined more closely: it consists of two large wings, which enclosed a walled compartment containing relics, in the great Sacristy of the Ospedale di Santa Maria della Scala at Siena; these wings were painted on both sides. I note first of all the subdivision of the scenes: in the upper part of the molding of the cornice, the Annunciation, the Crucifixion, and the Resurrection, on the *rear* of the wings the stories of the Passion; on the *central, external* part, the blessed and the saints of Siena, figures who occupy a preeminent position not only because of the place they are given, but also because of their dimensions, twice as large as those of the Madonna and Christ. The relics inside were those of the cross and a fragment of the veil of the Virgin: it is the images of the saints and the blessed of Siena that are offered as the real and true relics. And it is they who occupy the central part of the wings, relegating the "older" saints, consecrated by tradition, to the margins: filing from left to right, there are san An-

[6] *Sposizioni di Vangeli I*, cf. F. Sacchetti, *Opere*, ed. A. Borlenghi (Milan: Rizzoli, 1957), p. 813.

[7] A. Tenenti, "L'attesa del giudizio individuale nell'iconografia del Quattrocento," in *L'attesa dell'età nuova nella spiritualità della fine del Medioevo*, Convegno del Centro di studi sulla spiritualità medioevale, 3 (Todi: Accademia Tudertina, 1962), pp. 173–93; Antal, *La pittura fiorentina*, p. 259 and fig. 33, Maso di Banco, il Giudizio Universale. About this painter there are notices from 1343 to 1353.

[8] E. Baccheschi, ed., *L'opera completa di Giotto* (Milan: Rizzoli, 1966), p. 114, and figs. on p. 114. According to Antal, *La pittura fiorentina*, p. 230, the portraits are probably those of members of the Peruzzi family.

[9] Ibid., p. 279 and fig. 61, Florence, Uffizi.

[10] Torriti, *La pinacoteca nazionale di Siena*, fig. 427, cat. 204, pp. 351–56.

sano, the blessed Ambrogio Sansedoni (already promoted to saint-hood in the inscription), san Bernardino, the blessed Agostino No-vello, who invests the rector of the Ospedale with the habit of the Augustinian tertiaries, the blessed Andrea Gallerani (also made a saint), san Savino, and—in the second strip—san Vittore, santa Cater-ina of Siena, the blessed Pier Pettinaio, the blessed Sorore, san Gal-gano, and san Crescenzio.

At the angles where the cornices meet, there are four coats of arms: of Siena (a black and white band, or *balzana*), of the *popolo* of Siena (lion rampant on a red field), of the Ospedale (a stair with palings); while the fourth belongs to the donor, Urbano di Pietro del Bello, the probable rector at that time of the Ospedale. It is the city itself that comes gloriously to the fore: not only are the *balzana* and the lion ram-pant at the center, noticeably displacing the arms of the immediate donors and consignees toward the lower border, but the field is held entirely by recent, or even living, personages, portrayed with the ap-pearance, and the dress, of everyday life.

Modernization of this kind had the effect of a cultural shock wave, registered with pain by Sacchetti, who deplored the fact that "these *Santi novellini* . . . make people lose faith in the old ones."[11] The place of honor in the churches goes to them, as do "la luminaria e le imagini de la cera" ("candles and waxen images"), while Christ and the Virgin are overlooked. "The preachers have Beata Giovanna, painted with a jug of oil . . . , they have Beata Villana, who was my neighbor, a young Florentine woman; she went about dressed like everyone else—and now they celebrate her feast day."[12] Sacchetti catches this trans-mutation taking place even in iconographic particulars, in the form of the halo, and in an inscription altered without scruple ("the rays are changed into a diadem, and 'beato' to 'santo' ").[13] It is symptomatic of an urban "takeoff" that brings about profound alterations in the social and religious fabric—one thinks of the emerging figure of the mer-chant, of the stunning growth of the mendicant orders—and catches Sacchetti entirely unprepared. With clinging nostalgia for the old days (like Dante, he is hostile to the "new people" and their "quick prof-its"), he gives a blunt negative judgment on his own times: "people of means, and *nouveaux riches*, they abandon the old things and go over to the new ones. . . . The religious fishermen we have today try every means at hand provided they can catch their fish, not in the manner of the disciples of Christ. And this comes about entirely because of the

[11] Sacchetti, *Opere*, letter 5, p. 1115.
[12] Ibid., pp. 1115ff.
[13] Ibid., p. 1115.

damnable cupidity that governs them."[14] And he notes in another no-
vella: "In recent years they have begun to make cavaliers of manual
workers, of artisans right down to the level of bakers, and even
worse—carders, usurers, and rascally traffickers."[15] Money contami-
nates everything. A cavalier might properly become learned "but
without gaining by it, without standing at a lectern to give advice,
without frequenting the palace of the rectors as an advocate. . . . But
there's worse, the notaries are made cavaliers, and people lower than
them; the quill case turns into a gilded sheath."[16] The quill case on one
hand, and the sheath of a dagger on the other, are symbols of social
identities felt to be dangerously unstable.

The desire to be continually "on stage" is evident not only in the
unbridled luxury, in the ostentatious display of clothing and jewels
against which the sumptuary laws battle in vain, in the profane side of
life in sum, but also on the religious one, in the *ex voto* for example
that throng the churches, causing Sacchetti to remonstrate that God
wishes "our heart and our mind; he doesn't go looking for waxen im-
ages, nor these vainglories and vanities."[17] In the moralist's condem-
nation there is at the same time, it seems to me, an exact identification
of the cause of this new form of religiosity: the need to put oneself
before the collectivity by means of a permanent sign, by continually
recalling oneself to others. There is a chorality of religious sentiment,
but at the same time a flowering of individualism through the prestige
and the distinction that the saint has conferred, and thus it is that the
ex voto are "vainglories and vanities," celebrating the miracle and the
person to whom it was granted, a celebration like that of a war and its
victorious condottiere.

With an *ex voto* a person always puts himself or herself forward
within a collectivity and inside a public building. But one does not yet
have oneself represented for private purposes of self-celebration, as in
the Renaissance, when the portrait will aim to fix not what is "typical"
in a visage, but what is "authentic."[18]

Along with increasing attention to the person as an individual, there
appears a new type of punishment: in the meeting hall of the Nine,
Simone Martini had painted in 1330, probably following the conven-
tions of the so-called "pittura infamante" ("genre of defamation"), a

[14] Ibid., pp. 117ff.
[15] Ibid., novella 153, p. 491.
[16] Ibid.
[17] Ibid., novella 109, p. 347.
[18] E. Castelnuovo, *Il significato del ritratto pittorico nella società*, in *Storia d'Italia*, vol. v,
2, *Documenti* (Turin: Einaudi, 1973), p. 1037.

rebel against the commune, Marco Regoli,[19] hanged with his head downward.[20] This practice appears to have been so widely used that there was a proposal made to debate "in council . . . what is to be done about the traitors painted in the palazzo and in the buildings of the commune of Siena, and whether such paintings should be erased or not."[21] In the statutes of the Florentine republic for the years 1322–1325, it is stated that in the event a merchant who had fraudulently gone bankrupt succeeded in escaping, the podestà and the capitano del popolo were obliged to "have him depicted on a wall of the Palazzo del Podestà, so that it is openly visible to everybody, and write the first name and family name in large, legible letters of him who should have fled in this way, and the name of the guild of which such an absconder and fugitive was a member."[22]

Such punishment in effigy was always carried out in public palazzi or in places of prominence—the gates of the city for example, or the principal piazza. The picture and its inscription involve the whole collectivity, because of the stain that extends from the individual to the guild to which he belongs, and because the spectator may be invoked directly in the inscriptions that explain these images, as in the phrases "you who behold these paintings . . . you who read, attend to these briefs,"[23] so that he feels himself, finally, implicated in the penalty. Thus the wise men of Florence complained of the injurious images that appeared after the fall of the duke of Athens, "because they memorialized the failure and the shame of our commune in making him our lord."[24]

If the progressive use of this punishment in effigy "against persons whose renown was identified with their honor, honor being configured as a particular attribute of the social stratum to which they belonged,"[25] was the main reason it fell out of use, interfering as it did with important and delicate social sectors, the weight attached to the "public" image of the citizen—as an external, *physical* projection of him—remains clear. It cannot be fortuitous that in so many views of

[19] The painting, which is lost, is known from a document, the original of which is also lost, recording the payment; it is published in G. Milanesi, ed., *Documenti per la storia dell'arte senese, I (secoli XIII–XIV)* (Siena: Porri, 1854), p. 218.

[20] G. Ortalli, *La pittura infamante nei secoli XIII–XVI* (Rome: Jouvence, 1979).

[21] Cit. ibid., p. 18 (Costituto del Comune di Siena, 1309–1310).

[22] ". . . facere pingi in Palatio Potestatis in muro dicti palatii, ita quod videri possit palam et publice, et de lictera grossa et patenti facere scribi nomen et prenomen talis qui sic cessaverit, et vocabulum artis de qua talis cessans et fugitivus fuerit," ibid.

[23] Ibid., p. 104. In this interpellation there seems to be an echo of *Lamentations* 1.12: "o vos qui transitis . . . ," the words which in so many Crucifixions Mary addresses to the spectator, inviting him to have compassion for her sorrow.

[24] G. Villani, *Cronica* XII 34 (p. 465).

[25] Ortalli, *La pittura infamante*, p. 171.

cities the windows appear half-opened, or more often occupied by persons intent on observing, from within the picture frame, the event taking place. A related example of this trend is the way in which real, living personages break into religious representations, personages that by this time are painted to the same scale as the sacred protectors. An example is the reproduction by Lippo Memmi of the Sienese Maestà of Simone Martini in the council chamber of the Palazzo Pubblico of San Gimignano (figure 47): among the saints, in the foreplane, appears Nello dei Tolomei, the podestà who in 1317 commissioned the work: kneeling and holding in his hands his rich headgear, wrapped in the sumptuous lined robe of fur proper to his station, he is presented to the Virgin by san Nicola. The latter is holding in his hand a large scroll containing this fervid and legalistic address: "Salve regina mundi, mater Dei . . . vobis commendo devotum infrascriptum . . . ut placeat vobis suscipere istum et inter sanctos viros esse mistum angelos patriarcas vivi Dei."[26] The request documents, through the coats of arms that bedeck the painting and the figure who officially represents it, the self-awareness of the city; it feels that it can take its place in the court of heaven.

Time, actual and contingent, human time, has inserted itself into the eternal temporality of God: the immobility of the golden background, which is the sky of Paradise, of the sacred, where nothing occurs, has been ruptured. Now instead we see painted, on a uniform blue background (timidly transforming that dazzling brilliance into daytime), birds in flight and clouds in movement: the perennial light can be overcast (figure 48). Ambrogio Lorenzetti was the composer of "a huge and egregiously executed history," which must have made a particular impression on Ghiberti, who gives a minute description of it,[27] the first record, I believe, of a painting of a tempest: "we see the onset of a tremendous storm; the sky darkens, hail falls, there are thunderbolts, and we seem to hear them rumble. . . . For a painting, it seems to me that this storm has been rendered in a marvelous fashion."[28]

[26] Kaftal, *TS* s.v. "Nicholas," col. 766 (but the inscription is reported with many errors).

[27] ". . . una storia grandissima ed egregiamente fatta," L. Ghiberti, *Commentari* II 11 (ed. O. Morisani [Naples: Ricciardi, 1947], p. 37). The text continues: "pare a vederla dipinta pericoli el cielo e lla terra, pare tutti cerchino di ricoprirsi con gran tremore, venghossi gli huomini e le donne arrovesciarsi e panni in capo e gli armati porsi in capo e paluesi, essere la grandine folta in e paluesi, pare veramente che la grandine balçi in su paluesi con venti meravigliosi. Vedesi piegare gli alberi insino in terra et quale speççarsi et ciascheduno pare che fugga. . . ." Translation: "One seems to see, right in the painting, the earth and the sky imperiled, everyone fleeing in terror to find shelter, the men and women turning their garments up to cover their heads, and the soldiers covering their heads with their shields. The hail falling on the shields is dense, you really seem to see it bouncing off them in the terrific wind. The trees are seen bent right to the ground, and some have snapped. Everyone is fleeing. . . ."

[28] "si muove una turbatione di tempo scuro con molta grandine, saette, tuoni, tre-

The time of saints becomes the time of men: the daytime, which had its beginning and its end in the occurrence of natural phenomena, dawn and sunset, had always been *rhythmed* rather than *measured* by the sound of the bells that announced the "hours," the times of religious ceremonies.[29] To the temporal scheme of the cleric and the believer, that of the worker was joined; the transfer of the great bell from the bell tower of the church to the tower of the commune, and then the appearance of large clocks on the towers[30] and on the walls of the communal palazzi signify an important change in the conception of time: certainly it continues to be public time rather than time of individuals, managed by an organ of power and regulating only hours of work, but it is a sign of urban, secular, and developed civilization that feels the need to measure time to maintain its own life.

The variation of the points of reference from which time is measured is of interest, as they emerge for example from several depositions made in the trial for the canonization of Chiara da Montefalco, according to whether it is a religious or a layman that must describe it: for the first, the time it takes to recite the psalms, or to say a Paternoster, for the second, the time it takes to cover a given amount of space.[31]

This change of conception is reflected in the new mode in which the virtue of Temperance is represented: in the Buon Governo of Lorenzetti (figure 72), but in a place restored after 1350, an hourglass appears for the first time[32] as a symbol of this virtue, replacing the traditional two pitchers with which a liquid was blended [*temperato*]. In a bour-

muoti . . . per una storia pitta mi pare una meravigliosa cosa." Ibid. A few fragments of this painting came to light during the recent work to restructure the ex-cloister of San Francesco at Siena; the most conspicuous is in fact the one relative to the tempest (which burst at the moment of the execution of three Franciscans in the city of Thanah by Muslim soldiers). The restored painting was presented in 1979. See *Mostra di opere d'arte restaurate nelle province di Siena e Grosseto*, ed. P. Torriti (Genoa: Sagep, 1979), pp. 58–60 and fig. 47.

[29] A. Koyré, *Dal mondo del pressappoco all'universo della ragione* . . . (original edition, 1948; Turin: Einaudi, 1975), pp. 89–110, esp. 103.

[30] J. Le Goff, *Tempo della Chiesa e tempo del mercante* (Turin: Einaudi, 1977).

[31] The proceedings are in the Archivio segreto vaticano, in a codex copied in 1856 by F. Massi from the fourteenth-century originals, which disappeared in the nineteenth century; the shelfmark is Congregazione dei riti, Proc. 2929 (see fols. 269r, 464r, 1011r). A part of the original manuscript, however, has fortunately come to light, and the text is edited in E. Menestò, *Il processo di canonizzazione di Chiara da Montefalco* (Florence: La Nuova Italia, 1984). On Chiara da Montefalco, I refer to the entry by G. Barone in *DBI*; and A. Vauchez, *La sainteté en Occident aux derniers siècles du Moyen Age* (Rome: École Française de Rome, 1981), passim.

[32] L. White, "The Iconography of Temperantia and the Virtuousness of Technology," a study of 1969, reprinted as a chapter in *Medieval Religion and Technology* (Berkeley: University of California Press, 1978), pp. 192ff. and 203. Honorius Augustodunensis, *De imagine mundi* 2–3 (*PL* CLXXII, 147), had already affirmed "Tempus autem a temperamento dicitur," without the etymology having been translated into an image. The hourglass is an essential detail, and Lorenzetti himself was, without question, responsible for it.

geois ethical system, the hourglass is the symbol of an active, ordered, and coordinated way of life. Without the mediation of Lorenzetti's whole fresco, which, in the effects of the Buon Governo, celebrates the industrious, ordered, and coordinated life of the citizens, and the embellishments it brings to the city (so that the latter mirrors the former), the *Temperance* of casa Minerbi at Ferrara (figure 49), painted at the close of the Trecento,[33] would remain incomprehensible. It shows a woman gazing intently at a towered city, thick with palazzi and dwellings of citizens; the absence of churches is notable. In a citation from Lorenzetti (figure 50), a few builders are at work on the roofs. Temperance here is entirely transfused into the concept of a city laborious and socially harmonious.

Time as it is lived is reflected, in painting, by the contemporary interiors and furnishings that appear in so many scenes of the birth of Mary, in the realism of gestures (see for example the diaper held between the teeth of the nurse intent on looking after the newborn Virgin in the frescoes of the Tau at Pistoia),[34] or in the cult that was paid to the "Santi novellini," the "contemporary saints" discussed previously. This brings us back to the *arliquiera* that we were discussing (figure 46). The absence of a halo, the simple floor boards on which these figures stand, create an everyday atmosphere around them. In the scene of the investiture, although the rector of the Ospedale has kneeled, a few bystanders have remained calmly upright, and in fact one of them, who must certainly have been an important personage of the period, assists the blessed Agostino Novello in a familiar fashion to put on his habit. The coats of arms and the privileged place given to these local saints have already been mentioned. The sentiment pervading the work is profoundly civic, despite its subject, advertising a glory entirely Sienese.

Only a year after the death of Ambrogio Sansedoni (1287), the commune intervenes with a subvention to the Dominicans for the construction of his tomb, and several months later with another for the construction of a chapel; a few years later it even offers a Palio in his honor. In the year of the death of the blessed Pietro Pettinaio (1289), the commune, with a virtually unanimous decision—a sign, it has justly been noted, of the popularity of the deceased—allots a large sum to be paid to the Friars Minor for a tomb with a canopy, and even ten years after we have a record of a substantial offering of candles. In 1324 the registers of the Biccherna note payments made for the feast day of the blessed Agostino Novello.[35]

[33] C. L. Ragghianti, *Gli affreschi di Casa Minerbi a Ferrara* (Imola: Cassa di risparmio di Imola, 1970), p. 28, and plate IX.

[34] E. Carli, *Gli affreschi del Tau a Pistoia* (Florence: Edam, 1977), pl. 41.

[35] A. Vauchez, "La Commune de Sienne, les ordres mendiants et le culte des saints.

In 1328 the commune of Siena had sought, amid financial difficulties, to absolve itself from the obligation to make such contributions, but in the general ordinances voted a few months later by the General Council, the commune was forced by the pressure brought by the clerics to make a future commitment to participate regularly (not, as in the past, intermittently) in this financial burden, and also to send its own official representatives to take part in these ceremonies.

The prior of the Dominicans, urging the case for Ambrogio Sansedoni, observes that every city in Tuscany has "aliquem sanctum proprium," solemnly venerated, and that the cult offered up to the present time at Siena has brought and will bring "multa commoda . . . communi praedicto," guarding the city and defending it from many evils; he concludes by requesting the official participation of the commune "ad festivitatem sancti Ambrosi, *nobilissimi civis vestri*."[36] These concluding words, with which the Dominican makes it impossible for the commune not to participate in the celebration of one of its own glories, are noteworthy, all the more in that the *physical* memory of him (and the Dominican insists on this) is still very much alive: "whom you knew, whom you heard . . . whom your hands touched, through whom the words of eternal life were made manifest and expounded to this most noble city."[37]

For Pietro Pettinaio on the other hand, it is the guardian of the convent of the Minors who intervenes, with a series of arguments which all boil down to the fact that Pietro belonged to the citizen community: his having been "de civitate ista nativus" and thus having a special love "ad civitatem et ad cives," the advantage of having such a locally interested protector in heaven, the "honor" it would be "civitati et civibus quod ex eis provenerit tantus sanctus."[38]

The petition of the Augustinian friars in favor of the blessed Agostino Novello is very similar: in addition to all the reasons previously adduced, they recall that his body "est in ecclesia dicti loci de Senis," and that it should properly be honored by the commune "both because of his sanctity, and because of the great love and affection he had to the commune of Siena and the individual members of the commune."[39]

The success of all these petitions demonstrates the close ties between

Histoire et enseignements d'une crise (novembre 1328–avril 1329)," in *Les ordres mendiants et la ville en Italie centrale, vv. 1220–1350* (*MEFRM* 89, no. 2, [1977]: 757–67).

[36] Ibid., p. 761, nn. 21–22.

[37] "quem cognovistis, quem audistis . . . quem manus vestrae contractaverunt, per quem verba vitae aeternae civitati isti generosissime manifestata et exposita sunt," ibid., p. 763, n. 32.

[38] Ibid., p. 761, n. 25.

[39] "tam propter eius sanctitatem quam propter magnam dilectionem et affectionem quam habuit ad comune Senense et singulares homines et personas ipsius comunis," ibid., p. 765.

the mendicant orders and the political class, with the result that a "civic" religion is born: the honors paid to saints who are not yet canonized, but already addressed as if they were by the religious themselves, out of a desire to encourage the cult, find a ready reverberation in local patriotism, which sees in those saints primarily its own illustrious citizens.

The influx of the mendicant orders into the cities seems to be decisive in resolving the major problems posed by the emergence of the new values of commerce and profit, values that are decisively strengthened by the precipitous social ascent of the figure of the merchant. The lack of a Christian ethic favorable to the city, to merchants, to money loans (just as the traditional ecclesiastical structures, which were unable to find a place in their rigid mental and cultural frame of reference for the problems arising from a new social reality, had shown themselves unprepared when faced with usury) was, paradoxically, resolved by the mendicant orders, for whose members the outstanding ideal was that of poverty. Above all, the urban schools, the universities as they were later called, set about providing the required intellectual grid; students and teachers formed part of a single social fabric, and they faced practical problems. The instruction, based on the study of the liberal arts, and at a higher level on that of law and theology, aimed to prepare teachers, notaries, advocates, and clerics, but these last were entering a course of study whose structure had already been set previously. The close study of the Bible in the monastic schools had had as its consequence a preponderant conservatism and a subservience to tradition, inasmuch as the holy word could not be the subject of critical discussion. The city school is based instead on the disputation—it searches for contradictions in order to overcome them, it develops the idea of progress.[40] "There are so many holders of a master's degree these days, all the cities are full," affirms the Dominican Giordano da Pisa; "so many preachers good and truthful; the schools in every convent, of which there are thousands, where every day knowledge is sought and formulated and taught. . . . The religious orders, the Brothers, all produce books, at Paris they are produced every day."[41] The laity and the mendicant orders share a common terrain and means of subsistence, for the monetary economy is the only possible alternative to the landed estates of traditional monasticism. Hence the new orders are "professionally" constrained to deal with the problems created by the wealth and the money on which they themselves depend,

[40] On this, see the fine book of L. K. Little, *Religious Poverty and the Profit Economy in Medieval Europe* (London: Elek, 1978), esp. pp. 178ff.

[41] Giordano da Pisa, *Prediche del 1304, dell'Avvento, e della Quaresima*, ed. D. M. Manni (Florence: Viviani, 1739), pp. 152–53 and 189.

to search for a solution to the problems of private property, of the just price of money, of economic profit, of the gain resulting from intellectual activities, of loans in cash; to be tolerant toward a new social reality, in which they are involved because they live in the middle of it, unlike the monk whose ideal was detachment; in sum, to assume the role of guide. The result was a new apostolate: "first the bow is bent in study, then the arrow is released in the sermon"—this is the vivid metaphor of Ugo di San Caro.[42]

The governing elites in the cities are made up of merchants, bankers, advocates, notaries, teachers: they neither pray nor fight professionally, nor do they live by the labor of their hands.[43] Consequently the traditional tripartite division of functions crumbles,[44] concomitantly with the rise of the city. Alongside the peasants, the only working class conceptually possible till then, a place is now made for merchants, smiths, builders (according to Guillaume d'Auxerre), for merchants and artisans (in the eyes of Jacques de Vitry).[45] As the social immobility of the feudal era is broken, so the mental landscape changes: the countryside is abandoned, and a cityscape emerges. Here these strange workers speak, negotiate, write, converse, dispute—above all they seek to persuade, perhaps even to cheat people, as the merchants sometimes do. This is the common denominator of city life. It is understandable then that the sermon was the most useful means to get an audience among the citizens, taking as its own the problems of those to whom it spoke, using the vocabulary of the merchants and their techniques of exposition.[46] The two groups even had a common tongue, for as the merchants express themselves in the volgare, in volgare the friars preach, translate, and propagate their doctrines.[47] Thus the syllogistic gesture defines the apostolate of san Pietro Martire, engaged in disputing with the heretics until the moment of his death, in the great fresco of the Capellone degli Spagnoli in Santa Maria Novella at Florence, directed toward the celebration of Dominican triumph,[48]

[42] Little, *Religious Poverty*, p. 184, who cites the *Opera omnium in universum vetus et novum testamentum* (Venice, 1600), col. 1, 14, col. 1.

[43] Little, *Religious Poverty*, p. 197.

[44] G. Duby, *Lo specchio del feudalesimo: sacerdoti, guerrieri, lavoratori* (Bari: Laterza, 1980), pp. 270ff.

[45] Guillaume d'Auxerre, *Declamationes ex S. Bernardi sermonibus* X 10–11, XI 12 (*PL*, CLXXXIV, 443–44); Jacques de Vitry, *Historia Occidentalis* 34 (ed. J. F. Hinnebusch [Freiburg, 1972], pp. 165–66). These passages are given in Italian translation in M. L. Picascia, *La società trinitaria: Un'immagine medioevale* [Bologna: Zanichelli, 1980], pp. 113 and 116.

[46] C. Delcorno, "Predicazione volgare e volgarizzamenti," in *Les ordres mendiants et la ville*, pp. 679–89.

[47] A. Stussi, *Lingua, dialetto e letteratura*, in *Storia d'Italia*, vol. 1: *I caratteri originali* (Turin: Einaudi, 1972), esp. pp. 688ff.

[48] Kaftal, *TS*, col. 834 and fig. 946.

and the same gesture is the last one the philosopher makes as the arrows pierce him, in the Triumph of Death at Clusone, demonstrating calmly to the king how useless it is to rebel and try to evade, with gifts and offerings, the fate of all.[49]

A new religiosity that involves the laity directly is formalized in a series of associative rites, for example in the processions and the confraternities, in which the layman, with the aid of insignia and special apparel, and carrying a standard, becomes an active director and participant in that chorality of wills, the religious counterpart to the ideology of the common welfare, which is felt as the only way to reconcile the hostilities created by the excessive rapidity of social change. One thinks of the recurrent problem of the "truces" (called *paci*, though they were not the same as true *pace*, peace), and of the flagellant movements.[50] On the standards, on the processional panels, as in a theater within a theater, it is the faithful themselves who are represented participating in the ceremony in which they really do participate. An example is a painting (figure 51) from the school of Orcagna, from 1375, in which san Pietro Martire hands out the banners of the Compagnia Maggiore di Santa Maria—founded by him to combat heresy—to his own adepts.[51] Another is a processional panel of the Compagnia di san Donnino from the close of the Trecento, by Taddeo di Bartolo: at the feet of the saint are five kneeling hooded members of the company itself.[52]

In another devotional standard—a rare work on canvas of the early Quattrocento[53] (figure 52)—there appear, flanking the donor who kneels at the feet of the Virgin and Child, his wife with her tiny son in her arms. The presence of the entire family is symptomatic of the dawning awareness of a new way of living, community-based, peculiar to the city, whose essence the family reproduces on a reduced scale in its own associative bond. Children and old people appear in the fresco of the Buon Governo of Lorenzetti, to signify, even in their diversity of age and role, how useful and necessary such variety is in the urban fabric. That the concord of the family should reproduce in miniature the concord that ought to reign in the city, the one guaranteeing the other, seems to me to be illustrated in a panel by a follower of Barna[54] in which (figure 53) the matrimony of Christ (shown as an

[49] A. Frugoni, "I temi della morte nell'affresco della Chiesa dei Disciplini a Clusone," reprinted in idem, *Incontri nel Medioevo* (Bologna: Il Mulino, 1979), pp. 217–51 and fig. after p. 287.

[50] Idem, "Sui flagellanti del 1260," reprinted in *Incontri nel Medioevo*, pp. 179–203.

[51] Kaftal, *TS*, col. 826, fig. 937.

[52] Carli, *Il Museo di Pisa*, fig. 70 and p. 60.

[53] Torriti, *La pinacoteca nazionale di Siena*, p. 209 and fig. 242.

[54] M. Meiss, *Painting in Florence and Siena after the Black Death* (Princeton: Princeton

adult) with santa Caterina of Alessandria occupies the top level, with the boy Jesus between sant'Anna and the Virgin in an affectionate scene of familial intimacy in the middle, and beneath them the arch-angel Michael bringing about the embrace of two enemies—one is the donor, as the inscription below makes clear: "Arico di Neri Arighetti fece fare questa tavola"—who clasp each other fervently while their weapons, useless now, fall to earth. At the sides, santa Margherita and, again, the archangel Michael, frustrate any chance of violence by driv-ing away the demons.

The capacious churches of the mendicant orders and the large piazze onto which they normally give provide a suitable urban setting for the crowds drawn by the beckoning preacher. This is the reason that a piazza or a portico is so often the place in which an event takes place, in paintings and in texts. For example, a mouse that suddenly scram-bles up the "short stockings and old-fashioned loose breeches falling below the knees" ("calze sgambate e le brache all'antica co' gambuli larghi in giuso") of the gentleman Matteo di Cantino throws into tur-moil a moment of peaceable sociability, "while stories were being told in a group composed of gentlemen and merchants in the piazza of the Mercato Nuovo," as Sacchetti relates.[55] And again in the "Testamento di Pisa,"[56] the city imagines that in the piazza all of its disgraces will be cruelly passed in review.

In paintings, with great frequency it is in the piazza that miracles take place, or else, in a more everyday and familiar dimension, the people tarry, intent on the words of the preacher. In a panel of Luca di Tommè (figure 54) (documented from 1356 to 1389) that illustrates the preaching of Saint Paul,[57] right behind the front row of perturbed in-fidels, placed there so as to form a circle and to sustain momentarily the notional theme, there bursts in a varicolored medieval crowd full of lively chatter; the tiny donor, on his knees beside the saint, and dressed in a manner extraordinarily out of tune with the solemn robes of Paul and his immediate public, is the second intrusion of reality, making us see that this sermon, so remote in time and space, is not the real subject of the painting, and that a few retouches would make it completely contemporary.

University Press, 1951; reprinted, 1978), fig. 107 and p. 110; Italian translation: *Pittura a Firenze e Siena dopo la Morte Nera* (Turin: Einaudi, 1982). The panel, painted between 1350 and ca. 1370, is at the Museum of Fine Arts of Boston; cf. also Kaftal, *TS*, p. 230 and fig. 218.

[55] Sacchetti, *Opere*, novella 76, p. 245.

[56] G. Varanini, *Lamenti storici pisani* (Pisa: Nistri-Lischi, 1968), p. 94. This text, whose components are *Il lamento di Pisa*, *Risposta dell'Imperatore*, and the *Testamento di Pisa*, is to be attributed to Puccino d'Antonio (around or shortly after 1430); cf. pp. 33ff.

[57] Torriti, *La pinacoteca nazionale di Siena*, p. 159, fig. 172.

The church and the piazza are by this point so functionally necessary for preaching that they claim the attention, at Siena for example, of the commune, which wishes to safeguard the beauty and the panorama of the city, and at the same time assure a space large enough to satisfy the needs and desires of the crowds. The commune first intervenes in favor of the completion of the church of San Domenico: "in order that the length of the church, with the altars placed at its cross, shall be more beautiful, more extended, and spacious enough to accept and hold the multitude of people, which often gathers there to benefit from the sermons and divine offices." To improve the piazza of the same church, the commune then proposes to knock down a wall that was creating a series of problems, inasmuch as it was "badly arranged, so that this wall or part of it, impedes and defaces the whole piazza; it gets in the way of those who are standing there to hear the sermons that are given; furthermore, it blocks the view of the church from the city, so that it absolutely should be removed and reerected in some other more suitable place."[58]

The preacher's privileged interlocutor is the merchant, with whom the friar maintains a continual dialogue, attempting to divert into philanthropic and charitable works a part of the riches derived from monetary operations that by now are accepted as the foundation of city life. "Do you believe that gold is evil, or silver, or money, or enjoyment?" asks Giordano da Pisa, hastening to deny it, in one of his sermons. "They are not evil, no, for all these things are good, God has made them all."[59]

The archbishop of Pisa, Federico Visconti, in an annual sermon, goes so far in 1261 as to make this amazing but illuminating declaration: "How welcome it must be to the merchants to know that one from their ranks, the blessed Francesco, was himself a merchant, and has been made a saint in our time. What a capital hope it must be for the merchants, to have a merchant such as he for their intercessor with God."[60]

[58] E. Guidoni, "Città e ordini mendicanti, il ruolo dei conventi nella crescita e nella progettazione urbana del secolo XIII e XIV," *Quaderni medievali* 4, no. 2 (1977): 104, n. 37. In another case it is the friars themselves, evidently aware of the solicitude of the commune, who come forward: the Minors of San Francesco at Siena ask the commune that "manum eis porrigeret adiutricem" to complete the facade of the church, itself already built thirty years since. They suggest that the commune should redirect to them the income from several sanctions that some citizens had to pay, along with the faculty on the part of the friars to absolve those who paid from the guilt they had incurred. The argument they use is significant: that the facade is ugly not only in the eyes of the bishop and the cardinals, but reflects badly on the good name of the commune of Siena (G. Milanesi, ed., *Documenti*, I, p. 161; the document is dated 16 November 1286).

[59] Giordano da Pisa, *Prediche*, ed. Moreni, vol. II, p. 95.

[60] Little, *Religious Poverty*, p. 217. The text is published by R. Davidsohn, *Forschungen*

After a thorough reading of the approximately seven hundred sermons left by Giordano da Pisa, one is left in no doubt about how obsessive, repetitive, and heavy-handed he is in referring to the figure of the merchant and his burning love for earthly goods (the list of which Giordano, however, reels off in a kindred spirit). The first place among the latter is always given to the "palagi" [palazzi]. What negligence it would be, not to wish to go to heaven! "If you could easily enter a beautiful city or a beautiful palazzo, and you chose not to, this would be great negligence."[61] The soul must not be kept empty of God: "if it were a palazzo, and even if it were made entirely of gold and silver, and as beautiful as it might be, but there were no one to live there, and no one dwelt in it, what a great pity this would be."[62] Life lasts sixty years at most, a figure incredible in itself: why not think of eternity? And yet "people set their hearts [on this life] and in it build their houses and their other works."[63] "Look how many possessions the avaricious usurer has: house, tower, wife, children, a field, a vineyard, a horse, money:"[64] that is (to interpret the significance of this listing), the man who deals in money has prestige in the city, then family, then riches in the countryside and its fruits. In this enumeration, money, the sought-after reward of so many labors,[65] slips to last place, being a mobile and fluctuating good. The first item on the list is always the embodied symbol, public and tangible, of success. Even the saints in paintings—says Giordano—are always shown as rich men, given that God wants especially to be brought to mind through them.[66] The merchants do the same thing when they imprint their trademark on their letters, on their bales: "their houses bear their seal, the palazzo has its sign, its coat of arms that is, as do their shields, so that the image reveals who

zur Geschichte von Florenz (Berlin: E. S. Mittler u. S., 1908), vol. IV, part IV, p. 87: "set nota, quod delectabile debet esse mercatoribus, quod eorum consetius, scilicet beatus Franciscus fuit mercator, et sanctificatus in tempore nostro. O quanta spes bona debet esse mercatoribus, qui habent talem intercessorem mercatorem apud Deum."

[61] Giordano da Pisa, *Prediche*, ed. Narducci, p. 139.

[62] Idem, *Prediche*, ed Manni, p. 60.

[63] Idem, *Prediche*, ed. Moreni, vol. II, p. 146.

[64] Idem, *Quaresimale fiorentino*, 1305–1306, critical edition, ed. C. Delcorno (Florence: Sansoni, 1974), p. 34.

[65] "Così è degli usurai e de' mercatanti che vanno oltremonte . . . hacci sempre affannato," idem, *Prediche*, ed. Narducci, p. 296. Translation: "That is what it means to be one of the lenders and merchants that travel across the mountains . . . they are always under stress."

[66] Idem, *Prediche*, ed. Moreni, vol. II, p. 310: "Vedi come sono dipinti i Santi, che ti sono posti innanzi acciocché vedendo una donzella così nobile e così bella, con tante richezze, prendi allegrezza e fortezza e sicurtade, e di non dubitare . . . che Iddio ti vuol dare memoria di se in loro." Translation: "See how the saints are painted: they are placed before your gaze so that, when you see such a noble and beautiful girl, with so many riches, you may become joyful and feel yourself strong and secure and free of doubt . . . since God desires that through the saints you should recall him."

the owner of the thing is."[67] The name is propagated "on banners, on coats of arms, on shields; many coats of arms are composed of letters" and it is sometimes still the custom "to write on cups and vessels, and in similar conspicuous places."[68]

"The great painter Giotto was given a shield to paint for a small tradesman, and he, in jest, paints it *per forma*, so that the fellow falls into confusion."[69] This is the title of the novella in which Sacchetti scorns the desire for social ascent of a "vulgar tradesman," preparing perhaps "to go to take command of a castle"—whence the request to Giotto. "I want you to paint my coat of arms on this body shield." Giotto then decides, "considering the person and his manner," to have his assistants paint, after having sketched the design himself, a collection of pieces of armor, from the thigh piece to the throat protector, equivocating deliberately on the word *arms*. Giotto's sharp retort to the surprised and disappointed client is:

> If someone asked you who you are, you would hardly know the answer yourself, yet in you come and say "paint my coat of arms."
> If you had been one of the Bardi, that would have been enough.
> What arms do you bear? From what sort are you descended? Who were your ancestors? For shame! Think about arriving in the world before you talk of arms, as though you were the Dusnam of Bavaria. I made you a whole set of armor on your shield; if there is any piece missing, say so, and I'll have it painted too.[70]

The dispute is taken to law, and both parties go before the board of commercial standards in Florence. Giotto wins, "since he explained his side of the case better," and Sacchetti concludes in resignation: "Every wretched rogue wants to have arms and found a line of descent bearing his name, including people of the sort whose own fathers were probably foundlings."

When Giordano da Pisa adverts to different historical situations, the city is the touchstone, the term of reference he uses. Mohammed "gained possession of villas, castles, and cities . . . so it is not so surprising that he also gained a following."[71] The punishment that afflicts the Jews, the eternal killers of Christ (when they painted a Crucifixion, Giordano recalls, blood flowed from it),[72] is that "they have no city." Likewise the devil will always use an irresistible temptation, he "blinds

[67] Ibid.

[68] Giordano da Pisa, *Prediche*, ed. Narducci, p. 154.

[69] Sacchetti, *Opere*, novella 63, pp. 207–10.

[70] Ibid., p. 209. "Dusnam" is Namo of Bavaria, a personage of the chivalric romances.

[71] Giordano da Pisa, *Prediche*, ed. Moreni, vol. I, p. 156.

[72] Ibid., vol. II, pp. 232ff.

you with external things, showing you beautiful palazzi, beautiful ornaments, the things of the world."[73] What do people talk about, he asks; "they'll have seen a beautiful palazzo or a horse . . . and they talk of nothing else."[74] In the woodcuts that accompany the *Ars moriendi*, an illustrated opuscule that appeared in print for the first time in 1465, but which had already circulated in manuscript form, in which the rules of dying well are codified, all the tempting memories that distract the sick man from the thought of the next world are shown clustered about his bed.[75] In one of these woodcuts, *Temptacio dyaboli de avaricia*, (figure 55) the sick man seems to be preoccupied more by his riches, at which he gazes in sorrow, following the words of the devil, *Intende thesauro*, than he is by the Jew, by his wife and small child, or by the relatives beside him, whom he ignores.[76] The image is entirely filled up by a beautiful palazzo; the wide-open doors allow us to glimpse the full tuns, while a groom takes a horse with harness to his stall. These things are his "corporales diviciae atque alia quae magis in vita sua dilexerunt," those temporal goods, the demon suggests, "quae sollicitudinibus et laboribus maximis sunt congregata." The nun Herrad of Hohenbourg in her *Hortus Deliciarum* (twelfth century) had already shown herself to be an attentive observer of the world and its allure, when she made the city, with its magnetic power to attract, the primary obstacle to ascending the celestial ladder of the virtues (figure 56). The *laica* and the *miles* plunge down because they are unable to lift their gaze from the *eques*, from the *armati milites*, from the *urbes*, from "the secular splendor that the laity are drawn to" ("ornatus saeculi cui intendunt laici"), which is how the didactic inscription defines the various images.[77]

[73] Idem, *Prediche*, ed. Manni, p. 160. The sensibility and the attention to the "belli palagi" are found as well in a petition to the Nine of 28 October 1316, in which it is requested that no more fires should be lit in a hall of the Palazzo del Podestà which recent pictures and frescoes have made "oculo delectabilis, cordi letabilis et singulis sensibus humanis amabilis," a source of precious pride not only for the official inhabitant of the Palazzo, but "tum ratione forensium qui persepe ad domos rectorum accedunt ex causis plurimis et diversis" (Milanesi, ed., *Documenti*, p. 180). E. Castelnuovo called my attention to this passage and the one in n. 58.

[74] Ibid., p. 91.

[75] A. Tenenti, *La vie et la mort à travers l'art du xvᵉ siècle* (Paris: Colin, 1952), p. 49.

[76] Ibid., pp. 115 (ill.), 116 (text).

[77] *The Hortus Deliciarum of Herrad of Hohenbourg (Landsberg)*. A reconstruction by R. Green, M. Evans, C. Bischoff, M. Curschmann, under the direction of R. Green (London and Leiden: Warburg Institute, 1979), vol. II, p. 353, facing figure; vol. I, p. 201 (transcription of the inscriptions that comment on the illumination). The codex, the work principally of Herrad of Hohenbourg (1167–1195), more commonly known as Herrad of Landsberg, was lost in the terrible fire at the library of Strasbourg in 1870. Fortunately it had been almost entirely copied forty years earlier by Count Auguste de Bastard d'Estaing (text and illuminations). The monumental edition cited finally gives a

"When you think back," writes Giordano, "and you remember things, all those things you have in your mind, towers and palazzi[78] . . . don't you then see also how many things your thoughts invent? Some make beautiful houses, beautiful palazzi, beautiful churches . . . purely in thought."[79] The love of the city ("and for love they built the cities, for the people took pleasure in being together"),[80] not just love for the buildings, but because the city is the home of sentiments, of bonds of association that only living in common gives rise to ("Man is called the social and herding animal . . . for the aid one person gives another . . . and this was the reason that castles and cities and hamlets and families were made")[81]—this love becomes tangible in the invincible nostalgia of the exile: "To return to his own city is one of man's greatest desires; all his desire is here. So strong is it that many born far from Florence, to Florentine citizens, and who never saw the city, long for it and long to return there; they feel that elsewhere they live in prison."[82]

When Giordano wishes to arouse the desire for heaven, for the heavenly city, he finds an ideal example in the febrile wandering of the young on this earth, in search of the perfect city; as he captiously suggests, man does not know how to recognize his own desires, he scours the earth, failing to see that his desire is for heaven. This is the reason that people want so much

> to search the world, and cities, and lands, and especially the young go to see all the cities and the castles, if they can. If it were not for the uncertainties of travel, and for the fatigue and the cost, if it were certain that is, and easy and cheap, they would like to visit all the cities of the world. Why? Because there is one city of men which they have never seen and yet desire, and believe that they will find in searching the cities. So they go in haste, and when they have seen one city, they wish to move on to another.[83]

In Paradise, the friar attempts to convince his hearers, memory will not be a source of pain; while in the inferno it will: "all the goods of the world torment us when they depart . . . but memory will torment

total reconstruction of the codex and an ample commentary. However it is still useful to consult C. Cames, *Allégories et symboles dans l'Hortus deliciarum* (Leiden: Brill, 1971).

[78] Giordano da Pisa, *Prediche*, ed. Manni, p. 224.

[79] Idem, *Prediche sulla Genesi recitate in Firenze nel MCCCIV*, ed. D. Moreni (Milan: Silvestri, 1830), p. 42.

[80] Idem, *Prediche*, ed. Moreni, vol. II, pp. 77ff.

[81] Idem, *Prediche*, ed. Narducci, p. 85.

[82] Ibid., p. 403.

[83] Ibid., p. 404.

those in inferno forever because memory is nothing but not having something with one."[84]

"Since prosperity has left us, come, O death, medicine of all ills, to give us now the last supper," cry the impoverished and blind, the lame and the leprous, in the fresco of the Triumph of Death in the Campo-santo at Pisa[85] (and in the fragment of the Triumph of Death by Or-cagna at Santa Croce in Florence).[86] An end to life is invoked not be-cause it is the gateway to the extraterrestrial destiny of the Christian, but, in an entirely profane perspective, because of the loss—felt as un-bearable—of those riches, of that well-being that once was enjoyed, or that others are now seen to enjoy. Though it was able to find a place on the walls of a holy building where even the blasphemous wordplay on the Last Supper was accepted, this argumentation carries a destruc-tive charge that should not be underestimated; and yet as the vision of the unhappy ones fails, their last horizon is one of corporeal goods: a banquet. The Church opens its doors to riches, then, and to the city, in sanctifying a merchant, Omobono di Verona, active in the second half of the twelfth century,[87] an artisan, Facio di Cremona (1196–1272), who nevertheless belonged to the Society of the Holy Spirit "in quo consortio erant omnes nobiles Cremonenses et mercatores,"[88] and fi-nally, in Brittany, a jurist, Ivo Hélory (1253–1303), who specialized in legal aid to the poor.[89] On the prothyrum of the cathedral of Cremona, where he appears to have been placed in 1335 (figure 57), sant'Omobono flanks the Madonna in a position of extraordinary prominence. The work, by a Tuscan artist at the beginning of the Tre-cento, is striking for its faithfulness in preserving on the face of the saint the signs of fatigue, and of wholly worldly cares.[90]

A mark of the credit increasingly accorded to worth, to fame,[91] to

[84] Giordano da Pisa, *Quaresimale*, ed. Delcorno, p. 122.

[85] On this fresco, recently attributed to Buffalmacco and dated to before the plague of 1348, see L. Bellosi, *Buffalmacco e il Trionfo della Morte* (Turin: Einaudi, 1974). On the program of the Pisan cycle, see C. Frugoni, "Altri luoghi, cercando il paradiso (il ciclo di Buffalmacco nel Camposanto di Pisa e la committenza domenicana)," *Annali della Scuola Normale Superiore di Pisa* (1988) no. 4: 143–229.

[86] C. Settis Frugoni, "Il tema dell'Incontro dei tre vivi e dei tre morti nella tradizione medioevale italiana," *Atti dell'Accademia nazionale dei Lincei, Memorie, Classe di scienze morali, storiche, e filologiche*, series VIII, 13, fasc. 3 (1967): 213, n. 299. The inscriptional text cited is reproduced with minor variants in both frescos.

[87] Little, *Religious Poverty*, p. 215.

[88] Ibid.; and A. Vauchez, "Sainteté laïque au XIIIᵉ siècle: La vie du bienheureux Facio de Cremona (v. 1196–1272)," *MEFRM* 84 (1972): 13–53.

[89] Little, *Religious Poverty*, p. 216.

[90] P. Toesca, *Il Trecento* (1950; reprint, Turin: UTET, 1971), p. 274, n. 56 and fig. 247.

[91] Giordano da Pisa, *Quaresimale*, ed. Delcorno, p. 396; worldly delights, according to the preacher, are the following: "l'onore, ch'è sommo diletto; fama, ch'è nome sparto

the urban professions, is the diffusion of the monumental tombs of jurists or of physicians. On that of Cino da Pistoia (figure 58), the work of a Sienese sculptor of the early years of the Trecento,[92] an audacious calque of the forms of Christian iconography has in my opinion taken place: as in the ideal lunette of a church portal, where the chord of the arc is dedicated to historical events, and the lunette itself to the celebration of the personage in question (an example chosen at random is a relief of Antelami (figure 59) in the Baptistery of Parma, where beneath the Madonna on her throne with the child runs the story of the life of the Baptist),[93] so on this tomb we see represented along the ideal architrave the jurist Cino in his professorial chair with his students in the lecture hall and then, above, Cino in a frontal position with a group of his learned hearers, as if Christ among the apostles. The impression is reinforced as well by the fact that the figure of Cino is outsized, the convention having been adopted that the proportions of the figures are graded according to a scale of values—the usual pictorial practice to discriminate between a sacred personage and the humble human donor.

The physician Ligo Ammannati, who died in 1359, "vir prudens et discretus," is also represented among his students on his professorial chair in the monumental Camposanto of Pisa.[94] Not only do his arms and an inscription assure the fame of the deceased, "in medicina philosophia et septem liberalibus artibus doctoratus" (the nobility of his line accompanying his nobility of spirit), but a book, his learning, reposes on his breast in the second representation, in which he is distended on his deathbed.

The growing importance attributed to education and documentation, made possible by the diffusion of the volgare in written form—Giordano da Pisa had recommended that even women should read "good little books"[95]—transpires in the disdainful description that Sacchetti gives of an ignorant physician from Prato:[96] "he always went

e dura più; apresso è la scienza." Translation: "honor, which gives great pleasure; fame, which means one's own name is widespread and enduring; and then comes knowledge."

[92] Toesca, *Il Trecento*, p. 297 and fig. 267.

[93] Ibid., vol. II, p. 796, fig. 503.

[94] B. Supino, *Arte pisana* (Florence: Alinari, 1904), p. 208.

[95] Giordano da Pisa, *Prediche*, ed. Moreni, vol. II, pp. 220 and 310. In another sermon (*Prediche*, ed. Manni, p. 152) he exclaims enthusiastically: "oggi è alluminato ogne semplice, tanti sono i libri e la sapienza, ch'è scritta, che non hanno numero. Ma il nostro non sapere non è se non per negligenzia di non leggere; che ogne cosa avemo apparecchiata." Translation: "today even a simple person can become educated, there are so many books, and so vast is the wisdom they contain; books are really without number. Hence our ignorance derives only from our neglecting to read, since we have all the material for instruction ready."

[96] Sacchetti, *Opere*, novella 155, pp. 499–504 (here at pp. 500 and 504).

about with a very high hood with a short, wide *becchetto* [a strip of material attached to the tip of his hood] hanging on one side . . . and with two *batoli* [cheek flaps] which seemed two smoked *sugnacci* [pieces of lard] of a pig, before . . . he died carrying his book with him on his corpse in the coffin as though he were Hippocrates or Galen." In images too the figure of the physician assumes a prominent visual position: observe for example, in a panel of the fourteenth century with legends of the blessed Humility (figure 60), with what self-possession and importance the physician is portrayed as he pronounces that the monk must have his leg amputated (the intervention of the saint will upset the diagnosis).[97] Or again in the Gondi chapel at Santa Maria Novella in Florence (fourteenth century?), in the fresco illustrating the death of Gregory the Great, it is the physician with headgear and suit of vair who gathers the last words of the dying man, whose wrist he holds in a professional manner, rather than the clerics, who stand apart at the foot of the bed.[98]

Even in the nether world the memory of the social stratum to which one belongs is not lost. The vair [*vaio*], the robe of fur that distinguishes with its lining of ermine and sable the category of the learned and the noble,[99] still covers the shoulders and the head of one of the damned, otherwise nude, in the fresco of Giotto in the chapel of the Scrovegni of Padua (figure 61),[100] while next him, still dressed in his suit, a merchant arrives at the mouth of hell with a sack on his shoulders: a demon with a scrap of a suit and a ridiculous cap, a parody of the robes of a judge, unwinds a long scroll and shows him the list of his illicit gains. Above, a friar is about to be caught with a hook; further along, a bishop, naked but still wearing his miter, blesses a friar while grasping a purse full of the money he demanded for the absolution. Still further along, the desolate and macabre figure of Judas hangs, identified less as a traitor by now than as a *mercator pessimus.*[101] In this way, with a presentation in rapid series of the defining figures of the new urban way of life and economy, each one branded with the sin most characteristically connected to his own social standing, the fresco of Giotto begins. Even in the underworld they do not renounce their "febrile busyness," or the now useless symbols to which they

[97] Kaftal, *TS*, fig. 572 (Florence, Uffizi, Florentine school of the fourteenth century).

[98] Ibid., fig. 546.

[99] C. Frugoni, "Le decorazioni murali come testimonianza di uno 'status symbol,' " in *Un palazzo, una città: Il Palazzo Lanfranchi in Pisa* (Pisa: Pacini, 1980), pp. 141–58, esp. 143ff.

[100] Baccheschi, ed., *L'opera completa di Giotto*, pls. 40–41.

[101] He is so labeled in the caption to an illumination of the *Hortus Deliciarum* (cf. n. 77), in which he appears richly clothed with a purse at his belt, and scales and money in his hands. See also Cames, *Allégories*, pp. 98–99 and fig. 93.

cling—symbols that concentrate the essence of the riches and honor that have become the foundations of an entirely profane conception of life.

When the intention is to magnify the sanctity of san Francesco (figure 62), rich clothing and a splendid palazzo are displayed in heaven as symbols of an extraordinary renunciation, just above the mystic matrimony of the saint with Madonna Povertà, on one of the *vele* (dome vaults) of the lower church at Assisi.[102] Always, the image of the city, in its tantalizing fascination, speaks; the message it conveys may be one of severe admonition or triumphalistic exhortation, as the church addresses itself to the faithful in paintings, stooping, as it strives to turn the thoughts of believers toward the afterlife, to make use of those worldly values that it is no longer able to suppress in their hearts.

The pious Lapo Mazzei reproves in vain "the excessive pleasure taken in building projects"[103] by his friend Francesco Datini: "Use restraint in this business of building, use your reason! If you are doing it for God, God isn't asking you to be a manual laborer . . . if you are doing it for the world, then you deserve reproach, wasting all your time in projects that won't be finished when death comes; and you may find yourself, although a rich man, empty-handed when that happens." This opposition between the thought of God and the thought of the world is reconciled in the thanks that Giovanni Rucellai gives to God in 1464, tranquil and grateful

> for the good fortune that He has conceded to me in my affairs. . . . And not only did I have his grace in my profits, but also in spending them well, which is an art just as difficult as that of winning gains. And I believe that I got more honor from having spent them well than from having won them, and more contentment of spirit, principally from the construction undertaken at my residence in Florence, at my place at Quarachi, on the facade of the church of Santa Maria Novella, and on the loggia begun in the vineyard directly opposite my house.

Ten years later, returning to this subject, he wrote, "Having done nothing but gain and spend for the last fifty years . . . I have had a great deal of pleasure and contentment, and I realize again that the spending was even more sweet than the gaining."[104] Giovanni Rucellai's gaze is bounded by a horizon composed of edifices alone; he takes

[102] *Giotto e i giotteschi in Assisi*, p. 182 and fig. 176.
[103] Cited in Ginzburg, *Folklore, magia, religione*, pp. 623–24.
[104] Ibid., pp. 626 and 627.

pride in offering the eloquent symbols of his success to be admired by his fellow citizens. In the words of Michelangelo: "An honorable house in the city brings great esteem, because it is more visible than other possessions."[105] At this point the spectacle and its public are indivisible, men and the city are the characters on stage.

[105] The passage is cited by R. Goldthwaite, "The Florentine Palace as Domestic Architecture," *American Historical Review* 77, no. 2 (1971): 992.

Chapter Five

The Curtain in the
Open Air: A Few Steps
toward the Truth

In the city, before the palazzo of the commune appears, the only public building is the church. Those who dwell there are saints or, if members of the laity, particularly pious persons in the guise of donors, and in any case protagonists; there is no room for generic, anonymous man. When, as in the theme of the Months,[1] it is the simple peasant who is represented, he is there not in his own right but as an object of morality: he signifies in fact the biblical condemnation of labor. (Later, in the High Middle Ages, other buildings, public but not necessarily religious, will be the theater of representation. Then we will see the proliferation of scenes from profane life, of genre scenes—scenes from the chase and stories of love in the Palazzo Pubblico of San Gimignano, for example—alongside new themes like the mechanical arts,[2] mirroring the city's consciousness of itself. The world of the everyday thrusts in, too, in the representation of saints who are near contemporaries. The dimension of time changes, no longer being oriented to eternity

[1] I refer to my own "Chiesa e lavoro agricolo nei testi e nelle immagini dall'età tardo antica all'età romanica," in *Medioevo rurale: Sulle tracce della civiltà contadina*, ed. V. Fumagalli and G. Rossetti (Bologna: Il Mulino, 1980), pp. 321–41.

[2] P. Sternagel, *Die "Artes mechanicae" im Mittelalter: Begriffs und Bedeutungsgeschichte bis zum End des 13. Jahrhunderts* (Regensburg: Lassleben, 1966); C. Frugoni, "Das Schachspiel in der Welt des Jacobus de Cessolis," in *Das Schachbuch des Jacobus de Cessolis, ms Pal. lat. 961*, vol. 2 (*Kommentar*) (Stuttgart: Belser, 1988), pp. 35–79. Franco Alessio has studied the "philosophical" reflection on the mechanical arts from the twelfth to the fourteenth centuries, with particular attention to the *Didascalion* of Hugh of St. Victor, the fortune of whose topoi he traces, in "La filosofia e le *artes mechanicae* nel secolo XII," *Studi Medioevali* 6, no. 1 (1965): 71–161; and in "La riflessione sulle *artes mechanicae*" in *Lavorare nel Medio Evo: Rappresentazioni ed esempi dall'Italia dei secoli X–XVI*, Atti del XXI convegno del Centro di studi sulla spiritualità medioevale (Todi: Accademia Tudertina, 1983), pp. 257–93. The *auctoritas* of Hugh of St. Victor sustains some damage over time, and some reversals (Pierre de Maricourt, Domenico Gundisalvi, Pierre Dubois, and above all Roger Bacon, too "precocious" for his age). But already in Hugh, as Alessio points out, there is an interesting attenuation of the biblical motif of work as penitence, through the redefinition of it as *remedium*. It is the city, however, with its new ethic of material well-being, and with a highly articulated division of labor, which causes the topos of the seven liberal arts to crumble, along with the "ethic of parsimony" that accompanies them, according to which they are necessary for survival, but to be condemned if they produce *superfluitas*.

as its sole point of reference, and public space changes too: it becomes usable by men, as well as by the faithful.) In the church, characterized by the large door inviting one to enter, the common space is the interior, gathering together the dwellers in God's house. Externally on the other hand, the edifice, which is intended to be viewed in general from an angle, thus giving a view of all its basic elements at the same time, is conceived like a painting, offering an image of itself that is immediately "readable" *in toto* and in each one of its parts, following the same aesthetic principles that we have seen operating in manuscript illuminations.[3] The internal space imposes an axial view and is planned for the crowd that assembles there, joined by the rite that it witnesses, while on the exterior the diagonally laid out piazza resulting from the angled positioning of the building invites one to pass in front of it, as in a museum: the external area is not organized as a place of shared enjoyment, delimited by a series of linked structures. The relation is always between the single individual and the building, there is no chorality. The rectangular piazze planned to receive the crowds coming to hear the sermons of the new mendicant orders will be very different, almost like a plane projection of the facade of the church in a strictly frontal view. Piazza Santa Croce at Florence (figure 63) is an example, with its interpenetration of external and internal space, though the overall ambit is sacral.[4]

Earlier, however, the church, and sometimes the bell tower and the baptistery, present themselves in isolation, each on its own (an example is the piazza dei Miracoli at Pisa), like blocks sitting in an empty space,[5] in the same way as the figures in paintings, which for clarity of visual comprehension are shown dispersed and entirely unconnected. In images, faces and figures in profile are detached from the spectator, and belong to the space shared by the other figures (also in profile); whereas the frontal view of a figure immediately grips the spectator to whom it is turned, occupying as it does a space virtually continuous with his own;[6] in the same way, "angled" buildings have an excluding

[3] See above, chap. 1, p. 9; and Guidoni, *Arte e urbanistica in Toscana*, esp. the chapter "Il quadrato sull'angolo," pp. 69–84. I am not however in agreement with the general idea of the book—that is, with the symbolic readings of single buildings or monumental complexes (the piazza dei Miracoli of Pisa, for instance, is said to reproduce the constellation of the Ram)—because it is unsupported, as far as I can see, by any real documentation.

[4] Ibid., fig. 117 and p. 236.

[5] Even when the individual buildings are linked in a single monumental complex, the vision they offer is always broken up, as though it were unrolled before the gaze of the viewer. An example would be the cathedral and campanile of Massa Marittima: cf. ibid., fig. 78 and p. 122.

[6] M. Schapiro, *Words and Pictures: On the Literal and the Symbolic in the Illustration of a Text* (Paris: Mouton, 1973), pp. 37ff.

function with respect to the observer, to whom they offer themselves, indeed, as a visual composition, and not as an inviting, designed, space. One may think of the difference between the piazza dei Miracoli at Pisa (where the buildings are presented to the spectator, from the various directions of approach, according to different "angulations") and the piazza del Campo at Siena.

The vantage point from which the buildings or the circle of walls of a city are represented is always distant. In Giotto still, the city is formed of edifices from which the frontal wall has been removed, exactly as when in the theater the stage curtain is raised. The very monotony with which the architectural elements, nothing more than perspectival containers forming the background to the personages, are repeated, as opposed to the interest shown in adopting new solutions to the representation of the human figure, reveals the difficulty for Giotto in creating a vision of a figure interreacting with its surroundings. In the foreground there are the humans, in the background the buildings, pure backdrops, detached from the pulse of life, like the uniform and abstract blue sky, unrelieved by any cloud. Sometimes the individual edifices, generally condensed into a few of their more striking architectonic particulars, enclose like a shell—and isolate—the single persons, as though each felt the need to be defended by a topographical setting. In fact, in the Death of the Cavaliere di Celano[7] (figure 64), while san Francesco, who has barely finished pronouncing the terrible prophecy, is within the banquet hall, the dead man surrounded by his distraught relatives is "outside," in an undefined and undefinable blue space.

The different architectures follow the actions of the persons, and so a unified perspectival representation is absent. Things are seen from an angle, or in profile, reflecting the positions in space that concrete reality must actually have imposed: the points of view, that is, offered by the mostly winding and tortuous streets.[8]

The buildings, even when they consist of open galleries, are like a stage set with nothing behind them: there is never an "interior with a view," a window opening onto other streets or other houses, nor is a landscape ever glimpsed through the solid structural block which they compose, huddled against one another in a row in the background. See

[7] Assisi, superior church of San Francesco; Baccheschi, ed., *L'opera completa di Giotto*, pl. 14 and cat. 35.

[8] Alberti, *De re aedificatoria* 4.5, recommends for a "settlement" or a "fortified town" that it is better "if the roads are not straight, but meandering gently like a river. . . . For . . . the longer the roads seem, the greater the apparent size of the town." The aesthetic principle that Alberti enunciates here is in fact the rationalization of an existing reality. [Translator's note: the translation is taken from Leon Battista Alberti, *On the Art of Building in Ten Books*, trans. Joseph Rykwert, Neil Leach, and Robert Tavernor, p. 106.]

for example the painting of the homage of the humble man before Francesco in the superior church at Assisi.[9]

In sum, even as late as the time of Giotto, there lives on a predominantly symbolic vision of the city. And in the earlier Middle Ages, a radical split which abolished the unity of the viewpoint was preferred: the ring of walls as an ideogram represented the city through the only aspect of it that was considered characteristic—that of defense; or else a building was shown, and before it, in the open, the persons who are always meant to be thought of as "inside" it. In the High Middle Ages the personages have entered the rooms in which they are acting, but these rooms are always either blind shells, or cropped bits of architecture, the précis of a whole structure, or roofless, simply a notation necessary to complete the narrative and also a heraldic symbol, speaking of the person and his actions.

For example, in the driving of Joachim from the temple in the chapel of the Scrovegni at Padua, Giotto depicts a sort of condensed interior of the building, bounded by a high platform but located in the open: the characters thrust out to the impassable limit of its edges as though they were on an island.[10] Alternatively, it is Francesco alone (figure 65) who is located before an altar enclosed by an apse—metonymy of the church—in the Vision of the thrones[11]; the follower who is present at the miracle is "outside," somewhere undefined, for in this case the sacrality of the edifice belongs to the sanctity of Francesco alone. It is enough to show some part of the church as, simultaneously, indication of an interior and "suitable" attribute of the saint, just as the cap and the collar trimmed with fur of the damned man are enough to connote his complete dress and social status, in the Universal Judgment (discussed previously) in the chapel of the Scrovegni, differentiating him from the others, simply nude, who share his punishment.

The employment of an individual architectural element in connotation of an individual—for instance, the bench on which a subject sits, whereas his king occupies a throne—is very ancient: it has been pointed out that in the mosaics of San Vitale at Ravenna, the double sacrifice of Abel and Melchizedek is highlighted by the contrast between the hut of the shepherd and the temple of the priest in the background.

The representation of space by the Renaissance artists will be completely different, and not just because the widespread use of window

[9] Baccheschi, ed. *L'opera completa di Giotto*, pl. 2 and cat. 20.
[10] Ibid., fig. 53 and cat. 53.
[11] Assisi, superior church of San Francesco (ibid., pl. 8 and cat. 28).

glass[12] brought about the normal possibility of seeing beyond the window frame. The evolution of the forms of political life, giving chorality to the feeling of citizenship, allowed as well a realistic, interreactive perception of space, external and internal; and just as concord and cooperation are felt, at any rate ideologically, as necessary for the life of the city, the relation between one's house and the houses of others, and between the single edifice and the landscape, is perceived and represented in the same way. The relation exists not only among individuals but among the different types of space—both among those constructed by man, and between man-made and natural spaces. Observe for example the Elemosina di san Pietro (figure 66) by Masaccio,[13] in which an artfully arranged group of persons holds the stage, and reveals subtly orchestrated reciprocal sentiments. They are joined in this by edifices that are really fused with them, placed according to various points of view, some more distant and as if overshadowed, some so close that the only part of them visible is the part at eye level; yet wooded hills, a castle, a real sky, all peep naturally between the houses. There is no frozen pause in the close interplay of the gestures of the crowd, and the green of the plants and the undulating peaks follow on from the houses in spontaneous succession.

If a city is seen in the distance, it will appear reduced in size, miniaturized, but it will be placed, in a manner entirely realistic and plausible, in a landscape with forests, rivers, houses, and scattered villages. Compared with depictions from the past, this is a real innovation, and is felt as such by contemporaries: Vasari is a faithful and knowledgeable reporter[14] when he mentions among the paintings by Pinturicchio for Pope Innocenzo VIII "a loggia full of cities" ("una loggia tutta di paesi") in which were reproduced Rome, Milan, Genoa, Florence, Venice, and Naples "in the Flemish manner, which was a novelty and gave great pleasure."

The invention and the widespread use of lenses and of eyeglasses[15]

[12] Giordano da Pisa speaks enthusiastically of the windows made all of colored glass in the churches in one of his sermons of the period 1303–1306 (Giordano da Pisa, *Prediche*, ed. Moreni, p. 74). It is clear that the glass used was not properly diaphanous, but the light that did enter through it formed a bond between the perceived and lived-in internal space, and the joyously imagined space beyond.

[13] G. Duby, *Le basi di un nuovo umanesimo 1280–1440* (Geneva: Fabbri-Skira, 1966), pl. 51.

[14] G. Vasari, *Le vite de' più eccellenti pittori, scultori et architettori*, ed. P. Barocchi (Florence: Sansoni, 1966), vol. III (text), p. 574. On the birth of landscape painting, see the fine pages of E. H. Gombrich, "The Renaissance Theory of Art and the Rise of the Landscape," in *Norm and Form: Studies in the Art of the Renaissance* (London: Phaidon Press, 1966), pp. 107–21.

[15] "It was not twenty years ago that they invented the art of making glasses, for seeing well, which is one of the best arts and the most necessary that the world has, though it was invented so recently; and nothing more novel or extraordinary has been produced"

is in material terms the sign of a changed attitude: the need is felt really to see, to investigate nature with a scientific eye, to discover the side of it hidden by the immobility of the symbol.[16] In religious iconography there were indeed themes connected with the rural world (Joachim among the shepherds, the drunkenness of Noah, for example) but all attention was directed to the religious figures. Circumambient nature, incapable of transmitting any lesson, lacking any didactic content, is only a neutral ground, which tradition repeats in stereotypical fashion.[17] Additionally, since the aim is to impress and to admonish, the sole protagonists are men and their sentiments.

The countryside, the fields and the woods, the places where the peasant labors in the theme of the Months, are therefore not represented, although a man shown with his agricultural implements, or with a few animals, is an allusion to them. Because work was subject to God's curse, all attention is turned to the fatigue that is borne, to the sufferer. When nature is seen in exclusively utilitarian terms (the price of bread is paid in sweat), the result is that the possibility of aesthetic enjoyment vanishes. "Nor is the earth as such damned; but it is damned, it says, in your works; the earth is damned if your works are of the earth, *that is if your works are worldly*": this is the commentary of Saint Ambrose on the biblical verse containing the divine curse.[18]

says Giordano da Pisa in a sermon of the Florentine Quaresimale of 1305–1306 (*Quaresimale fiorentino*, 1305–1306, ed. C. Delcorno, p. 75).

[16] Saint Ambrose (*Hexaemeron* VI 2 = *PL* XIV, 258) feigns that he hears his assembled congregation whispering these words among themselves: "Quandiu aliena discimus et nostra nescimus? Quandiu de reliquis animantibus docemur scientiam et nosmetipsos ignoramus? Illud dicat quod mihi prosit, unde me ipsum noverim." And he responds: "Et justa est conquestio: sed ordo servandus est quem Scriptura contexuit; simul quia non possumus plenius nos cognoscere, nisi prius quae sit omnium natura animantium cognoverimus." But, almost a reply to Ambrose, comes the peremptory affirmation of Petrarca, when, after having summarized, in an extremely terse bestiary, the fabulous properties of the animals (properties, he says, that are "false in great part, as has been seen in many similar cases when these animals were within our ken in our lands"), he concludes: "anyhow these things would not help us to live happily even if they were true. I pray, what use can it be to know of beasts, birds, fish, serpents, and be ignorant or oblivious of man: ignorant of the purpose of our lives, of where we come from and where we are going?" F. Petrarca, *De sui ipsius et multorum ignorantia liber*, in *Prose*, ed. G. Martellotti (Milan and Naples: Ricciardi, 1955), pp. 714–15. Villani maintains a timid and submissive attitude toward the natural science transmitted on the authority of the bestiaries (*Cronica* X 186, p. 360) even when he discovers that lion cubs in Florence are born alive and not dead, "as the authors say in the books on the nature of the animals; . . . and it was held a great marvel, that on this side of the sea there were born lions that were alive, for there was no record of such a thing before in our time."

[17] M. J. Friedländer, *Essays über die Landschafts-malerei und andere Bildgattungen* (Stols den Haag: Aam, 1947), esp. pp. 338ff.

[18] "Nec terra in se maledicta est; sed maledicta—inquit—in operibus tuis; tunc terra maledicta est, si habeas opera terrena, id est opera saecularia," Ambrose, *De Paradiso* (*PL*, XIV, 314), cited in D. Pearsal and E. Salter, *Landscapes and Seasons of the Medieval World* (London: Elek, 1937), p. 127.

In literature and in images, the hostility of the environment surfaces; and in reality, with the poor tools available to medieval technology, it was not possible to gain mastery of it. In this light, idealization of the landscape is related to the possibility of not feeling overwhelmed by it; it must be dominated by one's gaze, measured, one must be able to feel oneself at the center of it. The result: not open spaces but an enclosed garden,[19] separated by a fence from an outside that is savage and hostile, and as such not the object of any reflection. The natural landscape has to be brought under human control; a typical example of this is the description in the *Roman de Thèbes* of the garden that the two heroic protagonists, after a long and arduous journey on horseback, come upon: a marvel surpassing that which anyone has seen or described, "mout esteit bien enclos li jarz de forz paliz de totes parz" ("the garden was very well closed on all sides with strong palings").[20] But even in the description given by Petrarca of Genoa, though there is a panoramic sense of observing the city "from the heights," and from the seaward side, still the admiration felt is linked indissolubly to the works of man. "Who would not look down with amazement on the towers and palazzi, *nature conquered by man*, the rough hills covered by cedars, vines, and olives."[21] "I wondered at the mole lying against the sea, and the port, *a work of man* of inestimable value, *and product of much labor*."[22] Nor is it casual that in the *Hortus Deliciarum* nature appears in a negative function: the miniature garden, well cultivated, which dominates the thoughts of the hermit, is the cause of his fall from the ladder of the virtues.[23] On the other hand, it has a positive connotation if it renders assistance through metaphor, or as allegory; and hence *Hortus Deliciarum* is the title of this vast religious encyclopedia.

For Honorius Augustodunensis the Church as an outpost of Paradise is—again—a *hortus deliciarum*;[24] and on the basis of the Song of Songs (4.12), the Madonna is symbolized by the *hortus conclusus*. In the *Carmina Burana* there is a striking description of nature, a description that draws its terms of praise from pictorial reproduction and from literary elaboration, so that a meadow is beautiful because it seems ar-

[19] On the enclosed garden, see P. Piehler, *The Visionary Landscape: A Study in Medieval Allegory* (London: Arnold, 1971), pp. 99ff.

[20] Lines 2141–48; cf. Pearsal and Salter, *Landscapes and Seasons*, p. 54.

[21] *Familiarum rerum libri* XIV 5.23 (cited with Italian translation in G. Petti Balbi, *Genova medioevale vista dai contemporanei* [Genoa: Sagep, 1978], pp. 76–77).

[22] *Itinerarium syriacum* in *Opera* (Basel: Henricpetri, 1554), f. 618; cf. Petti Balbi, *Genova medioevale*, pp. 80–81.

[23] Herrad of Hohenbourg, *Hortus Deliciarum*, f. 215v (vol. I, p. 201): "hic heremita falsorum heremitarum personam gerit qui ortum suum excolens et superfluis cogitationibus plantationi sue intendens, ab oratione retrahitur et a divine contemplationis dulced[ine] . . . sequestratur."

[24] *Speculum Ecclesiae* (PL, CLXXII, 833).

tificial, contrived, conventional: "erat arbor hec in prato | quovis flore picturato, herba, fonte, situ grato, | sed et umbra, flatu dato. Stilo non pinxisset Plato loca graciora."[25]

When the content of art is religious, both spatiality and history are absent. The divinity lives immortally, in eternity, and the fact that only the time experienced by God in this way is considered to have positive value entails a devaluation of the time that humanity experiences, a lack of attention to its atmospheric variation. In the midst of a world of flux and change, men embrace an exemplary idea of temporality in which everything settles back into the same condition, as in the liturgical cycle. Only with Lorenzetti will we see the first representation of a storm, only with Crivelli the first candle flame bent by a gust of wind.[26] Christ is not thought of as being present in a given time and place (for example, at the Wedding in Cana), but lives on in the actuality of the representation, with the gilded background the symbol of the absence of place and time.[27] The different persons are identifiable not because they resemble a reality, which is in fact unknown to all, but by means of a grid of signs furnished by tradition. To have cognizance of them means *recognizing* them, just as a personage is not required to be lifelike, but to be *recognizable*, to correspond to the patrimony of conventions possessed and accepted by the observer. Note for example the degree of stylization attained by the trees that, in the *Liber floridus* of Lambert of Saint-Omer (figure 67) illustrate the Beatitudes (twelfth century).[28] At times the inscription is the principal characterizing trait, as in an illumination from the codex of Egbert (figure 69), from ca. A.D. 980 that portrays the burial of Christ.[29] Beside Joseph of Arimathaea and Nicodemus stand two emaciated trees against a completely barren background; they are enough to justify, for the medieval artist, the inscription *Hortus* that appears between them. In the *Noli me tangere* episode from the gospels (figure 68), the plants scattered about Christ certainly recall the fact that he was thought by Mary Magdalene to be a gardener, but as late as the time of Giotto[30] (in the chapel of the Scrovegni at Padua) it was impossible to say to what spe-

[25] Pearsal and Salter, *Landscapes and Seasons*, p. 52. For the *Carmina Burana*, see the edition of A. Hilka and O. Schumann, vol. II (Heidelberg: Winter, 1941), p. 60, n. 79.

[26] A. Bovero, ed., *L'opera completa del Crivelli* (Milan: Rizzoli, 1974), pl. 62, cat. 179: a detail from the Pietà in the Brera gallery of Milan (1493).

[27] M. Schild-Bunin, *Space in Medieval Painting and the Forerunners of Perspective* (New York: AMS Press, 1940), pp. 151ff.

[28] L. Behling, *Die Pflanze in der mittelalterlichen Tafelmalerei* (Weimar: Bölaus, 1957), pl. 60 and p. 178.

[29] G. Pochat, *Figur und Landschaftsmalerei: Eine historische Interpretation des Landschafts-malerei von der Antike bis zur Renaissance* (Berlin: De Gruyter, 1973), fig. 20 (Trier, Stadt-bibliothek, cod. 24).

[30] Ibid., pl. 3.

cies they belonged. Yet in a German panel of the Quattrocento, show-
ing Mary in a beautiful garden enclosed by a solid, tenaciously tradi-
tional battlement[31] (she is called "hortus clausus et amoenus omni flore
sempér plenus" in a poem of the fourteenth century),[32] each flower can
be identified by its proper name, lily of the valley, ox-eye daisy, field
rose, and so on.

But in the coffers of Giotto's campanile, in which the protagonists
are Adam and Eve, the trees are perfectly recognizable;[33] note for ex-
ample the beautiful hazel, heavy with fruit, in the creation scene. In
this respect there has been a notable change, in comparison with the
personages shown on the door of the Baptistery finished by Andrea
Pisano in 1336.

The passage from the conventional to the verisimilar was slow, and
understandably the close examination of the human figure, and of the
interiors of buildings, came about more rapidly than that of the "nat-
ural" landscape. The reason is that man was the center of attention of
an art that was above all, as stated, religious and didactic, and this at-
tention reverberated onto the interior space that is the *theater* of so
many events, and so is also the object of an emotional investment. In
Duccio, for example, although the gilded backdrop remains unaltered,
and the mountains barren, deforested by ax blows, we find attentive
observation of domestic furnishings. A famous example is the section
of rhombus-patterned pavement inside the temple in the Temptation
of Christ (on the temple), recalling the cathedral of Siena.[34] Another
example is the Temptation of Christ (on the mountain)[35] in which we
are struck by the variation in the painter's approach to the landscape,
which is rendered without any inventiveness, and to the two towns,
which contain precise reference to buildings contemporary to the
painter.

In the thirteenth century, motion accelerates. Heads start to turn,
and gazes to meet, although without betraying any emotion; figures
can be drawn from behind (see for example the servant in the Betrayal
by Pietro di Duccio),[36] suggesting depth in a space that before was
purely two-dimensional. Out beyond the dark windows of the build-
ings in the background, the sky may now appear, even if it is still a sky

[31] Ibid., p. 20 and pl. 9: the panel, by a Rhenish master, is in the Staedel Museum of
Frankfurt am Main.

[32] Ibid., p. 61. The poem is entitled *De gloriosa imperatrice coeli et terrae*.

[33] G. Romano, *Studi sul paesaggio* (Turin: Einaudi, 1978), p. 26.

[34] Baccheschi, ed., *L'opera completa di Giotto*, pl. 58 and cat. 80: Siena, Museo
dell'Opera del Duomo, reverse of the predella of the Maestà (1308–1311).

[35] Ibid., pl. 59, cat. 81: New York, Frick Collection.

[36] Ibid., pl. 47b, cat. 48, and Schild-Bunin, *Space in Medieval Painting*, pp. 112ff. (Si-
ena, Museo dell'Opera del Duomo, reverse of the Maestà).

of gold, as in the healing of the blind man by Duccio (figure 78)[37] in which, once again, the very lively architecture of a typical medieval city is portrayed.

Filippo Villani, tracing a rapid sketch of developments in painting from the Duecento to the Trecento, shows that he is perfectly well aware of such changes, emphasizing that Cimabue[38] "commenced, with art and genius, to recall to a likeness of nature the art of painting, which was in decay, having strayed wantonly and departed from fidelity to nature in a childish fashion because of the insipience of painters." Giotto occupies a higher level, with his figures that imitate perfectly sorrow and laughter, seeming to live "and draw breath" ("et anhelitum spirare"). Only when Villani gets to Taddeo Gaddi is his attention turned to the *hedificia* that Taddeo painted *tanta arte*, "so that he seemed a second Dinocrates or Vitruvius, who wrote on the art of architecture."

The methods of introspective analysis are refined, sentiments are examined without the need any longer to manifest them through symbolic personalities outside oneself, like those for example of the *Roman de la Rose*.[39] It becomes possible to turn inward, to feel the necessity of giving room to one's own interior individuality; nature itself, and the landscape, are regarded as they really are, and a consonance is then discovered between one's own state of mind and nature, the resonating chamber of one's own feelings.

Not by chance, it is Petrarca who first gives us a description of a panorama shot through with the emotions and sentiments that the vista from the peak of Mont Ventoux aroused in him.[40] He was also the first, as Burckhardt has noted,[41] to separate the picturesque aspect of a place (felt now to be important) from its utility.

In the *Itinerarium Syriacum*,[42] describing from the sea the riviera di levante of Liguria, he compresses into a brief sentence an extraordinary impression of a landscape (the natural and the inhabited in perfect in-

[37] Baccheschi, ed., *L'opera completa di Duccio*, pl. 63 and cat. 85; London, National Gallery, reverse of the predella of the Maestà.

[38] "antiquatam picturam et a nature similitudine pictorum inscicia pueriliter discrepantem cepit ad nature similitudinem quasi lascivam et vagantem longius arte et ingenio revocare," F. Villani, *De famosis civibus*, chapter "De Cimabue, Giocto . . ." (cited in J. von Schlosser, *Zur Kunstgeschichte des Mittelalters* [reprint, Hildesheim and New York: Olms, 1976], p. 370).

[39] C. S. Lewis, *L'allegoria d'amore, saggio sulla tradizione medioevale* (Turin: Einaudi, 1969), pp. 108–50 (the chapter entitled "Il Roman de la Rose").

[40] *Familiarum rerum libri* IV 1 (with Italian translation in Petrarca, *Prose*, pp. 830–45, esp. 838–39).

[41] J. Burckhardt, *La civiltà del Rinascimento in Italia* (1866; reprint, Florence: Sansoni, 1955), p. 273. Cf. also O. Pächt, "Early Italian Nature Studies and the Early Calendar Landscape," *JWCI* 13 (1950): 13–47.

[42] Petrarca, *Opera* (1554), f. 618.

tegration), one that draws him with the beauty of wilderness while at the same time he observantly notes the yield from cultivation: "you see agreeable valleys, rippling streams, hills that are delightful in their untamed state, and also extraordinarily fertile [*colles asperitate gratissima et mira fertilitate conspicuos*], gilded houses scattered along the lido."

Equally important for this new attitude to nature, which breaks with an established tradition, is a passage from the *Genealogia deorum* of Boccaccio.[43] The writer pauses to enumerate the advantages of woodland and pastoral solitude compared to the restless and mean life of the town, where he can neither meditate nor compose, and this classical topos is transformed by the emotion he is able to communicate in describing the fascination of woods full of shadow and silence, the winding of sparkling brooks, the rustling of the wind and the subdued twittering of the birds: "which soothe the spirit not only by filling the eyes and ears with their delights" ("que non solum satiatis oculis auribusque deliciis suis animum mulcent"). To let the senses engage with this strong stimulation is no longer, as with Anselm,[44] a temptation from which one flees on account of the possible unfortunate consequences (on the moral plane). Rather for Boccaccio it opens the way to a constellation of beneficent sentiments which predispose to meditation and introspection ("verum mentem in se colligere"), and of which the desired and appreciated fruit will be a reawakened alacrity of mind: "desire to meditate on things sublime, and eagerness to get down to writing" ("desiderium meditationis sublimium et aviditatem etiam componendi"). So, nature acquires the highest value for the wise man, who meditates on it and through it with the same intensity and seriousness with which he pores over a text from antiquity.

The new array of sensations aroused by the natural environment survives when it is translated into pictorial art. Leon Battista Alberti,[45] reviewing at length the different styles of panoramic mural painting, enumerates, among the subjects suitable for the decoration of the walls of pleasure buildings (*horti*), those pertaining to the hunt, to fishing, and to swimming. Although he deals primarily with the human activities that can be shown in this way, he is aware that such preference is

[43] XIV 11 (ed. V. Romano [Bari: Laterza, 1951], p. 713).

[44] Eadmerus Monachus, *Liber de S. Anselmi similitudinibus* 12 (*PL*, CLIX, 608): "horum autem sensuum delectatio raro est bona, saepius vero mala."

[45] The passage (*De re aedificatoria* 9.4) is cited in Romano, *Studi sul paesaggio*, p. 42: "pictura . . . quae aratoriam vitam exprimat . . . hortis maxime conveniet, quod omnium sit ea quidem iocundissima. Hilarescimus maiorem in modum animis, cum pictas videmus amoenitates regionum et portus et piscationes et venationes et natationes et agrestium ludos et florida et frondosa." [Translator's note: the translation of part of this passage used in the text is taken from Leon Battista Alberti, *On the Art of Building in Ten Books*, trans. Joseph Rykwert, Neil Leach, and Robert Tavernor, p. 299.]

based on the psychological effects induced. The soul has its own particular way of rejoicing "when we see paintings of pleasant landscapes or harbors, scenes of fishing, hunting, bathing, or country sports, and flowery and leafy views." Characteristically, he redefines agricultural pursuits as *agrestium ludos*, canceling any notion of fatigue in connection with the labor of the peasant, though it is heavily burdened, from the conceptual point of view, by the biblical curse.

His theoretical city has indeed a precise functional relationship with its territory, but in the descriptive richness with which he defines it we sense that the taste for the fine panorama has by now blossomed fully: "Furthermore a city ought to be located in the middle of its territory, where the view extends to its very boundaries, so that it can read the situation and be ready to intervene promptly if it should prove necessary; and in a position that allows the farmer and the ploughman to go out frequently and work in the fields, and return quickly laden with fruit and produce." Further, "its territory should be healthy, extensive, and varied in its terrain; it should be agreeable, fertile, naturally fortified, well stocked and furnished with plentiful fruit and abundant springs. There should be rivers, lakes, and convenient access to the sea to allow the importation of goods in short supply and the exportation of any surplus."[46] More than a century earlier the great fresco of the Buon Governo took up the challenge of demonstrating to the Sienese the necessity of a perfect interaction of the city and its territory, including its outlet to the sea, as the prerequisite of harmonious and well-diversified industriousness. But at the same time this fresco suggested an aesthetic appreciation of the vast landscape that it contained, a landscape depicted with a new sensibility and (if the word be permitted) with genius.

The moment has come, then, to turn our attention to the work of Lorenzetti in all its detail.

[46] *De re aedificatoria* 4.2, cited by Simoncini, *Città e società nel Rinascimento*, vol. II, p. 14. [Translator's note: the translation of this passage used in the text is taken from Leon Battista Alberti, *On the Art of Building in Ten Books*, trans. Joseph Rykwert, Neil Leach, and Robert Tavernor, pp. 96 and 97.]

Images Too Beautiful:
Reality Perfected

In the years 1338–1339 Ambrogio Lorenzetti frescoed, in a hall of the Palazzo Pubblico of Siena (now known as the "Sala della Pace" or hall of peace) and on a commission from the Nine who at that time governed the city, the images of *Buon Governo* and *Mal Governo* (Good and Bad Government). Each of these allegories is completed by panels depicting the practical effects of the one and the other.[1]

On one of the shorter end walls of the room (the other being the source of illumination through a single large window) is the allegorical representation of the Buon Governo (figure 72). It contains a number of figures: that of *Sapientia* (Wisdom) floats aloft, holding a large pair

[1] A contemporary source from the first half of the fourteenth century gives a summary description of it: see *Cronaca senese* (*RIS*, XIV, 6, 78). For the date, confirmed by seven notices of payments made to Lorenzetti in 1338–1339, see A. Cairola and E. Carli, *Il palazzo pubblico di Siena* (Rome:1936), p. 120. Among the scholars who have devoted their attention to the fresco most recently, I note N. Rubinstein, "Political Ideas in Sienese Art: The Frescoes by Ambrogio Lorenzetti and Taddeo di Bartolo in the Palazzo Pubblico," *JWCI* 21 (1958): 179–207, esp. 179–89; and U. Feldges-Henning, "The Pictorial Program of the Sala della Pace: A New Interpretation," *JWCI* 35 (1972): 145–62. Both of these have examined a part of the complex of paintings, and therefore each has brought to light a particular aspect of its significance. I shall limit myself to discussing their observations, which formed the indispensable premise for my own study, referring the reader to the original articles for the complete documentation and bibliography that they provide. For the inscriptions that comment on the fresco, I have taken account of the transcription given in G. Rowley, *Ambrogio Lorenzetti* (Princeton: Princeton University Press, 1958), pp. 127–28. The best reproductions are in González-Palacios, *Ambrogio Lorenzetti: La Sala della Pace* (but for the Mal Governo part, the old plates of the Sienese photographer Grassi are still of use). [Since the first edition of the present work, restoration of Lorenzetti's frescoes has been carried out, and several new illustrations of parts of them have been included in this edition.] My thanks to L. Carbone, who permitted me to read his thesis *Note sulla ideologia e la prassi politica di un'oligarchia borghese del '300: i Nove di Siena 1287–1366*, defended at the University of Florence in 1977 and directed by Giovanni Cherubini, who brought this work to my attention. In an earlier version, now substantially modified, the present chapter on Lorenzetti's fresco appeared in *Quaderni medievali* 7–8 (1979): 14–42 and 71–103. I thank the editor, G. Musca, for permission to rework that article. [Two significant publications have also appeared since 1983: Q. Skinner, "Ambrogio Lorenzetti: The Artist as Political Philosopher," *Proceedings of the British Academy* 72 (1986): 1–56; and R. Starn, "The Republican Regime of the 'Room of Peace' in Siena, 1338–1340," *Representations* 18 (1987): 1–31. Skinner's article is discussed critically in a short appendix to the present book, and also by Starn, pp. 28–29; and by M. Donato, "Un ciclo pittorico ad Asciano (Siena): Palazzo pubblico e 'iconografia politica' alla fine del Medioevo," *Annali della Scuola Normale Superiore di Pisa* (1988) no. 3, pp. 1271–72.]

of scales, while beneath her the imposing figure of Justice, with her eyes turned to Sapientia, holds the pans of the balance in equilibrium, and on these, two angels administer justice *distributiva* and *comutativa*.[2] Justice lets down two cords which *Concordia*, on a still lower plane, draws together and twines into a thicker cord, and this is grasped in turn by twenty-four persons who pass it from one to another until it is firmly attached to the wrist of the right hand of the imposing figure of the *Bene Comune*[3] (Common Good), seated on a throne. His colors are those of Siena (black and white), and the symbol of the city, a she-wolf giving suck to the twins, lies at his feet.[4] Above the figure of the Bene Comune are the three theological virtues, *Fides*, *Caritas* and *Spes*, while beside him are the four cardinal virtues, as well as *Pax* and *Magnanimitas*. At the feet of the Bene Comune, there is a little group of foot soldiers and mounted militia, those on the right more heavily armed and menacing, who hold at bay a file of chained prisoners, while two lords offer their castles in sign of submission.

On one of the adjacent walls Lorenzetti portrayed the effects of the Buon Governo in the city and in the countryside (figures 70–71). In the first of these, the subject is the city of Siena (the Duomo is recognizable in the angle at the top left)[5] and in the second the secure and happy life

[2] For the Thomistic-Aristotelian sources, see Rubinstein, "Political Ideas in Sienese Art," pp. 182ff. The figure of Justice, painted by Giotto at Padua (cf. n. 74 below), also has a scales balanced above her head, held by an invisible divinity, with these lines of commentary: "Equa lance cuncta librat | perfecta iusticia | coronando bonos, vibrat ensem contra vicia" (Rubinstein, p. 183).

[3] That the two cords, one red and one grey, are knotted to his wrist, is a correct observation of Skinner, "Ambrogio Lorenzetti," p. 43, with whom I agree, not as regards his identification of the figure, but in respect of this affirmation: "he is shown as bound or constrained to wield it [the scepter] according to the dictates of justice and the will of the citizens as a whole." Rubinstein, p. 181, has convincingly shown that, though many interpretations have been proposed, the figure is that of the Commune of Siena, and that the letters CSCV painted around his head (omitting a further "C" which appears to be a recent addition), are the initials of "Commune Senarum civitas Virginis." A personification of this kind, the author notes, has an extended significance, because of the "terminological ambivalence" (p. 185) in texts of the fourteenth century of the words *bonum commune* as both "the good of all" and "the good of the Commune." He states: "the rule of the common good thus merges with that of the Commune. . . . The *persona publica* of the Sienese city-state and the concept of the common good," are expressed in the same figure (ibid.). The inscription that comments on this part of the fresco is careful to render this concept explicitly: "Questa santa virtù [Justice] ladove regge | Induce adunita li animi molti | Equesti accio riccolti | Un Ben Comun perlor signor sifanno" ["Where this holy virtue reigns, she induces many spirits to unite, and these, thus gathered, create a Common Good for their lord"].

[4] Although undoubtedly a replica of the she-wolf of Rome, this image had long since become the autonomous emblem of Siena, and its use betrays no intention, contrary to the opinion of Rowley, *Ambrogio Lorenzetti*, p. 99, of vaunting a filiation with the eternal city. The twins are not Romulus and Remus but Aschio and Senio: cf. M. Donato, unpublished thesis, Scuola Normale Superiore, Pisa, 1977–78, p. 54.

[5] Among the houses it is possible to make out with difficulty two other churches; their

of the countryside beyond its walls. In the city the activity of the inhabitants stands out against the compact background of palazzi, houses, and towers: merchants in their shops, peasants who have come in to sell their produce, artisans (the tailor, a weaver, a goldsmith), a schoolmaster, and on the roofs the eager industriousness of workmen intent on beautifying the city. The culture of work has its joyous counterpart: a wedding procession, a chorus of ten maidens dancing and singing, a group of nobles leaving the city on horseback for a hawking expedition in the countryside. And in the rural landscape, in the second part of the panel, the labors of the vineyard and the grainfield are seen; a file of merchants and peasants; fields and woods. In the distance is the port of Talamone, the never-to-be-realized dream of the Sienese,[6] while in the sky *Securitas* hovers. The Mal Governo, and her effects in the city (which is her dwelling anyway), and in the devastated, insecure, and sterile countryside, form a more compact group on the single wall facing the effects of the Buon Governo.

Mal Governo (figure 74), with a diabolical aspect, is surrounded by six vices: *Crudelitas, Proditio,* and *Fraus* (Cruelty, Betrayal, Fraud), and then *Furor, Divisio,* and *Guerra* (Rage, Division, War). Above, in antithesis to the theological virtues depicted on the contiguous wall, are *Avaritia, Superbia, Vanagloria* (Avarice, Pride, Vainglory). At the feet of the Mal Governo is Justice on the ground, her scales broken, and then scenes of violence and killing. In the adjacent city, emptied of labor and of its inhabitants (figure 75) (only a smith is at work, forging weapons), bands of soldiers are destroying the buildings (figure 76) and threatening those who have not succeeded in fleeing. In the fields there are the ruins of villages and churches, the aftermath of murder and flight, while in the darkened sky *Timor* (Fear) wheels menacingly (figure 77).

Above and below the frescoes are two friezes containing medallions, friezes that unfortunately have suffered much damage and reworking in the course of time. Thus, on the wall that contains the allegory of the Buon Governo, only the figure of the Sun has remained identifiable on the superior moulding, positioned directly above the Bene Comune.[7] In the lower one Grammar and Dialectic, the arts of the Trivium, are visible still (Rhetoric has disappeared). On the adjacent wall (the effects of the Buon Governo in city and country) we see on the

reduction to a position of marginal visibility confirms the entirely profane perspective from which the city is presented.

[6] The Sienese can be recognized, says Sapia to Dante, "tra quella gente vana | che spera in Talamone, e perderagli | più di speranza ch'a trovar la Diana; | ma più vi perderanno li ammiragli" (*Purg.* XIII 151–54).

[7] The figure placed in the adjacent medallion is now cut off by a beam. It is possible to read only the word "piviere."

lower frieze the arts of the Quadrivium (Arithmetic, Geometry, Music, and Astrology, plus Philosophy),[8] and on the upper one the beneficent planets and seasons: Venus, Springtime, Mercury, Summer, and the Moon. There is also a coat of arms with the keys of Saint Peter.

On the side of the Mal Governo, and placed over it, are the maleficent planets and seasons: Saturn, Jove and Mars, Autumn and Winter, and the lilies of France.[9] The sequence of the planets, starting with the Moon, is traditional; it is that of the Dantean *Paradise*, for example. Beneath, there must have been shown the tyrants of antiquity: Nero is the only one visible, in the act of throwing himself upon his sword.[10] The complex allegory is rendered clearer by inscriptions that comment on the frescoes: *Timor* (figure 77) and *Securitas* bear two large scrolls, and another is placed beneath the twenty-four individuals, in order to privilege the positive role of the Buon Governo, the fresco having been commissioned by the Nine to propagandize their policies. Finally, a long inscription runs underneath the lower border of the frescoes immediately before the friezes, as a continuous explanation of the images that follow one another above.

NICOLAI Rubinstein, who gave his attention exclusively to the representation of the allegory of the Buon Governo, has emphasized the fact that the two concepts that the artist especially wanted to underline in this part of the fresco are, first, "the Aristotelian theory of justice in its contemporary scholastic and juristic interpretation,"[11] and, second, the equally Aristotelian idea of the *bonum commune,* and hence the subordination of private interests to those of the community.[12] The divulgation of these ideas was assured by the Dominican Remigio de' Girolami, who between 1302 and 1304 composed *De bono pacis* and *De bono communi* (and the incomplete *De iustitia*). Rubinstein observes that the distinction between distributive and commutative justice in this fresco obviously incorporates these points of Aristotelian theory,[13] but

[8] Cf. Alessio, "La filosofia e le *artes mechanicae* nel secolo XII," and "La riflessione sulle *artes mechanicae.*"

[9] The lilies and the keys are said to be allusions to the political situation in Siena at that time; cf. Rowley, *Ambrogio Lorenzetti*, p. 103.

[10] Nero remained a proverbial symbol of cruelty; see Cames, *Allégories et symboles dans l'Hortus deliciarum*, p. 63; and M. Feo, "Per la 'commedia elegiaca' I: Nerone e il cuculo nella fantasia medievale (Babrio, 236)" *Annali della Scuola Normale Superiore di Pisa,* Classe di lettere, ser. III, 3, no. 1 (1971): 87–107, esp. 87–96. It can be maintained that in fact these personages are there to exemplify the vices that form a crown for the Mal Governo, vices to which they correspond closely.

[11] Rubinstein, "Political Ideas in Sienese Art," p. 182; he was the first to demonstrate the relationship between the relevant sources and Lorenzetti's painting.

[12] Ibid., p. 181.

[13] Ibid., pp. 182, 185; cf. also M. C. De Matteis, "Il *De bono communi* di Remigio de' Girolami," *Annali dell'Università degli studi di Lecce* 3 (1965–1967): 13–86; O. Capitani,

he overlooks very unusual aspects of their representation; nor do the
sources he gives, Aristotle and Thomas Aquinas, provide any help in
understanding it. In fact, to understand the figures placed under the
two *tituli*, it is necessary to invert them. It is necessary, that is, to read
comutativa on the left, where the angel holds the sword and the crown,
and *distributiva* on the right, where the angel holds money and arms.[14]
With this inversion, suggested to me by Gianfranco Fioravanti, the two
subjects finally become clear, and the sources a reliable guide. We
know that already in the fifteenth century a few lines of the fresco were
no longer legible, and some of the words and letters seen on the paint-
ing in its present state are certainly due to innovating restorers.[15] Since
the two words in question have the same two final syllables, it is easy
to hypothesize that, when they had become difficult to read through
deterioration, they were misread and misrestored; to imagine an orig-
inal mistake on the part of Lorenzetti is much more difficult. Aquinas
in fact, in commenting on the *Nicomachean Ethics* of Aristotle, says:
distributive justice is that which "consists in the allocation of a com-
mon stock of things that are to be divided among those who share in
a bond of citizenship. Examples of these might be honorable offices,
or financial wealth."[16] And in consequence the angel distributes a
strongbox full of money, a lance, and a staff, all signifying an assign-
ment of responsibility, to two persons of distinction (as their clothing
reveals). Commutative justice has two components:

> The reason is that there are two kinds of human transaction re-
> quiring juridical intervention. Some are voluntary, some invol-
> untary. . . . It is to be noted that the distinction between volun-
> tary and involuntary in these transactions makes a distinction in
> the kind of juridical remedy applied, inasmuch as in voluntary
> transactions there occurs the pure loss of a thing, which requires
> to be *made good* in accordance with the equality of justice; whereas

"L'incompiuto *Tractatus de iustitia* di fra Remigio de' Girolami," *Bullettino dell'Istituto
storico italiano per il medioevo* 72 (1960): 91–134; C. T. Davis, "Remigio de' Girolami OP
(d. 1319), lector of S. Maria Novella in Florence," in *Le scuole degli ordini mendicanti*, Atti
del XVII Convegno di studi (Todi, 1967; printed in 1978), pp. 281–304.

[14] The container held by the angel might be a bushel for measuring grain. In that case,
the assignment of responsibility would consist in the demand for honest dealing by sell-
ers. I offer this hypothesis with considerable reservations, because, in light of the com-
mentary of Aquinas, it seems to me more probable that what we have here is a container
for coins.

[15] Rubinstein, "Political Ideas in Sienese Art," pp. 181–82.

[16] ". . . consistit in distributionibus aliquorum communium quae sunt dividenda inter
eos qui communicant civili communicatione, sive sit honor sive sit pecunia." Thomas
Aquinas, *Sententia libri ethicorum, V, lectio 4 ad Arist. 1130b 30* (Editio Leonina, t. XLVII,
vol. II [Rome, 1969], p. 276, lines 15–18; Marietti edition, ed. R. M. Spiazzi [Turin,
1964], n. 927).

in involuntary transactions some injury also occurs, whence the thief is not only compelled to return the thing that he stole, but also has *punishment inflicted* on him because of the injury he did.[17]

And thus we see the angel reestablish the equilibrium that had been disturbed, recompensing a person with a symbolic crown (this is made clear by the palm frond that the recipient holds in his hand),[18] and punishing another by cutting off his head.

Confirmation of the necessity of inverting these titles comes from a miniature that illuminates a French translation of the *Ethics* of Aristotle.[19] On the left *Justice distributive* dispenses coins and attestations, on the right *Justice commutative*, crossing her arms, gives something to two persons beside her; in the air, the scales and instruments of punishment, a whip, a pillory, an ax.

It seems to me that what is represented in this illumination is expressed by Remigio de' Girolami in the following gloss on the first line of the biblical *Liber Sapientiae*: "This maxim sees justice from two perspectives: that is, as an operation, hence *iustitiam;* and from the point of view of the agent, hence *diligite*."[20] With the assault (mentioned above at the beginning of chapter 4) on the jails, and the destruction of the books "of penalties and forfeitures" from the Biccherna, the revolt against the Nine began in 1355; evidently these things were symbols of the penal and fiscal justice that should have been exercised by the regime.[21] On one side therefore we see justice in operation, rewarding and punishing, and on the other, the moment at which this justice is entrusted to the leaders of the Commune of Siena, with the duty to administer properly the public purse and confer fittingly honors and

[17] ". . . eo quod duo sunt genera commutationum. Quaedam enim sunt voluntariae, quaedam involuntariae." Ibid., *ad Arist. 1131a 1* (Ed. Leonina, p. 276, lines 36–37; Marietti ed., n. 929). "Est autem considerandum quod voluntarium et involuntarium in commutationibus diversificat iustitiae speciem; quia in commutationibus voluntariis fit subtractio solius rei, quam oporteat *recompensari* secundum aequalitatem iustitiae; in commutationibus autem involuntariis fit etiam quaedam iniuria, unde raptor non solum compellitur reddere rem quam rapuit, sed etiam ultra *punitur* propter iniuriam quam intulit." Ibid., *ad Arist. 1131a 5* (Ed. Leonina, pp. 276–77, lines 74–83; Marietti ed., n. 931).

[18] This detail has not been noted before. There is a parallel: *coronando bonos, vibrat ensem contra vicia* is what Justice does in Giotto's Scrovegni Chapel; cf. n. 2 above, and p. 140 below.

[19] Brussels, Bibliothèque Royale, MS 9505/06, f. 89 (from after 1372), reproduced in *Lexikon der christlichen Ikonographie*, vol. II, ed. E. Kirschbaum (1970), s.v. "Iustitia" (by R. Kahsnitz).

[20] ". . . preceptum iustitiae ex duplici parte, scilicet ex parte operis quia iustitiam et ex parte operantis quia diligite." Cf. Capitani, "L'incompiuto *Tractatus de iustitia* di fra Remigio de' Girolami," p. 126. The biblical *Liber Sapientiae* or "Book of Wisdom," is also known as the "Wisdom of Solomon." In the Vulgate text glossed by Remigio it begins with the words "Diligite iustitiam qui iudicatis terram . . ."

[21] Donato di Neri, *Cronaca senese* (ed. A. Lisini and F. Iacometti, *RIS*, XV, 4, 577–78).

assignments. Although the elucidation of these images with reference to Aristotle and Aquinas is certainly correct, it covers only part of the fresco, for the painting continues on two other walls, and I believe it is legitimate to consider it as a unified narrative, taking full account of the inscriptions, which are already in themselves "sources" and do not require, as the images often do, to be clarified *from* a source.

In other words Rubinstein has in my opinion examined only one branch of the tradition (to use the metaphor of the *stemma codicum*) of this fresco. The derivations and the passages used by him to justify the growth of that branch are clearly accurate, but their point of origin remains unaccounted for, as do the other branches. Naturally, this critical reservation on my part is valid only within the parameters of my own project, the aim of which is to furnish a global explanation of the whole fresco—so that in utilizing Rubinstein's study I find myself in the condition of someone who, wishing to splice together a celluloid composite of a landscape, encounters difficulty in joining up shots of the same terrain taken from different distances and vantage points.

It is my impression that the biblical injunction from the *Liber Sapientiae*, "Diligite iustitiam qui iudicatis terram," placed around the figure of Justice, has not been brought into sharp focus. This line, it seems to me, was intended to suggest to medieval spectators, and to us, how to read the entire fresco—the more so in that this complex allegory, in which a city and its government wish to be represented, holds very many references to the religious sphere. They include the figure of Sapientia with her gaze directed upward (in the direction of the deity that is) and with a book in her hand, certainly the *Liber Sapientiae*;[22] justice defined as holy (*Santa*) in the plaque posted below the twenty-four citizens; the *theological* virtues; the face of Christ, to whom *Spes* turns; and the Madonna and Child, painted on the shield of the Bene Comune, a shield framed by the inscription "Salvet Virgo Senam veterem quam signat amenam."[23] In the last case, object, words, and images form a perfect protective concatenation. Furthermore, the phrase *diligite iustitiam*, the first line of the *Liber Sapientiae,* is also the starting point for Lorenzetti's whole allegory: from the figure of Wisdom, with her book, Justice issues, just as from the line in question the biblical book followed. This is an example of the "memoria incipi-

[22] M. T. D'Alverny, "La sagesse et ses sept filles. Recherches sur les allégories de la philosophie et des arts libéraux du IX\e au XII\e siècle," in *Mélanges dédiés à la mémoire de Felix Grat* I (Paris, 1946), pp. 245–78, esp. 265; A. Katzenellenbogen, *Allegories of the Virtues and Vices in Medieval Art* (London: Warburg Institute, 1939; reprint, Kraus, 1977), p. 32.

[23] Feldges-Henning, "The Pictorial Program of the Sala della Pace," p. 144.

taria" which is often employed in the medieval art of memory.[24] The *De iustitia* of Remigio de' Girolami begins as well with a citation from the first line of the *Liber Sapientiae*. The virtue of justice "is to be loved for its own sake, not by limiting it to its own sphere, but in relating it to a further end, to blessedness, that is, and the highest good, as the Master teaches in I *Sententiarum*."[25]

The inscription that frames the shield of the Bene Comune had appeared earlier in a few medallions of the Maestà by Simone Martini, painted in the hall immediately adjacent, that of the Buon Consiglio (1315–1316). In these cases it was an alternative to *Sena Vetus Civitas Virginis*, the usual motto of the seal of Siena, and of Sienese coinage.[26] As well the Virgin, protector of the city after the battle of Montaperti, directs straight at the observer, in the words written at the foot of her throne, the exhortation to renounce personal interest in favor of that of the community, while on the scroll held in the Child's hand can be read the same initial verse of the biblical *Liber Sapientiae*.[27] In Simone Martini's painting, the discourse was explicit and limited to a religious context; in that of Lorenzetti, it has to be reconstructed through the accurate and interlinked reading of symbolic figures, including profane ones, and supplementary inscriptions.

[24] F. A. Yates, *L'arte della memoria* (Turin: Einaudi, 1966), p. 84, suggests that the fresco of Lorenzetti be seen as a series of *Imagines agentes*, that is, of figures having an impressive and unusual character, suitable for storing in memory following those rules of artificial memory that the Middle Ages sought to recover from antiquity. On the "memoria incipitaria," see G. B. Conte, *Memoria di poeti e sistema letterario* (Turin: Einaudi, 1974), pp. 53ff., and further p. 10 and n. 14. In a very long letter of San Pier Damiani to the monks of Montecassino (*PL*, cxlv, 764–92), it is particularly evident that the biblical citations that *open* and *close* the letter are chosen preponderantly from the *beginning* or the *end* respectively of the various books of the Holy Scripture: see C. Frugoni, "Letteratura didattica ed esegesi scritturale nel *De bono religiosi status* di san Pier Damiani," *Rivista di storia della Chiesa in Italia* 33 (1979): 1–53.

[25] ". . . propter se amanda est, non tamen ibi sistendo, set in ulteriorem finem, idest in beatitudinem et summum bonum ipsam referendo sicut docet Magister in I Sententiarum." Capitani, "L'incompiuto *Tractatus de iustitia* di fra Remigio de' Girolami," p. 126. The complete citation is: *Libri Sententiarum*, I, d. I, c. III, par. 14.

[26] Rubinstein, "Political Ideas in Sienese Art," p. 181; M. C. Gozzoli, ed., *L'opera completa di Simone Martini* (Milan: Rizzoli, 1970), p. 85.

[27] Ibid. The Maestà painted by Duccio between 1308 and 1311 also represented an important civic event in the history of Siena. Before it was given its permanent location in the cathedral, it was carried in a solemn procession through the city, and the notices of this in the chronicles express devotion certainly, but also communal pride. In the *Cronaca senese* (in *RIS*, xiv, 6; cited in n. 1), p. 90, the hope is expressed that the Madonna "who is our advocate may defend us in her infinite compassion from all adversity and evil, and keep us from the grasp of traitors and enemies of Siena." Agnolo di Tura, *Cronaca senese* (ed. A. Lisini and F. Iacometti, *RIS*, xv, 6, 313) shows himself to be even more conscious of the importance of the event, recalling the many charitable gifts to poor persons and the many prayers to the Madonna: "may she aid and preserve and cause to grow in peace and good condition the city of Siena and its jurisdiction, as advocate and protectress of this city; and save it from every danger and every evil deed against her."

The image that the government of the Nine wants to give of itself (their complete titulature is that of "gubernatores et defensores comunis et populi Senarum")[28] is reflected in the imposing old man who carries the mace of a regal judge, but also a shield;[29] the proud antiquity of Siena *vetus* gives him his beard and white hairs.

The whiteness of his hair perhaps also leads us back to the Bible, to the dream personage who appears to Daniel, and constitutes one of the most important parts of his prophecy, "quando throni positi sunt, et antiquus dierum sedit: vestimentum eius candidus quasi nix, et capilli capitis eius quasi lana munda; thronus eius flammae ignis: rotae eius ignis accensus" (7.9). The judicial mace, the shield, the headpiece with the radiant motif, recall immediately the scepter, the globe, and the crown of a king, and so suggest still greater authority and power; the shield seems to me all the more comparable to a globe, in that it is not, properly speaking, worn on the arm of the old man, but held up by him. Ambrogio Lorenzetti will underline this particular feature even more when he is called upon to paint—in 1344, some years later—the wooden cover of a "gabella" of the Commune of Siena (preserved in the Archivio di Stato), with the figure, once more, of the Buon Governo, seated on a red throne, dressed in the colors of Siena, and holding at his feet the wolf of Siena: in sum, an entire replica of the great figure from our fresco in the Palazzo Pubblico—and here the "shield" is clearly held by the left hand. Mention can also be made of the version by an anonymous artist of this beautiful (and as it seems, rapidly known and copied) image conceived by Lorenzetti. The artist in question painted, on a book cover belonging to the Biccherna in the year 1385, the following subject: the Buon Governo on a red throne with the two colors of the *Balzana* (the Sienese flag) on his cap and all over his mantle, holding with his hands a single cord, which a host of persons to left and right also hold devotedly. Long trumpets with little cloths and the coat of arms of Siena form a sort of crown on his white

[28] W. Bowsky *Le finanze del Comune di Siena, 1287–1355* (Florence: La Nuova Italia, 1976), p. 1. Earlier articles on Siena by the same author are cited in nn. 45, 62, 181 below. Arguments strongly opposed to the theses of Bowsky, considered "favorable" to the oligarchical regime of the Nine, are advanced by A. K. Chiancone Isaacs, "Fisco e politica a Siena nel Trecento," *Rivista storica italiana* 85 (1973): 25–75. [Bowsky's later monograph is *A Medieval Italian Commune: Siena under the Nine, 1287–1355* (Berkeley: University of California Press, 1982). It appeared when the first edition of the present work was complete, and for this translation I have thought it unnecessary to add detailed references to it, given that the previous works of Bowsky's which I cite provide all the support required by my exposition.] See also A. Lisini, *Il constituto del Comune di Siena volgarizzato nel 1309–1310* (Siena, 1903), vol. II, p. 492.

[29] Cf. the following text. Villani, in his *Cronica* (1.56, p. 26), among many explanations adopted to justify the name of Siena, and to connect it to the Latin word *vetus*, also speaks of a certain "madonna Veglia" in whose honor the city is supposed to have been called "Siena la Veglia."

head, and he bears in his right hand the scepter and in his left what is by now very clearly a small globe. This precious "reading" by an anonymous painter, who had the fresco before his eyes only a few years after it was painted, and was still able to share the emotions of Ambrogio Lorenzetti himself, puts us on the track of a true understanding of that shield.[30] The inscriptions and the colors of the robe are intended to underline the presence of the city as an active element, united with the magistracy that governed it, for the full realization of the Bene Comune. But this ideology, attributed to the city's consciousness of itself, is manifested within the structural framework of a religious discourse, in the same way as the violent judgments of Dante the exile on the contemporary political situation and on earthly passions are voiced in the otherworldly regions of divine judgment.[31]

The detail (which I mentioned descriptively at the outset) of the "repentant" castellans who come to put themselves under the protection of the Bene Comune, kneeling to offer their castles, also seems to me to form part of this mode of representing the scene, ambiguously balanced as it is between secular themes and religious forms. Surely it is plain how much the scene resembles, to give just one example, the particular scene from the great fresco of Giotto containing the Last Judgment in the Scrovegni chapel, where Enrico Scrovegni, the dedicator of the church, kneels in the act of offering the model of it, not far from the Cross and not far beneath Christ in triumph.

The figure of the Mal Governo (*Tyranny*), symbol of evil,[32] shows more openly still a religious connotation, but from the underside, with his demonic aspect (horns and tusks, horrid tightly drawn face) against the background of a red-black grotto, an Inferno.[33] And immediately beside him there are *Fraus* with the wings of a bat and feet with claws, further demonic features, and then *Furor*, the monster half-man and half-beast who recalls the Minotaur in Dante, and who in canto XII (11–33) of the *Inferno* symbolizes, precisely, "bestial anger."

A series of further details seems to me to be programmatic directions to see in Tyranny an echo of *Babylonia,* the infernal city (Apoca-

[30] See further C. Frugoni, "Immagini politiche e religiose: Trama e ordito di una stessa società," in *Storia d'Italia. Annali*, vol. 9 (Turin: Einaudi, 1986), pp. 349–53, figs. 1–21, and especially figs. 14 and 15: a book cover by an anonymous artist, and a "gabella" by Lorenzetti. Jacques Le Goff states: "The medieval mentality can almost be defined as the impossibility of expressing oneself without religious references" (Le Goff, *Tempo della Chiesa e tempo del mercante*, p. 135). It will be enough to mention the various corporations that are represented with the tools of their trade on the windows of the churches.

[31] See below, pp. 136–37.

[32] The inscription is almost illegible, but the first part of the word *Tyrann-* can be made out, so it was either *Tyrannia* or *Tyrranides*. [After the recent restorations, completed in 1988, it is possible to read clearly the letters *Tyrannide-*.]

[33] I am not aware that this detail has been noted.

lypse 17.3–18): the rich and feminine hairstyle with knotted braids, the mantle of gold, pearls, and precious stones, the golden cup and the he-goat, traditional symbol of lust: "et mulier erat circumdata purpura et coccino et inaurata auro et lapide pretioso et margaritis, habens poculum aureum in manu sua plenum abominatione et immunditia fornicationis eius. . . . Mulier . . . est civitas magna, quae habet regnum super reges terrae."

In one of the oldest copies (from the second quarter of the twelfth century) of *De fructibus carnis et spiritus* of Pseudo-Hugh of St. Victor,[34] the two trees of the vices and the virtues are distinguished by the inscription "Babylonia" and "Hierosolyma" in the miniature that illuminates them, trees that have their roots in the "Superbia, radix vitiorum" and "Humilitas, radix virtutum."[35] In the illumination the highest points of the foliage produce as their ultimate fruits *Luxuria* and *Charitas*, but the text offers an interesting variation:[36] "et omnium malorum radix cupiditas, et omnium bonorum radix charitas." Further, among the many virtues that bloom on the *arbor virtutum* we find *all* those present in the program of our fresco, not only the theological and cardinal virtues, but also *Concordia, Pax, Magnanimitas*.

With this constatation I have absolutely no intention of suggesting that the work of the Pseudo-Hugh of St. Victor is one of the sources of the fresco in Siena, but only that of pointing out the diffusion, in the religious sphere, of concepts that we see represented there. With the aid of the theological and cardinal virtues, and those derived from them, "the framework of the vices is dissolved, the body of the devil is overcome, and one goes on the path of justice, source and origin of all the virtues."[37] God has created "the rational spirit . . . from no necessity, but from charity alone, so as to make it a sharer of his beatitude" (in our fresco *Caritas* has her gaze turned on high).

So that undivided association and perfect *concord* should apply on both sides [between God and the soul], the nexus is redoubled in

[34] Pseudo-Hugh of St. Victor, *De fructibus carnis et spiritus* (*PL*, CLXXVI, 997–1010) ; cf. Feldges-Henning, "The Pictorial Program of the Sala della Pace," p. 160, who does not, however, make further use of this source.

[35] Katzenellenbogen, *Allegories of the Virtues and Vices in Medieval Art*, pp. 66–67, figs. 66–67.

[36] Pseudo-Hugh of St. Victor, *De fructibus carnis et spiritus* (*PL*, CLXXVI, 1005). So also in the *Somme le Roi*, a tract that presents again the thought of the Pseudo-Hugh, written for Philip the Bold by his confessor, the Dominican Frère Lorens, the two trees have charity and egoism for their roots: "ainsi tous les vices naissent de l'amour de soi, comme toutes les vertus sortent de l'oubli de soi." (Cf. E. Mâle, *L'art religieux du XIIIᵉ siècle en France* [Paris: Colin, 1931], p. 108.)

[37] "vitiorum compago dissolvitur, corpus diaboli superatur, et per semitam iustitiae fons et origo virtutum omnium aditur." Pseudo-Hugh of St. Victor, *De fructibus carnis et spiritus* (*PL*, CLXXVI, 998).

charity toward God and one's neighbor, so that all men should join as one through charity toward God [this is the concept of Concordia and of the joined cord grasped by all], through charity all neighbors should in turn become one, so that from that one thing in which all were included, anyone might possess, more fully and perfectly, that which he lacked on his own, through the charity of a neighbor to his fellow; and the good of all should become the whole good of each [this is the same idea as that of the Bene Comune].[38]

And it is possible, again, to look at the three theological virtues that stand around the Bene Comune with the guidance of the words of Pseudo-Hugh, who recalls, speaking of faith, that it is impossible "sine fide placere Deo: *iustus ex fide vivit.*"[39] And just as *Caritas* has its source in God, *Spes* shows, in the movement of her hands, her confidence in Christ, whose face appears in a cloudlet: in the illumination of the *arbor virtutum*, Faith, Hope, and Charity, placed at its top, *fructus spiritus*, have their conclusion in Christ, *novus Adam.*[40] It is to be noted that in Italy *Charitas*, through the influence of Bonaventure above all, assumed the significance of *Charitas-Amor (Dei et proximi)* symbolized by the flame.[41] More precisely yet, the Charity of Lorenzetti will be understood as *amor patriae*, following the definition of Tolomeo da Lucca: "amor patriae in radice charitatis fundatur,"[42] therefore as the virtue that places on the highest level the good of the community. As Justice is an emanation of divine Wisdom, so the unfolding of this justice in the reality of the Bene Comune always has its point of reference in God, bearing witness to the high principles by which it is inspired. The role of God as the point of reference for human actions is emphasized in the fresco by the direction of the studied gazes. Wisdom and the large figure of Justice immediately below her (like *Caritas*) have their eyes turned to the heavens.

In the initial letter of the *Liber Sapientiae* in the illuminated Bible of Sant'Antimo (second half of the twelfth century)[43] instead of *Sapientia*,

[38] "[Omnipotens Deus] . . . rationalem spiritum creavit sola charitate, nulla necessitate, ut eum suae beatitudinis participem faceret. . . . Propter quod etiam ut indivisa societas et concordia perfecta utrobique haberetur geminatus est nexus in charitate Dei et proximi ut per charitatem Dei omnes uni cohaererent, per charitatem proximi omnes ad invicem unum fierent, ut quod de illo uno, cui omnes inhaerebant, quisque in semetipso non caperet, plenius atque perfectius per charitatem proximi in altero possideret; et bonum omnium fieret totum singulorum." Ibid., (1006).

[39] Ibid., (998).

[40] Katzenellenbogen, *Allegories of the Virtues and Vices in Medieval Art*, fig. 67.

[41] R. Freyhan, "The Evolution of the *Caritas* Figure in the Thirteenth and Fourteenth Centuries," *JWCI* 11 (1948): 68–86, 74.

[42] Rubinstein, "Political Ideas in Sienese Art," p. 186.

[43] In the Museo diocesano of Montalcino; see Carli, *Montalcino.*

Iustitia has been painted with two balances in her hands: the rarity of the double attribute, the very strange position of her hands, the geographical proximity of the manuscript may allow the cautious hypothesis that this figure was the model for Lorenzetti. The first line of the *Liber Sapientiae* ("diligite iustitiam qui iudicatis terram"), divided into two distinct phrases around the blond figure of Justice in our fresco, substitutes for the inscription that identifies every other figure. Dante in the *Paradiso* (XVIII, 88–117)—in a complicated allegory illustrating his political ideas—sees the lights of the blessed arranged so as to form the letters and consonants composing the beginning of the same verse from the *Liber Sapientiae*:

> "Diligite iustitiam" primai
> fur verbo e nome di tutto il dipinto;
> "qui iudicatis *terram*" fur sezzai.
>
> (*Paradiso* XVIII, 91–93)

In the continuation of this passage, the *M* of *terram*, which is at the same time the initial letter of *Monarchia*, then changes into the eagle, the imperial symbol. The poet, in the final part of the complex allegory, resumes and recalls the concept of the biblical line, concluding that the actualization on earth [*terra*] of the universal idea of justice always has its source in God:

> "O dolce stella, quali e quante gemme
> mi dimostraron che nostra giustizia
> effetto sia del ciel che tu ingemme!"
>
> (*Paradiso* XVIII, 115–17)

Analogously, in our painting the scales and their cords link the figures of Wisdom, Justice, and the Bene Comune in an identical relation of dependence and derivation (for Dante: God, justice, and earth); and the Bene Comune, as mentioned, has the ambivalent appearance of a royal judge.

In an illumination (figure 79) from the *Carmen ad honorem Augusti* of Pietro da Eboli (from the end of the twelfth century), Henry VI, who in the poem is always placed under the protection of divine wisdom, appears at the height of glory[44] surrounded by the theological and cardinal virtues: the Nine for their part were unable to go to the length of representing the Bene Comune as an actual sovereign, but they show that they have been influenced by the prestigious image of the monarchy.

[44] C. Frugoni, " 'Fortuna Tancredi', temi e immagini di polemica anti-normanna in Pietro da Eboli," in *Studi su Pietro da Eboli* (Rome: Istituto storico italiano per il Medioevo, 1978), pp. 147–69.

The figure of *Concordia* (figure 80), carrying in her lap a large carpenter's plane with two handles (of a kind still seen today), is completely new as representation. With her hand she braids the strands of the cord of Justice and passes it to the twenty-four Sienese citizens, an image that evidently symbolizes the power this virtue has to resolve every discord. It is meant to be contrasted to the saw of *Divisio*, the vice that in the Mal Governo tears at her own flesh, and that has the colors of the city of Siena, with the words *sì* and *no* clearly in evidence, an allusion to the sedition to which the city was prey.[45] I wish to emphasize the way in which there is a clear distinction of attributes and language, according to whether the fresco is dwelling on the representation of an ideal Buon Governo, or confronting concrete necessities—perils and threats that the Nine saw as real and imminent. To the calm self-composure of the traditional attributes of the virtues gathered around the Bene Comune is juxtaposed the new symbol of Concord, which expresses not an ethical attitude, the simple appurtenance of the just man, but rather the brisk industriousness of the inhabitants of Siena, keen in their work and keen in their understanding of how to maintain themselves in concord. That the attribute is a carpenter's plane may be a sign, too, of great respect for manual work; even the feet, the lowest or least noble part, contribute to the proper functioning of the body in the fable of John of Salisbury on the good of the State.[46] Graziolo de' Bambaglioli defines concord as "mother of the good arts," capable of suppressing wars, source of a "secure and pleasant state."[47] *Securitas* has a gallows with a hanged man in her hand as she floats over the tranquil countryside, a threat and a warning to those who did not give allegiance to the rigorous and authoritarian leadership of the Nine: an image transposed bodily into the painting from reality.

Just as it was possible to find in representations of the *Arbor bona* virtues that appear in our allegory of the Buon Governo, we also find in its counterpart Pride, Avarice with its offshoot of Fraud, Vainglory, and Rage (the offshoot of Ire, which however is not represented), all of which are fruits of the *Arbor mala*. But other capital vices from the *Arbor mala* are absent, and further, the attributes we see are not at all canonical and stereotyped, but innovative and precise; where the contact with reality turns violent, the Latin is even abandoned in favor of the volgare. *Sì* and *no* are the words pronounced by *Divisio*, and on

[45] W. Bowsky, "The Medieval Commune and Internal Violence: Police Power and Public Safety in Siena 1287–1355," *American Historical Review* 73 (1967): 1–17.

[46] See n. 239 below.

[47] Graziolo de' Bambaglioli, *Trattato di virtù*, in *Rimatori bolognesi del Trecento*, ed. L. Frati (Bologna, 1915), p. 14.

the shield of the warrior who sits beside her *Guerra* is written, not *Bellum*. The Nine fear and detest the dangers of concrete situations that arise in the life of the city, especially riots, wars, betrayals, and revolts.[48] It is to the frequent revolts of the nobles, which sections of the artisan class were also capable of joining for entirely contingent reasons, that the words placed under the Mal Governo seem to allude, in their incitement to the overthrow of tyrants: "chi turbar la [Giustizia] vvuol sie per suo merto | discacciate diserto | in sieme con qualunque sia seguacie" ("and he who wishes to disturb her, let him, according to his merits, be chased away and deserted, together with his followers, if he has any").[49] At the feet of *Tyrannide*, furthermore, *Iustitia* (identified in the inscription) lies vanquished: she has the colors of the Sienese flag. But when they are constrained to set out their own program, the Nine present only a rather generic and catechistic one, ideologizing in the manner of all ideologues. I think this is the reason it is possible to find a number of sources for the allegory of the Buon Governo (how many voices are always raised in praise of the good!). On the other hand I believe it is impossible to find an equal number of sources for the Mal Governo, because it is not "the bad" in general, but that which is bad in Siena at just that time.

Concord, which is greatly enlarged with respect to the other virtues, and so declares herself to be one of the most important points of the allegory, in conformity to the well-known medieval scale in which proportion is correlated to worth,[50] sits (and this requires emphasis) on the same level as the citizens. It is another element, together with the carpenter's plane, that underlines her belonging to the real life of the city, to the most living and immediate sentiments of its inhabitants. It is concord that makes the commune possible: "with discord nothing good is possible in the city; with concord, which is nothing other than

[48] This is a particularly unsettled period. Conspiracies to overturn the regime of the Nine, and revolts caused by food shortages, are frequent. (See Bowsky, "The Medieval Commune and Internal Violence," pp. 3 and 17ff.)

[49] Text, and the translation used, from Rowley, *Ambrogio Lorenzetti*, p. 128. And see for example a passage from the deliberations of the Consiglio generale of October 1311 (Siena, Archivio di Stato, *Consiglio generale*, t. LXXIX, f. 106r–v, cited by L. Carbone, *Note sulla ideologia e la prassi politica*: "Quidam de civitate senensi in non modica quantitate tam de nobilibus et magnatibus quam de popularibus, fecerant et composuerant settam, coniurationem et conspirationem sive societatem in preiudicium aliquorum, et iacturam de civitate predicta, propter quas settam, conspirationem, ordinationem et tractatum poterat status civitatis senensis et populi perturbari." The decision taken is to procede against the conspirators, "qui dicuntur multi esse numero, et eos acriter condenpnare propter que posset de levi scandalum et discordia maxima oriri in civitate senensi, quod Deus avertat, et ad comune senensem et offitium dominorum Novem principaliter, qui sunt capud ipsius comunis, pertineat providere quod predicta non possint occurrere ullo tempore et maxime odierno."

[50] The same hierarchical criterion is applied in the representation of the inhabitants of Siena: the nobles are noticeably taller than the peasants, and the latter often wear obtuse expressions.

the union or conjunction of hearts, that is, of wills, in desiring the same thing, the city's highest good would be achieved."[51] The two strands of the *cord* are presented as the explanation of the name *Concordia*, in an effort to appropriate, even with a false etymology, the hidden sense of the word: "nam dum videris unde ortum est nomen citius vim eius intelligis. Omnis enim rei inspectio etymologia cognita planior est."[52]

The interpretation of *concordia* in the sense of *cum chorda*, as an alternative to the true derivation from *concors*, begins with Quintilian: "nam ut cantus vocis plurimum iuvat sociata nervorum concordia . . ." ("for just as the united concord of the strings greatly assists the melody of the voice . . .").[53] And again it is possible to cite Dante, who has an

[51] "Cum discordia nullum potest esse bonum in civitate, cum concordia, quae nihil aliud est quam unio vel conjunctio cordium, idest voluntatum ad idem volendum, sit summum bonum civitatis." Cf. L. Minio Paluello, "Remigio de' Girolami's *De Bono Communi*: Florence at the Time of Dante's Banishment and the Philosopher's Answer to the Crisis," *Italian Studies* 11 (1956): 59. Cf. also M. C. De Matteis, "La pacificazione cittadina a Firenze nelle componenti culturali di Remigio de' Girolami," in *La pace nella politica, negli ideali del Trecento*, Atti del XV Convegno del Centro di studi sulla spiritualità medioevale (Todi: Accademia Tudertina, 1975), pp. 201–74. The text of *De bono communi* and that of *De bono pacis* are published by the same scholar in "*La teologia politica comunale" di Remigio de' Girolami* (Bologna: Patron, 1977), pp. 1–93.

[52] Isidore of Seville, *Etymol.* 1.29. Rubinstein, "Political Ideas in Sienese Art," p. 186, rightly notes that the rope is a frequent symbol, from the thirteenth century, of civic unity. [Translator's note: The Latin adjective *concors* and its Latin and Italian derivative *concordia* are formed from the prefix con- and the neuter noun *cor, cordis*, meaning heart or mind, so that they signify "agreement, being of the same mind." The Latin noun *chorda*, and its Italian form, *corda*, are derived from a Greek word signifying "gut, string of an instrument," and one of their meanings is that of the English word "cord"—a rope or line of small diameter. In describing the fresco of the Buon Governo, C. Frugoni in the original Italian uses *corda* to refer to the two cords or lines that descend from the feminine figure of *Iustitia* to that of *Concordia*, where they are twisted or braided into a single cord or line or rope—called by Frugoni both *corda* and *fune*, "rope"—which then connects these two figures to a group of citizens and through them to the masculine figure of the Bene Comune. In sum, there is an acoustic resonance, etymologically false but metaphorically true, between *chorda/corda/*cord and *concordia/*concord which, as Frugoni explains here, was felt and articulated as early as Quintilian, and is exploited by Frugoni herself throughout the chapter, as it is by Ambrogio Lorenzetti, who in the fresco gives this metaphor a concrete visual form (when *Concordia* plaits the two *cords*, they are literally *con-corded*). There is a further level of confusion in English, in which the noun derived from the Latin *chorda* and spelled *chord*, is used to mean the vibrating strings that produce sound in the throat—but also harmonic combinations of musical notes. The Italian word for these harmonic combinations is *accordo*, a word whose etymology is in fact similar to that of *concordia*; it means the bringing together of hearts, and this literal sense is of course also one of its available meanings in usage, as it is the primary meaning of the word "accord" in English. In the text which follows, Frugoni will elaborate on the metaphorical significance of the double meaning of *accordo* as musical harmony and as agreement among persons. A further note: the verb for "remembering" in Italian is *ricordare*—to bring back to heart or mind. When used by Frugoni in the context of her discussion of *concordia* and *accordo*, it resonates in a way impossible to render in English.]

[53] Quintilian, *Inst. Orat.* 5.10.124; and see also Seneca, *Epist.* 88.9: "doces me . . . quomodo nervorum disparem reddentium sonum fiat concordia." In Martianus Capella

evident play on words between *concordia* and the strings of musical instruments:

> Per intelletto umano
> e per autoritadi a lui *concorde*
> de' tuoi amori a Dio guarda il sovrano.
>
> Ma dí ancora se tu senti *altre corde*
> tirarti verso lui, sì che tu *suone*
> con quanti denti questo amor ti morde.
>
> (*Paradiso* XXVI 46–51)

In Cicero the comparison between the harmony of sound and the good accord of the city is explicit: "quae harmonia a musicis dicitur in cantu, ea est in civitate concordia."[54] In our fresco, right in the middle of the coming and going about their business of the inhabitants of Siena, stands out a chorus of maidens, dancing and singing—a striking restatement, visual this time, of the harmony, of the concord, and of the joy, that rule in the city. And the inscriptions that accompany the painting show that the reference to the musical sense of the word is a conscious one: "la dove sta legata la Iustitia | nessuno alben comune giamay *sacorda*" ("there, where bound is Justice, no one for the common good ever joins together"). And as well, tyranny "per adempir la sua nequitia | nullo voler ne operar *discorda* | dalla natura lorda | de vitii che con lei son qui congionti" ("in order to carry out her wickedness, is unwilling either to wish or do anything against the dirty nature of the vices, which with her are here joined").[55] Again, it is important to clarify the presence of the two cords wound into one, and to remember that in medieval theoretical writings a "chord" [in Italian: *accordo*] is felt as the just unison of *two* sounds: "concordant intervals result when *high and low tones sound agreeably together.*"[56] In a sermon of Giordano da Pisa on the city, more or less contemporary with our fresco, concord is exemplified by the good harmony between *two* companions: "the other reason for the birth of love is the unity of wills. When the wills of two persons unite in one knot, they are good companions. A

9.960 the musical implication of the term is fully present: "tetrachordum quippe est quattuor sonorum in ordinem positorum congruens fidaque concordia." Sano di Pietro reechoes these motifs, taking them from the fresco of Lorenzetti, which clearly must have inspired a sort of catechistical reverence among his successors for a long time, in a little panel of 1479 from the Biccherna, in which the Madonna girds Siena with a cord, crying piteously "Hec est civita(s) mea."

[54] Cicero, *De republica* 2.42.69.

[55] Text and translations from Rowley, *Ambrogio Lorenzetti*, p. 128.

[56] "Symphonia est modulationis temperamentum *ex gravi et acuto concordantibus sonis*," Isidore of Seville, *Etymol.* 3.20.3. [Translator's note: The translation used in the text is adapted from Isidore of Seville, *Etymologies Book 3, Chapters 15–23*, trans. H. D. Goode and G. C. Drake (Colorado Springs: Colorado College Music Press, 1980).]

rare thing, since we see today that one goes this way, the other that way; one with this party and the other with that party, so that there is a split between them and they come to evil words, and hate each other."[57] Pride, placed at the summit of the Mal Governo, holds a yoke all askew in her hand, in antithesis to the perfectly balanced position of the scales of Justice. The yoke is a symbol of humility as well, as is shown for example by its being imposed on san Francesco in the fresco at Assisi glorifying the obedience of the saint.[58] It is meant to force those beneath it to keep an equal pace, side by side, each one's step coordinated with that of the other. But the yoke of the Mal Governo has its thongs loosened and in disarray, to show a complete lack of unity and concord—the concord extolled in the tranquil advance, two by two, of the twenty-four persons who bear the symbolic rope to the Bene Comune.

AT the same period at which the fresco was painted, the regime of the Nine had been endangered more than once by conspiracies among the nobles, to which they had responded with lists that excluded the noble houses from the supreme magistracy; and also, in order not to lose their base of support, with promises to open the government to new "buoni omini" (acceptable men) from the people, whose mounting discontent they feared.[59] To these political difficulties were added, in 1339, famine and pestilence.[60] In this extremely precarious situation, the commissioning of the fresco was intended as a propaganda manifesto for the regime of the Nine, providing reassurance of its beneficial effects, and a warning to all who thought of attempting to replace it. The allegory is placed on three levels of composition, earth, podium, and heavens—symbols of the hierarchical levels of the different worlds of experience (city, allegorical mediation, God); and it is brought to life by real, not symbolic, personages: citizens, soldiers, prisoners. In fact, it is possible to speak of the recycling of a religious concept, even

[57] Giordano da Pisa, *Prediche*, ed. Moreni, vol. II, p. 79. U. Feldges-Henning has already cited many very pertinent passages, and I do not repeat these citations here. Instead I add others which seem to me useful for a better understanding of the fresco.

[58] Here a centaur is also present, with a gesture of rage and defeat; cf. R. Cianchetta, *Assisi* (Narni: Plurigraf, 1976), figure on p. 20. "Per centaurum superbus designatur," says sant'Antonio of Padua in the first of the *Sermones dominicales*: cf. *Lexikon der christlichen Ikonographie*, s. v. "Kentaur," by P. Gerlach. A line from Ecclesiasticus 6.2, "non te extollas in cogitatione animae tuae velut taurus," will have contributed to this connotation.

[59] Examples are a *Costituto* of the commune of Siena from 1337 (Siena, Archivio di Stato, *Consiglio comunale di Siena*, ff. 197–98), in which a list is given of the families excluded, and another *Costituto* of 1337 (ibid., 23, f. 512r–v) which contains a promise to increase the number of those eligible for the supreme magistracy. This documentation has been gathered by L. Carbone, *Note sulla ideologia e la prassi politica*.

[60] Agnolo di Tura, *Cronaca senese* (*RIS*, XV, 6, 524).

though the original is to some degree "smudged" by the superabundance of figures: the procession of twenty-four citizens, whose protector is Justice, takes the place of the donor, seen in very many medieval panels and frescoes, who entrusts himself to the saintly patron so that the latter may present him to God or the Madonna, and the goal of the procession is no longer divinity but the commune, surrounded not by angels but by the virtues.

Historians have wondered for a long time why the Nine should have wanted to see represented not their own government, but the one which lasted from 1236 to 1270, a regime of twenty-four citizens who constituted themselves as a council called "Eletto Concistoro" against the absolute power of the podestà and the influence of the great families. The fact that this earlier magistracy marked the ingress of the *populus* into the government of the commune may have contributed to their choice,[61] for in propagandistic discourse the appeal to the past can give the reassuring support of tradition and history to one's own actions, furnishing through the myth of a remote reality the model of one's own future program.

The government of the Nine, principally bankers and large-scale merchants (figure 73) (but the twenty-four citizens also include a cavalier, the individual with the short robe), was flanked by other important organs like the Biccherna, guided by four "provvisori," which controlled the finances of the commune; the three consuls of the Guild of Merchants; the three consuls of the Cavaliers or Captains of the Guelf Party; and other minor magistrates. Together the Nine, the Provvisori, and the Consuls, formed the Concistoro,[62] and therefore it may be that the procession has been composed as a body representing the various magistracies of the city, offering an image that would show the participation of a number of "voices" in its government.[63]

The placing of the Bene Comune among the virtues and, on the level below, the disposition of the citizens and prisoners seem to me to have been taken from the plan of the Last Judgment.[64] The substitution of Christ for the Bene Comune, and the apostles for the virtues, is not difficult; and further, following the canonical disposition of super-

[61] Cairola and Carli, *Il palazzo pubblico di Siena*, p. 124.

[62] Cf. W. Bowsky, "The Buon Governo of Siena (1287–1355): A Medieval Italian Oligarchy," *Speculum* 37 (1962): 368–81, which delves into the social stratum of the origin, and the position in Sienese society, of this magistracy, its connections with other social strata, and its investments.

[63] An extraordinarily similar image of the commune was painted by a disciple of Lorenzetti on the cover of one of the books belonging to the Biccherna: see Rowley, *Ambrogio Lorenzetti*, p. 77 and fig. 101. And see p. 126 and n. 30 above.

[64] See for example the Last Judgment painted by Giotto in the Scrovegni Chapel at Padua.

posed registers, in place of the twenty-four citizens (twenty-four like the twenty-four elders of the Apocalypse?), the blessed, and in place of the prisoners, the damned. Additionally, Justice with the two pans of her balance recalls immediately the archangel Michael in the psychostasis. In an enamel from the region of the Meuse (ca. A.D. 1160) on which a Last Judgment is represented, it is precisely the figure of *Iustitia* who weighs the actions of the deceased, a perfect metonymy of the archangel.[65] In my opinion we ought to think of a scheme tied to a precise message: order comes only from severe and just judgment.

A precedent, from a conceptual point of view, for the two figures of the Bene Comune and Tyranny can be traced in the images of the good and bad judges, carved on a capital of the campanile (bell tower) of the cathedral of Modena (figure 82), formerly attributed to Antelami.[66] On one side is seated the good judge, *iustus iudex*, crowned by an angel, with a man approaching in the attitude of a supplicant: "si mandata servaris iuste iudicabis" is written alongside. I note rapidly that the expression *iustus iudex*, which, as is well known, comes from the Bible, is always found—and this I want to emphasize—in eschatological contexts that concern the end of the world, and especially the Last Judgment. The Seventh Psalm may be adduced, for example (verse 12: "Deus iudex iustus, fortis et patiens") or the celebrated passage from Paul (2 Tim. 4.8) in which he speaks of the crown that awaits the souls of the saved at the moment of death ("in reliquo reposita est mihi corona iustitiae, quam reddet mihi Dominus in illa die, iustus iudex: non solum autem mihi, sed et iis qui diligunt adventum eius"); not to mention another famous passage, the "iuste iudex ultionis" of the *Dies irae* in the liturgy for the dead. The signification passed over to other expressions as well, such as "sedisti super thronum qui iudicas iustitiam" (Ps. 9.5), or the one that triumphantly concludes a psalm (number 97) dedicated wholly to the divine judgment, drawing to a close thus: "flumina plaudent manu, simul montes exultabunt a conspectu Domini: quoniam venit iudicare terram. Iudicabit orbem terrarum in iustitia, et populos in aequitate" (8–9).

Once again, therefore, we are driven to see, on the wall at the end of the Sala della Pace, because of the great emphasis there placed on the concept of Justice, an echo, in substance, of the Last Judgment, the place and the moment at which (I repeat) God in the Bible principally

[65] P. Verdier, "Un monument inédit de l'art mosan du XIIᵉ siècle," *Revue belge d'archéologie et d'histoire* 30 (1961): 115–75, esp. 131 and fig. 10.

[66] G. De Francovich, *Benedetto Antelami e l'arte del suo tempo* (Milan and Florence: Electa, 1952), pp. 56 and 68, figs. 98 and 105. He is now called the "Maestro dei giudici" by R. Grandi, "I Campionesi in Italia," in *Lanfranco e Wiligelmo, Il Duomo di Modena (Quando le cattedrali erano bianche, mostre sul duomo di Modena dopo il restauro)* (Modena: Panini, 1984), vol. 1, pp. 545–59, esp. p. 547.

merited the description of *iustus iudex*. On the other side of the capital at Modena is seen the iniquitous judge, the prey of the demon who has placed a chain about his neck, with his lap full of coins (in accordance with the iconography of the greedy damned), while he takes more money from a man egged on by a nearby devil: "diabolus suadet ut dives dat pecuniam." On the other sides of the capital we find the "uncertain" judge: a man with a purse full of money, and a barefoot man humbly pleading: a situation clarified by the inscription: "offert pecuniam pro falsa sententia." Finally the poor and suffering man, oppressed by corrupt justice, is seen; an angel consoles him: "angelus solatur virum gravatum ab iniquo iudice." In our fresco, the Bene Comune, wearing a crown, also has the appearance of a judge and is placed under the protection of the three theological virtues in angelic guise, and of Christ himself, whose visage appears in the sky. Tyranny, with diabolical features, is placed under the guard of *Avaritia*, who holds in his hand, which is claw-shaped, purses full of money[67]—a symbol of private interest and of injustice, whose effects (ruin, violence, killing) are suffered by the defenseless persons placed under the podium. And Justice too lies on the ground, overcome.

From a rapid notice by Ghiberti,[68] to which can be added a longer but vague description by Vasari, we know that Giotto had painted in the great hall of the podestà at the Bargello in Florence, "the commune robbed by many, in which, in the form of a *judge* with scepter in hand, he depicted him seated, and above his head he placed level scales for the just decisions delivered by him, aided by four virtues, which are Fortezza [Strength] with the soul, Prudenza [Prudence] with the laws, Giustizia [Justice] with arms, and Temperanza [Temperance] with words—a fine picture and a conception true to life."[69] At Padua, in the hall of the Palazzo della Ragione, there still exists an inscription, the only remaining portion of an image that must have been very similar to the one in Florence: "The commune, or community, exclaims: thus every sort of person tears at me, thus they spatter my blood. Alas, no pity, nor mercy, restrains them."[70] We find, then, in two buildings destined, like the Palazzo Pubblico at Siena, for meetings of the commune, two frescoes conceptually similar, with a difference however

[67] The purses bulge from a tightly shut casket, which has a cover with two handles, to keep the purses from opening.

[68] Ghiberti, *Commentari*, pp. 33–34: "dipinse [Giotto] nel palagio del podestà di Firenze, dentro fece el comune come era rubato."

[69] Vasari, *Vite*, vol. II, p. 116.

[70] "Dicit Comune seu Comunitas: sic me dilacerat, sic me omne genus cruentat. Heu nulla hos pietas, nulla hos clementia temperat." See A. von Meyrburg, *Ambrogio Lorenzetti: Ein Beitrag zur Geschichte des sienesischen Malerei in vierzehnten Jahrhundert* (Zurich, 1903), p. 50.

that I plan to return to: in Lorenzetti's fresco the commune is missing in the representation of the Mal Governo.

The tearing apart of the commune is also described in two sonnets of Antonio Pucci, which Morpurgo considered to be related to the two frescoes of Florence and Padua already mentioned, and also to the tomb of the bishop Tarlati at Arezzo.[71] They are "Omé, Comun, come conciar ti veggio" and "Se nel mio ben ciascun fosse leale." In the first sonnet in particular, it appears to me that a few instruments of persecution are referred to, instruments used against the commune, which at Siena we see in the hands of the Vices that surround tyranny:

> Chi più ti de' onorar quel ti fa peggio;
> legge non v'ha che per te si declini:
> co' raffi con la sega e con gli uncini
> ognun s'ingegna di levarne schegge.

He who ought to honor you most is he who treats you worst. You are unable to promulgate a single law; and everyone attempts to detach a piece of you with grapnels, with a saw, with hooks.

Avaritia has grapnels (*raffi*), *Divisio* has a saw (*sega*), and *Fraus* has hands like hooks (*uncini*). On the tomb of the bishop Tarlati (1223) by Agostino di Giovanni and Angelo di Ventura (but the program seems to have been furnished by Giotto), the *Comune in Signoria* is shown (figure 83) in the aspect of a judge (beside whom sits the Bishop-Lord with three counselors). The judge orders the execution of a few criminals and hears the plea of those who ask for mercy, presenting an image extraordinarily similar to the part of our fresco where we see, beside the subdued rebels, two lords who submit themselves, offering their castles.[72] Even the figure of the judge is closely related to that of the Bene Comune, right down to the identical mace. On the other hand the *Comune pelato* (the commune "peeled" or "stripped" or even "ripped off") of the tomb at Arezzo (figure 84) is set about by people who rip at his hair, beard, and clothing, an image of weak government in which everyone seeks only his own advantage to the detriment of the community.

> Capel non ti riman che ben ti voglia;
> chi ti to' la bacchetta e chi ti scalza,
> chi il vestimento stracciando ti spoglia.

[71] S. Morpurgo, *Un affresco perduto di Giotto nel palazzo del Podestà di Firenze* (Florence: G. Carnesecchi, 1897), p. 81.

[72] H. Wieruszowski, "Art and the Commune in the Time of Dante," *Speculum* 19 (1944): 14–33 and pl. IV.

> No one is left, not even a hair of one, who wishes you well. One man seizes your staff, the symbol of command, another pulls off your footwear, a third strips you naked, ripping your clothing.

So said Antonio Pucci, almost as though offering a commentary on this sculpture.

The figure painted by Giotto at the Bargello was commissioned by the commune of Florence, the tomb at Arezzo by a private family.[73] It follows that the fresco of Giotto, although in fact a manifesto of the power elite of Florentine society, was intended to embody a universal discourse, like a treatise on Good Government (Buon Governo). The two personified communes in the sculpture at Arezzo, on the other hand, appear, in the context of the entire work, only as moments through which the political exaltation of the bishop finds its justification, given that *all* his undertakings are also punctually narrated. Giotto's fresco can more readily be compared to the *Maestà* of Simone Martini, which, albeit in a religious sphere, is the vehicle of a fully political discourse, rather than one tied to the activity of an individual.

Two more images painted in the Scrovegni Chapel at Padua by Giotto (figures 86, 87), those of Justice and Injustice (at whose feet unfold two little scenes that represent their respective effects), seem to me to be a precedent, even in iconographic detail, of Lorenzetti's work. Justice with her crown and severe dress is seated on a throne that frames her in perspective in an ordered, "just" space. In her hands she has the two pans of the balance, above which are two angels, one rewarding a man and the other punishing an offender, with the support of invisible divine wisdom;[74] in a rectangle entirely distinct from the throne of Justice, riders with their falcons, girls dancing and singing, and perhaps merchants are shown.

The inscription comments: "equa lance cuncta librat perfecta iusticia; coronando bonos, vibrat ensem contra vicia. Cuncta gaudet [et] libertate ipsa si regnaverit agit cum iucunditate" ("perfect justice balances everything with even scales; she crowns the good, and aims her sword at the vices. She gladdens all things and when her reign is untrammeled, her action brings pleasure"). The grim individual who personifies Injustice is seated on a throne located in the middle of a crumbling gateway surrounded by large trees, a landscape that in no way betrays the modifying work of human wisdom. In his clawlike hands he holds a sword and a spear, which is equipped with a hook as

[73] Vasari, *Vite*, vol. II, p. 112, asserts in fact that the work was commissioned by the family of the dead man.

[74] Rubinstein, "Political Ideas in Sienese Art," p. 183; for the illustrations, Baccheschi, ed., *L'opera completa di Giotto*, pl. 37, cat. 96 and 103, Padua, Scrovegni Chapel.

well; his head is turned in an unnatural way, while the position of his body and the folds of his garment reveal an internal tension that is only the violent affirmation of power. As with the other figure, there is an explanatory scene at his feet, but this time, instead of being separated from the architectonic elements, it is intimately tied to them, taking place at the foot of a steep rock which is also the unstable support of the throne, and it has the force not of allegory but of a realistic account. (In the fresco of the Mal Governo also, there is no division between the allegorical and the narrative portions.) Those represented in the fresco of Giotto are a rider who has been thrown from his horse, a girl forced to disrobe, two warriors armed to the teeth.

In our fresco the old man who personifies the Bene Comune, and also the virtues, is seated in a space that is well ordered and defined by podiums and platforms; in fact the throne of the Bene Comune is brought forward with respect to that of Justice (whom we also see rewarding and punishing), thus imposing itself as the culminating moment of the image. The hunt and the dance are among the *effects* produced in the city by the Buon Governo, but Tyranny and the vices are *themselves* already inside the city as it collapses and burns, while the fields are bare and uncultivated, in the same way that vices and crimes are represented without any architectonic separation from the diabolical being. To return to Giotto, it is to be noted that the throne of his *Justicia* has been borrowed from the one that he gives to the Madonna (see for example the Madonna in maestà in the Uffizi[75]) and furthermore that a beautiful blue sky forms the background to the open back of the chair. *Iniusticia*, however, stands out against the battlemented arch of the gate of a city and the background is a uniform heavy red— the same color as that of the niche that encloses Tyranny in Lorenzetti. Giotto clearly has suggested in the architecture and in the color of the backgrounds a contraposition of paradise and inferno, operating within a frame of reference still entirely ecclesiastical, according to which the works of man, being profane, are unjust per se, and so are able to achieve equilibrium, a stable place, only if they lead to God. And the great difference between Giotto and Lorenzetti is this: entering the hall of Peace (to accept the name "Sala della Pace," and so submit to the ideological pressure of the claims made by the Nine in all these frescoes, in a hall that ought at least to have been called "della Giustizia"—and what precise justice it was!), one feels genuine astonishment at the unaccustomed liberty with which Ambrogio has treated secular subjects while making massive use of figurative schemes proper to the world of religion, such as a spatial arrangement similar

[75] Ibid., pl. 44, cat. 109, from the Uffizi at Florence.

to the conventional one used for the Last Judgment, a Justice who derives from Saint Michael, and the use of the features and the throne of Christ for the Bene Comune. There are some elements of this complex narrative, that is, which the painter felt to be so dignified and "sacred" that he had no fear of being immediately charged with blasphemy for borrowing "words" and "phrases" from religious discourse, whereas Giotto at Padua barely thirty years earlier and with a strongly ecclesiastical stance, sets down *sic et simpliciter* the equation: city walls = Injustice, inferno, disorder. Setting over against this the throne of Justice, so obviously ecclesiastical (take note—in addition to the comparison already made between her throne and that of the Madonna— of the "chain" that secures the arch behind her, a tiny exaggeration that draws us into the interior of a church), he carries us back to the same intransigent confidence with which he will place, before the walls of wretched, demon-possessed Arezzo, a proud and grandiose church. (The point about the nature of that "chain" does not require much argument: I simply note the similar ones between the arches of the temple from which Joachim is driven, likewise in Giotto's Scrovegni chapel.)

Lorenzetti has carried off an audacious innovation that reveals a frankly secular approach to life. Although Tyranny is "didactically" inside the walls of the city, Justice is no longer explicitly counterposed to her: that is, the dichotomy justice/injustice is not there. And Justice also occupies a secondary place, even visually, with respect to the Old Man (the Bene Comune): it is the citizens with their right actions, with their respect for the common good, who guarantee respect for the law and its beneficial effects to the city and the countryside, both of which are presented in a strikingly positive vision. The "diligite iustitiam" that takes the place of the usual inscription identifying Justice seems to direct our attention to the divinity—more as the source of the scriptural passsage than as necessary origin. Furthermore, the imperative immediately postulates the existence of someone to hear it: those who govern the city. Attention is displaced from divinity to man, to the men of government that is, who administer this justice *in this world*. It seems almost blasphemous, in sum, this easy use of the program of the Last Judgment for the administration of profane city justice.

To underline the extreme originality with which Lorenzetti and his patrons thought of a way to represent the city, I wish to adduce in comparison a particular from the legend of san Francesco, already mentioned, which Giotto painted in the superior church at Assisi (figure 85).[76] Tommaso da Celano relates in the *Vita seconda*[77] that, arriv-

[76] Ibid., pl. 9, cat. 29, from Assisi, upper church of San Francesco.

[77] Chap. 74; published in *Archivum Franciscanum* 10 (1917): 127–268. For the Italian translation, see *Fonti francescane* (Assisi: Movimento francescano, 1978), pp. 640–41.

ing one day at Arezzo while the city, shaken by civil war, was facing collapse, san Francesco halted at a group of houses outside the city walls, and saw "demons exulting above the city and spurring the citizens on to mutual destruction." So he summoned friar Silvestro, commanding him to go to the city gate[78] and in the name of God to order the demons to leave the city immediately. This is done, the demons depart, and in a short time the city is at peace again, tranquil and unanimous. Giotto illustrated this episode, but introduced on his own a stark and emphatic opposition between the spiritual world to which Francesco and his companion belong, and the profane one of the colorful city. An enormous church (not mentioned in the text) forms the background to the two friars, in fact it "recapitulates" their sanctity— a gigantic edifice, which by itself equals and surpasses in height the dimensions of the whole of Arezzo. But in the city there is *absolutely no sign* of any religious structure. There is only a large tower with a wooden summit, within which a large bell is partly seen, with another bell clearly visible under a species of pulpit immediately above the gate: bells that sound the call not to the religious life, but to rekindle the flames of discord and war.[79] Above the tower of the palazzo of the commune (?) there is no loggia or battlements, but a wooden scaffolding takes their place, surmounted by a large windlass—perhaps to signify a construction project interrupted because of the internal divisions, rather than simply incomplete. The array of civil, and exclusively civil, edifices that are portrayed has an entirely negative sense: for the city to recover concord and peace, and a positive sense, it has to be sanctified from without, through the intervention of the two friars. Giovanni Dominici,[80] with a vision of city life still ecclesiastical and pessimistic, also places his trust in the power of prayer. "The wicked could not have so much power to do evil by God's explicit permission; rather, God puts the false hypocrite in power to punish the sins of the people. If they were driven out by the power of prayer, there would not be so many demons in the city . . . but where there are few preachers and many blasphemers, . . . it becomes the habitation of inferno and goes from bad to worse."

Again I want to emphasize that the greater height of the campanile of the church outside the city, and the presence of the bells inside it, are particulars to which it is necessary to pay close attention, as so many chronicles testify; but in the chronicles the towers of the clans

[78] The *Leggenda antica perugina* specifies that Francesco halts at a hospital in the part of the town outside the walls (that is, in the *borgo*); see *Fonti francescane* p. 1247. The translation there is based on the edition of M. Bigaroni, *Compilatio Assisiensis* (Porziuncola: Santa Maria degli Angeli, 1975).

[79] *Giotto e i giotteschi in Assisi*, pp. 72–78 (V. Mariani is the editor here).

[80] G. Dominici, *Regola del Governo di cura familiare*, ed. D. Salvi (Florence: Garinei, 1860), p. 181.

can be admired for being the highest structures (which is what Opicino de Canistris does in the case of Pavia),[81] and the many bells on those towers are expressions of civic pride. Giotto therefore has consciously employed in reverse, in accordance with a "conservative" and ecclesiastical point of view, what to the eyes of his contemporaries appeared as elements of secular novelty. The images of communes antecedent to Lorenzetti, or those that in any case can be shown to derive conceptually from the antecedent period, have as a constant characteristic the antithesis between the commune *pelato* and the commune *in signoria*. What stands out in Lorenzetti's fresco is that the antithesis is no longer located inside one concept of which the two poles are presented, but exists between two diverse political entities: Commune and Tyranny.

Rubinstein has convincingly demonstrated that the figure of the Old Man represents "the *persona publica* of the Sienese city state and the concept of the common good;"[82] but, it can be added, it represents the idea of the commune as well, inasmuch as it is something good: a *communitas*. One thinks of the lament of the commune of Padua: "dicit Commune seu Communitas. . . ."

In the *De bono communi* of Remigio de' Girolami continuous emphasis is placed by the Dominican on the natural way in which the abstract notion of "that which is shared" (in Latin *commune*, in Italian *comune*) passes over into concrete expression as *communitas*. He recalls the bees, who "neglecting their own labors, and danger to themselves, naturally aim for the common good"; and also the fact that "men naturally join in groups to make a city, or find some other way of sharing, because their own advantage lies in supplying the requirements of human life, which one person alone cannot do."[83] The writers of treatises invest the political organism with the notion of *corpus mysticum*[84] as a *communitas*, which has a moral value *as such*. If therefore the Commune is

[81] Anonymus Ticinensis [Opicino de Canistris], *Liber de laudibus civitatis Ticinensis*, p. 19. Pavia "mirabilem prebet aspectum non solum ob innumerabilium *celsitudinem* turrium, sed etiam propter palatiorum et ecclesiarum *sublimitatem* . . . Campanile vero maioris ecclesie, licet plures sint ibi turres laicorum paulo celsiores illo, quod videtur etiam non fuisse completum, latitudine tamen superat universas." (The regret felt by Opicino for that campanile of the cathedral, irremediably shorter than the towers of the citizens, comes through clearly, I think.)

[82] Rubinstein, "Political Ideas in Sienese Art," p. 185. See as well Antal, *La pittura fiorentina*, p. 337.

[83] ". . . propriis neglectis laboribus et periculis naturaliter ad bonum communem intendunt. . . ." ". . . homines ad naturaliter congregantur et faciunt civitatem vel aliud commune propter utilitatem propriam ad subveniendum defectibus vite humane quibus unus subvenire non potest." De Matteis, *"La teologia political comunale" di Remigio de' Girolami*, pp. 7 and 29.

[84] For the concept of *Corpus Reipublicae mysticum*, cf. E. H. Kantorowicz, *The King's Two Bodies: A Study in Medieval Political Theology* (Princeton: Princeton University Press, 1957), pp. 207ff.

invested with a *corpus mysticum*, it is not possible to contrast it with a Bad Commune, but only with its total negation, which in Ambrogio is Tyranny. As evil is defined by Aquinas as *privatio boni*,[85] so tyranny could be defined as *privatio Communis*, a condition against nature, bearing a conceptual significance equal to that of the Old Man–Commune. In our fresco, a countryside and a city in ruins form the background to Tyranny, where the good of the individual, and of each individual thing, is missing. Indeed, "in bono totius absque dubio includitur bonum partis" and "bonum commune indubitanter preferendum est bono particulari, et bonum multitudinis bono unius singularis persone."[86]

The first and most important choice the fresco suggests is that between a political situation (a civil one, that is, in accordance with nature) and an unpolitical and uncivil situation (against nature). The disposition of the frescoes in a certain order has the sole purpose of placing before the spectator a sharp alternative: the room is entered through a door placed in the wall containing the effects of the Buon Governo, and facing the combined group of the Mal Governo and its effects in both city and country. It is therefore this combined group that the spectator is *forced* to observe before the others. The restriction of this allegory and its effects to a single wall leads to a choked presentation, coherent with the painter's aim of rendering "at a glance" the immediate and hence more significant vision of an "unpolitical" situation, offering the spectator images of evil and violence, creating within him a situation of unease that can only be resolved by turning to its antidote. But in the same instant that Ambrogio puts the spectator in a position to choose, he offers him, in addition to the motives that are *illustrated* (and so more easily comprehensible) a more valid one for being able to draw *only one conclusion*: the political absurdity of tyranny. And while in the allegories of the Buon and the Mal Governo the discourse takes place on the level of the *corpus mysticum*, in the two sets of effects it comes down to the *corpus naturale* of the commune. So Ambrogio selects from the reality of Siena itself the images with which to illustrate the rightness of the common good and the absurdity of the particular good: in the "effects" the discourse is transferred to the plane of the concrete, everyday, specifically Sienese political reality; the reality, that is, of how the city, divested of all transcendental significance, can be governed. In the "effects" the two governments no longer exist each as the negation of the other (as is the case for the allegorical part);

[85] Thomas Aquinas, *Summa theologica*, I q. 14, 100.
[86] De Matteis, "*La teologia political comunale*" *di Remigio de' Girolami*, pp. 38 and 3.

in the effects of the Mal Governo are presented scenes that must not have been unfamiliar to the Sienese themselves.

The abundant use made of images by Cola di Rienzo in his political propaganda, through his "cartelloni" (large posters), also indicates that such a technique was widespread. The image for him was an essential instrument, not simply an ancillary one. It is with images that he succeeds in representing the dramatic political and economic condition of Rome, and likewise the hope of an end to the time of injustice.[87] Commemorative pictures of important events in the history of the communes are part of the same phenomenon. Representations with a political content, for that reason, are most subject to destruction: extolling the accomplishment of the party in power, they suffer the consequences of every political change. Famous among such works are the frescoes of the battle of Campaldino at the Bargello in Florence, now lost, and the one on the expulsion of the duke of Athens, which belonged to the genre of "defamatory" painting particularly in vogue at Florence in the first half of the Trecento.[88] But this type of painting was to be found in Siena also, as we discover from two articles of the Sienese statute of 1310.[89]

Let us return now to the allegorical part of the Buon Governo. The procession of the twenty-four from Justice to the Bene Comune signifies that it is from her that they receive the mandate to join in seeking the good of the city: for the Nine, Peace[90] (as a ready answer to perilous situations) is no doubt important on the ideological level (where discourse is bent to propagandistic ends), but Justice is certainly more so, for she hangs, imprisons, and overcomes those who oppose her, and gives to each the place that belongs to him. Justice and subordination of the private interest to the public were the two fundamental concepts of the inscription on the *Maestà* of Simone Martini. That this was the concept of justice held by the Nine is confirmed by an ordinance of the commune of Siena: "the most excellent part of justice, which exceeds

[87] "Anco secunnaria lo preditto Cola ammonio li Rettori e lo Puopolo allo ben fare per una similitudine la quale fece pegnere nello Palazzo de Campituoglio nanti lo Mercato" (Anonimo romano, *Vita di Cola di Rienzo*, ed. A. Frugoni [Florence: Le Monnier, 1957], p. 37; for other relevant descriptions, see pp. 41–42, 48–49).

[88] Wieruszowski, "Art and the Commune in the Time of Dante," p. 21. Cf. Ortalli, *La pittura infamante nei secoli XII–XVI*.

[89] Lisini, *Il constituto del Comune di Siena*, vol. II, fifth *distinzione*, art. LXXXIX, p. 271, and art. XC, pp. 271–72.

[90] Peace is only *one* of the virtues, even if she is presented with attributes that are less stereotyped, and not as didactically frontal and rigid as the others. The beauty and the novelty of the position of this figure struck Ghiberti so forcefully that he remembered the fresco of Lorenzetti as the "Sala della Pace" (*Commentari* II 12, p. 38), a denomination still used today, even though a more appropriate one would be, in my opinion, "Sala della Giustizia."

all the other virtues, and which ought to be the main duty of all lords, governors, and citizen bodies, is to strike at, and punish, those who breach the law, above all through betrayal and rebellion, which bring danger, death, and injury for the public as well as for private individuals."[91]

A subject didactic and political at the same time, as this complex allegory is, requires an extremely clear language in order that everything be fully understood by a public composed for the most part of the laity: indeed the patrons who commissioned the murals probably were of the laity too. The absence (in the fresco) of clerics and the marginal position of the cathedral both seem to me to confirm this, even if we suppose that some learned cleric took part in the preparation of the subject. The allegory has to be able to find roots in the commonly shared culture of the observers, which will naturally be composite.

Again I come back to the inscription "Diligite iustitiam," the necessary guide for understanding the essential underpinnings of the discourse. The *Liber Sapientiae* develops the same theme as that of the whole fresco with which we are concerned. Its theoretical part deals with the problem of our destiny, a problem resolved by participating in wisdom, from which comes justice, the reward of the just and the punishment of the impious; and it also offers precepts on behavior for those who must govern. The historical part describes the intervention of wisdom in the destiny of Israel during its struggle with the Egyptians. We shall look for a moment at the allegory of the Buon Governo with the guidance of the words of this book of the Bible. After Lorenzetti's citation of its first line, which had evidently made such an impression on him that it suggested giving to *iustitia* a place that at bottom it does not have in the biblical text, whose protagonist is of course always *Sapientia*, he does not show a literal dependence on the *Liber Sapientiae*, until the words "et si iustitiam quis diligit labores huius magnas habent virtutes" (8.7) remind him with their echo, *diligit iustitiam*, of that first line. The text then continues with a presentation of the four virtues: "Sobrietatem enim et Prudentiam docet et Iustitiam et Virtutem [the four commonly understood as temperance, prudence, justice, and fortitude] et . . . scit praeterita et de futuris aestimat [these

[91] "Excellentissima pars iustitiae, que virtutes omnes excedit et ad quam magis decet intendere universos dominos, rectores et populos, est vendicare ac punire commissores excessium, sed maxime proditionis et rebellionis, in quibus non solum privata, quin imo publica, consistunt pericula, exterminia et offense." *Costituto* of the commune of Siena 1323–1338 (Siena, Archivio di Stato, 23, f. 477), cited in L. Carbone, *Note sulla ideologia e la prassi politica.*

are the words of the body of Prudence in the fresco]."[92] This passage seems to me to clarify the repeated presence of the figure of Justice, once as an emanation of divine wisdom, and again as one of the virtues.

The *Liber Sapientiae* continues to be the key to the interpretation of the other parts of the painting. The industrious city, which is placed to the right of the allegory of the Buon Governo (of which it is one of the "effects"), has its buildings illuminated from a source that is not the natural one (the window in the Sala della Pace), but that which is imagined as coming from the point occupied by Wisdom/divine Justice. The farther one progresses from her, the more the colors of the open Sienese countryside fade. The landscape of the Mal Governo is in contrast all dark and desolate. The walls of Siena are a deep and splendid pink, those of the city of Evil are an opaque grey. The city of Siena, taken on its own apart from the allegory of the Buon Governo, shows itself open to the light of God, while in the Mal Governo, evil is immanent, inside the walls of a city closed to any transcendent influence:

> La gloria di Colui che tutto move
> nell'universo penetra, e risplende
> in una parte più o meno altrove . . .
> Chè la luce divina è penetrante
> per l'universo secondo che è degno.[93]

The inscription on the fresco takes a similar stance:

> questa virtù [Justice] kepiù daltra risprende
> Ella guarda e difende
> chi lei onora e lor nutrica e pascie
> da la sua *lucie* nascie
> el meritar color coperan bene
> e agliniqui dar debite pene.[94]

. . . this virtue which more than any other shines. She guards and defends those who honor her, and nourishes and feeds them. From her light is born the rewarding of those who do good, and giving to the iniquitous due punishment.

[92] Ambrogio takes as offshoots of *Iustitia* a few virtues that in the biblical text spring instead from *Sapientia*. If one studies the syntax carefully, the word *huius* in 8.7 does signify "of Sapientia." But if one concentrates on the portion of text dealing with *Iustitia*, it is easy to take the latter word as the antecedent of *huius*, instead of *Sapientia*, which lies at a distance from the pronoun. The Italian translation of the Bible, ed. S. Garofalo (Turin, 1964), falls, for example, into the same error as Lorenzetti.

[93] *Par.* I 1–3; XXXI 22–23.

[94] Text adapted, here and below, from Rowley, *Ambrogio Lorenzetti*, p. 128. His translation is the one used in the text.

In the *Liber Sapientiae* 7.29, wisdom is called "speciosior sole . . . luci comparata, invenitur prior. Illi enim succedit nox, sapientiam autem non vincit malitia." The contrast between the heroes and the villains, between the Hebrews and the Egyptians that is, is expressed in the opposition between the light and the darkness, industriousness and desolation, exuberant nature and sterile nature: "omnis enim orbis terrarum limpido illuminabatur lumine, et non impeditis operibus continebatur. Solis autem illis superposita erat gravis nox."[95] This night is a metaphor of that desolation, in nature and in life, which will seal the fate of the wicked. In Lorenzetti also, in the allegory of the Buon Governo, which offers a reassuring picture of reality, the wicked are overcome and held at bay by a threatening militia, on foot and on horse. The hoods that cover their faces and blind them are in contrast to the gaze of one of the horsemen, who turns his face toward the virtue of Justice with a very animated motion, as though heeding the command of the inscription: "Volgiete gli occhi a rimirar costei | voi che reggiete che qui figurata | e per sue ciellencia coronata." ("Turn your eyes, you who are governing, to gaze attentively at her who is here represented, and for her excellence is crowned.") The solidarity of "class" and of interests that continued in reality to bind the Nine (predominantly bankers and large-scale merchants) to the rich Sienese nobility is also reflected in the representation of the defeated. Of the two submissive lords, whose faces recall the description of Manfredi in Dante, one is offering his castle, but the other, with a decided gesture of his extended thumb, is pointing to the prisoners, distancing himself explicitly from that tattered group. In a certain sense *Magnanimitas* and *Temperantia* (who are closest to *Iustitia*) express the same notion: among the frescoes of Taddeo di Bartolo, painted approximately a century after in the antichapel of the same Palazzo Pubblico, we read under *Magnanimitas* the inscriptions "Nec successibus extollitur nec infortunis deicitur" and "Opus eius parcere subiectis et debellare superbis."[96] *Magnanimitas*, here represented in the act of killing one man and protecting another, imitates the scheme of Lorenzetti's *Iustitia*. I believe it is possible to state that Taddeo di Bartolo took the fresco of Ambrogio Lorenzetti as his inspiration, for in his fresco the *Magnanimitas* from Lorenzetti has been united, as an independent virtue, with the concept of Temperance (in Lorenzetti's verses), and the image and concept of Justice

[95] *Liber Sapientiae*, 17.19–20.

[96] The inscriptions are from, respectively, the *Nicomachean Ethics* of Aristotle, and from the *Aeneid*; cf. Rubinstein, "Political Ideas in Sienese Art," p. 192, n. 83, and fig. 17d. On the medieval concept of *magnanimitas*, cf. R. A. Gauthier, *Magnanimité: L'idéal de la grandeur dans la philosophie païenne et dans la théologie chrétienne* (Paris, 1951), esp. pp. 55–118. On Taddeo di Bartolo, see S. Symeonides, *Taddeo di Bartolo* (Siena: Accademia degli Intronati, 1965), pl. 72a.

(in the verses and in the painted image of Lorenzetti). Indeed, Justice in the Buon Governo has a crown on one side, and a sword with a severed head on the other. She is represented in accordance with the iconography of Judith, who in the twelfth-century *Speculum Virginum*, for example, joins with *Humilitas* to defeat *Superbia* (Pride).[97] Temperance with an hourglass in her hand is a symbol of a well-regulated life, affirming—even in the unvarying flow of the sand through the glass—the equilibrium of what is just, in contrast to the fluctuating outcomes of chance.

Magnanimitas with her crown and the coins in her hand "est generosa quaedam excellentia animi res difficiles et arduas pulchre et fortiter administrantis" ("is a certain generous excellence of spirit that takes on difficult and arduous burdens in a fine and confident way").[98] These are the virtues to be exercised against enemies, the "military" virtues: to humble the proud, not to lose heart in defeat, to pardon those who submit. On the other side there are the virtues "of the civil power," which make possible government in peace and wisdom, but always with just firmness. "Pax est concordantium in bono animorum ordinata tranquillitas"[99]: the famous figure, dressed in white (figure 88) with an olive branch in her hand, has as her pedestal a heap of weapons. Semireclining, distinguished from the others in manner and attitude, she is perhaps meant to suggest through her condition of quiet passivity that she is the final product of a wholly benign political situation. "Per iusticiam conservatur pax civitatis" states Aquinas,[100] promoting peace to the rank of a virtue.

In this fresco, if Justice knows how to reward, she also knows how to punish very severely, as is shown by the angel leaning forward to cut off the head of a criminal on one pan of the scales, and the severed

[97] Katzenellenbogen, *Allegories of the Virtues and Vices in Medieval Art*, p. 16 and fig. 15.

[98] Pseudo-Hugh of St. Victor, *De fructibus carnis et spiritus* (PL, CLXXVI, 1003). Matteo Frescobaldi (in *Rimatori del '300*, ed. G. Corsi [Turin, 1969], pp. 96–97) understands it as the virtue of a warrior: "Fortezza, che l'uom fa sicuro e franco | Siche non smaga ne l'aversitate | E nel periglio non si trova manco | Perchè s'accosta a magnanimitate, | Signor, or l'abbracciate." ("Strength, which makes man assured and forthright, so that he does not lose spirit in adversity, nor show himself lacking in the courage to face danger, embrace that strength, the twin of magnanimity, O Lord.")

[99] Pseudo-Hugh of St. Victor, *De fructibus carnis et spiritus* (PL, CLXXVI, 1004). The figure of Peace, crowned with olive and with an olive branch in her hand, recalls the description of the same virtue given by Alanus of Lille, in the *Anticlaudianus* (PL, CCX, 502): "Virginis in dextra foliorum crine comatus, | flore tumens, fructus expectans, ramus olivae | pubescit. . . ."

[100] *In libros Politicorum Aristotelis expositio* 271 (cited in Rubinstein, "Political Ideas in Sienese Art," p. 187). "Concordes sunt enim pax et iusticia. Et ideo sicut in iusticia, ita regnum eius quievit in pace": these are the words of Bonifacio VIII in a speech in praise of St. Louis; see A. Vauchez, *La sainteté en Occident*, p. 416, n. 379.

head and unsheathed sword that are the attributes of the "second" Justice. For this reason, *Fortitudo* with arms is properly seated beside *Pax*, her cudgel and shield signifying the same watchful firmness that the soldiers on horse and foot (but with long staffs) clustered about her feet are certainly ready to show. Likewise a tight phalanx of armed soldiers keeps watch on a group of prisoners under *Iustitia* and her companions, to the right of the Bene Comune. Peace (I reemphasize) reposes on a heap of weapons, and her bench is formed of weapons as well.

It is a military peace, therefore, achieved through the defeat and overthrow of the enemy, often through his physical destruction as well. The attitude of this virtue, softly semireclining, is an enticement to a stable political situation, without conflicting demands or painful disturbances. To this end the concord of all the inhabitants will be necessary. "Peace, in the words of the saints and philosophers, signifies repose, a state in which there is no change,"[101] preaches Giordano da Pisa. But the context, bristling with arms, into which Lorenzetti has inserted Peace and the attributes with which he has endowed her (in addition to the olive branch, weapons, and more weapons) underline the fact that she is the result of military superiority. The closest ally of Peace is *Fortitudo*; she is based not on a treaty with the enemy, but on the enemy's defeat: peace means the same thing as victory. In fact, the twig (which we tend to think of in the beak of the dove at the end of the Flood) appears in the medieval chroniclers as a symbol not of a truce or a treaty between two parties, but of an imposed settlement following a defeat. Giovanni Villani says that the Florentines, in memory of their victory over the Sienese in 1260, erected a tower on a hillock which was visible from the city of Siena, "and to spite the Sienese planted an olive tree on it, which was still there down to our day, in memory of their victory and the territory they had gained."[102]

Cola di Rienzo, when he had succeeded in overcoming the forces of the Colonna, "became immensely proud and pompous. And he sent letters and messengers with olive branches to our commune [Florence] signifying his great victory, and to the communes of Perugia and Siena, and other nearby communes that had trust in him."[103] Examples of this could be multiplied.[104]

In the iconography of the Tuscan saints, the olive tree, rather than a

[101] Giordano da Pisa, *Prediche*, ed. Narducci, p. 248.

[102] G. Villani, *Croniche* VI 75 (p. 101).

[103] Ibid., XII 105 (p. 501). [Translator's note: This chapter is included in G. Villani, *Cronica*, ed. G. Aquilecchia, p. 281.]

[104] Anon., *Cronaca senese* (RIS, XV, 6, 57 and 117); Anonymus Ticinensis [Opicino de Canistris], *Liber de laudibus civitatis Ticinensis*, p. 25.

genuine attribute characterizing one of their specific qualities, is secondary, merited because it is linked to a victorious event. San Barnaba,[105] in Florentine paintings, always has an olive branch in his hand: he is one of the protectors of Florence because of the victory of the Florentines over the Sienese at Colle Val d'Elsa in 1269, and over the Aretines in 1289, both of which occurred on 11 June, his feast day. San Vittore I (the pope)[106] likewise has an olive branch in his hand (figure 89); on his feast day (28 July) in 1364 the Florentines had an unlooked-for victory over the Pisans, as Filippo Villani recounts.[107] The other san Vittore[108] also has the same attribute and for the same reasons: in 1299, on the day of his feast (15 May), Siena took Sarteano. Finally, san Dionisio[109] holds the olive branch in his hand because on 9 October, his feast day, in 1406 the Florentines vanquished the Pisans.

The figure of Peace created by Lorenzetti, reposing on a menacing layer of weapons, is a Peace that is always alert. The fact that she is placed in profile, and in a very unusual attitude compared with the frontal and composed position of the other virtues, who appear rather mannered, emphasizes her novelty, but even more the degree to which, in this guise, she was close to the problems that were troubling the commune of Siena—local problems. Conversely *Prudentia*, upon whom is written "praeterita, praesentia, futura," recommends wider and deeper knowledge as a basis for judgment.

Immediately under the virtues, on both sides, there are soldiers bearing arms; those who guard the prisoners have large shields decorated with dragons, and sharpened pikes, to indicate the sureness of victory over the enemies of the Bene Comune. Those beneath the figure of *Fortitudo* are without shields, and have staffs: they seem to be there simply to carry out urban police duties, since concord and peace reign inside the city, and there is practically no need to go armed when the dangers are only on the outside.[110]

[105] Kaftal, *TS*, col. 130 and fig. 137: Florence, Museo dell'Accademia, Niccolò Gerini and Iacopo di Cione (1372–1373). Here the saint appears with other Florentine protectors, among them san Vittore I (see the following note), beneath the coronation of the Virgin.

[106] Ibid., col. 1012: another panel with the same attribute, by Bicci di Lorenzo, is in the cathedral of Florence.

[107] F. Villani, *Croniche* XI 99 (in the edition cited in the Bibliography under G. Villani [Trieste: Lloyd austriaco, 1857], vol. II, pp. 410–11).

[108] Copenhagen, Museum, panel by Lippo Memmi: Kaftal, *TS*, 1012, and fig. 1137; Siena, Pinacoteca, panel by Sassetta: Torriti, *La pinacoteca nazionale di Siena*, p. 244, fig. 285.

[109] Kaftal, *TS*, col. 308 (Florence, church of Orbatello, Maestro di San Miniato).

[110] The urban police are called indifferently *birri, fantes, pedites* in the sources; cf. Bowsky, "The Medieval Commune and Internal Violence," p. 10. Once again, the image will certainly correspond to the *appearance* of these police agents, but not to their real

The figure of *Pax* has been taken from Roman coins bearing the effigy of *Securitas*.[111] For this reason the latter personification appears just outside the walls of the city in the "effects of good government," portrayed in her turn according to the classical iconography of victory. In Lorenzetti's reprise of these schemes, we see him striving to connect up with a precise classical content, as it seems to me, not merely expressing his love of things Roman, which Ghiberti had already mentioned.[112] *Securitas* and *Pax* are paired in the state of concord, the Nine warn: "floret securitas et pax et bonum habundantia ceterorum."[113] The image suggests a yet more subtle distinction: in the city, security lies in peace among its inhabitants, there are no enemies. On the distant horizon (since "concordia civium murus urbium")[114] assault might lie in wait (*robbatores, malandrini, predones*[115]) but the streets themselves are victoriously tranquil.

> Amore al ben comune dispone e liga
> onde cessa la briga
> e stanno aperte i cammini e le strade;
> per te, buona amistade, il mondo è pace e 'l ciel felicitade.

Love disposes to, and compels, the common good, so that strife ceases and the roads and the highways are free; through you, good amity, the world is peace and heaven is felicity.

So says Graziolo de' Bambaglioli in a passage from the *Trattato di virtù*.[116] *Securitas* in fact displays a gallows, and a scroll on which yet again the concept of justice "chel alevata arei ogni balia" ("because she has removed all power from the guilty") is repeated. The productive labor underway in city and country highlights the concord and the reciprocal utility that flow to all its inhabitants, but the light, winged figure calls to mind the ever-watchful presence of Justice, who represses with violent and peremptory force those who oppose her operation. In Siena the Capitano della Guerra (the War Captain) had the significant hon-

function, which was not one of simple vigilance, as the fresco suggests, but that of continuous and often violent repression, as we know from the documents.

[111] Rowley, *Ambrogio Lorenzetti*, p. 95 and fig. 141.

[112] *Commentari* III 3, p. 56; Rowley, *Ambrogio Lorenzetti*, pp. 94–97, identifies all the figures that Lorenzetti has copied from ancient art.

[113] *Consiglio generale*, t. CLII, f. 10 (Siena, Archivio di Stato, *Consiglio generale, Deliberazioni*, tt. XXXIII–CLVIII [1287–1355], cited by L. Carbone, *Note sulla ideologia e la prassi politica*.

[114] H. Walther, *Proverbia sententiaeque Latinitatis Medii Aevi* (Göttingen, 1963), s. v. "Concordia," p. 355, 41b.

[115] *Consiglio generale*, t. XCIV, f. 79r–v (see n. 113): "providendum, quomodo mercatores et vecturales et alii bone conditionis et vitae possint per dictum iter et stratam predictam eundo et redeundo esse *securi* in avere et persona."

[116] De' Bambaglioli, *Trattato di virtù*, p. 12.

orific of "Salus, Securitas ed Defensio dominorum novem" ("Salvation, security and defense of the Lords of the Nine").[117] It is the justice of the Nine that is the only guarantee of prosperity and peace!

In the Mal Governo the two most important personages, according to their proportions, are Tyranny and Justice, the latter a prisoner at the feet of the former. The figures are disposed following a plan identical to the one adopted for the Bene Comune and his court, to emphasize even more the contrast, and the threat from a real danger. But the contraposition is not that of an exact mirror image. *Fraus*, for example, is not the counterpart of *Veritas*, as she is in the relief (semidestroyed after the last war) of Wiligelmo on the cathedral of Modena. The two poles of Lorenzetti's discourse answer to different demands: that of envisaging an idyllic, stylized reality in the allegory of the Buon Governo; and in the Mal Governo, that of indicating with extreme concreteness the exact dangers that the social and political situation of the time held for the stability of the government of the Nine, a government naturally presented as the best one possible. An identical scheme has been adopted to reinforce the propaganda message, but this artifice conceals a very different content. The Bene Comune, solemnly mantled, shows himself triumphantly wearing the insignia of Siena, an image answered in the Mal Governo by a figure that the discords tearing apart the city have clothed in black and white—not Tyranny, however, but rather the smaller one of *Divisio*. In the Buon Governo, these colors cloak a symbolic figure, a pure allegory, but in the Mal Governo a concrete reality, which in its *sì* and its *no*, and with its saw, appeals to the language and the common experience of the spectators (one thinks of Dante and the fullness and emotion of his geographical designation of Italy as the "bel paese là dove 'l sì suona").[118] Moreover in this part of the fresco there is a studied convergence of menacing looks in the direction of the Buon Governo, and the insistent presence of drawn blades; the figures of Autumn and Winter, seasons that are here presented as sterile and desolate, and also Mars with his drawn sword,[119] are turned against the allegory of the Buon Governo. *Furor* brandishes menacingly a dagger, *Guerra*[120] *Tyrannide, Superbia*, and *Timor*, the sword.

Everywhere in the city and in the country we see soldiers intent on

[117] *Costituto* of the commune of Siena, f. 583r–v.

[118] *Inf.* XXXIII 80. In the *De vulgari eloquentia* I, 8.5, Dante says: "Nam alii oc, alii oïl, alii sì, affirmando locuntur; ut puta Yspani, Franci, et Latini" (and immediately after he cites Guido Guinizelli).

[119] Contrary to Saturn and Jupiter, who are shown full face. It is worth noting that Mars is placed very close to where the allegory of the Buon Governo begins.

[120] Who has before him an eloquent symbol, a coffin.

bringing death. *Timor* (figure 77) is a horrid old woman, dressed in rags and with claws on her hands and feet; she is similar to the figure of Death in the Camposanto of Pisa,[121] except that a sword takes the place of the scythe. The words on the scroll she displays contain a precise reference to her annihilating action:

> per volere elbenproprio in questa terra
> sommesse la giustitia a tyrannia
> unde per questa via
> non passa alcun sença dubbio di morte.[122]

For wanting his own good on this earth, he subjected justice to tyranny; wherefore along this road passes no one without dread of death.

A coffin (this has already been mentioned) lies at the feet of *Guerra*. This then is the kingdom of the wicked, of those who say: "opprimamus pauperem iustum et non parcamus viduae, nec veterani revereamur canos multi temporis; sit autem fortitudo nostra lex iniustitiae; quod enim infirmum est inutile invenitur. Circumveniamus ergo iustum, quoniam inutilis est nobis et contrarius est operibus nostris."[123] In fact Justice, who is privileged by her inscription and her white and black dress, lies tied on the ground at the feet of the diabolical tyrant, her scales broken. About her we see the effects of her capture: a girl is stabbed by a soldier, another, in the city, is violently seized by two armed men (yet a third is on the ground) (figure 90), men whose motto is "utamur creatura tanquam in iuventute celeriter . . . nemo nostrorum exsors sit luxuriae nostrae."[124] A wretched fellow drags himself along below *Guerra*, showing the stumps of his arms, scenes of violence and killing fill the portion of the fresco beneath the podium of the vices, and also, as noted, the "effects" in city and country: "invidia autem diaboli mors introivit in orbem terrarum."[125] And just as Pride, Avarice, and Vainglory (the three Dantean vices) inspire Tyranny, likewise in the *Liber Sapientiae* they are the properties of the impious, properties that recall their *superbia* and *divitiarum iactantia*, branded by

[121] *Camposanto Monumentale di Pisa, affreschi e sinopie* (Pisa: Opera della Primaziale pisana, 1960), fig. on p. 46; and Frugoni, "Altri luoghi, cercando il paradiso" (1988).

[122] Rowley, *Ambrogio Lorenzetti*, p. 129, for text and translation.

[123] *Liber Sapientiae* 2.10–12.

[124] *Liber Sapientiae* 2.6 and 2.9.

[125] *Liber Sapientiae* 2.24. In the city a man is violently slapped by a soldier, while another takes away his coins, and two others are held prisoner. Soldiers in full battle array are leaving through a gate that is opened just enough to let them pass; the gate of Siena in the "effects" of the Buon Governo is wide open.

the divine judgment: "vani autem sunt omnes homines in quibus non subest scientia Dei."[126]

In the allegory of the Buon Governo, the gazes of *Caritas* and of *Spes* reveal their complete faith in the divine power; *Fides*, embracing the cross, the highest example of the sacrifice of the One for the benefit of all, looks at the Bene Comune, whose great eyes are fixed on the spectator. In the Mal Governo, *Superbia* in spectacular antithesis, turns to the viewer, while *Tyrannide*, raising his eyes, shows that he takes all his guidance from her. *Vanagloria* takes the place of *Spes*, no longer directing her gaze toward God, but lowering it to the image of herself that the mirror sends back to her. Finally *Avaritia* substitutes for *Fides* (the direction of the look is the same), holding tightly in her clawed hands a purse from which overflow packets of money, and a hook to assure further satisfaction of her own desire. Gold, and a hook, are also attributes of Avarice, *idest diabolus*, in the *Hortus Deliciarum*, in which an illumination, supplemented with a number of inscriptions, shows her at the center of a wagon drawn by a fox and a lion (*Fraus* and *Crudelitas*).[127] A scroll comments on her attributes: "male vivit sordido cultu avaritia et tenet in manu tridentem propter rapacitatem" ("avarice lives badly, in a wretched condition, and holds in her hand a fork, to show her rapacity"). Six other monsters, human beings with animal heads, each equipped with a pennant, illustrate her effects: "de avaritia nascitur proditio, fraus, fallacia, periuria, inquietudo, violentiae, et obdurationes cordis contra misericordiam,"[128] but while the vulture, the pig, the dog, and the ox are glosses on the baleful fascination of gold, the wolf and the bear, symbols of violence and rapacity, bring to mind the way in which *Avaritia* goes about satisfying her hungers.

"Sença guerre" ("without wars") is how the saintly virtue of Justice conducts herself, "and every civil effect follows": this is the claim of the Nine. The wars, death, and destruction brought by armed bands (images from the whole panorama of the Mal Governo) are indeed an anguish present in the life of the city. The three vices standing over the tyrant, as well as those beside him on the podium, can also be seen as the fruits of an *arbor vitiorum* that has its roots in the use of weapons. Albertus Magnus in fact recalls the three dangers of a soldier's life: "the killing of innocents," "the attraction of greater gains," "the vain ostentation of force."[129] In contrast to one of the prerequisites of the Buon Governo, the stability of power that ensures its continuity, *Guerra* and *Divisio* express the precariousness of a political situation that brings

[126] *Liber Sapientiae* 5.8, 13.1.
[127] Cames, *Allégories*, p. 63 and pl. 36.
[128] Ibid., pp. 63–64.
[129] Le Goff, *Tempo della Chiesa e tempo del mercante*, p. 58.

only rending torment and ruin. *Furor* personifies the uncontrolled sur-
render to external stimuli. *Proditio* (who holds in her lap a lamb with
the tail of a scorpion) and *Fraus* (with gloved hands that appear to be
holding a pastoral) allude to those who cloak themselves to act, adopt-
ing attributes that are not theirs: daughters of avarice, of the immod-
erate *amor habendi*, according to Thomas Aquinas,[130] vices that account
for the will to make one's own good prevail, and that are therefore
extremely grave on the moral and civil plane. *Crudelitas,* finally, alludes
to a despotic manner of administering justice, following an entirely
individual and private criterion, whereas Justice (the virtue), even if
she punishes, does so on the basis of the laws, and therefore of the
society that formulated them. Perhaps it is not mere chance that
among the personages on the lower frieze of this part of the fresco,
rendering tyranny more vivid by making it visual, there is the cruel
Nero.

Like the virtues in the allegory of the Buon Governo, the vices too
are divided into two analogous groups, those on the left alluding to
ethical attitudes, those on the right emphasizing primarily practical be-
havior. Dagger, stones, saw, and sword are distortions of the sword
and the severed head of *Iustitia*. In the city, destruction of things and
of persons reigns. The houses are wrecked and burned, the streets are
filled with rubble, the inhabitants persecuted and killed. Like the
wicked in the *Liber Sapientiae*, the soldiery cares nothing for the divine
warning. Nobody except for an artisan intent on forging weapons is
at work: solitude and the disordered wandering of the soldiers have
taken the place of the concord, unity, and industry of the good city of
Siena: "sapientiam enim et disciplinam qui abicit infelix est; et vacua
est spes illorum, et labores sine fructu et inutilia opera eorum."[131] In
the vast landscape of hills, men are busying themselves only to bring
death, or the destruction of churches, villages, and isolated houses,
without working the land, which appears desolate and sterile, punc-
tuated only by scattered brush. "Confringentur enim rami inconsum-
mati, et fructus illorum inutiles et acerbi ad manducandum et ad
nihilum apti."[132] The dark colors communicate a sense of squalor and
sadness. The spectacle of the devastation of the war is timeless; how
consonant it is with the description of Florence given by Remigio de'
Girolami, for example: "platee sunt explatiate, idest evacuate, domus
exdomificate . . . poderia videntur expoderata, quia arbores evulse,

[130] Thomas Aquinas, *Summa theologica* 2, 2 q. 55.80 and q. 118.1.8.0: "Avaritia est
vitium capitale, cuius filiae sunt septem, scilicet proditio, fraus, fallacia. . . ."
[131] *Liber Sapientiae* 3.11.
[132] *Liber Sapientiae* 4.5.

vinee precise, palatia destructa, et non est iam podere, idest posse, ut in eis habitetur vel eatur ad ea, nisi cum timore et tremore."[133]

ON the contrary the city of Siena shows itself joyous and full of light, bathed in the brightness of Justice and divine Wisdom. Much space is given to the architecture of the city, in a tightly packed and highly colored inventory of all its most beautiful buildings: palaces and towers adorned with pictures, vases of flowers, amphorae; huge galleries and series of mullioned windows sustained by little carved columns. The very number of windows shown, and of simple open vaults providing access to buildings, gives a feeling of expanded and airy space. On the roofs the builders are at work, demonstrating the incessant construction activity that continues to improve the face of the city.[134]

What cannot fail to strike us in such an accurate and ardent representation of the exterior, architectural aspect of the city is the undeniably marginal position given to the cathedral, which is allotted nothing more than a restricted corner on the left. I would ascribe this to the *secular orientation* which was predominant in Lorenzetti while he was in the process of building up the whole fresco, and which sorts perfectly with the characteristics of the wall containing the allegory of the Buon Governo, including some we have already discussed, and others that have still to be addressed. Comparisons with totally different situations are easily possible, to show how charged with significance the "exceptional" choice made by Lorenzetti is: compare the panel of Bartolo di Fredi (in the Museo civico of Montalcino, and already mentioned above), which represents[135] san Giovannino led by the angel in the desert, with a small city in the background, nestled on a cliff and entirely surrounded by walls. The model used by Bartolo was certainly Siena, as we see from the church, looming at the center, which forces all the rest of the city back against the walls, and is clearly marked out by its facing of black and white stripes as the cathedral of Siena. The central position given it here contrasts to the highest possible degree with the same cathedral as it appears in Lorenzetti.

In the Siena of the latter, a few women, showing their faces from their houses, observe the coming and going in the streets and piazze; under a balcony a swallow has made its nest, a cat is perilously balanced on a handrail, a bird is suspended in a cage in a sunny window:

[133] "The *piazze* are *spiazzate*, that is, emptied, the houses are 'unhoused' . . . country estates seem to be 'dis-estated,' because trees are torn up, the vineyards slashed, the houses destroyed, so that no country estate any longer is a *podere*, that is, it no longer offers the possibility to be lived in or visited, except in fear and trembling." De Matteis "Il *De bono communi* di Remigio de' Girolami," p. 70.

[134] Bowsky, "The Buon Governo of Siena (1287–1355)," p. 368.

[135] See chapter 1, n. 29 and p. 11.

this is the "sweet and placid life" guaranteed by Justice.[136] No material worry harasses the inhabitants. Their labor is serene, almost without fatigue, but there is room as well for pure pleasure: a wedding procession, symbol of concord,[137] and hunting, dancing, and singing.[138] Likewise a chorus of girls and a group of mounted nobles with falcon in hand accompany the image of Justice in Giotto's Scrovegni Chapel at Padua, where the inscription comments: "cuncta gaudet et libertate, ipsa si regnaverit agit cum iucunditate."[139] Here in the city of Siena, immediately after the girl escorted to her wedding (the model is the decorative scheme of so many marriage chests), we see a group of men with two children near them, then a tailor seen from behind while sewing, then in the distance the shop of a goldsmith (where a woman seems in fact to be choosing jewelry), a cloth merchant who consults his account book, noble lords on horseback. On the right in the foreground there is a shoemaker's shop, in front of which a man has halted with his donkey to make a purchase: between the hands of the men at work a baby's head pops up. A teacher is shown with his attentive hearers,[140] and there is a shop for wine and cured meat, toward which a peasant is headed, his animals loaded with wood and a basket of eggs on his arm.[141]

[136] As the board placed beneath the twenty-four citizens who have the task of holding Justice always in their minds affirms: "vogliete gliocchi a rimirar costei | voi che reggiete . . . Guardate quanti ben vengan da lei | e come e dolce vita eriposata | quella della città due servata | questa virtù."

[137] Even if the memory of the goddess Concordia who in Roman marriages presided over the rite had been lost (but how many sarcophagi there were to bring her to mind!), harmony between spouses was still a guarantee of private concord and, by a natural reflex, of public concord (see also n. 136). On this subject, see C. Frugoni, "L'iconografia del matrimonio e della copia nel medioevo," pp. 901, 966. [My hypothesis finds confirmation in a sermon of san Bernardino, with which I was unacquainted in 1983. The preacher, describing Lorenzetti's fresco of the effects of the Buon Governo in the city, says that, among other things, "veggo andare fanciulle a marito" ("maidens I see going to wed"). These are not, however, to be identified, as Starn, "The Republican Regime," p. 20, believes, with the group of nine dancing girls, because for one thing Bernardino had already mentioned the dancing: "veggo le mercanzie andare attorno, veggo balli . . ." ("I see the circulation of merchandise, I see dances . . ."). Cf. Bernardino da Siena, *Le prediche volgari: Predicazione del 1425 in Siena*, ed. C. Cannarozzi (Florence, 1958), vol. II, pp. 266–67.]

[138] On the second, allegorical significance of the scene, see the subsequent discussion in this chapter.

[139] A. Moschetti, *La cappella degli Scrovegni* (Florence, 1904), pp. 115–16.

[140] The interest on the part of the government in having a regular university in Siena, testified to for example in the articles of the statute of 1310 (see A. Lisini, *Il constituto del Comune di Siena*, vol. II, pp. 158 and 185) is not incidental.

[141] Behind the donkey a youth can be seen. In Lorenzetti's time the marked presence of children, often caught in attitudes that denote prolonged and affectionate attention on the part of the painter, was still fairly unusual. Note for example those who avidly suck the milk of the she-wolf, or the one with a tender gesture of helplessness, who is struck down by horrid *Crudelitas*.

A shepherd makes his way out to the countryside with his flock[142] and his dog, while a peasant is entering the city, his mules bearing bundles of wool, which he will certainly bring to the nearby shop where men and women are busy weaving and inspecting cloth. From the countryside two peasant women have also just arrived, the older one with a hen in her arms, the younger with a basket of foodstuffs elegantly balanced on her head. The walls of the city are only an architectonic screen; they do not separate the city from the surrounding countryside, but rather serve to underline the fact that men and animals are continually moving from one to the other. Indeed a pair of noble lords with a companion and a servant are setting out for a hunting expedition, detained for a moment perhaps by a beggar who asks for charity. A peasant prepares to go to the city to sell a piglet,[143] followed by another who leads his asses, loaded with sacks of flour; still other peasants, alone or in family groups, travel the same road in both directions, as they do the other roads of the extended countryside, where men and women are intent on their work.

Such a vast array of human activities taking place in different areas (even the port of Talamone is present) has induced Utha Feldges-Henning[144] to scrutinize this part of the painting, using for her guideline the definition of the mechanical arts as it was given, for example, by Hugh of Saint Victor: "mechanical knowledge is that knowledge, they say, to which the skilful production of any sort of thing contributes," including "the wool trade, armaments, marine transport, agriculture, hunting, medicine, and theatre."[145] Therefore she meticulously incorporates every one of the figures into the scheme she has adopted, and it must be said that her method of adducing parallels between passages from Hugh of Saint Victor, which describe each of the trades, and all the particulars of the painting, is suggestive and sometimes convincing. But there remain a number of scenes, especially those of teaching, that obstinately resist all attempts to pigeonhole

[142] Evidently he has his house and his sheepfold inside the city. The link with the countryside is made visually more direct through this very detail.

[143] Medieval pigs, raised in herds in oak forests, normally resembled wild boars, given that there were frequent crosses between them and their wild cousins. On the extreme right of the fresco is seen the beginning of a wood, perhaps the famous *Selva Lacus*. On the senseless restoration carried out here, see Rowley, *Ambrogio Lorenzetti*, p. 118.

[144] Feldges-Henning, "The Pictorial Program of the Sala della Pace," pp. 151–55.

[145] "Mechanica est scientia ad quam fabricae omnium rerum concurrere dicunt . . . [e.g.] lanificium, armaturam, navigationem, agriculturam, venationem, medicinam, theatricam," Hugh of St. Victor, *Eruditio didascalica*, II 21–28 (in *PL*, CLXXVI, 760ff; the critical edition is by C. H. Buttimer [Washington, D.C., 1939], pp. 38–44). For the history of the mechanical arts in the Middle Ages, I refer to the bibliography given by Feldges-Henning at p. 151, n. 14, and to Frugoni, "Das Schachspiel in der Welt des Jacobus de Cessolis."

them in this way. Further, the range of the mechanical arts is, for the author, so extensive as to embrace human activities in general, and one is led to wonder if there was anything more Ambrogio could have shown, if there was any activity left out by a net cast so wide. The explanation is too inclusive to be of much use. From a methodological point of view I find the thesis of this scholar unacceptable, to the extent that she takes Lorenzetti's representation of the countryside to be a faithful illustration of the mechanical arts—because if that were the case, there ought not to be scenes left over: ones, that is, impossible to comprehend in the scheme she proposes to explain them.[146] In the same way, the various classes that compose society, and which form the other theme of the fresco according to her, cannot be singled out by following the *Liber de moribus hominum et officiis nobilium super ludo scaccorum*[147] of Iacopo de Cessoles (1275). In fact, she is forced to baste together, as though it were all one, the allegory of the Buon Governo and its effects in city and country, mixing symbolic and real figures. They constitute two separate frameworks, each with its own narrative and its own unity, and it is improper to pick out pieces from one and the other in order to build up an image or a situation. For Iacopo de Cessoles the chessboard is the world, on which he observes the various social classes in movement, enumerated like entries in a catalog, and disposed hierarchically from the king down to the rapscallions. But from what point of view has the fresco been painted? From that of the Nine, who use images as vehicles of propaganda. Hence they have themselves portrayed in the guise of the twenty-four citizens only in the allegorical part, the preamble to their ideological statement. In the "effects," where they wish to show the results of their policy, no banker or rich merchant appears. There we find only the class of artisans, small traders, peasants, the poor—"subjects," that is, who are able to work under the protection of the regime.

[146] Though she deploys a platoon of hypotheses, the author has to withdraw all of them when it comes to explaining the cortege of nobles and the teaching scene (Feldges-Henning, "The Pictorial Program of the Sala della Pace," pp. 153–55). Again, it is forcing the evidence to understand the woman at the window with a vase of flowers as the representation of vegetable and flower gardening (Feldges-Henning, p. 152; it is the conditions of modern, not medieval, life, that have led her to think of a balcony as a place for gardening). It seems to me difficult to maintain that *Armatura* is represented by the goldsmith, in the absence of the most characteristic practitioner of the armorer's art, the ironsmith. *Navigatio* as defined both in its images and in the words "continet omnem in emendis, vendendis, mutandis, domesticis sive pereginis mercibus negotiationem. . . . Huius studium gentes conciliat, bella sedat, pacem firmat, et privata bona ad communem usum omnium immutat," seems to be less a definition of one of the mechanical arts than an inclusive portrait of the entire city.

[147] Feldges-Henning, "The Pictorial Program of the Sala della Pace," p. 156. Cf. also M. Mehl, "L' 'exemplum' chez Jacques de Cessoles," *Le Moyen Age* 84 (1978): 227–46; and see n. 145 above.

The nobles, excluded as we know from the supreme magistracy,[148] were tied into the professional activities of the Nine by their wealth, but were often dangerous aspirants to replace them in the government of the city. They do appear, but not in the allegory of the Buon Governo, only in the "effects." Clearly set apart from the lowly and busy crowd, they are intent on pastimes of pure enjoyment, on going to feasts, on hunting, on riding. Their dislocation to the extreme edges of the city, from which they are always on the point of exiting, as though wishing to leave the scene occupied only by those directly subjected to the regime of the Nine, is intentional, I think, on the part of the painter. They are present in the social pyramid, but their marginal position in the fresco, distancing them on one hand from the *popolo minuto*, suggests on the other their diminished participation in the government of the city. In exalting manual work, the artisan and practical activities codified as "mechanical arts" which form a counterpart to the liberal arts of tradition, the fresco is not in the least an isolated example. Giotto's campanile at Florence and the Fontana Maggiore at Perugia,[149] each with a different program, reveal an analogous conception of the knowledge (practical and theoretical) that is born from the new social reality: the city, where all the professions are reciprocally "useful and necessary."[150]

A statute of the city of Siena prohibited dancing in the streets,[151] and the existence of this prohibition leads us to realize that the dance of the girls depicted by the artist is not meant to be a real episode, but rather a symbolic figure,[152] in fact a declared allegory, with the purpose of emphasizing the significance of the image that is presented of city life. I believe that the dancing maidens are there to symbolize the concord of the inhabitants, each content with the place he occupies in society. In the fable of John of Salisbury, the republic will be totally safe only if (comparing the various classes to the parts of the body) "the superior members care for the inferior ones, and the inferior members fulfill the same mutual obligation toward the superior ones."[153] Dante has divine

[148] Bowsky, "The Buon Governo of Siena (1287–1355)," pp. 370ff.; G. Martini, "Siena da Montaperti alla caduta dei Nove (1260–1355)," *Bullettino senese di storia patria* 68 (1961): 75–128; see p. 17. A list of the families excluded from the supreme magistracy is given in L. Sbaragli, "I mercanti di mezzana gente al potere di Siena," *Bullettino senese di storia patria* n. s. 8 (1937): 59. A faithful report of the continual conspiracies of the nobles is in Agnolo di Tura, *Cronaca senese* (*RIS*, xv, 6, 307).

[149] See further below and n. 187.

[150] Giordano da Pisa, *Prediche*, ed. Moreni, vol. II, p. 90.

[151] Feldges-Henning, "The Pictorial Program of the Sala della Pace," p. 154.

[152] A further sign is their disproportionate size with respect to the other citizens.

[153] ". . . superiora membra se impendant inferioribus et inferiora superioribus pari iure respondeant." John of Salisbury, *Polycraticus*, VI 20 (*PL*, CXCIX, 618).

Justice assign different rewards to souls according to their merits, without this damping in any way their harmony and concord:

> ma nel commensurar di nostri gaggi
> col merto è parte di nostra letizia,
> perchè non li vedem minor ne maggi.

> Quindi addolcisce la viva giustizia
> in noi l'affetto sì, che non si puote
> torcer già mai ad alcuna nequizia.

> Diverse *voci* fanno dolci *note*;
> così diversi scanni in nostra vita
> renden dolce armonia fra queste rote.[154]

The same concept is taken up again by Dante in an image that has a close analogy with the dance of the maidens: "concordant divinities" sing and dance "whirling" in "double dance."[155] In Ambrogio the musical concord of the dance recalls the musical terms of the inscriptions. His exaltation of working in concord is not however for the city alone but for the countryside as well, profoundly linked to the urban center by topographical contiguity and by the throngs of persons of all social classes who enter and leave the city. The proximity of the poor blind man to the nobles on horseback has already been mentioned; in a sermon of Caesarius of Arles,[156] the elm that bears no fruit but that joyously blankets its limbs with the grape clusters of the vine, which without its aid would rot, is the rich man: only by extending the branches of charity toward the needy (the vine) will he not be deprived of the fruits of eternal life. This complementarity of riches with poverty means that hollow eye-sockets are not out of place in an optimistic vision of reality: the poor are one of the social classes that compose the pyramid, whose order is immutable (figure 81).[157]

Giordano da Pisa for example insists in various places on the necessity of the existence of both the poor man and the rich one, and of not changing one's state: "whence it is that every man must remain in the state in which God places him, nor should he leave it;" and if "through

[154] *Par.* VI 118–26.

[155] *Par.* XIII 20–31.

[156] A. M. Abel, "La pauvreté dans la pensée et la pastorale de saint Césaire d'Arles," in *Études sur l'histoire de la pauvreté (Moyen Age—XVIe siècle)*, ed. M. Mollat (Paris: Publications de la Sorbonne, 1974), vol. I, pp. 111–25.

[157] A. Vauchez, "Charité et pauvreté chez sainte Elizabeth de Thuringe, d'après les actes des procès de canonisation," in *Études sur l'histoire de la pauvreté*, vol. I, pp. 163–73, bringing to light the really extraordinary awareness of social injustice that the queen had for her time (thirteenth century), even if it was a consciousness that remained on a theoretical level only.

his pride and his virtue he wants to break ranks, all confusions are the result."[158] "Why does God create such diversity in the world, the rich, the poor, the strong, the weak? Yet he cares for all. For if each was king, who would bake bread or work the soil?"[159] Then, with a fine metaphor in which the poor, the paupers, and the afflicted are the fuel, and pity and charity the fire, he explains his thought fully: the fire grows in proportion to the wood that is put on to burn "so that good increases through the evil and trouble of the world, which provide the wood for the fire. See then how necessary are the poor and the afflicted. If God had not created such great evils, all these goods, which are so many and so great, would not be. If there were not the poor, there would be none to practice charity or mercy or the virtue of pity."[160]

This is why the hard labor of the peasants is shown, with no sense of incongruity, in proximity to the nobles heedlessly bursting out to hunt with a pack of dogs in a field of stubble,[161] or a group of men armed with crossbows spreading out through the vineyard in the foreground, where every plant is meticulously tied to its support, one beside the other in compact rows. Here Lorenzetti takes the pains almost of an illuminator in representing every detail of the happy situation of the countryside.

An effort has been made to count the number of the persons and animals present: the totals are fifty-six and fifty-nine respectively (including five mules, five donkeys, six horses, nine dogs, two falcons, four oxen, a pig, and additional sheep, chickens, game, and magpies).[162] It is clear that the agricultural products of spring and summer (represented in the upper frieze) have been combined into a single harvest, as though the two seasons were one. The unreality of this representation has been noted[163] and Feldges-Henning has rightly observed that in order to maintain the "positive" slant given to work in the fields, the produce of autumn and winter is not shown in the Mal Governo.[164] Yet the painter, feeling that this gap had somehow to be

[158] Giordano da Pisa, *Prediche*, ed. Narducci, pp. 51–52.

[159] Ibid., p. 53.

[160] Giordano da Pisa, *Prediche*, ed. Manni, p. 146.

[161] We observe a provisional barrier of dried branches to protect the grain that the harvesters are sifting. But here all protection has been removed.

[162] C. M. de la Roncière, P. Contamine, and R. Delort, *L'Europe au Moyen Age, Documents expliqués*, vol. III: *Fin XIIIᵉ siècle–fin XVᵉ siècle* (Paris: Colin, 1971), p. 142. (I observe, however, that in the entire fresco not a single wheel is present, an eloquent absence that in itself indicates the scarcity of resources in the Middle Ages.)

[163] Pächt, "Early Italian Nature Studies and the Early Calendar Landscape," p. 41, having observed that some agricultural activities belong to different seasons, defined the fresco as a species of "precursor of the calendar pictures of the Limbourg brothers."

[164] Feldges-Henning, "The Pictorial Program of the Sala della Pace," p. 150.

filled, makes a reference to it nevertheless, for the peasant who brings his pig to the city, the one who has already arrived with a supply of wood, the wine and the cured meats in the shop, the vineyard and the healthy olive bush standing out against the bright pink of the walls,[165] the ploughing and the seeding (though this could also take place in springtime), all allude to the traditional canon of the months from August to December: the preparation of the casks, the vintage, the ploughing and seeding, the fattening and slaughter of the pig, the laying-in of wood for the winter.

As is natural, we see a group of harvesters (there is a woman among them) in a sunny field, and also, in the foreground, another group of peasants who are threshing grain in cadenced rhythm using flails. One of their companions arrives with his donkey, and farther off we see a man guiding a little caravan of animals, with full sacks slung sideways over their packsaddles, as they prepare to cross a stream leading to a mill. The cultivation of the fields is shown in all its phases: there is the peasant who guides the plough behind his oxen, the sower, and the helper with a hoe who covers the furrows with light strokes, while a few birds (a beautiful pheasant is visible) attempt to steal the seeds that have just been deposited. The great sweep of tawny fields is also meant as a reassuring response to the riots that broke out so frequently in the first half of the fourteenth century because of the shortage of food.[166]

A multitude of other figures, drawn with a few swift strokes of the brush, also animates the landscape: beside the house of the threshers of grain we see a passing peasant, holding two flapping chickens, and behind him a donkey burdened with a swaying wicker basket which is also full of chickens. A little farther on a shepherd keeps watch over his flock, while close by on a hillside a family rests beside its herd, in the shadow of a beautiful tree. Above the train of pack-animals heading for the mill, a peasant is seen with his mule, going out through the gate of the nearby village, while in the adjacent wood two stags face each other. In the canebrake near the port of Talamone horses graze, and a herd of deer races past. And again, along the roads that fade into the horizon, there are riders, foot travelers, animals; on the bare hillside thicketed with cane bushes, a hare flees, chased by hounds. The canebrake lies near the grain field, and this is not incidental, given the

[165] The harvesting of olives is not a part of the medieval canon of the labors of the months, because of the limited alimentary use of the oil; but it is widely attested for antiquity. Cf. A. Pelletier, "Viticulture et oléiculture en pays allobroge dans l'Antiquité: A propos du calendrier rustique de Saint Roman en Gal," *Cahiers d'histoire de Mon-Grenoble* 20, no. 1 (1975): 21–26. In the Sienese countryside the olive tree was in fact widespread and so it has a strong presence in the fresco where it alludes to the winter work of the peasants.

[166] Bowsky, "The Medieval Commune and Internal Violence," p. 5.

importance that these plants had in the economy of the time.[167] On the hills the vine plantations[168] extend in regular rows, enclosed by quick-set hedges and trees. There are orderly gardens beside the houses, also enclosed by quickset hedges, and fruit trees here and there, occasion-ally clustered into pleasant groves.[169] Everywhere among the hills, and on the plain, run brooks and streams, opening out sometimes into small lakes, and with the darker blur of the sea in the distance. This insistence on the abundance of water is also part of the propagandistic intent of the fresco, since we know how difficult the search for new sources of water supply for the city of Siena was.[170] Real elements taken from geographical areas that may in fact be far distant from each other have been bound into a sort of bouquet to describe an imaginary landscape which nevertheless, in its mosaic juxtaposition of concrete particulars, is recognizably that of Siena.

Equally pointed is the depiction of the roads that divide the hills and fields into a sinuous checkerboard. These roads are commodious, just as the magistracy in charge of road transport "in civitate et extra civi-tatem Senarum per totum comitatum" had always prescribed that they should be.[171] The road that leads to the city is even paved with stones and sustained by an unmortared stone wall. A handsome bridge in the foreground, with three arches made of bricks (not poor and temporary wooden structures) permits passage to an imposing convoy, and other bridges of the same type are seen in the distance. The donkeys are loaded with bales of wool, similar to those we see arriving at the weav-er's shop: on the swollen sacks, there is an identical trademark, which must belong to the merchant, dressed in lordly fashion, who leads the party. The construction and maintenance of bridges was another of the duties of the magistracy for transport. On the extreme right appears the edge of a wood; this part of the painting has been badly restored, and must originally have been intended as the *Selva lacus*, a large forest

[167] The canes were used as supports for the vines, for trellises, barriers, and the walls of sheds. The canebrake, as an economic asset, is often listed in the "Table of posses-sions" (compiled at Siena between 1317–1318): see G. Cherubini, *Signori, contadini, borghesi: Ricerche sulla società italiana del basso medioevo* (Florence: La Nuova Italia, 1977), p. 155, n. 269.

[168] Noteworthy is Lorenzetti's insistence, in portraying the cultivation of the vines, on showing the rows at right angles to the slope of the hillside—although that was seldom the case in reality. He represents as actual a technique that was certainly optimal, but which was more often found in treatises on agriculture than in the field (cf. E. Sereni, *Storia del paesaggio agrario italiano* [Bari: Laterza, 1962], p. 99).

[169] These are followed unexpectedly by a few dead trees, but the fresco has been radi-cally restored, and certainly misunderstood by the restorers in this case (even the plaster surface was redone: see n. 143 above).

[170] See n. 6 above.

[171] T. Szabò, "La rete stradale del contado di Siena: Legislazione statutaria e ammi-nistrazione comunale del Duecento," *MEFRM* 87 (1975): 141–86, here at p. 159.

of oaks, important for the economy of the city since it provided wood, and a place to nourish pigs and sheep. Even the supervision of woodland in the city's territory (Ghiberti records the absolute security enjoyed by travelers)[172] was in the care of the transport magistracy.[173] The commune profited doubly from the circulation of goods, directly from tolls and indirectly from the availability of merchandise. Finally, the roads were indispensable for provisioning the city with foodstuffs[174] and supplying the city market. The sources insist particularly on this last point: the population tightly massed in the area bordered by the walls feels the practicability of the roads as essential to its own existence. Among the cogent reasons for repairing roads and bridges, the one very often emphasized is the necessity of making sure that the city is not cut off from persons using animal transport ("homines et personae cum bestis") so that they can easily bring abundance of foodstuffs to Siena by a vital road ("cum salmis comode possint venire Senas cum dicta via utilissima et fructuosa sit . . . et propterea maxima habundantia fiat in civitate Senarum"). Another road has to be usable in winter and at every other season ("tempore yemali et quolibet tempore"), since viability is *valde utilissima* for the purpose of making sure that victuals flow in ("per eandem victualia multa deferant ad civitatem").[175] Pride in the full efficiency of the roads that bring wealth, always in good condition and free of any danger, is underlined by the words and the attribute of *Securitas*: "sença paura ognuom franco camini" ("let every free man travel without fear"). Scoundrels and outlaws fall speedily into the hands of the forces of order.[176] In the Mal Governo, conversely, there are murders, thefts, burnings, and devastation everywhere, and no one is sure of being able to preserve his life, or keep possession of whatever he is carrying. "Per questa via," *Timor* warns, "non passa alcun sença dubbio di morte | che fuor sirobba e dentro dele porte" ("None passes this way except in fear of death, for there is robbery within and without the gates").

In the "effects" of the Buon Governo this network of communication is instrumental in terms of Siena's desire to extend its hegemony over the contado "from the point of view both of administration and that of power," since "the roads constituted the link between the city

[172] The painting, "contains that which pertains to peace, and how merchandise travels in great security, so that merchants are even able to leave it in the woods and come back for it later" (Ghiberti, *Commentari* II 12, p. 38).

[173] Szabò, "La rete stradale del contado di Siena," p. 160.

[174] Ibid., p. 182.

[175] *Statuta viarum* (begun in 1290), f. 26v, cited by Szabò, "La rete stradale del contado di Siena," n. 2, p. 182ff. (with many other examples in the notes on succeeding pages).

[176] See n. 91 above.

and the hinterland subjected to its dominion."[177] Cherubini notes that "the architectural and agricultural pattern of this landscape was by this time dominated by the criteria and the capital of city proprietors."[178] Nobles, merchants, and bankers had considerable estates in the contado, which must have seemed in the eyes of those who beheld them to represent extraordinary economic success, like the great palazzi inside the city. In fact the areas depicted as being most pleasant and fertile are those closest to Siena, "zones of predominantly citizen-owned property farmed by sharecroppers . . . and of the sectioning of isolated habitations into estate units. Castles have given way to open villages and dispersed dwellings."[179] Thus it seems to me that the placement in the fresco of various types of habitation and clusters of dwellings has not come about by chance, given that constructions in an innovating style are shown synchronically alongside those of a traditional style, as Plesner has noted.[180]

In the background there are placed examples of the "more recent" type of castle, comprising a long boundary wall which encloses a solidly constructed central fortress, a castle built exclusively for the defense of a great family of dominating lords. Two of these can be seen just above the port of Talamone, and another, also in the background, beside the scroll of *Securitas*. Together with the strongholds and the towers that dot the undulating profile of the hills as far as the horizon, they are there to signify, I think, a need for defense—a need that is not part of the public responsibility of Siena for its contado. The city already projects over its countryside the secure and unthreatened peace that reigns within its own walls. In the plain, in the middle of fields of grain, there is a group of rural dwellings with a pretty garden and a thatched hut, edifices built in peace, therefore, and intended to be used in peace. Little groups of scattered houses or isolated buildings, even a church with its campanile, rise everywhere on the hills. The great battlemented edifice surrounded by an airy arbor, placed underneath the figure of *Securitas*, is the palazzo of a rich citizen, who must have wanted a second residence on his country property. A long, low wall ends "with a simple carriage gate covered by a roof,"[181] a gate therefore

[177] Szabò, "La rete stradale del contado di Siena," p. 182.

[178] Cherubini, *Signori, contadini, borghesi*, p. 477.

[179] Ibid., p. 155.

[180] J. Plesner, *L'émigration de la campagne à la ville libre de Florence au XIIIᵉ siècle* (Copenhagen: Gyldendal, 1934), pp. 10ff., esp. p. 13.

[181] Cherubini, *Signori, contadini, borghesi*, p. 154. It might also have been one of those wealthy gentlemen of the contado who had urban citizenship, and who were obliged to pass a part of each year inside the walls, but who in fact lived in the countryside. Cf. W. Bowsky, "Cives sylvestres: Sylvan Citizenship and the Sienese Commune (1287–1355)," *Bullettino senese di storia patria* 77 (1965): 64–74.

that opens onto the courtyard lying before the palazzo. The wall thus has no value for defense, it merely sets the limits of the area of the house and protects it from possible disturbance by neighbors. A dense quickset hedge closes the frame, of which the wall and the arbor are two sides, allowing a view of well-cultivated fields. Near the port of Talamone there is an "incastellated" village, surviving from an earlier and less secure age of rural settlement. It contains a defensive tower, but a campanile and the roofs of habitations likewise emerge from it, and through its open gate a peasant with his mule has just passed. A narrow strip of cultivated land with vineyards and trees appears outside its walls, in a display of tranquil confidence in the territorial infrastructure and in the food supply.

The interest that the painter reveals in the nonepisodic illustration of the life of Siena, his rediscovery of the landscape and of nature in its most varied aspects, are extremely novel phenomena. The diffuse and precise revelation of the details of communal life, the interest in the things that matter to men—these are also what make the allegorical discourse of Lorenzetti substantially new. In this part of his composition too the theme is didactic and political, but it is immersed in the natural environment of the observer, with the symbolic aspect restricted to the chorus of girls and to the aerial figure of *Securitas*. For the rest, the realistic attention to nature and to the life of the city and its inhabitants, in the low-keyed language of familiar places, produces a convincing picture, as if it might be an exact reproduction of reality—a reality that probably existed only in the propaganda of the Nine. This perspective accounts for the very large space given over to the countryside and the work of the peasants in the fresco. The gamut of medieval values changes with the rise of the city and a structure of specialized, differentiated manual labor: every trade has to meet the test of social utility.[182] This revaluation includes agricultural labor, the motor of the economic process; and meanwhile the continually growing population of the city brings about an ever-increasing food requirement. A symptom of this is the recurrence in the Statutes of Siena of the specter of food shortage and the efforts of the magistracies to get a sufficient stock of cereals.[183]

Manual work, in particular agricultural work, is no longer purely something to which one is condemned in expiation of Adam's sin.[184] In a fresco (figure 91) of the fourteenth century, in the church of the

[182] Le Goff, *Tempo della Chiesa e tempo del mercante*, pp. 63ff., esp. p. 66.
[183] Szabò, "La rete stradale del contado di Siena," p. 183.
[184] I refer to my article "Chiesa e lavoro agricolo nei testi e nelle immagini dall'età tardo antica all'età romanica," pp. 321–41.

Tau in Pistoia, Adam is seen hoeing, naked.[185] His clothing, symbol of the divine curse, has disappeared. Vincent de Beauvais, significantly, is able to entitle a chapter of his work "On the results of sin and the reparation of man's fall through penitence and the virtues."[186] The program of the Fontana Maggiore of Perugia (figure 94), finished in 1278,[187] expresses the same idea in adapting traditional themes to new purposes, symbolizing the recent urbanistic and economic renewal and bearing witness to the presence of new political forces. To demonstrate this, it will be enough to point out the presence of themes that derive from the policies followed by Perugia: Rome is shown on her throne, the concrete image of the two powers of the Church; Perugia, beside her, is depicted with no less emphasis, being placed on a sumptuous throne as well, the only personification aside from Rome to have a cornucopia in her hand. The figures of Chiusi and Trasimeno are so many witnesses to the political and economic links formed in those years between Perugia and the Umbrian cities.

A long inscription invites the passerby to take pleasure in the fountain,[188] while Ercolano, the patron saint of the city, and Lorenzo, the saint to whom the cathedral was dedicated, are called upon to continue their prayers to God. Chiusi and Trasimeno are commended to the *Urbs Perusina* in a way that makes Perugia the apex of a triangular relationship among the three centers (figure 92), a stylistic effect that demonstrates the lofty conception the city had of itself. The creators of the fountain are then named and praised: Bevignate, Boninsegna, Nicola, and Giovanni Pisano. Perugine industriousness has found its voice: the fountain is the result of the combined efforts of art and hydraulic engineering, and the sequence of the months and of the liberal arts reveals the positive quality of human labor and human knowledge. This positive quality seems to be embodied in the four artificers, memorialized with such eulogy. The name of Giovanni is found again in the lower basin, where it is inscribed on the strongly charged symbol

[185] The fresco is part of a cycle recently recovered through fortunate restoration (cf. Carli, *Gli affreschi del Tau a Pistoia*).

[186] "De sequela peccati et reparatione lapsus per penitentiam et virtutes," *Speculum historiale* II 48 (cited by K. Hoffmann-Curtius, *Das Programm der Fontana Maggiore in Perugia* [Düsseldorf: Rheinland, 1968], p. 25).

[187] On the fountain (1274–1278) in general, cf. Hoffmann-Curtius, *Das Programm der Fontana Maggiore in Perugia* (to which I refer for the relevant previous bibliography; the work in itself is often nothing more than a mosaic of citations that are not at all probative).

[188] The fountain has been rebuilt, once after the earthquake of 1349 and again immediately after the last war (1948–49), but not all of the slabs have been put back in the right place. For the identification of these errors, and relevant proposals for correcting them (in regard to the upper basin only), see J. White, "The Reconstruction of Nicola Pisano's Perugia Fountain," *JWCI* 33 (1970): 70–83. The inscriptions still await adequate publication, as I have found in examining the monument personally.

of the eagle, a symbol that would have recalled to contemporaries the words of the Johannine gospel and the related decorative motif on church pulpits. Likewise, in the upper basin, among a preponderance of sacred personages, the contemporary face of the urban laity comes through in the figures of Matteo da Correggio and of Ermanno da Sassoferrato, podestà and captain of the *popolo* respectively, *nobiles viri* placed beside the *nobilis vir* Euliste, the mythical founder, to make a valid bulwark for the patrons, Lorenzo and Ercolano, both *sancti*, who flank *Augusta Perusia*.

The outset of human history is tragic, and so this is how the program in the lower basin of the fountain commences: with Adam and Eve and their sin, and with the twins Remus and Romulus, the latter a fratricide. Augustine had emphasized long before that the first founder of the earthly city, Cain, was a fratricide: overcome by jealousy, he killed his own brother, a citizen of the heavenly city and a pilgrim on earth. No need for astonishment, then, if much later at the time of the foundation of Rome, the city destined to become the "head" of the earthly city, a similar crime again took place. In the words of Augustine, "Rome was founded when Remus was killed by his brother Romulus, as Roman history attests."[189]

The juxtaposition of the two pairs of brothers, however, is suggested conceptually, not visually represented. And similarly the dangers that menace the proper course of city life and its institutions, dangers represented by those who oppress the innocent on false pretexts ("fictis causis innocentes opprimunt") while promoting the unworthy ("indignos adiuvat"), and who suffer personal harm for it themselves,[190] are indicated only by means of allusions (whose significance is however clear to the spectator) found in the fable of the wolf and the lamb, and the wolf and the crane. These two animal tales will later be repeated in the nearby meeting hall (now known as the Sala dei Notari) (figures 95, 96) of the Palazzo dei Priori, in confirmation of the force of the political counsel that they contain.

In sum, there are two areas of allusion here, the first to crime (but Romulus and Remus are shown in tranquil proximity, before the murder of the second by the first) and the second to the risks of political

[189] Augustine, *De civitate Dei* 15.5 (*CSEL* 40.2, p. 64; trans. Borgogno p. 817).

[190] These two phrases are the moral of the two fables of Phaedrus, the source of the representation: see Phaedrus 1.1, pp. 190–93, and 1.8, pp. 200–201, in *Babrius and Phaedrus*, ed. B. E. Perry, Loeb Classical Library (London: Heinemann; and Cambridge, Mass.: Harvard University Press, 1965). On the fountain are found instead the inscriptions "quando lupus comedit agnum sine causa; quando grus evasit os de gula lupi." According to Hoffmann-Curtius, *Das Programm der Fontana Maggiore in Perugia*, p. 29, there is an allusion here to the merchants who were financial backers of Charles of Anjou.

life (but the vehicle of the message is the two animal fables that are represented). The first, avoiding explicit reference to fratricide, attenuates the negative sign that had been attached to the founders of cities, allowing *Roma, Caput mundi* and Euliste, *nobilis vir* to take their place with their luster unshadowed in the upper basin. The second, referring to the real, contemporary political situation of the city, attenuates any direct accusation of responsibility or guilt, inasmuch as it is not men that are represented, but animals.

There is a third scene that has animals for protagonists, and of which, since it seems to me that a fully satisfactory interpretation has not been given, I wish to propose my own exegesis (figure 93). Beside a lion with a thick mane is seen a man beating a pup; above is the inscription: "si vis ut timeat leo verbera catulum."[191] This sculpture follows that of *Samson fortis* who has subdued the lion, and of Samson and Delilah. There is clearly a formal and visual link in the sequence of panels: in fact the two fables about the wolf follow the representation of the wolf "quae nutrivit Romulum et Remulum." The story of the lion and the pup does not belong to the classical repertoire of fables, but is found in Vincent de Beauvais, where it is described as a method for subduing the lion.[192] It was certainly very well known in any case, so much so that it became a proverb, in the form "corripitur catulus ut leo sit pavidus."[193] This story was not reproduced in the Sala

[191] "If you want the lion to be fearful, beat the *catulus*." The first problem is to establish what significance to give to the word *catulus* (in the inscription and in the visual image)— lion cub or canine pup? G. Nicco Fasola, who had identified (*Nicola Pisano* [Rome, 1941], p. 152) a very pertinent passage (as I think) from Vincent de Beauvais referring to the lion and the dog, later abandoned this comparison (*La Fontana di Perugia* [Rome: Libreria dello Stato, 1951], p. 23), having decided that the sculpture shows a man grappling with a lion cub. But whether it is a dog or a lion cub, there is no fable in the repertoire giving rise to this sculpture. There is a narrative that at first glance might appear to be the source: the protagonists are a man, a lion, and a lion cub, and the cub dies from the blows of the man; but it must be discarded because the story and the moral (a son who does not obey parental commands meets death) do not match the inscription on the fountain, where it is the adult lion who must be admonished and around whom the story revolves. Cf. the fable *De homuntione, leone, et eius filio* in L. Hervieux, *Les fabulistes latins* (Paris: Didot, 1894), vol. II, pp. 297–300 (= n. 706, Perry, *Aesopica*). It is my opinion that in the sculpture at Perugia, a canine pup is indeed portrayed. That the word *catulus* must in this case have this meaning appears to be confirmed by a passage from Giovanni Villani, *Cronica*, x 104 (p. 334), in which he speaks of Can Grande della Scala, whose actions fulfill a prophecy: "Paduae magnatum plorabunt filii necem diram et horrendam datam Catuloque Veronae."

[192] Vincent de Beauvais, *Speculum doctrinale*, 15.89: "Ira leonis capti sedatur arte tali. Verberatur catulus coram eo, creditque illius exemplo se debere timere hominem, quem in canis coercitione videt potentem."

[193] To translate according to the prevalent medieval sense: "the pup is treated harshly so that the lion shall be fearful." Walther, *Proverbia*, part I, p. 420, 66d. (I believe that the proverb was misunderstood because in the Middle Ages *catulus* was generally taken to mean a young dog. The true significance, in my view, is this: "the cub is treated harshly

dei Notari, which sets it apart from the other two (figures 95, 96), whose origin is in Phaedrus, and this makes me think that it was tied to a contingent phase in the life of the city—that it did contain a moral, but one tied to a particular historical moment.

If we consider the coat of arms of the family of the da Correggio, it is possible to make some interesting observations. First, the *correggia* (leather strap, girdle, or belt) appears, an emblem taken from the family name. It makes possible a semantic connection between the *correggia* and *corripere* (to seize, and by extension, to exercise coercive force), the verb that contains the point of the compressed narrative found in the proverb. Furthermore, after 1247 Guido di Gherardo da Correggio, brother of our Matteo, introduced the dog into his coat of arms "in memory of the famous victories" won against Frederick II, whose troops were defeated while the emperor was away hunting.[194] The lion, which on the fountain appears together with the griffin, is the second heraldic emblem of the city; he occupies "a vermilion flag on a white field,"[195] probably to underline the fact that Perugia belonged to the Guelf party. My suggestion is that, as an emperor had already been defeated, so the pontifical authority, or perhaps more simply the powerful men of the city, must fear ("ut timeat leo") the severe government of Matteo da Correggio.

In the upper basin the *Agnus Dei* recalls that in Christ's sacrifice all sin is canceled; in the Church, in its teaching, is the secure way of salvation. A movement from profane values to higher, religious ones is proposed. Yet Ermanno da Sassoferrato and Matteo da Correggio also appear in company with all these saints and biblical personages. The fact that these two are able to take their place close by such illustrious models means that they stand for the positive aspect of communal institutions, for the importance that these are recognized to have.

The joining together of human voices and intentions is also expressed by the *socius* and the *uxor*, the co-worker and helpmate who

so that the lion shall be fearful"; in other words, if you want an obedient lion, beat him from the time he is small.)

[194] P. Litta, *Famiglie celebri italiane* (Milan, Florence, and London: Molini, n.d. [but 1819–1899]), vol. II, p. 315 (which also shows the coat of arms, with the engraving watercolored by hand).

[195] Bonifacio Veronese, *De rebus a Perusinis gestis* and *Diario del Graziani*, in *Archivio storico italiano* 16, no. 1 (1850): 28–29 and 231 respectively. On the significance and value of coats of arms, it is very useful to consult the dense and probing article of E. Dupré Theseider, "Sugli stemmi delle città comunali italiane," originally published in 1966 and reprinted in his *Mondo cittadino e movimenti ereticali nel Medio Evo* (Bologna: Patron, 1978), pp. 103–45. On the present problem, see Hoffmann-Curtius, *Das Programm der Fontana Maggiore in Perugia*, p. 30 and n. 211. A passage of Dante, *Par.* VI 106–8, is relevant and may be adduced: "e non s'abbatta esto Carlo novello | coi *Guelfi* suoi; ma tema delli artigli | ch'a più alto *leon* trasser lo vello" (shortly before Dante had mentioned the Ghibelline eagle).

month after month accompany (on the lower basin) the peasant in his work: the latter is no longer left alone to remember that sin is punished in his hard fatigue. The sense is expressed of a social utility in that fatigue, and so it is shared, in a reflection, it seems to me, of the urban ideology of diversified and mutually useful work. Finally the fountain itself was felt in the Middle Ages as a symbol of social aggregation. In a manuscript of ca. 1380, the miniature[196] illuminating the pentecost shows in the upper half the Madonna and the apostles receiving the tongues of fire, and in the lower half a fountain—in the middle of the water hosts float—on which is written: "communis vita." A crowd of persons of every type and grade comes to it to drink, even a dog (like the wolf on the fountain of Perugia). The "flumen aquae vitae" of the Apocalypse (22.1) is interpreted, from Saint Ambrose on, as the Holy Spirit itself, of which all men partake; the "communis vita" is an allusion to the total community of goods in which the apostles and their followers lived (Acts 2.44–46).[197] Nor is this illumination an isolated example: in an older manuscript (figure 97) the significance of the fountain is expressed in a more ample fashion: "communis vita, qua causa tremuli conveniunt populi."[198] As a place for encounters in reality, for exchanges of opinion, the fountain is a symbol not only of the communion of faith but also of the "communis vita" of the city. For this reason, in the chronicles (I take as an example the Sienese one of 1313–1320) the fountains are so often praised together with the piazze.

THE complex iconographic program of the campanile of Santa Maria del Fiore, the cathedral of Florence,[199] occupied various artists for a number of decades: especially Giotto and Andrea Pisano for the reliefs of the Creation, of the mechanical arts, and the inventors of the arts (1334–1342), and Alberto Arnoldi and others for the remaining themes (until 1359). The liberal arts, however, except for astronomy, are by Luca della Robbia (1437–1439). The complex can nevertheless be said to be the result of a coherent idea:

> of the human activities, distinguished by scholasticism into the three categories of *Necessitas* (*Artes mechanicae* aimed at dominion over nature and including, by reason of their manual character,

[196] *Lexikon der christlichen Ikonographie*, s. v. "Brunnen": an evangelary of Kuno von Falkenstein, now at the cathedral of Trier, MS 66; and cf. S. Beissel, "Das Evangelienbuch des Kurfürsten Kuno von Falkenstein," *Zeitschrift für Christliche Kunst* 20 (1907): 167–70.

[197] Ibid. The passage from Ambrogio is found in *De Spiritu Sancto* I, 16, 157 and 30, 20, 154 (*PL*, XVI, 740 and 812).

[198] Codex of Egbert, Trier, Stadtbibliothek, cod. 24 (ca. A.D. 980); cf. S. Seeliger, *Der Pfingsten* (Düsseldorf, 1958), fig. 6.

[199] Toesca, *Il Trecento*, p. 320.

the figurative arts), of *Virtus* (arts lying in the practical organiza-
tion of the family, society, the state), and of *Sapientia* (*Artes Li-
berales* directed to theoretical speculation), the mechanical arts and
a few other activities from the domain of practical Virtue are the
ones here represented in the personifications of their mythical in-
ventors, classical and biblical. In the upper orders the program
will be completed with the allegories of the liberal arts of the triv-
ium and quadrivium which, with the higher guidance of the car-
dinal and theological virtues, will make man once again worthy
of redemption. This is alluded to in the large statues of the upper-
most order, portraying those who in classical and biblical antiq-
uity had prophesied it and prepared for it: the Patriarchs, the
Prophets, the Kings of the Old Testament and the Sibyls. The
Christian life, illuminated by Grace, will be signified by the sac-
raments.[200]

It is to be noted that here too the human journey begins with Adam
and Eve, but it is not followed—as at Perugia—by the original sin, but
by its consequence: work, shared equally by the two progenitors, and
point of departure for a gradual reversal of values, in which work be-
comes a means for acquiring merit in the eyes of God. In the kingdom
of Babylon, says Albertus Magnus, "there is no social role or technical
skill that allows man to *earn either his daily bread or any merit in God's
eyes.*"[201] Human creativity comes to have a place beside that of the di-
vinity: the creativity of Noah, inebriated by a precious discovery (the
earth too is not limited to producing only tribulation and the means of
nourishment); or of Gionitus and Tubalcain, inventors of astronomy
and the blacksmith's art, initiators of theoretical and practical specu-
lation; or finally of Daedalus, who in the flight of Icarus illustrated all
the audacity of the human mind. Jabal, the father of tent dwellers and
of shepherds (Gen. 4.20), who is present, I think, as an allusion to the
positive figure of Abel, is set in proximity to the image of the good
cultivator, Noah, who in this way effaces Cain and the refusal of the
work done by Cain.

On the west side of the campanile, the one most visible, near Adam
and Eve and Noah and Jabal (the hypostasis of Cain and Abel), have
been placed Jubal and Tubalcain (figures 98, 99), the artificer in every
sort of work in copper and bronze (Gen. 4.22) and the father of the

[200] Beccherucci and Brunetti, *Il Museo dell'Opera del Duomo a Firenze*, vol. I, p. 234, to
which I refer for the relevant bibliography.

[201] "Nullum officium vel artificium est ibi unde homo possit *panem lucrari vel aliquid
apud Deum mereri.*" Albertus Magnus, *In Apocalypsim B. Joannis Apostoli*, visio 21 (*Opera
omnia*, XXXVIII, p. 764), a passage cited by Feldges-Henning, "The Pictorial Program of
the Sala della Pace," p. 161.

players of lyre and organ (Gen. 4.21), portrayed respectively in a shop and in a well-furnished room in a city. The other urban activities continue on the remaining sides of the campanile, but the spade and the hoe hung in a clearly visible place in the panel of Tubalcain suggest the direct tie that binds the city to its contado, just as the expanse of countryside in Lorenzetti's fresco begins right at the foot of the rosy screen of the walls. For the rest, the bringing together of Jubal and Tubalcain indicates, on a theoretical plane, the disappearance of that rigid separation between mechanical and liberal arts that had been maintained in the tradition. Instead of the killing of Abel, the killing of Cacus is represented; Hercules, whose image was on the seal of the commune of Florence[202] represents virtue in its struggle with evil: "*kakón* in Greek means *evil*" in the words of Fulgentius in his widely read commentary.[203] Hercules, continually tested, is a fitting symbol of the incessant struggle of humanity toward perfection.

Giovanni Boccaccio in the *Genealogia deorum*,[204] speaking of Vulcan, who made possible the imitation of nature with the help of fire, makes the evolution of humanity spring from this gift through the formation of societies, the invention of language, the construction of buildings; in so doing he sketches a different perspective to the biblical one (to which he also alludes), a progress of mankind through time, "an arduous overcoming achieved through 'mechanical' necessity and experience."[205]

Sacchetti in the *Sposizione dei Vangeli,* imagining a sort of theatrical representation, states that four personifications ought to be there to lament their own death on the day of the death of Christ: Art, Nature, Custom, and Scripture. Each of these then summons the personality who best represents itself, to join in the sorrow: "Art summons Daedalus, who is the cavalier of Art, the master of the liberal and the mechanical arts."[206] Daedalus for his part turns to the single liberal arts, inviting them to weep, and then to the mechanical ones, recalling the silk workers, the wool workers, the tailors, the cobblers, the smiths, "et sic de singulis." (It is worth noting that Nature then summons Aristotle, who asks for the lamentation of the planets and the elements; while Custom—that is, morality—calls upon Solomon who turns to the cardinal virtues; and Scripture calls upon Saint Paul, who turns to

[202] G. Villani, *Cronica*, VIII 95 (p. 215).

[203] "*Kakón* enim Graece malum dicimus." Fulgentius, *Mythologiarum libri* II 3–4: cf. C. Frugoni, "L'ideologia del potere imperiale nella 'Cattedra di San Pietro,' " *Bullettino dell'Istituto storico italiano per il medioevo* 89 (1976–1977): 141.

[204] XII 70 (ed. Romano, pp. 624–25).

[205] A. Conti, "L'evoluzione dell'artista," in *Storia dell'arte italiana*, vol. II, *L'artista e il suo pubblico*, p. 121.

[206] Chap. XIII (p. 906ff.).

the theological ones: simplified, it is the program of the campanile it-self.)

In this unexpected promotion, which carries Daedalus the artificer inside the stronghold of the trivium and the quadrivium, we feel pal-pably how strong the pressure of reality was in the city, where the illustrious men by now also include the artists (fully three panels are occupied by painting, sculpture, and architecture), and where the en-trepreneurial drive of the merchant, the ability of the physician and the artisan bring tangible contributions to the well-being of everyday life. The classification of human activities offered by the tradition, which excluded so many, and such diverse, activities from the liberal arts (those worthy of a free man), is starting to crumble. And Sacchetti, in a fanciful etymology of the word *Magister* as meaning "greater than three" ("the divine understanding given by God" is superior, that is, to all knowledge), affirms—albeit with a moment of doubt as to the appropriateness of his comparison of the remote creator of the world to a schoolmaster—"he who lives in this world can learn in three ways: from nature, that is from philosophy, the natural things under heaven; from the mechanical arts, from the smith, wool worker, tailor, master of stonework, and all the others; from experience, as when the herb-alist prepares a medicine with many ingredients from a single word the doctor tells him. In these ways, and in the many others that follow from them, human nature can learn."[207]

Nor is it by chance that the traditional order of the liberal arts is restored, thus creating a few iconographic doublets, only in the part of the decoration executed by Luca della Robbia. In the earlier pro-gram the liberal arts had been audaciously compressed and fused with the mechanical ones; the arts of the trivium (grammar, rhetoric, dia-lectic) appear in the coffer devoted to Legislature, to emphasize that they are to be applied usefully in the city. The personality who repre-sents them (the source here being the *Tresor* of Brunetto Latini,[208] who was not a cleric but a member of the laity) is Phoroneus, inventor of the law and of order, the two cornerstones of city life in the ideology of the wealthy social stratum of the donors. In fact, the costs of the church and the campanile were largely borne by the guild of wool mer-chants, and this is another reason for the strong idealization of the art of weaving. In reality, we know, from the sermons of Giordano da Pisa for example, of the ill treatment suffered by these workers[209] and the very low pay they received. But in this context, where the aim is to

[207] Ibid., (pp. 863–64).

[208] Brunetto Latini, *Trésor* I 21 (cf. Antal, *La pittura fiorentina*, p. 342).

[209] Giordano da Pisa, *Prediche*, ed. Manni, p. 33: "dirty tricks that merchants play, having poor women excommunicated because their spinning isn't good enough."

give an entirely positive image of city life, every conflict and problem is sweetened over, and as work is represented without fatigue, so the faces of the artisans are serene.

Arithmetic, geometry and astronomy are concentrated in the scientist Gionitus (figure 100)—again the source is Brunetto Latini[210]—who with various instruments studies the universe. His concave room is a perfect circle, on whose circumference God appears among a chorus of angels, and from which the zodiacal band descends to his desk like a large celestial scroll, partly covering the globe that is placed there. Man reaches God, therefore, but by means of calculations and human measurements—"a fine and subtle art" is geometry[211]—putting himself at the center of the celestial vault.

Although the mercantile class may be only indirectly represented through the presence of the voyagers at sea (whose anxious expression however accords well with the portrait that Giordano da Pisa gives of the merchants, who "cross the mountains, and are always under stress"),[212] simply because ecclesiastical resistance is still too strong for them to be admitted to an ecclesiastical building, the images of the other arts are bathed in the reality of the city and of daily experience, from the physician examining the urine brought by the relatives of the sick man, to the female worker intent on her job at a large loom under the fixed gaze of her female employer, to the architect who directs the work for the construction of a tower, to the painter (figure 101) busily decorating little tabernacles (thus meeting the demand for a new type of more domestic and individual religiosity that desires the apparatus of devotion right in the home).[213] All of these images came into the world charged with innovation, never having appeared before in analogous cycles in Italy or northern Europe, and possessing the characteristics of an art that has made greater contact than before with the concrete reality of public life.

The cycle of the sacraments, by means of which the Church offers men salvation, is thus an occasion to show the priest "in his close contact with the life of the laity."[214] Beside this cycle are the planets, which influence, by divine permission, the life of men, but which are here represented with daring iconographic innovations, taken right out of the daily life of secular society. For example, Mercury, protector of the

[210] *Trésor* I 21; cf. Beccherucci and Brunetti, *Il Museo dell'Opera del Duomo a Firenze*, vol. I, p. 234.

[211] Giordano da Pisa, *Prediche*, ed. Manni, p. 37.

[212] Cf. chapter 4, n. 65, above.

[213] L. Becherucci, *Andrea Pisano nel campanile di Giotto* (Florence: Sadea Sansoni, 1965), fig. 22 (weaving), fig. 30 (the painter); Antal, *La pittura fiorentina*, fig. 102 (the physician).

[214] Ibid., p. 344.

sciences, is represented in a classroom, and Venus holds in her hand a pair of naked lovers; it is the first time since antiquity that the human body is shown unclothed, without any justificatory religious context.[215]

Antal has highlighted the enormous space given to the mechanical arts and their inventors: there are seventeen panels dedicated to them, "a conscious step toward the secularization of the cycle of salvation, toward the recognition, that is, of a greater importance in the doings and occupations of the life of every day,"[216] reflected also in the accumulation of realistic details—look at the physician's room—that the coffers receive.

In the early Middle Ages, technical regression and the disappearance of specialized trades reduce working life to pure subsistence labor on the land, giving preeminence to the two "otiose" castes of warriors and clerics. The Church justifies the condition of the unfree, the scapegoats of society, with the notion of subjection to sin, as is shown clearly in a famous passage of Adalbero of Laon (from A.D. 1025–1027),[217] which concludes with a detailed portrait of medieval society. But the tripartite scheme of *oratores, bellatores,* and *laboratores* (which appears in the ninth century, flowers in the eleventh, and becomes a commonplace in the twelfth) shows a precise development internally, reflecting the social promotion of the peasant caste. As a result of the increasing division of labor there thus arises in the twelfth century a new awareness of trades and professions, and a new theology of work. The fatigue of work becomes a merit; it will be recalled that the first merchant saint, Omobono, is canonized at the end of the twelfth century. Honorius Augustodunensis states that ignorance is a state of exile for humans, and *sapientia* or wisdom their homeland, at which they arrive by means of *scientia* or knowledge ("scientia enim in rebus physicis").[218] It is a spiritual itinerary that is realized in the progress through the seven liberal arts, to which are added not only physics and economics but mechanics, arts that are all compared to "cities and country estates" ("civitates et villae"). This interaction of city and country seems to me extremely significant, not only in the commixture of trades, which are seen as so many steps along the way of knowing, but also as a spiritual landscape.

[215] Ibid., p. 343.

[216] Ibid., p. 342.

[217] R. Latouche, *Le film de l'histoire médiévale* (Paris: Arthaud, 1959), pp. 107–9, giving in translation a large portion of the poem of Adalbero (with relevant bibliography at p. 383).

[218] Honorius Augustodunensis, *De animae exilio et patria* I (*PL*, CLXXII, 1243ff.); and Le Goff, *Tempo della Chiesa e tempo del mercante*, p. 146.

Even at Citeaux and at Prémontré,[219] manual labor is rehabilitated in the eleventh and twelfth centuries, in contrast to the previous monastic ideal of a purely contemplative life.

The complexity of the social context brings to the mind of Gerhoh of Reichersberg the image of the world as a *magna fabrica* and "quaedam universalis officina"[220] within which every profession is justified as a means to reach salvation. The concept of the common good (*bene comune*), born in reaction to increasingly diversified urban labor, is reflected in the view of society given by John of Salisbury,[221] who compares it to the human body, in which all the different parts, higher and lower, have to correspond harmonically with one another: "ad publicam utilitatem omnia referantur." The agriculturalists are naturally the feet, "for they always tread the earth," but "many types of wool working, and other mechanical arts, can also be included in this class." The peasant, once isolated in the distance of the countryside, and in the disdain felt for his servile condition, advances ever closer, penetrates the urban grid, becomes a factor in the day-to-day organization of the food supply, exchange, and commerce.

The Church itself promotes a new theology of work and it is from the eleventh century on that all those scriptural passages that stress the nobility of work are brought into new relief.[222] Theologians now note that labor had been entrusted to Adam *before* the fall, and that therefore it must have been felicitous: "posuit hominem in Paradiso voluptatis ut *operaretur* et custodiret eum" (Gen. 2.15–16). For that matter, the figures of Jubal and of Tubalcain are there to show that the advance of science and of technique is included in the providential design.

Albertus Magnus in his commentary on the *Politics* of Aristotle[223] emphasizes the dependence of the city on the mechanical arts: agriculture is by now one of these, "because without the mechanical arts it is impossible for man to live as he wishes." In Lorenzetti's fresco all the arts are related to each other in the harmonious pursuit of the common good, and the contado belongs indissolubly to the idea of *civitas*. Work, now a way to salvation and instrument for acquiring merit in

[219] C. Pellistrandi, "La pauvreté dans la règle de Grandmont," in *Études sur l'histoire de la pauvreté*, vol. I, pp. 229–45.

[220] Cited by M. D. Chenu, *Teologia nel Medioevo: La teologia del sec. XII* (Milan: Jaca Book, 1972), p. 271.

[221] John of Salisbury, *Policraticus* VI 20 (*PL*, CXCIX, 618–19). For commentary on this passage, see S. Epperlein, *Der Bauer im Bild des Mittelalter* (Leipzig: Urania, 1975), p. 79. It is cited and translated more fully at n. 239 below.

[222] Le Goff, *Tempo della Chiesa e tempo del mercante*, p. 144.

[223] "quia sine artibus mechanicis impossibile est hominem vivere ad votum . . . ," cited by Feldges-Henning, "The Pictorial Program of the Sala della Pace," p. 157.

God's eyes, can therefore be offered to the attention of the faithful as a Christian practice for attaining one's eternal reward.

Even within the religious life the horizon has changed, beginning with the revolutionary example of Francesco, who desires to live with his companions in poverty, and with the labor of their own hands.[224] And though the innovative consequences of this are attenuated by the Church, yet a number of spiritual movements remain to document the disquiet and the desire for change that were felt. The laity demands an active role in the Church; the first lay saints are found in this period, some taken into the Church (like Omobono), others kept out, like Alberto Brentatore of Crema, Antonio Pellegrino of Padua, or Armanno Punzilovo of Ferrara, all mockingly derided by Salimbene de Adam,[225] saints who offered dangerous competition to the style of life espoused by the friars minor and the preaching friars (the Franciscans and the Dominicans), and who therefore—according to Salimbene— received the support of the traditional clergy. But contingent polemics aside, the veneration for contemporary worker saints denotes a heightened consciousness of self, and an aspiration on the part of the laity to have a place of their own, one not subordinated within the religious structure. Bonvesin de la Riva, who is not conditioned by any factiousness connected with a particular order, is able to praise "the houses of the second order of the Umiliati of both sexes, who reach a total of two hundred; in them there is a high number of persons who conduct a religious life while at the same time working with their own hands."[226] And among the very few persons individually cited he gives a special place to Guglielmo della Pusterla, "the wise man of the laity," and to Uberto della Croce, a good giant.[227] An extraordinary miracle in Villani[228] no longer has the bishop as protagonist but "a poor shoemaker," a man of saintly life who appears *to the bishop* in a dream. And similarly in a divine vision the man elected chief of the Tartars is "a smith of poor condition, whose name was Cangius, who was elevated as emperor on a poor saddle blanket, and when he was made a lord his surname was changed to Cane, meaning emperor in their language. He was a valorous and wise man."[229] Villani recalls too that in 1331 "there died in Florence two good and just men of holy life and conduct and great charity, *even though they were of the laity*. . . . And for each the lord God caused public miracles of healing the sick and withered

[224] On this, see C. Frugoni, *Francesco, un'altra storia* (Genoa: Marietti, 1988).
[225] Salimbene de Adam, *Cronica* 418 c–d to 419 a–c (ed. Scalia, vol. II, pp. 733–35).
[226] Bonvesin de la Riva, *De magnalibus Mediolani*, p. 59
[227] Ibid., 19 and 17 (pp. 151 and 143–46).
[228] G. Villani, *Cronica* VII 46 (p. 131).
[229] Ibid., V 29 (p. 71).

and many other different things, and each was given a solemn funeral, with many waxen images set up in fulfillment of vows."[230] In the biographies of the female mystics, their ties to the city and to everyday life are often mentioned: they work, they spin or weave (for example santa Bona of Pisa), they are married with children, or are widows, they have a whole texture of relationships with the society that surrounds them, to which they address themselves with warnings or prayers, or the results of their visions.[231] It is naturally necessary not to forget the distinction between ideology and reality, for the two do not advance in lockstep: the former offers itself as a propaganda manifesto, free therefore to display as if entirely veracious a new consideration for the human person. Yet as such it is indicative of a tendency and an awareness, without being a direct mirror of the real situation.

The link with reality is maintained by the artists in an amelioration falling short of idealization in the scenes they portray. On the campanile of Santa Maria del Fiore, for example, the architect who directs the work has twice the stature of the simple workmen, in accordance with a clear hierarchy in the value placed on the work done. In the Buon Governo, although it is extraordinarily innovative and audacious to have represented the liberal arts *underneath* the great fresco, like a frieze, in a position physically and conceptually subordinate with respect to the "mechanical" industriousness of the city (which gives us the measure of the tendentiousness of the painting), the peasants still continue to be represented, in comparison to the nobles, as inferior in size and decidedly ugly. The same variation can be found in the textual sources: in a Sienese chronicle of the fourteenth century[232] the anonymous author, who cannot avoid recording the often dramatic popular revolts, registers an idyllic picture whenever he can, in a search, doomed to disappointment, for those factors that will assure the good of the city. Thus for 1317 he notes, after having recorded the beginning of work on the facade of San Giovanni: "and because the city was entirely at peace, many beautiful palaces and multiple dwellings were begun, and completed. This was possible because of the great tranquillity; and the peasants too, because of the peace, attended to their work with much devotion, and the whole population was desirous to accumulate stores and live in peace. It was heaven on earth, and everyone lived in charity and love" (words that might be the basis of the pro-

[230] Ibid., x 178 (p. 358).

[231] C. Frugoni, "Le mistiche, le visioni, e l'iconografia; rapporti ed influssi," in *Temi e problemi nella mistica femminile trecentesca*, Atti del xx convegno del Centro di studi sulla spiritualità medioevale (Todi: Accademia Tudertina, 1983), pp. 139–79; and on Santa Bona: C. Frugoni, "Santa Bona, pellegrina 'per desiderio,' " in *Gli universi del fantastico* (Florence: Vallecchi, 1988), pp. 259–72.

[232] *RIS*, XVI, 6, 112.

gram for the fresco of the effects of the Buon Governo!). In this, as in other Sienese chronicles, the moment at which the construction or the improvement of a building for the community begins (whether it be church or a gate or the tower of the Campo or a piazza or a street) is always felt as a time of peace and concord. But I want to point out how the chroniclers register more often the beginning than the completion of the work, just as the civic truce intended to last for the duration of these building activities (but destined so often to be ruptured) is a "pace di progetto": peace and industriousness "project" a desire for their own realization into a future of hope rather than in the reality of the present—just like the fresco of Lorenzetti, which begins its program by drawing upon a number of particulars taken from reality but stretches toward utopia in completing it. Yet it does so in an ensemble so harmonious and true to life as to be "cited" later in texts and pictures as a valid model.

Thus in the *Lamento di Pisa* of Puccino d'Antonio (written after 1431)[233] it is the emperor Sigismund of Bohemia who, in harshly reproving the city for its divisions and discords, traces for it the outline of *what should have been* its good government (here too the movement is on the plane of *hypothetical* reality), summarizing the fresco of Lorenzetti. I quote a few strophes, adding emphasis to the points of greatest consonance:

> Credimi, credi che fin dalla culla
> volsi *virtù con amore* bene apprendere
> e sempre mai attendere
> con ogni studio e cura *al buongoverno.*
> *Far star della bilancia ritto il perno*
> *punendo i rei, e premïando i buoni*
> *di qual vuol condizioni,*
> e sveglier del giardin ogni mala erba.
> E dove la sentenzia è troppo acerba,
> lì deve mitigar *misericordia,*
> *e con buona concordia,*
> *ciaschedun procurare il ben comune.*
> Debbe ciascun *tirare a una fune*
> *e prima si vorria privar di vita*
> che faccia dipartita
> per pregio o prezzo che al mondo sia.
> *Fede, larghezza, amore e cortesia*
> *con pace, libertà, buona divizia*
> *sbandendo ogni malizia*

[233] Varanini, *Lamenti storici pisani*, p. 33ff. (for the text, pp. 84–85, lines 113–40).

fan glorïosi le città e i regni.
Ma tu sempre hai seguito li sdegni:
partendo in te medesma tua possanza
or l'una or l'altra danza
guidato hai con diletti ne' tuoi danni.
Se' te condotta al segno *de' tiranni*
che fan dell'altrui case un ladroneggio,
c'agiunti, e ruffianeggio,
solevan parimente e' malandrini.

Believe me, believe, that right from the cradle I wanted, with much love, to learn all the virtues; and always to devote myself without cease to good government. That is, what I desired to do was to maintain in perfect equilibrium the pans of the balance, always to judge without partiality, rewarding the good and punishing the wicked, taking no account of their social condition; and I wanted to uproot from the garden every bad weed. When I pass too harsh a sentence, then it is necessary that Misericordia intervene to mitigate it. Every one [of the citizens] should remain in good concord, aiming to cooperate for the common good. Everyone ought to pull on a single rope; I would sooner deprive [any citizen] of his life than see him stop doing so, even if he should be offered honors and money. Cities and kingdoms become glorious if faith, generosity, love, and courtesy exist together with peace, liberty, and good wealth, banishing all malice. You on the other hand [O Pisa] unfortunately have always disdained all this, you yourself have contributed to the division of your own power. You have led now one dance, now another, with great pleasure but with great harm to yourself. You have been brought under the banner of tyrants, who make of the houses of others an object of plunder. And this is what brigands, joining with the tyrants, were accustomed likewise to do, and to pander as well.

In painting, the portion copied is the one that shows the greatest break with a well-established tradition: Lorenzetti's airy landscape, recognizably "Sienese" (no longer conventional and mannered), in which are inscribed the manifold labors of the countryside. Giovanni di Paolo (1400–1482) in the *Flight into Egypt*[234] (figure 102), almost certainly a fragment of a polyptych executed in 1436 for the family Fondi, copies its main features to the letter: the ploughing, the sifting of the grain, the hut of the peasants, the mill, the distant village; even the Holy Family and the two pious women who accompany them, imitate

[234] Torriti, *La pinacoteca nazionale di Siena*, p. 307 and fig. 374.

the two peasants and the family on horseback placed by Lorenzetti on
the road that leads to the city, developing his ideas along fully natural-
istic lines (figures 103, 104). The sunlight is brilliant now, making the
shadows of trees and men black; the birds, which in the "effects" of
the Buon Governo pecked at the seeds of grain in the fields in a rather
static fashion, now wheel impetuously in the sky, which has cleared
into a splendid blue, full of shading.

In a manuscript (of the eleventh to twelfth centuries) of Augustine's
De civitate Dei,[235] two illuminations at the beginning of the codex (fig-
ure 105) are intended to resume and illustrate the whole work. One
represents the heavenly city, the other the earthly city according to its
two potentials: as mirror of the inferno, or mirror of the heavenly Je-
rusalem. In one part of this illumination killings and violence are seen;
in the other the tranquil procedure of ploughing and seeding, just as
in our fresco the Mal Governo is represented by homicides and op-
pression, the Buon Governo by devotion to work in city and country.
In the Mal Governo (I repeat) it is the "uncultivated" land that *alone*
characterizes and summarizes its reign. The revaluation of agricultural
labor is a corollary of city life, which must avail itself of the labor of
all to function: every activity is complementary to the others, just as
every social class is, in a state of perfect concord. In our fresco the
joyous life lived together by the inhabitants of Siena is shown by the
frequent groups of persons who converse in tranquillity while holding
each other by the arm or shoulder—for example, the members of the
wedding train or, right next to them, those beneath the great vault.
The wedding contains an evident allusion to Concord, for the union
in private of the spouses is an example of that perfect union that pub-
licly binds the citizen. It is a representation of private peace, in a fresco
in which the connections between private life and *shared* life are given
so much weight ("per volere elbenproprio in questa terra | sommesse
la giustitia a tyrannia . . ." *Timor* declares menacingly).[236] "Nessuno
alben comune giamay sacorda" repeats the board beneath the Mal Go-
verno. In the countryside as well the individuals proceed in groups
along the main road in the foreground, conversing calmly. There are
parents walking on foot, with their child riding a donkey, a little fam-
ily making a trip.

Naturally the concept of shared activity does not make the explicit

[235] *Mostra storica nazionale della miniatura, Palazzo di Venezia, Roma*, ed. G. Muzzioli
(Florence: Sansoni, 1954), p. 105 and pl. XVIII; H. Swarzenski, *Monuments of Romanesque
Art* (London: Faber and Faber, 1974), p. 53, fig. 201.

[236] "For wanting his own good on this earth, he subjected justice to tyranny," Rowley,
Ambrogio Lorenzetti, p. 129. And the passage immediately following: "no one for the
common good ever joins together."

class distinctions of the period disappear, for the nobles are always shown in activities of pure enjoyment, dressed in a lordly manner, and much taller than the other inhabitants. At the opposite pole (for the artisans occupy an intermediate place) are the small peasants, their expressions frequently obtuse, their clothing humble. They are traditionally the lowest level of the social pyramid (or else, with a different metaphor, the lowest part of the body): "the mass whose labor sustains the Church is a pavement walked upon by feet,"[237] says Honorius Augustodunensis; and again, "you too . . . who cultivate the earth, are the feet of the Church, whose weight you bear in nourishing it."[238] In John of Salisbury the second metaphor is maintained, but the labor of the peasants is inserted in the framework of the mechanical arts, and the State, not the Church, gathers the fruits of it:

> Those who exercise the humbler tasks are, indeed, called "feet." Through their service the other parts of the commonwealth stride over the earth. Essential aspects of peasant life depend on the feet, for they tread the earth whether they are sowing or planting or pasturing or flower gardening. Many types of wool working, and other mechanical arts, can also be included in this class . . . which are useful in every respect to the commonwealth as a whole.[239]

Only with the reciprocal assistance of the various parts of the body, which all have their usefulness in a different manner, can the good of the State be maintained ("ad publicam utilitatem omnia referantur"— the echo of the fable of Menenius Agrippa is evident). The same concepts are picked up in the sermons of the Dominican Giordano da Pisa *ad civitatem*, which in many ways seem like a gloss on our fresco.[240] The comparison of the body and the members is repeated with an interesting addition: every part of the body has to be maintained, for even if the eye is more beautiful and noble than the feet, "which are the vilest and lowest members," it is so only if the body is not mutilated.[241] Further, no part of the body may change places with another:

[237] "pavimentum quod pedibus calcatur est vulgus cuius labore Ecclesia sustentatur," Honorius Augustodunensis, *Gemma animae* I 134 (*PL*, CLXXII, 586).

[238] "vos quoque . . . qui agrum colitis, pedes Ecclesiae estis, qui eam pascendo portatis," Honorius Augustodunensis, *Speculum Ecclesiae* (addressing himself *ad agricolas*) (*PL*, CLXXII, 866).

[239] "Pedes quidem, qui humiliora exercent officia apellantur; quorum obsequio reipublicae membra per terram gradiuntur. In his quidem agricolarum ratio vertitur qui terrae semper adhaerent sive in sationalibus sive in consitivis sive in pascuis sive in floreis agitantur. His etiam aggregantur multae species lanificii, artesque mechanicae . . . quae universitati reipublicae usquequaque proficiunt." John of Salisbury, *Policraticus* VI 20 (*PL*, CXCIX, 618ff.).

[240] Giordano da Pisa, *Prediche*, ed. Moreni, vol. II, pp. 82ff.

[241] Ibid.

"the foot is beautiful indeed in its place; if it were somewhere else, in the breast or the head, it would be loathsome. Or if it were cut from the leg, it would be loathsome. But joined to its members and in its proper place, see how beautiful it is, and how the whole body becomes beautiful, and the eye becomes much more beautiful."[242] The immutable perfection of the social pyramid is reconfirmed.

But "in this diversity there is more beauty than if all were equal."[243] In our fresco, all the components of society, men and women, rich and poor and those in between, are represented in industrious concord. In the ideal city of Giordano da Pisa, they all have affection for each other: the noble is loved "because the fine things that give rise to *pleasure and delight* in the city necessarily are loved."[244] Hence in this "well-ordered" city, the preacher says, in which there are "many trades" and "each corresponds to the others in a completely orderly way," "all are *useful and necessary* trades."[245] "Every civil effect follows, *useful, necessary, and delightful*": an analogous program stands inscribed under the procession of the twenty-four highly placed citizens, where in fact the same words resound. One may even be tempted to see in the last three words an allusion to the different social classes of the city, pleasure being the characteristic of the nobles, utility that of the merchants and artisans, necessity that of the peasants.

Utility for the commune and for the citizens is a term that often recurs in connection with the activity of traders and artisans.[246] The stratum of great merchants, however, reveals a desire to open a gap between such traders and artisans and themselves, through self-definition as "the more useful men in society" ("utiliores homines civitatis").[247] As in the *Animal Farm* of George Orwell, where all are equal, but some are more equal than others, at Siena all merchants are useful, but some are *utiliores*. The ordered and harmonious city is consequently strong,[248] and since even the Holy Scripture approves of a just battle, "if the part that has justice on its side wins, since a good conscience is a great good, what it wins belongs to it. See then how in this way for example the saintly man has the lordship of the world in

[242] Ibid., p. 86.
[243] Ibid., p. 82.
[244] Ibid., p. 77.
[245] Ibid., p. 90.
[246] Martini, "Siena da Montaperti alla caduta dei Nove," p. 17.
[247] "A moderate city that was well ordered, and in concord, would be so strong that it could never be conquered, and would overcome every other people. . . . Why are the saints so strong? Because they are united, and help one another, so that each has the strength of all, and all have the strength of the one. . . . Unity and order and concord make great strength" (Giordano da Pisa, *Prediche*, ed. Moreni, vol. II, pp. 84 and 85).
[248] Ibid., p. 84.

triumph and *profit*."[249] Again, the same inscription on the fresco says "contriunfo allui [to the Bene Comune] sidanno | *censi tributi esignorie diterre*" ("with triumph are given to him taxes, tributes, and lordships of lands").

Nobles, merchants, and peasants, in the political ideology of the Nine, and in the ideal city of Giordano da Pisa, a religious projection of that ideology, can therefore continue to operate under the strong shield of the guidance of the Nine, and know that the fruit of their labor is sanctified. "Do you think that gold is wicked, or silver, or coin, or pleasure? No, they are not wicked, all are good, God made them all, . . . The saintly man gains from having what God gives him, whether it is worldly riches, or bodily splendor, or health, or wisdom, or good sense, or the other things. And so that city will be a city all of saints."[250]

[249] Ibid., p. 93.
[250] Ibid., pp. 95 and 98.

Appendix

Although this translation of my work is not the place to undertake a full discussion of relevant publications that have appeared since 1983, I wish to record, and briefly allude to, the most important of them. Hence see: R. Starn, "The Republican Regime of the 'Room of Peace' in Siena, 1338–1340," *Representations* 18 (1987): 1–31, correctly stressing the importance of the inscriptions that both surround and are incorporated within the pictorial cycle; and Q. Skinner, "Ambrogio Lorenzetti: The Artist as Political Philosopher," *Proceedings of the British Academy* 72 (1986): 1–56. An abbreviated version of the latter article has been reprinted under the same title in Hans Belting and Dieter Blume, eds. *Malerei und Stadtkultur in der Dantezeit* (Munich: Hirmer Verlag, 1989), pp. 85–103 (in the same volume, the contribution by Bram Kempers, "Gesetz und Kunst: Ambrogio Lorenzettis Fresken im Palazzo Pubblico in Siena," pp. 81–84, adds nothing new). There are numerous points of disagreement between myself and Skinner: in addition to those I discuss in this appendix, readers are referred to the observations, with which I am in complete agreement, of Starn, pp. 28–29; and of M. Donato, "Un ciclo pittorico ad Asciano (Siena): Palazzo pubblico e 'iconografia politica' alla fine del Medioevo," *Annali della Scuola Normale Superiore di Pisa* (1988) no. 3, pp. 1271–72.

Since Skinner undertakes in several places to scrutinize, and to express his opposition to, various hypotheses of mine—quoting, in most cases selectively, from the original Italian edition of the present work—I do wish to reply briefly here, reserving for the future a more ample critique, in collaboration with Monica Donato, of his article.

An example of selection on Skinner's part will suffice. I had drawn attention to the linguistic variation employed to denominate the various symbolic figures: "where the contact with reality turns violent, the Latin is even abandoned in favor of the volgare. *Sì* and *no* are the words pronounced by *Divisio* [whose colors are those of Siena!], and on the shield of the warrior who sits beside her *Guerra* is written, not *Bellum*" (p. 146 in my Italian text, pp. 131–32 above). Skinner (p. 33) declares that *Guerra* is Latin, a "medieval barbarism," and that "it is misleading to claim (as for example Frugoni does) that this *titulus* is in the vernacular." Why does he fail to say anything about the vernacular words *sì* and *no*? I remain convinced that the language used here is the volgare; in any case, the inscription of *Divisio* leaves the question unresolved, and Skinner's word "misleading" is out of place.

The case is the same as regards the carpenter's plane of *Concordia*,

with the author displaying his conviction (although it is a matter of splitting hairs) that this tool indicates *aequitas*, in homage to a putative Ciceronian model, and not *concordia*, and so shifting the emphasis in an inappropriate fashion to an "external" text instead of privileging the "internal" opposition in the fresco itself of the plane and a different tool, the saw. The second procedure is the right one to follow whenever one wishes to decode such a symbolic message, for only from the alternative produced by two opposites does the sense arise. If the saw meant *Divisio*, then here the plane necessarily means *Concordia*, and for that matter it would be strange indeed if it meant anything else, since the object itself serves as a "scroll" bearing the word *Concordia*.

Again it is declared "misleading" (Skinner, p. 36, n. 1) to assert as I do that Justice is represented by two different figures, interpreting as one of them the important personage directly beneath *Sapientia* who is engaged in keeping the scales in balance. Her attribute speaks for itself, and if that were not enough, my interpretation is supported by the illumination from Montalcino that adorns the incipit of the *Liber Sapientiae,* which I adduced as a possible model (p. 145 in my Italian text, pp. 129–30 above). The illuminator established a close tie between the figure equipped with a balance (Justice, formally and precisely) and that exact book. Here, if Skinner wishes, is a solid link between a text and an image. This link, already made by the illuminator of Montalcino, leads me to posit the same relationship in Ambrogio Lorenzetti, and there is no need to lose oneself in a farfetched hunt for extraneous sources that are distant from the biblical text, a text cited in Lorenzetti's fresco immediately above the figure of Justice.

To pursue the linkage of image and text binding this symbolic personage to the *Liber Sapientiae* of the Old Testament: I think I have shown in sufficient detail the manner in which literal echoes of the latter are realized in the fresco. The citation from the book of Proverbs offered by Skinner (p. 37, n. 1) shows no similar resonance. His attack on the tracing of relevant passages precisely and in detail ("there is no reason to single out this particular text as a direct inspiration for any feature of Lorenzetti's work," p. 37) is typical of those who are not acquainted with the methods of iconographic research, and who view with suspicion those who do relate texts very closely to images. In this fresco especially, which is surrounded by texts of some length (not even mentioned by Skinner) and embroidered with scrolls and *tituli*, it is essential to give full weight to the overt presence of those initial words from a book of the Bible, rather than captiously excogitating intermediate channels of influence between Lorenzetti and the passage in question, which was very well known. Does Skinner imagine that the passage of Dante, also well known (*Par.* XVIII, 91–93), which

I cite (p. 145 in my Italian text, p. 130 above) should be explained as deriving from prehumanistic political theory?

Skinner dwells at length on two aspects of commutative and distributive justice: the clearest reply to his objections remains the illumination already cited prominently by me (p. 139 in Italian, p. 123 above). It shows *distributive justice* in the act of choosing the weights and measures to be handed out to a small group of bystanders, and on the other side *commutative justice* in the act of "giving to each his own," with her arms delicately *crossed* (as a sign of commutation) and a grim collection of instruments of torture (a whip, a pillory, an ax) in the background. These figures, explicitly identified on scrolls (and thus greatly strengthening my case) oblige us without equivocation to transpose to the left, in the fresco at Siena, the epigraph appearing on the right (*comutativa*), and the one on the left to the right (*distributiva*): it is immaterial whether the present arrangement results from a mistaken restoration that altered the original layout, or an error by the artist himself (which is far from being out of the question: the official depiction of san Francesco destined for the mother church of S. Maria degli Angeli at Assisi contains a striking and undeniable error in the epigraph). It is true that Aristotle does not refer to commutative justice: I had already written, and I now repeat, that *iustitia comutativa* is a term coined by Aquinas that renders exactly the significance of what, in the text of the Latin translation of Aristotle, is called *[iustitia] in commutationibus directiva* (Aquinas, Ed. Leonina, II, p. 274, p. 283, note to lines 1–13). It is not true that in Aquinas "these observations are made in the course of considering the nature of rectificatory, not commutative justice" (p. 39). Among the transactions that fall within the domain of *iustitia directiva* are those that, in modern parlance, we would call "criminal offenses" (pp. 1131a 1ff.). In such cases the judge must intervene to punish the guilty (cf. Aquinas, II, 277, 80–83).

On the left, in the dress of a guilty man, Lorenzetti painted an assassin, as is shown by the dagger thrown to the ground (compare the dagger clutched by the centaur in the Mal Governo), while in the dress of an honest man he depicted a cavalier (his sword hangs at his side), a man who will have given his life for his country in a praiseworthy example of *caritas*. This is the reason, in keeping with the strongly religious flavor of the iconography, that he receives the *corona iustitiae* and the martyr's palm, the attributes that we see awarded to saints in so many paintings, including Sienese ones, of the Trecento.

As for the two angels on the pans of the balance, who are conceived according to an identical scheme, how would a medieval observer (or we), who had not previously consulted the heap of sources raked up by Skinner, ever have managed to conclude that one angel gives, while

the other "receives," the various objects in question (Skinner, p. 40), since each is making exactly the same gesture?

Further, when it does happen that a figure in an image offers, from below, something to someone else above him, this always happens in a scene of donation: a donor presents his gift in a kneeling position because he recognizes the recipient as a superior authority, to whom extreme reverence is therefore due; a monk might offer his manuscript in this fashion to a king. How is it possible to suppose that the two "simple artisans" on the right (a smith and a rope-maker according to Skinner, p. 40) are using, so pointlessly and casually, the angel as a *mediator for the purpose of exchanging the objects with one another* "in accordance with the mediating rules of justice"?

It is the work of a moment for Skinner (p. 47, n. 2) to dismiss my citation from the *Liber Sapientiae* concerning Prudence on the specious pretext that the Latin Bible uses the words "de futuris" and not "futurum." What is at issue, in reality, is an entire context, not isolated words, and those with the patience to review what I wrote, particularly the detailed information in my n. 92, will be able to decide whether the indissoluble bond that ties the great Sala della Pace to the precepts of the biblical text can be ignored so flippantly.

A few additional points in Skinner's article, unacceptable in my view, should be mentioned in the interest of making clear how things really stand. I begin with the *central* position that the author assigns physically to the figure of *Pace* with respect to the entire cycle, spread as it is over three walls (p. 32). Evidently he has been misled by the term current even today "Sala della Pace" (Hall of Peace), a way of summarily designating the room containing Lorenzetti's frescoes which I made some attempt to obviate in 1983 (my n. 90). It is incorrect to think of all three walls as a unifed panorama, and above all it is an illegitimate distortion (one really ought not to have to point these things out) to apply to a work executed in 1338 criteria of symmetry that did not exist at that time. More is to be gained by recalling the well-known hierarchical principle according to which figures of greater importance were shown on a larger visual scale in the Middle Ages, the obvious example being the enormous gulf separating the large Madonna in majesty from the minuscule donor, who sometimes kneels at her feet, in Trecento painting. By this standard, we must conclude that the figure of Peace enjoys a rank not in the least superior to that of the other Virtues, whereas preeminence ought to be accorded, if anything, to the figure of Justice enthroned and to the hoary, elderly personage from the Buon Governo. In sum, it is pure recklessness to assert that the place assigned to Peace is a visual equivalent of the Ciceronian words *in medium* (p. 32). No judicious and experienced

student of iconography makes parallels between texts and images in this manner.

Apropos of the figure from the Buon Governo: Skinner denies that the epigraph *C.S.C.V.* amounts to a direct reference to this personage by name (which is the case with all the other inscriptions), and thus forces himself to adopt the following awkward exegesis: these letters are said to refer to a theme found in prehumanistic treatises, that of lords who "bear on their shoulders" the weight of the collectivity (p. 42); that is, according to Skinner, the letters bear down physically on the shoulders of the figure as if they were a heavy burden. For refutation of this it would be sufficient to read the scroll held by *Securitas*, which adverts directly to the two personages who are seated on thrones on the adjacent wall ("mentre che tal *Comuno* manterra questa *Donna*"). There is no need to discuss the impossible interpretation, provided by Skinner, of a line of the inscription that runs underneath the allegory: "un ben comun per lor signor si fanno" = "by means of, through the agency of, an elected signore." (It appears that once again his intention is to deny that the old man depicted above is the Bene Comune.)

It is methodologically incorrect to ignore almost entirely the inscriptions (of which Skinner discusses only a minimal portion), to omit consideration of the frescoes as a unified program, and above all to ignore the language of the images, which has its own, necessarily coherent, codification through which they can be understood.

A further example of a method that is, in my view, risky and ill-founded: Skinner first (pp. 52ff.) explains the iconography of the Virtues through a passage from Brunetto Latini (a passage which for that matter leaves a whole series of details unaccounted for), and then notes with disappointment that Lorenzetti might have made a better job of utilizing his source, rich as it was in iconographic particulars: "there is indeed only one point at which Latini offers a strong visual clue that Lorenzetti *fails to pick up*. Latini's suggestion—again without parallel in other texts—that the cardinal virtues can be associated with particular precious stones *is only imperfectly realized*" (emphasis added). But who, except for Skinner himself, guarantees that the source *is* Brunetto Latini? Latini referred to a green emerald, not to a cloak at all! Lorenzetti depicted a green cloak, and added an orange cloak that corresponds to nothing in Latini. And with that observation I will conclude.

Select Bibliography

Agnolo di Tura. *Cronaca senese*. Edited by A. Lisini and F. Iacometti. *RIS*, xv, 6.

Alberti, Leon Battista. *On the Art of Building in Ten Books*. Translated by Joseph Rykwert, Neil Leach, and Robert Tavernor. Cambridge, Mass., and London: MIT Press, 1988.

Alessio, Franco. "La filosofia e le *artes mechanicae* nel secolo XII." *Studi Medioevali* 6, no. 1 (1965): 71–161.

———. "La riflessione sulle *artes mechanicae*." In *Lavorare nel Medio Evo: Rappresentazioni ed esempi dall'Italia dei secoli X–XVI*, pp. 257–93. Atti del xxi convegno del Centro di studi sulla spiritualità medioevale. Todi: Accademia Tudertina, 1983: 259–293.

Anonymus Ticinensis [Opicino de Canistris]. *Liber de laudibus civitatis Ticinensis*. Edited by R. Maiocchi and F. Quintavalle. *RIS*, xi, 1.

Antal, F. *La pittura fiorentina e il suo ambiente sociale nel Trecento e nel primo Quattrocento*. Turin: Einaudi, 1960 (original edition: London 1948).

L'Apocalypse de Jean: Traditions exégetiques et iconographiques, IIIᵉ–XIIIᵉ siècles. Actes du Colloque de la Fondation Hardt, 29 février–3 mars 1976. Geneva: Droz, 1979.

Augustine (Augustinus, Aurelius). *De civitate Dei. CSEL* vol. 40. Also in the Italian translation of C. Borgogno. Alba: Edizioni Paoline, 1973.

Baccheschi, E., ed. *L'opera completa di Giotto*. Milan: Rizzoli, 1966.

———. *L'opera completa di Duccio*. Milan: Rizzoli, 1972.

Baldini, U., ed. *L'opera completa dell'Angelico*. Milan: Rizzoli, 1970.

Bambaglioli, Graziolo. *Trattato di virtù*. In *Rimatori bolognesi del Trecento*, edited by L. Frati. Bologna, 1915.

Bauer, H. *Kunst und Utopie*. Berlin: De Gruyter, 1965.

Becatti, G. *La colonna coclide istoriata, problemi storici, iconografici, stilistici*. Rome: L'Erma di Bretschneider, 1960.

Becherucci, L., and G. Brunetti. *Il Museo dell'Opera del Duomo a Firenze*. Milan: Electa, n.d. [1970].

Beckwith, J. *Early Mediaeval Art*. London: Thames and Hudson, 1964.

Blumenkranz, B. *Le Juif médiéval au miroir de l'art chrétien*. Paris: Études Augustiennes, 1966.

Boccaccio, Giovanni. *Genealogia Deorum*. Edited by V. Romano. Bari: Laterza, 1951.

Bonvesin de la Riva. *De magnalibus Mediolani (Le meraviglie di Milano)*. Latin text with Italian translation. Edited by G. Pontiggia, with introduction and notes by M. Corti. Milan: Bompiani, 1974.

Bowsky, W. "The Buon Governo of Siena (1287–1355): A Medieval Italian Oligarchy." *Speculum* 37 (1962): 368–81.

———. "The Medieval Commune and Internal Violence: Police Power and

Public Safety in Siena 1287–1355." *American Historical Review* 73 (1967): 1–17.

Braunfels, W. *Mittelalterliche Stadtbaukunst in der Toskana.* Berlin: Gebr. Mann, 1953.

Cairola, A., and E. Carli. *Il palazzo pubblico di Siena.* Rome, 1936.

Cames, C. *Allégories et symboles dans l'Hortus deliciarum.* Leiden: Brill, 1971.

Capitani, O. "L'incompiuto *Tractatus de iustitia* di fra Remigio de' Girolami." *Bullettino dell'Istituto storico italiano per il medioevo* 72 (1960): 91–134.

Carbone, L. *Note sulla ideologia e la prassi politica di un'oligarchia borghese del '300: I Nove di Siena 1287–1366.* Tesi di laurea, University of Florence, 1977.

Carli, E. *Montalcino. Museo civico. Museo diocesano d'arte sacra.* Bologna: Calderini, 1972.

———. *Il Museo di Pisa.* Pisa: Pacini, 1974.

———. *Gli affreschi del Tau a Pistoia.* Florence: Edam, 1977.

Cherubini, G. *Signori, contadini, borghesi: Ricerche sulla società italiana del basso medioevo.* Florence: La Nuova Italia, 1977.

La città nell'alto medioevo. Settimane di studio del Centro italiano di studi sull'alto medioevo. Spoleto, 1959.

Constantinus Porphyrogenitus. *Liber de caerimoniis.* Edited by A. Vogt. Paris: Les Belles Lettres, 1967.

Cracco Ruggini, L., and G. Cracco. "Changing Fortunes of the Italian City from Late Antiquity to Early Middle Ages." *Rivista di filologia e istruzione classica* 106 (1977): 448–75.

Dagron, G. *Naissance d'une capitale.* Paris: Presses Universitaires de France, 1974.

Deichmann, F. W. *Ravenna Hauptstadt des spätantiken Abendlandes, II: Kommentar,* part 1. Wiesbaden: Steiner, 1974.

De Matteis, M. C. "Il *De bono communi* di Remigio de' Girolami." *Annali dell'Università degli studi di Lecce* 3 (1965–1967): 13–86.

———. *"La teologia politica comunale" di Remigio de' Girolami.* Bologna: Patron, 1977.

Donato, M. "Un ciclo pittorico ad Asciano (Siena). Palazzo pubblico e 'iconografia politica' alla fine del Medioevo." *Annali della Scuola Normale Superiore di Pisa* (1988) no. 3: 1105–1272.

Duval, N. "Que savons-nous du palais de Théodoric à Ravenne?" *Mélanges d'Archéologie et d'Histoire de l'École Française de Rome* 72 (1960): 337–71.

———. "La mosäique du *Palatium* de Saint Apollinaire le Neuf représente-t-elle une façade ou un édifice aplani." *Corso di cultura sull'arte ravennate e bizantina* 25 (1978): 93–122.

Études sur l'histoire de la pauvreté (Moyen Age–XVIᵉ siècle). Edited by M. Mollat. Paris: Publications de la Sorbonne, 1974.

Fasoli, G. "La coscienza civica nelle 'Laudes civitatum.' " In *La coscienza cittadina nei comuni italiani del Duecento.* Atti dell'XI Convegno del Centro di studi sulla spiritualità medievale. Todi: Accademia Tudertina, 1972: 11–44.

Fasoli, Gina, and Francesca Bocchi. *La città medioevale italiana*. Florence: Sansoni, 1973.

Feldges-Henning, U. "The Pictorial Program of the Sala della Pace: A New Interpretation." *JWCI* 35 (1972): 145–62.

Fonti francescane. Assisi: Movimento francescano, 1978.

Frugoni, A. *Incontri nel Medioevo*. Bologna: Il Mulino, 1979.

Frugoni, C. "L'iconografia del matrimonio e della copia nel medioevo." In *Il matrimonio nella società altomedioevale*, Settimane di studio del Centro italiano di studi sull'alto medioevo, 24. Spoleto, 1977.

———. "Chiesa e lavoro agricolo nei testi e nelle immagini dall'età tardo antica all'età romanica." In *Medioevo rurale: Sulle tracce della civiltà contadina*, edited by V. Fumagalli and G. Rossetti, pp. 321–41. Bologna: Il Mulino, 1980.

———. "Altri luoghi, cercando il paradiso (il ciclo di Buffalmacco nel Camposanto di Pisa e la committenza domenicana)." *Annali della Scuola Normale Superiore di Pisa* (1988) no. 4: 143–229.

———. "Das Schachspiel in der Welt des Jacobus de Cessolis." In *Das Schachbuch des Jacobus de Cessolis, ms. Pal. lat. 961*, vol. 2 (*Kommentar*), pp. 35–79. Stuttgart: Belser, 1988.

Gerke, F. "Nuove indagini sulla decorazione musiva della chiesa ravennate di Sant'Apollinare Nuovo." *Felix Ravenna* 103–4 (1972).

Ghiberti, L. *Commentari*. Edited by O. Morisani. Naples: Ricciardi, 1947.

Ginzburg, C. *Folklore, magia, religione*. In *Storia d'Italia* vol. 1, *I caratteri originali*, pp. 603–76. Turin: Einaudi, 1972.

Giordano da Pisa. *Prediche del 1304, dell'Avvento, e della Quaresima*. Edited by D. M. Manni. Florence: Viviani, 1739.

———. *Prediche recitate in Firenze dal 1303 al 1306 ed ora per la prima volta pubblicate*. Edited by C. Moreni. Florence: Magheri, 1831.

———. *Prediche inedite recitate in Firenze dal 1302 al 1305*. Edited by E. Narducci. Bologna: Romagnoli, 1867.

———. *Quaresimale fiorentino, 1305–1306*. Critical edition. Edited by C. Delcorno. Florence: Sansoni, 1974.

Giotto e i giotteschi in Assisi. Rome: Canesi, 1970.

González-Palacios, A., ed. *Ambrogio Lorenzetti: La Sala della Pace*. Milan: Fabbri-Skira, 1968.

Gousset, M. T. "La représentation de la Jérusalem céleste à l'époque carolingienne." *Cahiers archéologiques* 23 (1974).

Gozzoli, M. C., ed. *L'opera completa di Simone Martini*. Milan: Rizzoli, 1980.

Grabar, A. *L'Empereur dans l'art byzantin*. Paris, 1936; London: Variorum Reprints, 1971.

———. *L'età d'oro di Giustiniano*. Milan: Feltrinelli, 1966.

Grodecki, L., F. Mütherich, J. Taralon, and F. Wormald. *Il secolo dell'anno Mille*. Milan: Feltrinelli, 1974.

Guidoni, E. *Arte e urbanistica in Toscana, 1000–1315*. Rome: Bulzoni, 1970.

Heitz, C. *Recherches sur les rapports entre architecture et liturgie à l'époque carolingienne*. Paris: Sevpen, 1963.

Heitz, C. "Retentissment de l'Apocalypse dans l'art de l'époque carolingienne." In *L'Apocalypse de Jean.* Geneva: Droz, 1979 [listed above].

Herrad of Hohenbourg. *The Hortus Deliciarum of Herrad of Hohenbourg (Landsberg).* A reconstruction by R. Green, M. Evans, C. Bischoff, M. Curschmann, under the direction of R. Green. London and Leiden: Warburg Institute, 1979.

Hoffmann-Curtius, K. *Das Programm der Fontana Maggiore in Perugia.* Düsseldorf: Rheinland, 1968.

Hubert, J., J. Porcher, and W. E. Volbach. *L'impero carolingio.* Milan: Feltrinelli, 1968.

Janin, R. *Constantinople byzantine, développement urbain et répertoire topographique.* Paris: Institut Français d'Études Byzantines, 1964.

Judentum im Mittelalter, Schloss Habturm, 4 Mai–26 Oktober 1978, Burgenland 1978. Eisenstadt: Rötzer-Druck, 1978.

Kantorowicz, E. H. "The 'King's Advent' and the Enigmatic Panels in the Doors of Santa Sabina." *Art Bulletin* 26 (1944).

Katz, J. Ehrenberger. "Les représentations de villes fortifiées dans l'art paléochrétien et leurs dérivées byzantines." *Cahiers Archéologiques* 19 (1969): 1–27.

Katzenellenbogen, A. *Allegories of the Virtues and Vices in Medieval Art.* London: Warburg Institute, 1939; reprint, Kraus, 1977.

Lamma, P. *Teoderico.* Brescia: La Scuola, 1951.

Lavedan, P. *Représentations des villes dans l'art du Moyen Age.* Paris: Vanoest, 1954.

Le Goff, J. *Tempo della Chiesa e tempo del mercante.* Turin: Einaudi, 1977.

Lexikon der christlichen Ikonographie. Rome and Freiburg: Herder, 1968–.

Lisini, A. *Il constituto del Comune di Siena volgarizzato nel 1309–1310.* Siena, 1903.

Little, L. K. *Religious Poverty and the Profit Economy in Medieval Europe.* London: Elek, 1978.

Mango, C. *The Brazen House.* Arkaeol. Kunsthist. Medd. Dan. Vid. Selsk. IV, 4. Copenhagen, 1959.

Martini, G. "Siena da Montaperti alla caduta dei Nove (1260–1355)." *Bullettino senese di storia patria* 68 (1961): 75–128.

Milanesi, G., ed. *Documenti per la storia dell'arte senese, I (secoli XIII-XIV).* Siena: Porri, 1854.

Mor, C. G. "Dalla caduta dell'impero al comune." In *Verona e il suo territorio.* Verona: Istituto per gli studi storici veronesi, 1964.

Oakeshott, W. *I mosaici di Roma.* Milan: Electa, 1967.

Les ordres mendiants et la ville en Italie centrale (vv. 1220–1350). MEFRM 89, no. 2 (1977). Special number.

Ortalli, G. *La pittura infamante nei secoli XIII–XVI.* Rome: Jouvence, 1979.

Pächt, O. "Early Italian Nature Studies and the Early Calendar Landscape." *JWCI* 13 (1950): 13–47.

Pearsal, D., and E. Salter. *Landscapes and Seasons of the Medieval World.* London: Elek, 1937.

Peroni, A. "Raffigurazione e progettazione di strutture urbane e architetto-niche nell'alto medioevo." In *Topografia urbana e vita cittadina nell'alto medioevo in occidente*. Settimane di studio del Centro italiano di studi sull'alto medioevo, 21. Spoleto, 1974.

Petrarca, F. *Opera*. Basel: Henricpetri, 1554.

————. *Prose*. Edited by G. Martellotti. Milan and Naples: Ricciardi, 1955.

Petti Balbi, G. *Genova medioevale vista dai contemporanei*. Genoa: Sagep, 1978.

Ricci, C. *Tavole storiche dei mosaici di Ravenna*, fasc. 4, *Sant'Apollinare Nuovo*. Rome: Istituto di archaeologia e storia dell'arte, 1933.

Romano, G. *Studi sul paesaggio*. Turin: Einaudi, 1978.

Rowley, G. *Ambrogio Lorenzetti*. Princeton: Princeton University Press, 1958.

Rubinstein, N. "Political Ideas in Sienese Art: The Frescoes by Ambrogio Lorenzetti and Taddeo di Bartolo in the Palazzo Pubblico." *JWCI* 21 (1958): 179–207.

Sacchetti, F. *Opere*. Edited by A. Borlenghi. Milan: Rizzoli, 1957.

Salimbene de Adam. *Cronica*. Critical edition. Edited by G. Scalia. Bari: Laterza, 1966.

Santi, F. *Galleria nazionale dell'Umbria: Dipinti, sculture, e oggetti d'arte di età romanica e gotica*. Rome: Poligrafico dello Stato, 1969.

Schild-Bunin, M. *Space in Medieval Painting and the Forerunners of Perspective*. New York: AMS Press, 1940.

Simoncini, G. *Città e società nel Rinascimento*. Turin: Einaudi, 1974.

Skinner, Q. "Ambrogio Lorenzetti: The Artist as Political Philosopher." *Proceedings of the British Academy* 72 (1986): 1–56.

Starn, R. "The Republican Regime of the 'Room of Peace' in Siena, 1338–1340." *Representations* 18 (1987): 1–31.

Storia dell'arte italiana. Turin: Einaudi, 1979–.

Szabò, T. "La rete stradale del contado di Siena: Legislazione statutaria e amministrazione comunale del Duecento." *MEFRM* 87 (1975): 141–86.

Tatum, G. Bishop. "The Paliotto of Sant'Ambrogio at Milan." *Art Bulletin* 26 (1944).

Toesca, P. *Il Trecento*. 1950; reprint, Turin: UTET, 1971.

Torriti, P. *La pinacoteca nazionale di Siena, i dipinti dal XII al XV secolo*. Genoa: Sagep, 1977.

Überwasser, W. "Deutsche Architekturdarstellung um das Jahr 1000." In *Festschrift H. Jantzen*, pp. 45–70. Berlin: Mann, 1951.

Varanini, G. *Lamenti storici pisani*. Pisa: Nistri-Lischi, 1968.

Vasari, G. *Le vite de' più eccellenti pittori, scultori et architettori*. Edited by P. Barocchi. Florence: Sansoni, 1966.

Vauchez, A. *La sainteté en Occident aux derniers siècles du Moyen Age*. Rome: École Française de Rome, 1981.

Verona e il suo territorio. Verona: Istituto per gli studi storici veronesi, 1964.

Versus de Verona, Versus de Mediolano civitate. Critical text and commentary. Edited by G. B. Pighi. Bologna: Zanichelli, 1960.

Villani, Giovanni [and Matteo Villani and Filippo Villani]. *Cronica*. Edited by A. Racheli. Trieste: Lloyd austriaco, 1857.

Villani, Giovanni. *Cronica.* Edited by Giovanni Aquilecchia. Turin: Einaudi,
 1979.

Walther, H. *Proverbia sententiaeque Latinitatis Medii Aevi.* Göttingen, 1963.

Wieruszowski, H. "Art and the Commune in the Time of Dante." *Speculum*
 19 (1944): 14–33.

Zovatto, P. L. "L'arte altomedioevale." In *Verona e il suo territorio,* vol. II. Ve-
 rona: Istituto per gli studi storici veronesi, 1964 [listed above].

Index

Illustrations

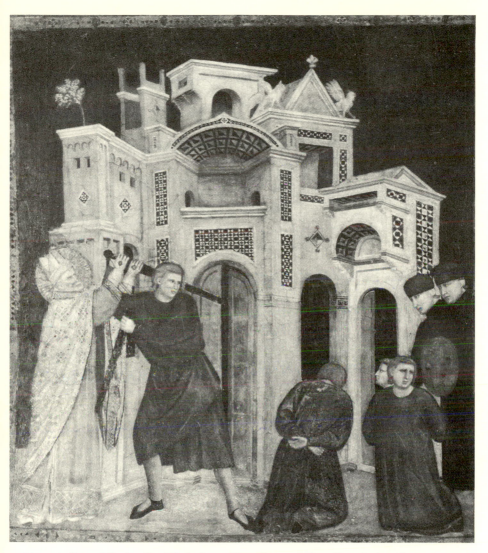

1. Maestro di san Nicola, *San Nicola Saves Three Innocents from Decapitation*, fresco, beginning of the fourteenth century. Assisi, San Francesco, Lower Basilica.

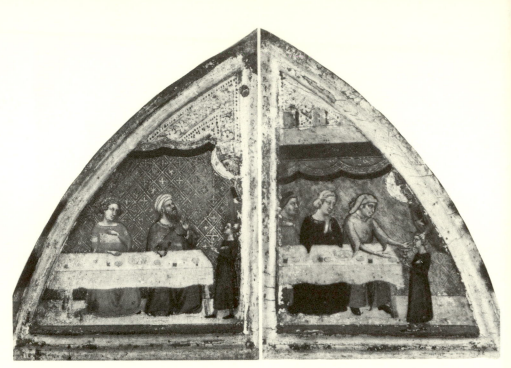

2. Bernardo Daddi, *San Nicola Liberates the Cupbearer Adeodato from Service to the Pagan King* and *San Nicola Restores Adeodato to His Parents, sportellini* (shutters) of an *altarolo* (little tabernacle), panel painting, 1336. Siena, Pinacoteca Nazionale.

3. *The Destruction of Jericho*, mosaic, 432–440. Rome, Santa Maria Maggiore.

4. *Scenes from the Life of Christ* (diptych of Harrach), ivory, end of the eighth–beginning of the ninth century. Cologne, Schnütgen-Museum.

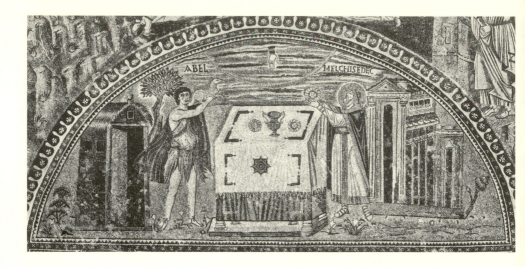

5. *The Sacrifice of Abel and Melchizedek* (detail), mosaic, 532–547. Ravenna, San Vitale, lunette above the lower arches of the choir.

6. *Adoration of the Magi and the Presentation in the Temple* (book cover formerly at Sens, then Metz), ivory, late ninth or early tenth century. London, Victoria and Albert Museum.

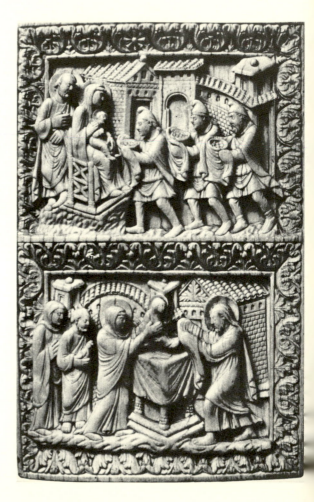

Perugine follower of Meo da Siena, *Adoration of the Magi* (detail from a shutter of a
·tych, now dismembered), tempera on canvas glued to a panel, middle of the four-
th century. Perugia, Galleria Nazionale dell'Umbria.

8. *King Henry III and His Wife Agnes before the Madonna*, illumination from the Codex Aureus of Speyer, from Echternach, 1043–1046. Escorial, library of the monastery, MS Vit. 17, f. 3v.

9. *Saint Matthew*, illumination from the "Gospels of the Célestins," middle of the ninth century. Paris, Bibliothèque de l'Arsenal, MS 1171, f. 17v.

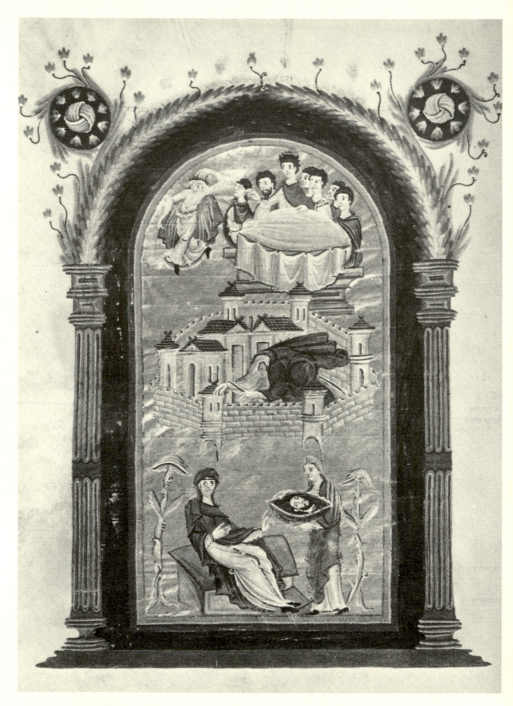

10. *The Dance of Salome*, illumination from the Gospels of Liuthard, ca. 990. Aachen, cathedral, unnumbered MS, f. 46v.

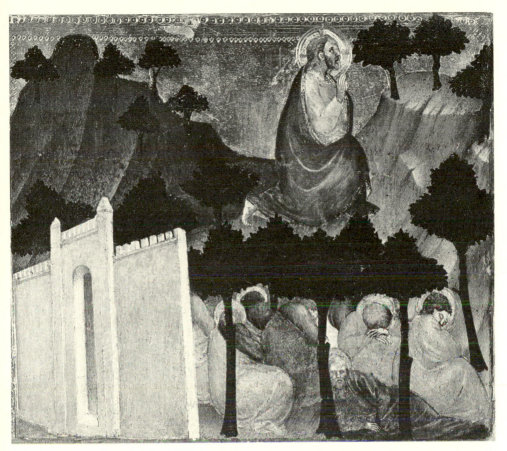

11. Giovanni da Milano, *Prayer in the Garden*, second predella of a polyptych, panel painting, middle of the fourteenth century. Prato, Pinacoteca comunale.

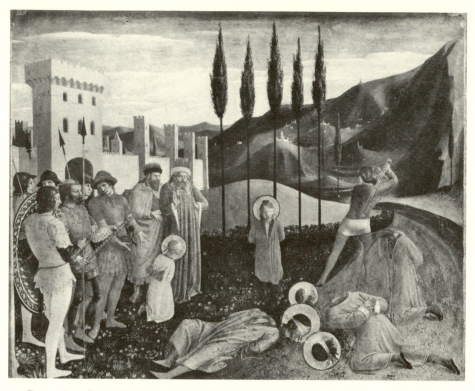

12. Beato Angelico, *The Decapitation of Saints Cosmas and Damian*, predella from the altarpiece of San Marco, tempera on panel, 1438–1440. Paris, Louvre.

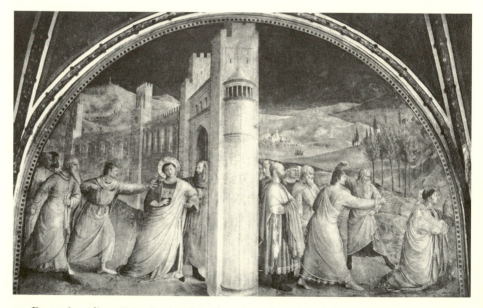

13. Beato Angelico, *Saint Stephen Brought to His Place of Torment and Stoned*, fresco, 1447–1450. Rome, Vatican, Cappella Niccolina.

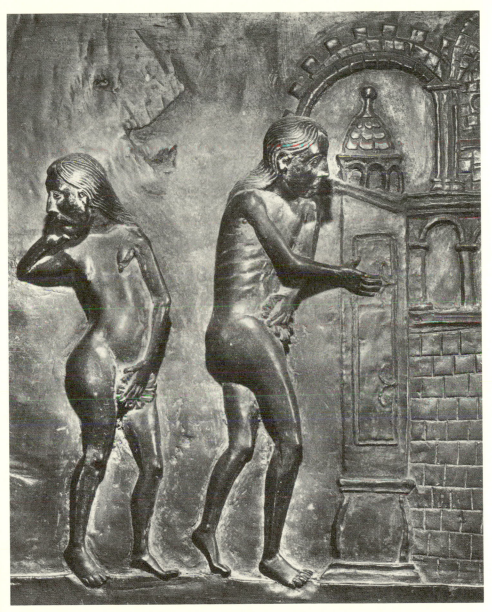

14. *The Expulsion of Adam and Eve*, bronze, 1015. Hildesheim, Cathedral of St. Michael, doors of St. Bernward.

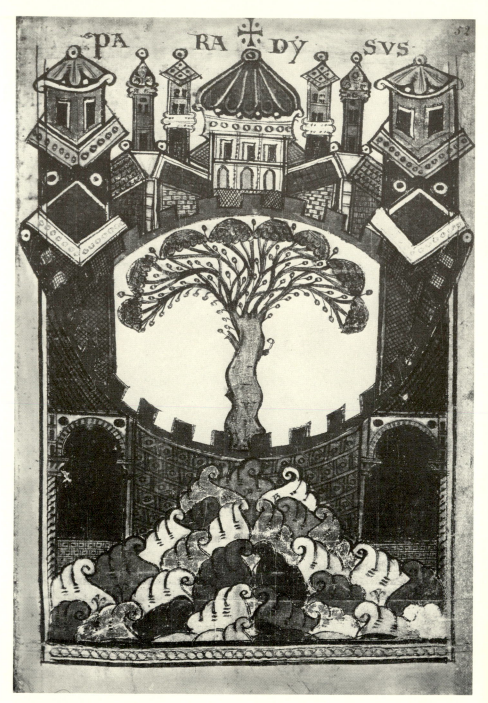

15. *Paradise*, illumination from Lambert of Saint-Omer, *Liber floridus*, ca. 1120. Ghent, Bibliotheek van de Rijksuniversiteit, Cod. 92, f. 52r.

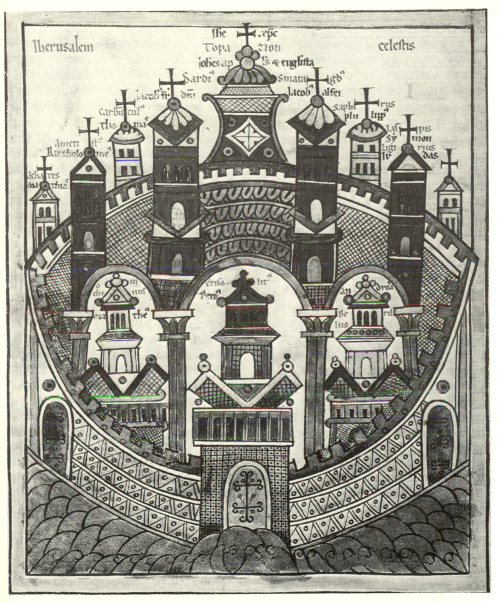

16. *The Heavenly Jerusalem*, illumination from Lambert of Saint-Omer, *Liber floridus*, second half of the twelfth century. Wolfenbüttel, Braunschweigische Landesbibliothek, MS Gud. Lat. 1, f. 43v.

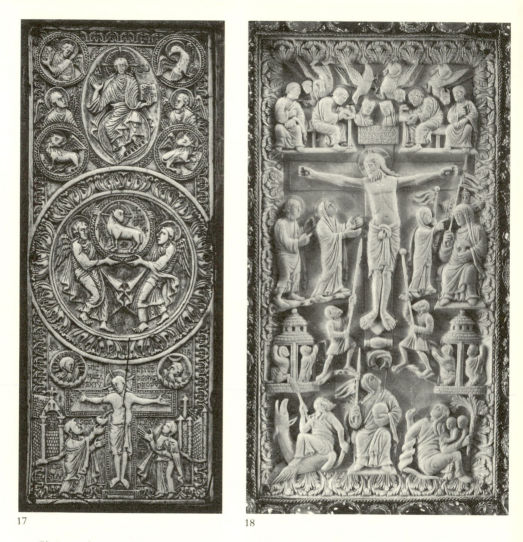

17

18

17. *Christ on the Cross between the Church and Jerusalem* (detail from the cover of an evangelary), ivory, tenth–eleventh centuries. Tournai, cathedral treasury.

18. *Christ on the Cross between the Church and the Synagogue*, cover of an evangelary from Metz, ivory, tenth century. Paris, Bibliothèque Nationale, MS Lat. 9883.

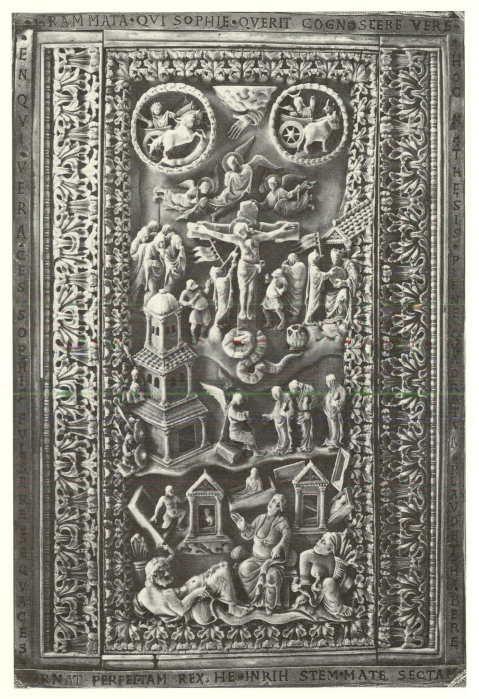

19. *Christ on the Cross between the Church and the Synagogue,* ivory from Reims inserted in the cover of the Perikopenbuch of Henry II, ca. 870. Munich, Bayerische Staatsbibliothek, Clm 4452.

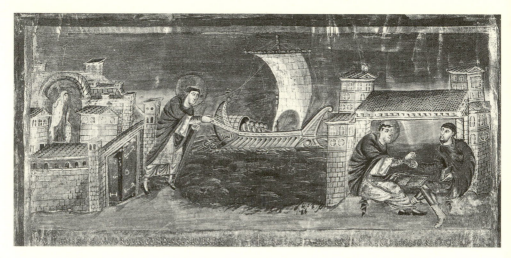

20. *Saint Jerome Leaves Rome for Jerusalem*, illumination from the "First Bible of Charles the Bald," ca. 846. Paris, Bibliothèque Nationale, MS Lat. 1, f. 3v.

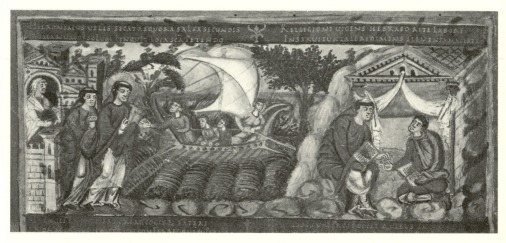

21. *Saint Jerome Leaves Rome for Jerusalem*, illumination from the "Bible of San Paolo fuori le mura," 869–870. Rome, Basilica of San Paolo fuori le mura, unnumbered, f. 2v.

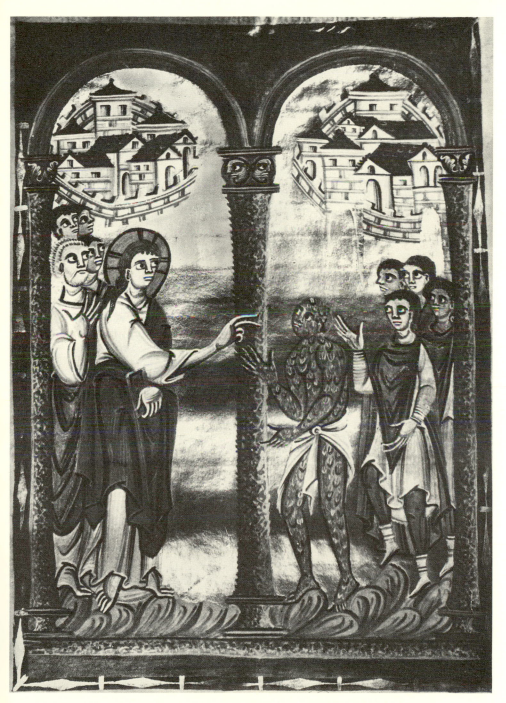

22. *The Curing of the Leper*, illumination from the Gospels of Limburg from Reiche-
nau, beginning of the eleventh century. Cologne, Erzbischöfliche Diözesanbibliothek,
cod. Metr. 218, f. 31r.

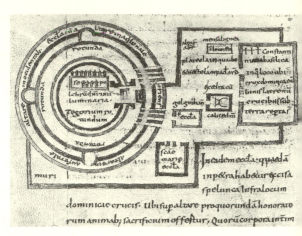

23. *The Holy Sepulcher at Jerusalem*, illumination, ninth century. Vienna, Nationalbibliothek, MS 458, f. 4v.

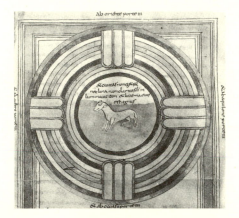

24. *The Heavenly Jerusalem*, illumination from the Apocalypse, ninth century. Valenciennes, Bibl. Meur., MS 99, f. 38r.

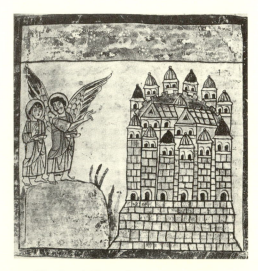

25. *The Angel Shows the New Jerusalem to Saint John*, illumination from the Apocalypse, ninth century. Trier, Stadtbibliothek, MS 31, f. 69r.

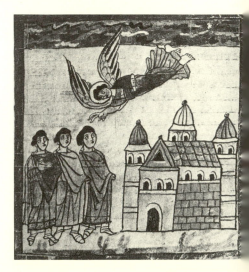

26. *The Elect Make Their Way to the Heavenly Jerusalem*, illumination from the Apocalypse, ninth century. Trier, Stadtbibliothek, MS 31, f. 72r.

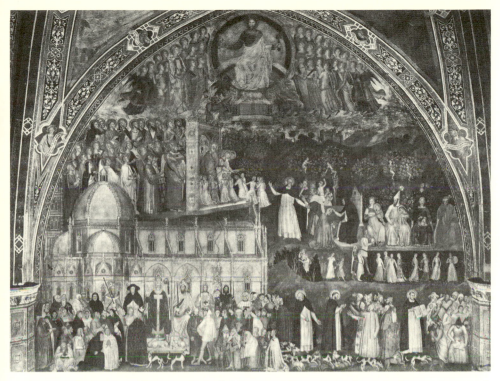

27. Andrea da Firenze, *The Government of the Church*, fresco, 1366–1368, Florence, Santa Maria Novella, Cappellone degli Spagnoli.

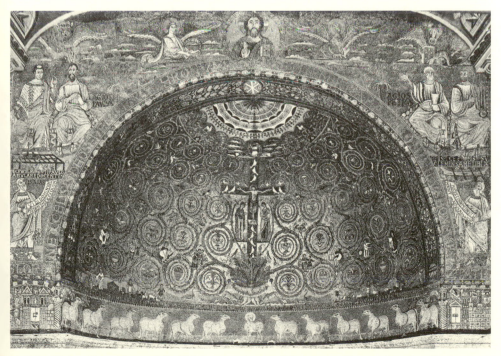

28. *The Cities of Jerusalem and Bethlehem*, mosaic, twelfth century. Rome, church of San Clemente, apse and triumphal arch.

29. *Miracle of the Ubiquity of Saint Ambrose*, mosaic, eleventh century (with modern restorations). Milan, Sant'Ambrogio, apsidal vault.

30. *Bull of Henry IV*, 1065. Hannover, Staatsarchiv.

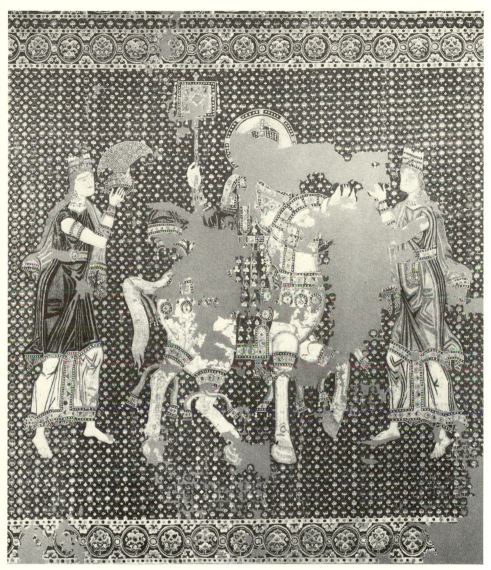

31. *Triumph of an Emperor*, Byzantine fabric, ca. 1000. Bamberg, cathedral treasury.

32. *Christ among the Apostles*, mosaic, ca. 400. Rome, Santa Pudenziana, apse.

33. *The City of Ravenna*, mosaic, first quarter of the sixth century (with alterations after 527). Ravenna, Sant'Apollinare Nuovo, nave.

34. *The City of Classe*, mosaic, first quarter of the sixth century (with alterations after 527). Ravenna, Sant'Apollinare Nuovo, nave.

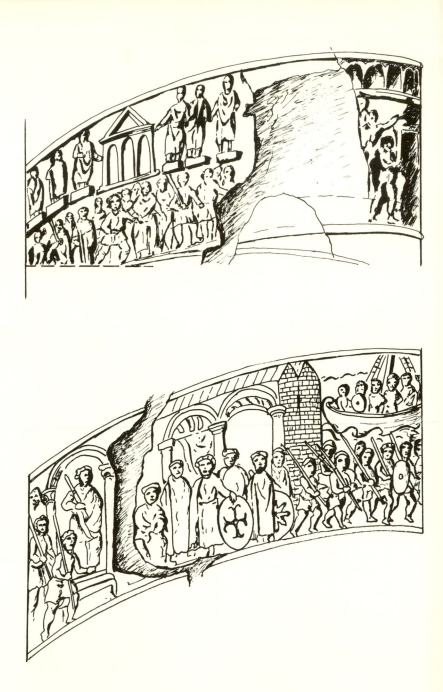

35–36. *Procession before the Emperor Arcadius*, reliefs from the west and south sides of the column of Arcadius at Constantinople (ca. 404), now destroyed (from a drawing by D. W. Freshfield, enlarged by Mario Epifani, Pisa).

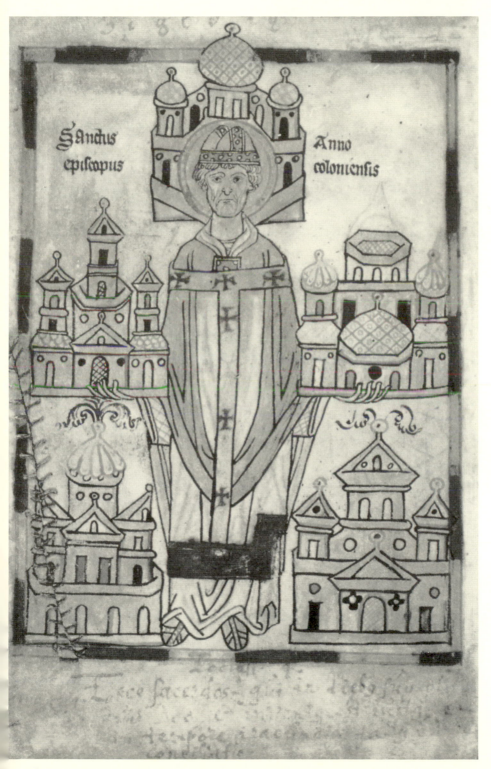

Sanctus
episcopus

Anno
coloniensis

37. *The Construction Activity of the Archbishop Anno*, illumination from the *Life of Anno*,
ca. 1183. Darmstadt, Hessische Landes und Hochschulbibliothek, MS 945, f. 1v.

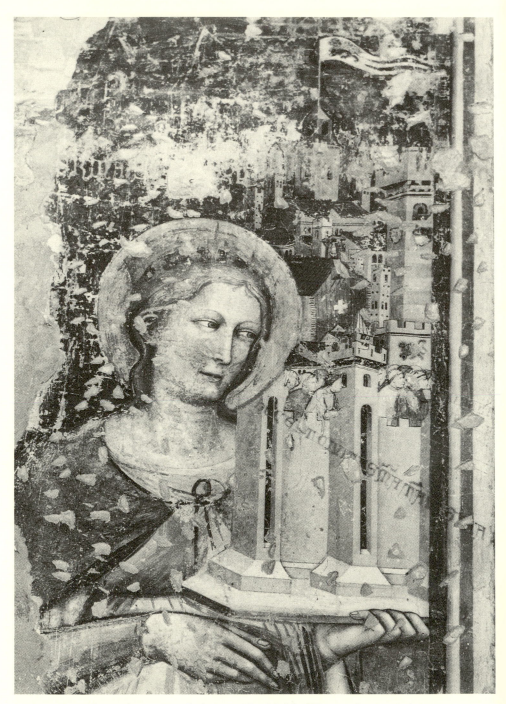

38. Tommaso da Modena, *Saint Catherine with a Model of Treviso*, fresco, sixth or seventh decade of the fourteenth century. Treviso, Santa Caterina.

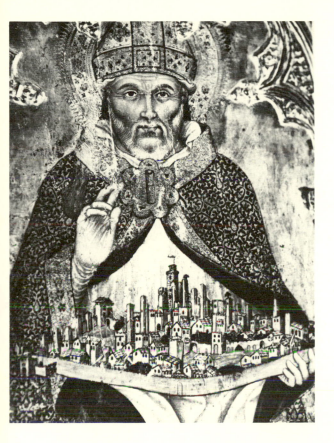

39. Taddeo di Bartolo, *The Bishop s. Gimignano*, panel (detail of the panel with *s. Gimignano and Histories of His Life*), 1393. San Gimignano, Museo Civico.

40. Taddeo di Bartolo, *Sant'Antilla with a Model of Montepulciano* (detail of the altarpiece from the high altar), tempera on panel, 1401. Montepulciano, cathedral.

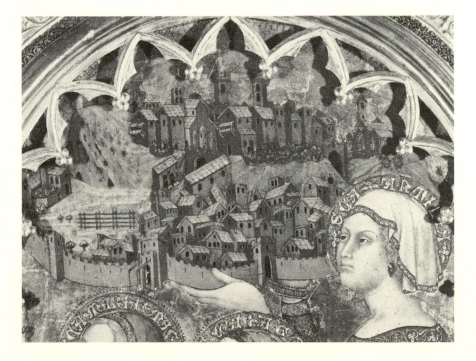

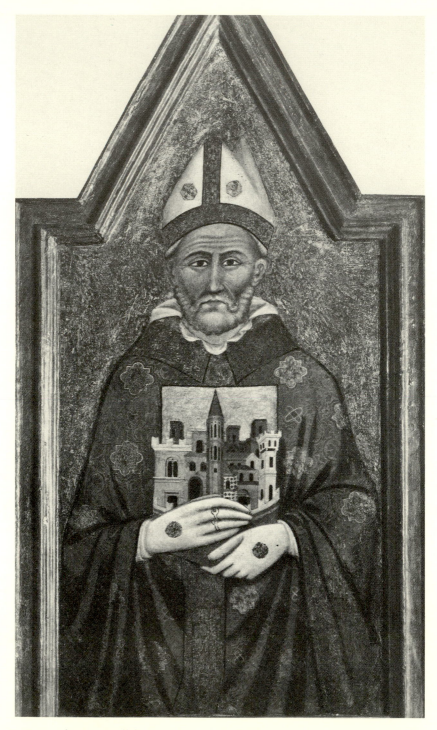

41. Meo da Siena (collaborator of), *The Bishop Ercolano*, tempera on canvas, glued to a panel, fourteenth century. Perugia, Galleria Nazionale dell'Umbria.

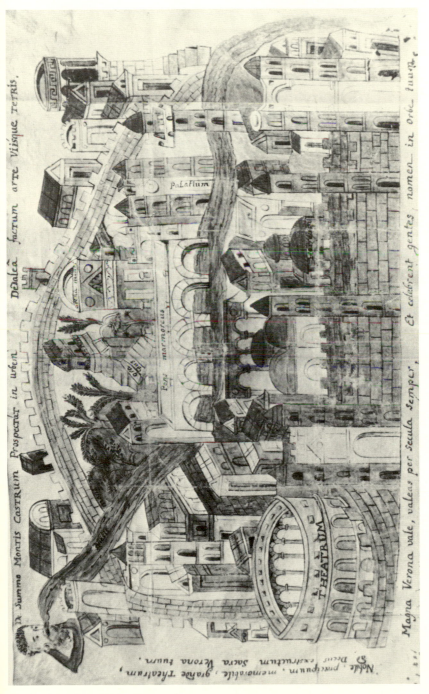

Labels within the image:

De Summo Montis Castrum Prospectat in urbem

Dedalea factum arte Viisque tetris.

Palatium

Pons marmoreus

THEATRUM

Magna Verona vale, valeas per secula semper, Et celebrent gentes, nomen in orbe tuum,

Nobile, praecipuum, memorabile, grande Theatrum,
Decus extructum Sacra Verona tuum,

42. *The City of Verona*, illumination, ninth–tenth centuries (from a copy by Scipione Maffei, after 1739, of the lost original). Verona, Biblioteca capitolare, MS 114 (106), ff. 187v–188r.

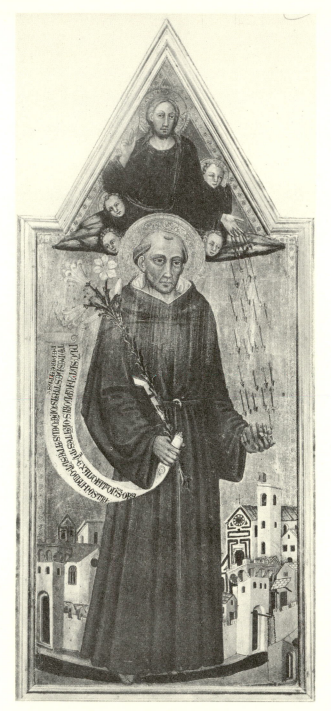

43. Bicci di Lorenzo, *San Nicola da Tolentino Protects
Empoli from Divine Wrath*, panel painting, ca. 1450.
Empoli, Santo Stefano.

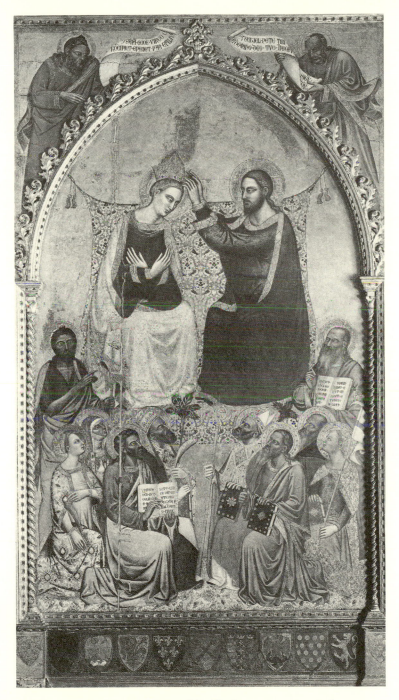

44. Jacopo di Cione, *Coronation of the Virgin*, tempera on panel, 1373.
Florence, Uffizi.

45. Duccio di Boninsegna, *Temptation of Christ on the Mountain* (detail from the predella of the *Maestà*), tempera on panel, 1311. New York, Frick Collection.

46. Lorenzo di Pietro, called Il Vecchietta, reliquary from the Great Sacristy of the
Ospedale di Santa Maria della Scala at Siena, shutters in wood, 1445–1446. Siena,
Pinacoteca Nazionale.

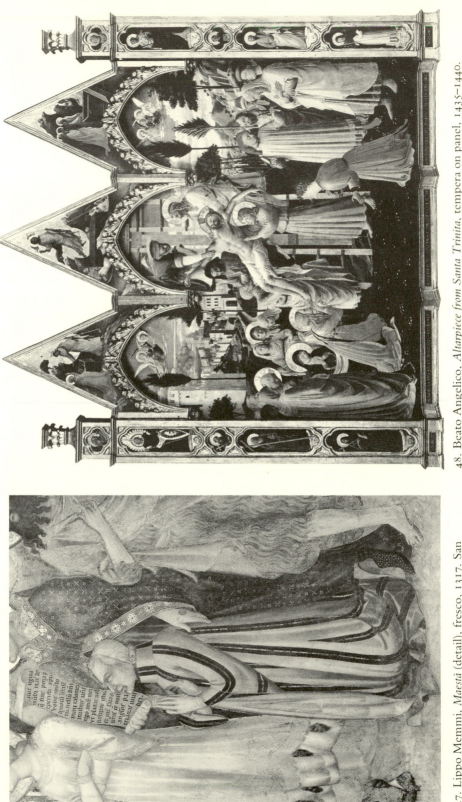

47. Lippo Memmi, *Maestà* (detail), fresco, 1317. San Gimignano, Museo Civico.

48. Beato Angelico, *Altarpiece from Santa Trinita*, tempera on panel, 1435–1440. Florence, Museo di San Marco.

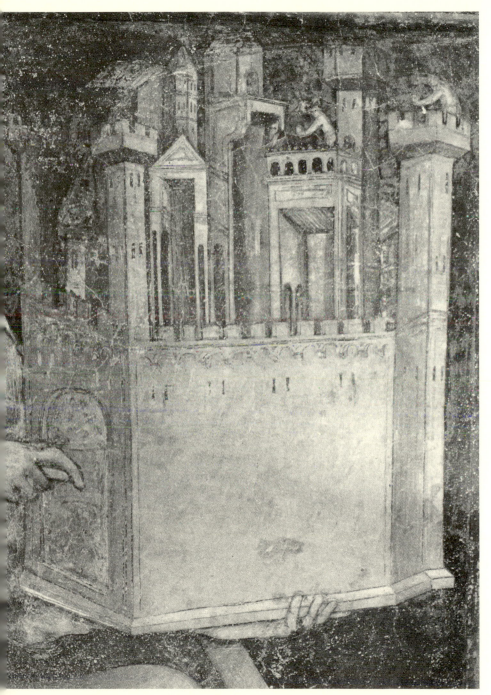

9. *Temperance* (detail), fresco, end of the fourteenth century. Ferrara, Casa Minerbi.

50. Ambrogio Lorenzetti, *Good Government, the Effects in the City (Il Buon Governo, gli effetti in città)* (detail), fresco, 1338–1339. Siena, Palazzo Pubblico, Sala della Pace.

51. Orcagna (school of), *Saint Peter Martyr Founds the Company of the Virgin*, panel painting, ca. 1360. Florence, Museo del Bigallo.

52. Taddeo di Bartolo (follower of), *The Madonna with the Baby Jesus*, canvas, beginning of the fifteenth century. Siena, Pinacoteca Nazionale.

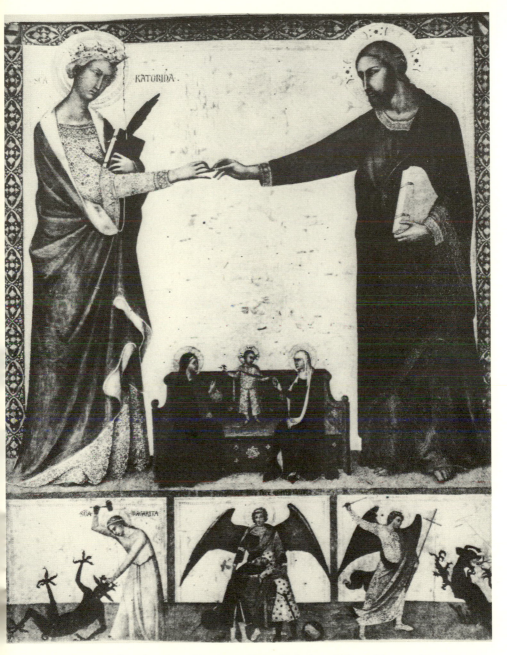

53. Barna (follower of), *The Mystic Marriage of Saint Catherine of Alexandria*, panel painting, 1350–1370. Boston, Museum of Fine Arts.

54. Luca di Tommè (documented from
1356 to 1389), *Preaching of Saint Paul*,
panel painting. Siena, Pinacoteca
Nazionale.

55. *Diabolical Temptation of Avarice
(Temptacio dyaboli de avaricia)*, woodcut
from the *Ars moriendi*, ca. 1470. Paris,
Bibliothèque Nationale, Rés. Xyl. 21, f.
ciii verso.

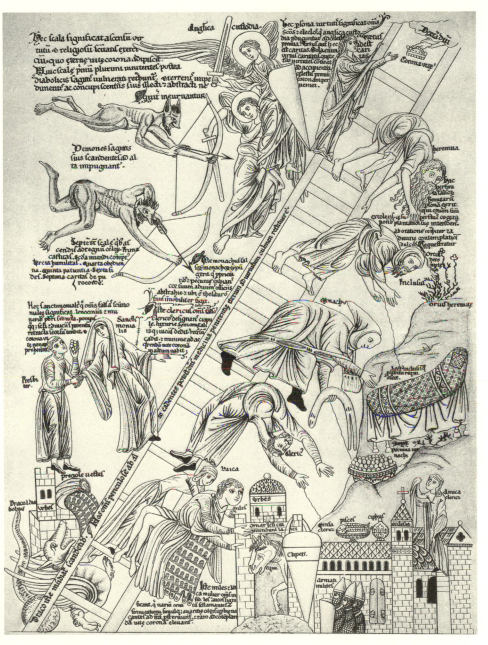

56. *The Ladder of the Virtues*, illumination from Herrad of Hohenbourg, *Hortus Deliciarum*, twelfth century (from a drawing by A. de Bastard d'Estaing, from the lost manuscript of the Bibliothèque municipale of Strasbourg).

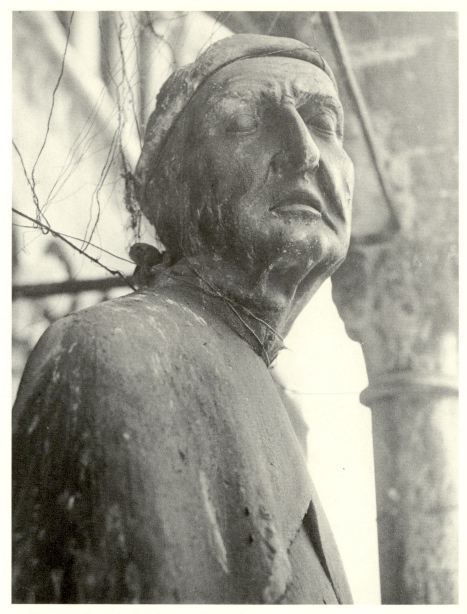

57. Tuscan artist, *Saint Omobono*, sculpture, beginning of the fourteenth century. Cremona, cathedral, vestibule.

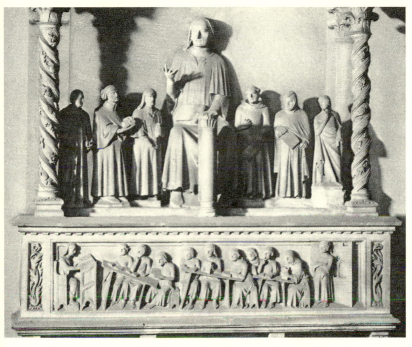

58. Sienese artist, *Tomb of Cino da Pistoia* (detail), sculpture, beginning of the fourteenth century. Pistoia, cathedral.

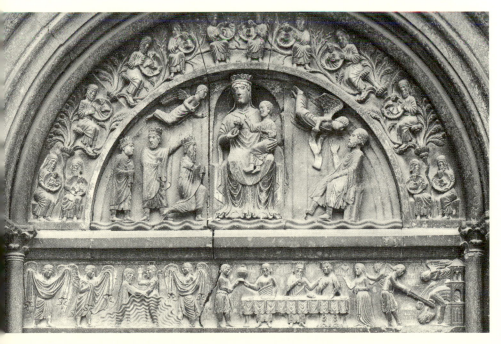

59. Benedetto Antelami, *Madonna Enthroned and the Story of the Baptist,* sculpture, end of the twelfth century. Parma, Baptistery.

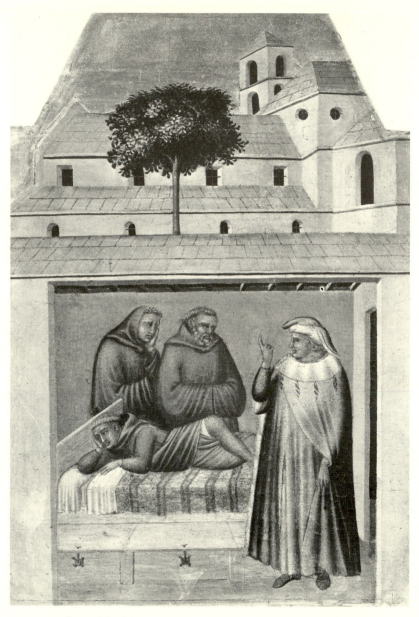

60. Bernardo Daddi (follower of), *Stories of the Blessed Humility* (detail), panel painting, fourteenth century. Florence, Uffizi.

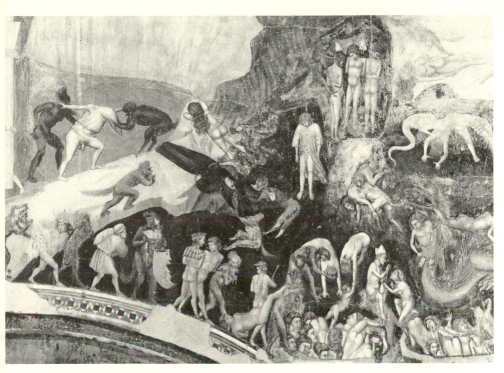

61. Giotto, *Last Judgment* (detail), fresco, beginning of the fourteenth century. Padua, Cappella degli Scrovegni.

62. Maestro delle Vele, *Allegory of Poverty*, fresco, ca. 1334. Assisi, San Francesco, Lower Basilica.

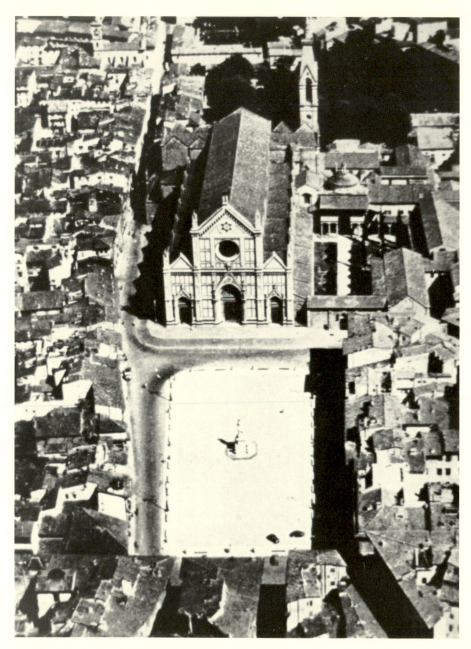

63. View of the Piazza of Santa Croce at Florence.

54. Giotto, *Death of the Cavaliere da Celano*, fresco, end of the thirteenth–beginning of the fourteenth century. Assisi, San Francesco, Upper Basilica.

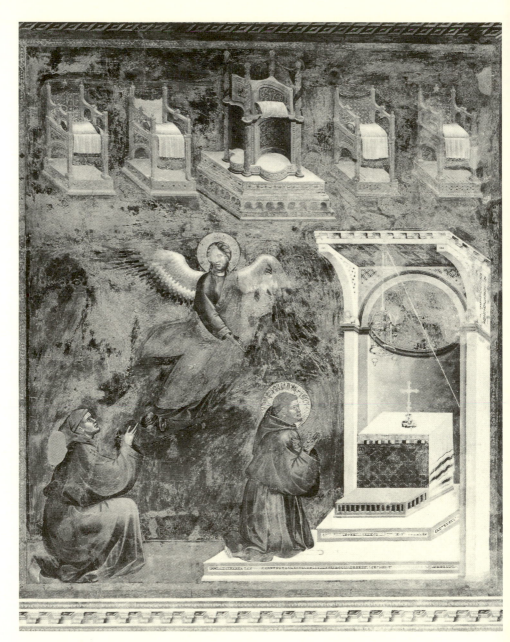

65. Giotto, *Vision of the Thrones*, fresco, end of the thirteenth–beginning of the
fourteenth century. Assisi, San Francesco, Upper Basilica.

66. Masaccio, *The Alms of Saint Peter*, fresco, 1425–1428. Florence, church of the Carmine, Cappella Brancacci.

Vox ecclesie. Quasi cedrus exaltata sum in lybano: humilitate per quá Beati paupes spú. Beatitudo uirtusq: prima:

Vox ecclie. Quasi cypress in monte syon: Pietate p quá Beati mites: qm ipfi possidebt triam. Beatitudo inq: fa..

lybanum

Syon

67. *The Beatitudes*, illumination from Lambert of Saint-Omer, *Liber floridus*, second half of the twelfth century. Wolfenbüttel, Braunschweigische Landesbibliothek, MS Gud. Lat. 1, f. unnumbered.

68. Giotto, *Noli me tangere* (detail), fresco, beginning of the fourteenth century. Padua, Cappella degli Scrovegni.

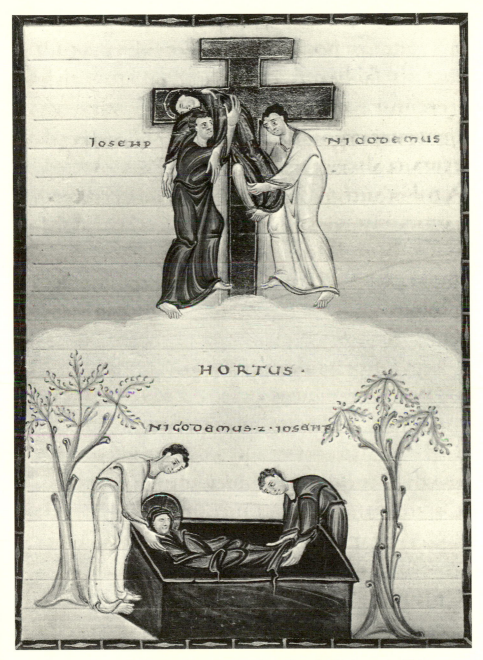

IOSEHP NICODEMUS

HORTUS ·

NICODEMUS · Z · IOSAHP

69. *The Deposition of Christ*, illumination from the codex of Egbert, ca. 980. Trier, Stadtbibliothek, MS 24, f. 85v.

70. Ambrogio Lorenzetti, *Good Government, the Effects in the City (Il Buon Governo, gli effetti in città)*, fresco, 1338–1339. Siena, Palazzo Pubblico, Sala della Pace.

71. Ambrogio Lorenzetti, *Good Government, the Effects in the Country (Il Buon Governo, gli effetti in campagna)*, fresco, 1338–1339. Siena, Palazzo Pubblico, Sala della Pace.

72. Ambrogio Lorenzetti, *Good Government (Il Buon Governo)*, fresco, 1338–1339. Siena, Palazzo Pubblico, Sala della Pace.

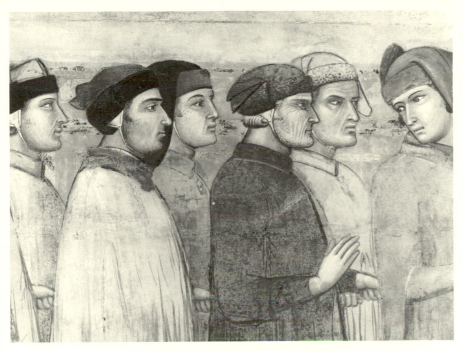

73. Ambrogio Lorenzetti, *The Procession of the Twenty-four* (detail from *Good Government*, fig. 72).

74. Ambrogio Lorenzetti, *Bad Government (Il Mal Governo)*, fresco, 1338–1339. Siena, Palazzo Pubblico, Sala della Pace.

75. Ambrogio Lorenzetti, *Bad Government, the Effects in the City* (*Il Mal Governo, gli effetti in città*), fresco, 1338–1339. Siena, Palazzo Pubblico, Sala della Pace.

76. Ambrogio Lorenzetti, *The Soldiers Destroy the City* (detail of *Bad Government, the Effects in the City*, fig. 75).

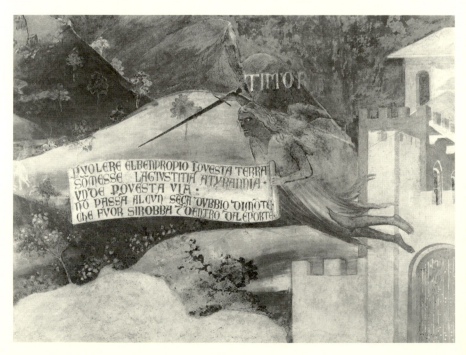

77. Ambrogio Lorenzetti, *Fear (Timor)* (detail of *Bad Government, the Effects in the City*, fig. 75).

78. Duccio di Boninsegna, *Healing of the Blind Man* (detail from the predella of the *Maestà*), panel painting, 1311. London, National Gallery.

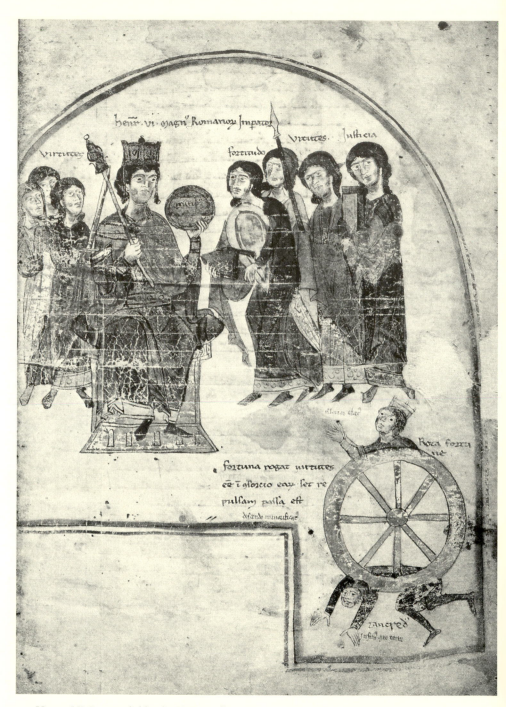

79. *Henry VI Surrounded by the Virtues*, illumination from Pietro da Eboli, *Carmen ad honorem Augusti*, end of the twelfth century. Bern, Burgerbibliothek, MS 120, f. 146r.

80. Ambrogio Lorenzetti, *Concord* (detail from *Good Government*, fig. 72), fresco, 1338–1339. Siena, Palazzo Pubblico, Sala della Pace.

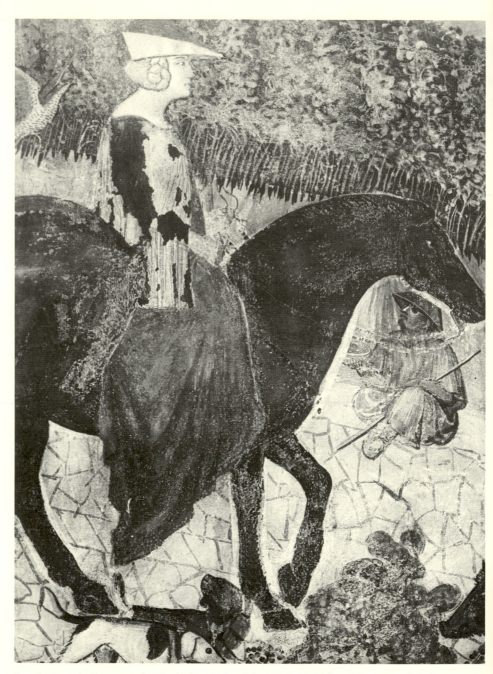

81. Ambrogio Lorenzetti, *The Noble Girl and the Blind Man* (detail from *Good Government*, fig. 71), fresco, 1338–1339. Siena, Palazzo Pubblico, Sala della Pace.

82. Benedetto Antelami (formerly attributed to), *The Just Judge*, capital, twelfth
century. Modena, campanile of the cathedral.

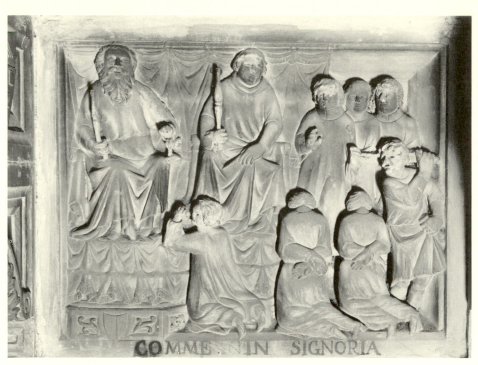

83. Agostino di Giovanni and Angelo di Ventura da Siena, *The Commune Ruling (Il comune in signoria)* (detail from the *Sepulcher of the Bishop Guido Tarlati*), sculpture, 1223. Arezzo, cathedral.

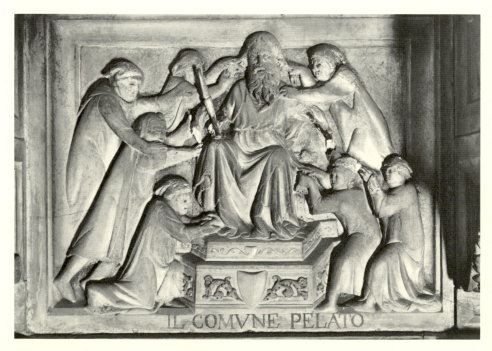

84. Agostino di Giovanni and Angelo di Ventura da Siena, *The Commune Stripped (Il comune pelato)* (detail from the *Sepulcher of the Bishop Guido Tarlati*), sculpture, 1223. Arezzo, cathedral.

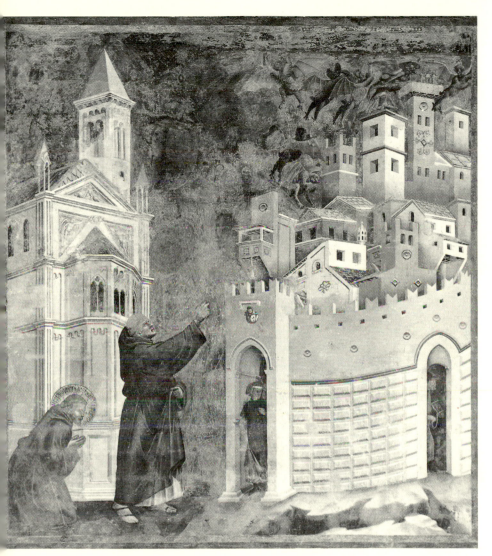

5. Giotto, *San Francesco Drives the Demons from the City of Arezzo*, fresco, end of the thirteenth–beginning of the fourteenth century. Assisi, San Francesco, Upper Basilica.

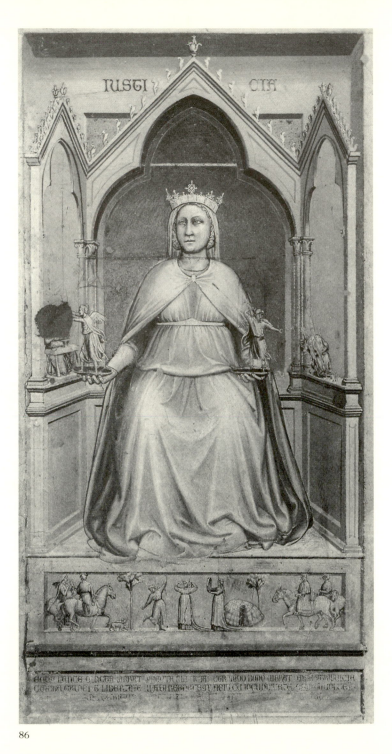

IVSTI CIA

86–87. Giotto, *Justice* and *Injustice*, monochrome fresco, beginning of the fourteenth century. Padua, Cappella degli Scrovegni.

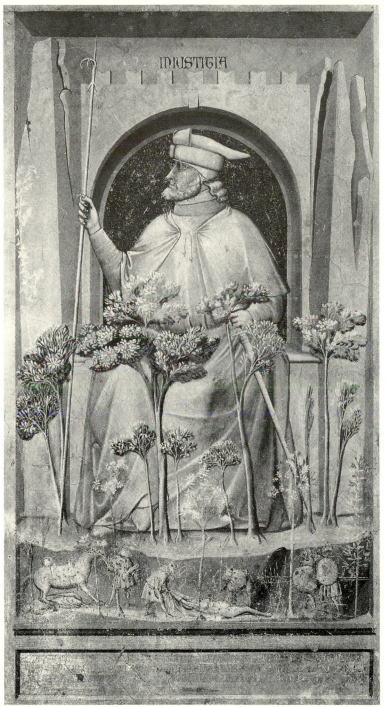

87

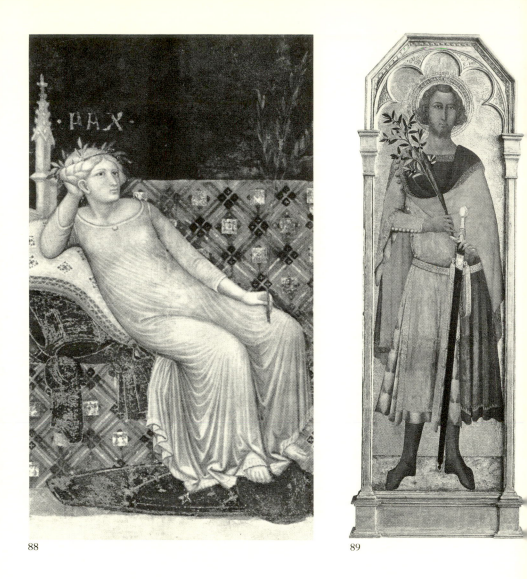

88 89

88. Ambrogio Lorenzetti, *Peace* (detail from *Good Government*, fig. 72), fresco, 1338–1339. Siena, Palazzo Pubblico, Sala della Pace.

89. Lippo Memmi (known from 1317 until 1356), *Saint Victor*, panel. Copenhagen, Statens Museum for Kunst.

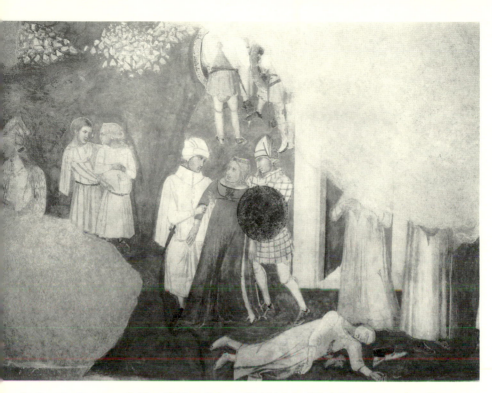

90. Ambrogio Lorenzetti, *Two Soldiers Seize a Girl* (detail of *Bad Government, the Effects in the City*, fig. 75), fresco, 1338–1339. Siena, Palazzo Pubblico, Sala della Pace.

91

91. Niccolò di Tommaso, *Adam and Eve at Work*, fresco, 1372. Pistoia, church of the Cavalieri del Tau.

92. Giovanni Pisano and Nicola Pisano, *The Cities of Perugia, Chiusi, Trasimeno*, sculpture, 1278. Perugia, Fontana Maggiore.

93. Giovanni Pisano and Nicola Pisano, *The Lion and the Pup*, sculpture, 1278. Perugia, Fontana Maggiore.

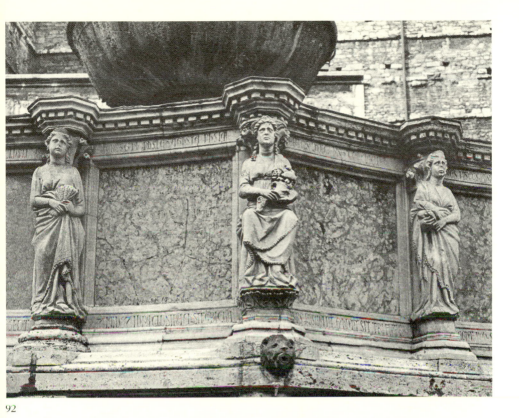

92

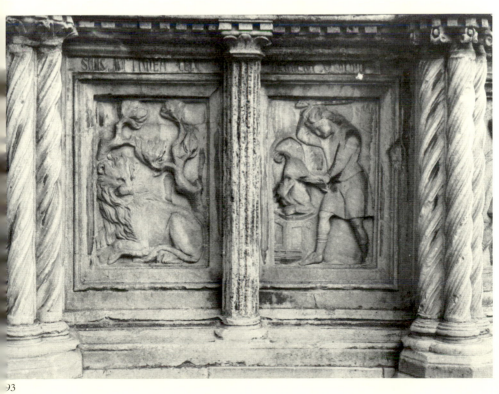

93

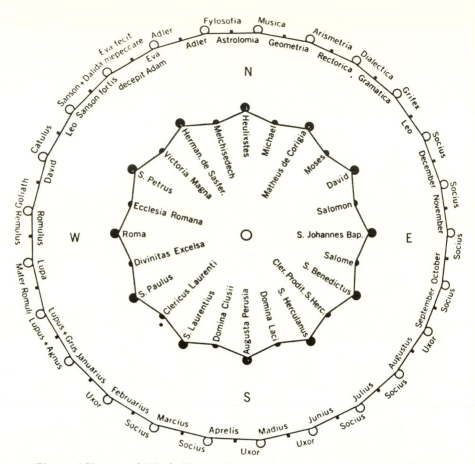

Outer ring (clockwise from top):
Fylosofia · Musica · Adler · Astrolomia · Geometria · Arismetria · Rectorica · Dialectica · Gramatica · Grifex · Leo · Socius · December · November · Socius · October · Socius · September · Socius · Augustus · Uxor · Julius · Socius · Junius · Uxor · Madius · Socius · Aprelis · Uxor · Marcius · Socius · Februarius · Socius · Lupus + Grus Januarius · Lupus + Agnus · Mater Romuli · Lupa · Romulus · Goliath Remulus · David · Catulus · Leo Sanson fortis · Sanson + Dalida mepeccare · Eva fecit · Adler · decepit Adam · Eva

Inner ring:
Heurixstes · Michael · Matheus de Corigia · Moses · David · Salomon · S. Johannes Bap. · Salome · S. Benedictus · Cler. Prodit S. Herc. · S. Herculianus · Domina Laci · Augusta Perusia · Domina Clusii · S. Laurentius · Clericus Laurenti · S. Paulus · Divinitas Excelsa · Roma · Ecclesia Romana · S. Petrus · Victoria Magna · Herman. de Sasfer. · Melchisedech

N · E · S · W

94. Giovanni Pisano and Nicola Pisano, *Fontana Maggiore*, drawing by John White.

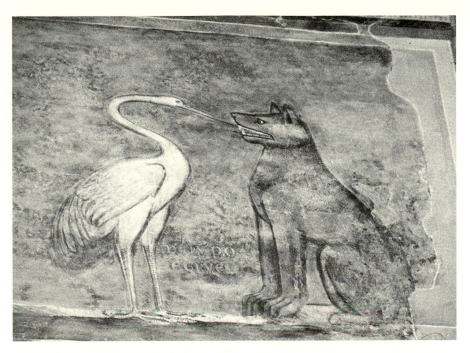

95. Cavallini (follower of), *The Wolf and the Crane*, fresco, beginning of the four-teenth century. Perugia, Palazzo dei Priori, Sala dei Notari.

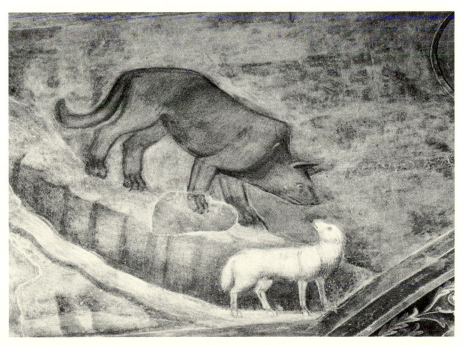

96. Cavallini (follower of), *The Wolf and the Lamb*, fresco, beginning of the four-teenth century. Perugia, Palazzo dei Priori, Sala dei Notari.

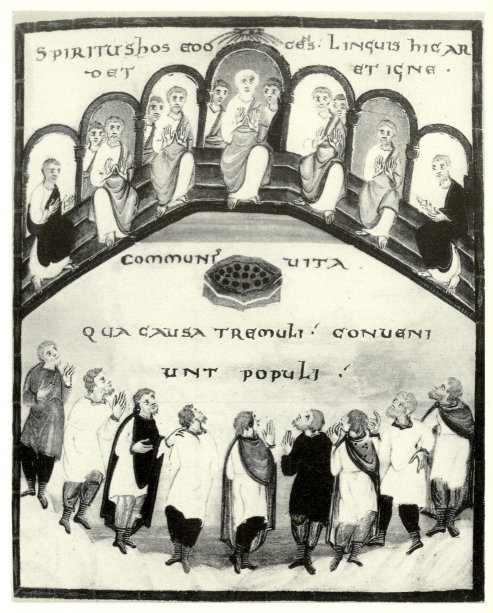

Within the illumination:

SPIRITUS̄ HOS ECCO CĒS̄ LINGUIS HIC AR
DET ET IGNE·

COMMUNIS̄ UITA·

QUA CAUSA TREMULI· CONUENI
UNT POPULI·

97. *The Pentecost*, illumination from the codex of Egbert, ca. 980. Trier, Stadtbib-
liothek, MS 24, f. 103r.

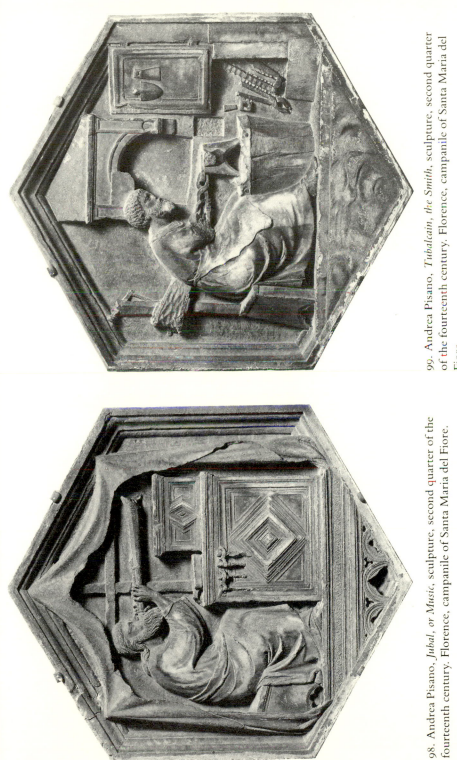

99. Andrea Pisano, *Tubalcain, the Smith*, sculpture, second quarter of the fourteenth century. Florence, campanile of Santa Maria del Fiore.

98. Andrea Pisano, *Jubal, or Music*, sculpture, second quarter of the fourteenth century. Florence, campanile of Santa Maria del Fiore.

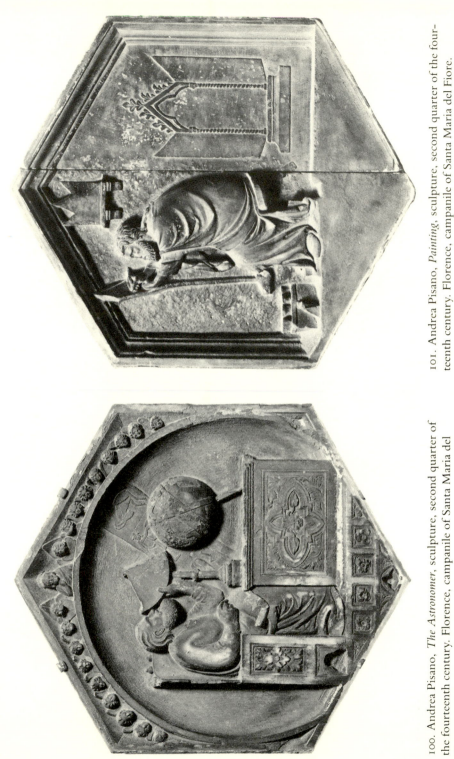

101. Andrea Pisano, *Painting*, sculpture, second quarter of the fourteenth century. Florence, campanile of Santa Maria del Fiore.

100. Andrea Pisano, *The Astronomer*, sculpture, second quarter of the fourteenth century. Florence, campanile of Santa Maria del Fiore.

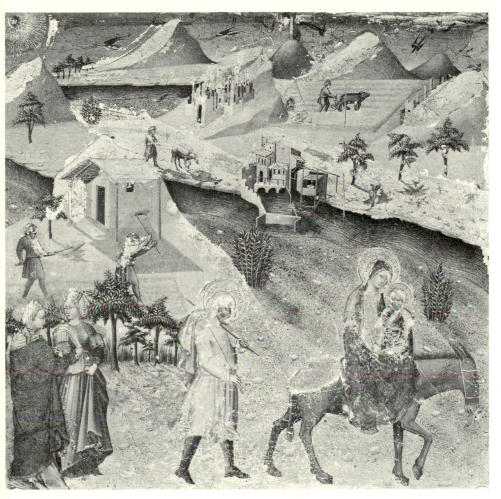

102. Giovanni di Paolo, *Flight into Egypt*, panel painting, 1436. Siena, Pinacoteca
Nazionale.

103. Ambrogio Lorenzetti, *Landscape with a Scene of Ploughing and a Watermill* (detail, reversed, from *Good Government, the Effects in the Country*, fig. 71), fresco, 1338–1339. Siena, Palazzo Pubblico, Sala della Pace.

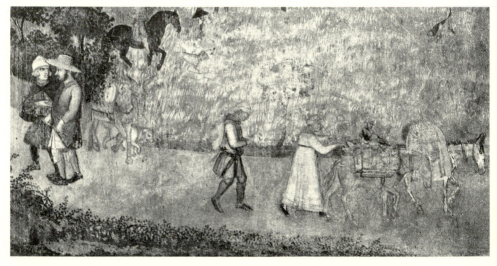

104. Ambrogio Lorenzetti, *The Family in the Countryside* (detail from *Good Government, the Effects in the Country*, fig. 71).

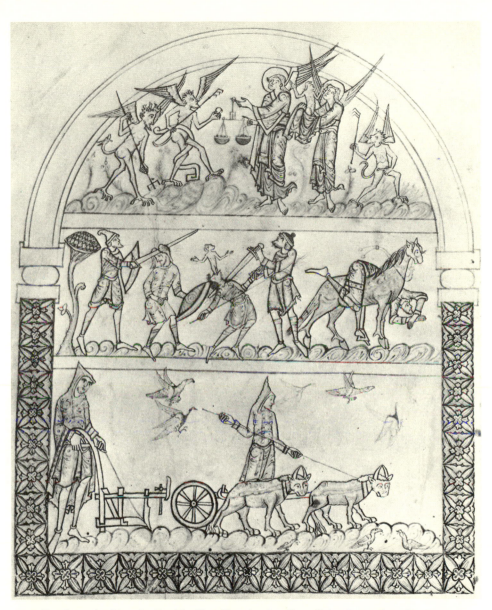

105. *The Heavenly City, the Earthly City*, illumination from Saint Augustine, *De civitate Dei*, ca. 1125. Florence, Biblioteca Laurenziana, MS 12.17, f. 1v.

DATE DUE

co, Inc. 38-293